FRAMES OF REFERENCE Looking at American Art, 1900–1950

FRAMES OF REFERENCE

Looking at American Art, 1900–1950
Works from the Whitney Museum of American Art

Beth Venn and Adam D. Weinberg, *editors*

with an essay by Kennedy Fraser
and contributions by

Robert Adams
Maurice Berger
Alan M. Dershowitz
Marianne Doezema
Charles Eldredge
Lewis Erenberg
Howard Gardner
Peter Gay
Brendan Gill
Henry Glassie
Elliott J. Gorn
Neil Harris
Kathryn Harrison
Alfred Kazin
Lisa Mahar
Karal Ann Marling
Richard Martin
Patricia McDonnell

Angela Kramer Murphy
Kathleen Norris
Brian O'Doherty
Sarah Whitaker Peters
Henry Petroski
George Plimpton
Frances K. Pohl
Kathryn Potts
Martin Puryear
Kate Rubin
Ellen M. Snyder-Grenier
John Updike
Naomi Urabe
Beth Venn
Anne M. Wagner
Adam D. Weinberg
Robert Wilson
John Yau

WHITNEY MUSEUM OF AMERICAN ART, NEW YORK

in association with UNIVERSITY OF CALIFORNIA PRESS
BERKELEY · LOS ANGELES · LONDON

Support for this publication was provided by Sotheby's.

Research for Museum publications is supported by an endowment established by The Andrew W. Mellon Foundation and other generous donors.

A portion of the proceeds from the sale of this book benefits the Whitney Museum of American Art and its programs.

Front cover (clockwise, from top left): John Storrs, *Forms in Space #1*, p. 70; Joseph Stella, *The Brooklyn Bridge*, p. 114; Edward Hopper, *Early Sunday Morning*, p. 176; Arthur Dove, *The Critic*, p. 72; George Bellows, *Dempsey and Firpo*, p. 146.
Back cover (left to right): Man Ray, *La Fortune*, p. 94; Marsden Hartley, *Painting, Number 5*, p. 204; Richard Pousette-Dart, *Within the Room*, p. 102.

LIBRARY OF CONGRESS CATALOGING-IN-PUBLICATION DATA
Whitney Museum of American Art.
Frames of reference : looking at American art, 1900–1950 : works from the Whitney Museum of American Art / Beth Venn and Adam D. Weinberg, editors ; with an essay by Kennedy Fraser and contributions by Robert Adams ... [et al.].
 p. cm.
Includes bibliographical references.
ISBN 0-87427-111-8 (Whitney : paper : alk. paper)
ISBN 0-520-21887-6 (UCP : cloth : alk. paper)
ISBN 0-520-21888-4 (UCP : paper : alk. paper)
1. Whitney Museum of American Art Catalogs. 2. Art, American Catalogs. 3. Art, Modern—20th century—United States Catalogs. 4. Art—New York (State)—New York Catalogs. I. Venn, Beth. II. Weinberg, Adam D. III. Fraser, Kennedy. IV. Title.
N6512 .W532 1999
709'.73'0747471—dc21
99-36420
CIP

Printed and bound in Italy
9 8 7 6 5 4 3 2 1

AHMANSON · MURPHY
FINE ARTS IMPRINT

THE AHMANSON FOUNDATION

has endowed this imprint

to honor the memory of

FRANKLIN D. MURPHY

who for half a century

served arts and letters,

beauty and learning, in

equal measure by shaping

with a brilliant devotion

those institutions upon

which they rely.

LOVE AND STRUGGLE: GERTRUDE VANDERBILT WHITNEY

VISUAL CONTEXTS FOR AMERICAN ART

AMERICAN ICONS INTERPRETED

The Whitney Museum of American Art's seventy-year commitment to art from the first half of the twentieth century has been unwavering. Whether speaking in a contemporaneous voice or a retrospective one, the Museum has never taken a simple posture of critical detachment, preferring instead to actively engage the work of living American artists as both an advocate and an interpreter. This approach has enabled us to take risks in collecting and interpreting that keep pace with the innovative spirit and open-ended creativity of our nation's artists. The structure of *Frames of Reference* reflects this unbounded diversity through an unusual three-part format that encourages a variety of perspectives from a wide range of scholars and writers. Their participation has helped to broaden our understanding of the masterworks in the Whitney's Permanent Collection. One further advantage accrues from the multifaceted viewpoints expressed in this book: seeing today's critics look back to earlier art from the vantage of present-day concerns opens fertile territory for speculation about the future.

Gertrude Vanderbilt Whitney, who founded the Museum in 1930, set this speculative dimension in motion by championing American artists, most of whom were then marginalized in the Eurocentric parlors and museum boardrooms of the Eastern seaboard. The first three curators at the Whitney were themselves artists, and Mrs. Whitney, aided by Juliana Force, the Museum's first director, assumed the role of patron-curator—an unusual position in the then culturally insecure United States. In Europe, however, noble and royal patrons had for centuries created a platform for artistic expression by unproven artists and then provided these artists with the means of support. The Museum continues this tradition today in the Whitney Biennials, where some of the participating artists are commissioned to make new work specifically for the exhibition, and in the Anne & Joel Ehrenkranz Gallery in the Lobby, which hosts the new

Contemporary Series, an ongoing series dedicated to presenting recent work by American artists.

Frames of Reference, with its divergent and sometimes contradictory interpretations of pivotal works of American art, continues this tradition of speculation. The texts offer different methodologies for studying art and thus encourage the reader to play an active role in considering works both familiar and little known, in the Whitney's collection and beyond.

Work on this publication began during the tenure of my predecessor, David A. Ross, and it is a great pleasure to see it to completion. The Whitney Museum strives to be the leading center for American art scholarship and education, and *Frames of Reference* represents one step in the pursuit of this goal. Adam D. Weinberg, former senior curator at the Whitney and now director of the Addison Gallery of American Art, conceived the unconventional and innovative approach of this publication and then worked to realize the project with curator Beth Venn, who deserves special thanks for shepherding the book to completion. Together, they selected the writers, with Julie Grau's assistance in the literary field, and also contributed texts of their own. Collectively, this remarkable group of thirty-seven writers—which includes scholars, historians, and artists—represents a broad scope of American life and thought. The Whitney greatly appreciates their efforts and insights. We are also grateful to Sotheby's, which generously provided support for the publication costs.

We hope that you accept this invitation to participate in a fresh consideration of American art of the first fifty years of this century and that your next visit to the Whitney will be all the more rewarding.

Maxwell L. Anderson
Director, Whitney Museum of American Art

How and why an art work earns a place in a museum collection is a complex and, for most people, a mysterious process. There is, of course, some consensus regarding a work's perceived "intrinsic quality" and its value in relation to other objects. But such judgments and values can shift depending on who is looking at a work—a patron, a critic, another artist, the public—and when, in what cultural or aesthetic climate? Divergent opinion is therefore as natural to the reception of a work of art as consensus. It is for this reason that *Frames of Reference*, unlike the typical collection catalogue, does not aim for a single, consistent, and omniscient voice. Rather, the volume highlights different readings of selected works from 1900 to 1950 in the Whitney Museum's Permanent Collection. Focusing on varieties of interpretation also keeps the controversial, founding spirit of the Museum alive along with the independent, experimental approaches of the artists themselves, many of whom had a close personal relationship to the Whitney.

To reflect the diversity of these creative spirits and the varied audiences that have been responding to their art for generations, *Frames of Reference* is conceived of as three volumes in one, each building on the others, addressing different topics, and employing different methodologies. The first "book" takes the form of a biography of Gertrude Vanderbilt Whitney and covers the decades that led to the opening of the Whitney Museum in 1931. This engagingly penned profile by Kennedy Fraser reveals how the early Whitney Museum, in all its splendid multiplicity, was the embodiment of the founder herself in her roles as benefactor, artist, and collector, not to mention daughter, wife, and mother. It was an institution that by today's standards would be seen as part foundation, part artist organization, and part museum. The youthful Whitney Museum was idealistic, passionate, embattled, and full of contradictions. How, for

example, could a museum collect the "best" art while simultaneously, following Mrs. Whitney's policy, purchase works by artists in need, no matter how serious or professional?—a contradiction that plagued and enlivened the Whitney for decades.

If the opening chapter is devoted to the life of an individual and, by extension, a museum, the second is devoted to the "lives of objects." Here the narrative is expressed as much in images as in words. Twenty-six key objects in the Whitney's Permanent Collection—paintings, sculptures, and works on paper—are treated from varying aesthetic, social, cultural, and biographical perspectives. The images are used not to illustrate a text in the traditional manner, but to suggest visual parallels, draw connections, make comparisons, raise questions, and propose interpretations. The purpose is to stimulate visual thinking and to allude to the numerous potential readings that are possible with any object. Rather than a single running text, extended captions provide signposts for multiple interpretations. Reginald Marsh's *Twenty Cent Movie*, for example, is envisioned as a reflection of the artist's passion for film and his directorial approach to art making. The images and captions further reveal how Marsh used a mix of observational tools—photographs and a sketch—to produce his final works, that "photographic aesthetics"—framing and cropping—influenced his compositional structure, and, finally, that his painting captures a particular moment in the history of the United States, New York City, and the film industry. Although central topics are identified for all twenty-six objects, our intention is not to provide a single, conclusive statement about each work, but rather to open a portal that allows the work to be accessed through a variety of approaches.

The third section of *Frames of Reference* focuses on ten icons in the Whitney Museum's Permanent Collection, works that immediately call to mind some of the greatest achievements of twentieth-century American art. Paradoxically, these images are generally so well known and so extensively written about that it is difficult to experience them with fresh eyes and an open mind. Unlike the multiple images in section two, this section depends on words that offer variant views of a single image. For each of the ten icons, the words are those of three different writers from different disciplines. The thirty authors range from artists, novelists, and art, literary, and cultural historians to a lawyer, a civil engineer, a theater director, and a psychologist. The writers were asked to explore what they found significant in the work. Our aim was to provide three distinctive verbal experiences, no matter whether they complemented one another or engendered conflicts.

Frames of Reference is designed to encourage casual reading, to replicate the experience of walking through the galleries and viewing the works themselves. The wide range of ideas and opinions found in these pages can stimulate readers' own thoughts and critical judgments as well as validate multiple and personal interpretations of art. Understanding any art work involves visual perception, aesthetic interpretation, psychology, historical, social, and political investigation, and technical analysis. What makes great art great is its multivalent effectiveness, its infinite complexity, and its capacity to be concise and comprehensible even as it remains open-ended. This guide to the Whitney Museum embraces some of the numerous strategies for understanding art and, ultimately, the pleasures of looking at it.

Adam D. Weinberg

The Whitney
Biography of an Institution

Exhibition titles are in **boldface**.

1907 Gertrude Vanderbilt Whitney, a wealthy thirty-two-year-old socialite and trained sculptor, begins her patronage of American art by organizing an exhibition of younger American artists at the Colony Club, New York.

1908 From the controversial exhibition of The Eight, the revolutionary artists who depicted the people and places of ordinary urban life, Mrs. Whitney buys four of the seven paintings sold.

1914 Mrs. Whitney purchases a brownstone at 8 West 8th Street and opens the Whitney Studio, an exhibition space and social center for young progressive artists.

1915 Mrs. Whitney leads the formation of the Society of Friends of the Young Artists, an organization that assists needy American artists and holds exhibitions in the Whitney Studio.

1918 Mrs. Whitney formally establishes the Whitney Studio Club at 147 West 4th Street, instituting nonjuried annual survey exhibitions of its members' work. During the decade of its existence, the Club (which moved to 8th Street in 1923) also hosts regular life-drawing classes and social events and mounts more than eighty-six exhibitions—including twenty-eight one-artist shows—promoting the work not only of established artists such as John Sloan and William J. Glackens, but also of lesser-known figures such as Edward Hopper and Reginald Marsh.

1924–25 Artist members of the Whitney Studio Club organize a series of exhibitions of work by their contemporaries; Charles Sheeler's show is "Works of Picasso, Marcel Duchamp, Marius de Zayas and Georges Braque" (1924).

1925 The Whitney Studio Club annual exhibition is so large that, for the first time, it is held off-site at the Anderson Galleries. A *New Yorker* critic calls it "the most important American show of the year."

1928 With four hundred members and four hundred more artists on a waiting list, the Whitney Studio Club closes its doors on May 15. Director Juliana Force explains that it has "not only fulfilled its purpose, but has outgrown itself" as an artists' club. It is replaced briefly by the Whitney Studio Galleries (1928–30), which focuses on exhibitions of contemporary art.

1929 Recognizing the need to highlight American art in an appropriate museum setting, Mrs. Whitney offers to give her entire collection of five hundred works by American artists to The Metropolitan Museum of Art. The gift is refused, and she resolves to establish her own museum.

1931 On November 18, the Whitney Museum of American Art opens its doors to the public in three brownstones on West 8th Street remodeled by the architectural firm of Noel and Miller. Juliana Force becomes the first director. The nucleus of the Museum's Permanent Collection is Mrs. Whitney's gift of some five hundred paintings, drawings, prints, and sculptures from her own collection, augmented by about one hundred works purchased by her for the Museum before it opened. Unlike more established museums, the Whitney declares its commitment to living artists through its exhibitions and by hiring artists as curators: Hermon More, Karl Free, and Edmund Archer.

1932 The Museum's first **Biennial Exhibition of Contemporary American Painting** continues the Studio Club's tradition of nonjuried exhibitions that survey new American art. In addition, a $20,000 annual acquisition fund is established to purchase works from these exhibitions for the Museum's collection. The Whitney Biennial remains a major feature of the Museum's exhibition program and an important showcase for current artistic achievements.

1934 **Maurice Prendergast Memorial Exhibition**

1936 **Winslow Homer Centenary Exhibition**

1937 Biennials are replaced by Annuals, which alternate between painting and sculpture. (Biennials resume in 1973.)

Charles Demuth Memorial Exhibition

1938 The Ten, a group of rebellious young artists— primarily expressionist painters such as Mark Rothko and Adolph Gottlieb—accuse the Whitney of a bias toward representational art. In November, The Ten hold a group show, "The Ten Whitney Dissenters," at the Mercury Galleries across the street from the Museum.

William J. Glackens Memorial Exhibition

1939 The Museum adds four new galleries, nearly doubling its exhibition space.

1942 Gertrude Vanderbilt Whitney dies, leaving $2.5 million to the Whitney Museum. Her daughter, Flora Whitney Miller, becomes president of the Museum (until 1966).

A History of American Watercolor Painting

1943 **Gertrude Vanderbilt Whitney Memorial Exhibition**

1946 **Pioneers of Modern Art in America**

1947 Negotiations are underway for a "Three Museum Agreement" to delineate the collection and exhibition priorities of The Metropolitan Museum of Art, The Museum of Modern Art, and the Whitney Museum of American Art. A year later, concerned that it will be unable to retain its distinct identity, the Whitney abandons the agreement.

Albert P. Ryder Centenary Exhibition

1948 Juliana Force dies. Hermon More becomes director.

The Whitney modifies its original policy of not giving one-artist exhibitions to living artists; Yasuo Kuniyoshi, Max Weber, and Edward Hopper are soon given retrospectives. The Museum begins to accept gifts of works of art.

The first work to enter the Whitney's Permanent Collection neither given by Gertrude Vanderbilt Whitney nor paid for by her funds is Ben Shahn's *The Passion of Sacco and Vanzetti* (1931–32), donated in 1949 by Edith and Milton Lowenthal in memory of Juliana Force.

1949 All pre-1900 works in the Collection are deaccessioned and the proceeds are used to fund purchases of contemporary American art. The Juliana Force Purchase Fund, for the annual acquisition of a work by an artist under thirty years of age, is established.

1950 **Edward Hopper Retrospective Exhibition**

1951 **Arshile Gorky Memorial Exhibition**

1952 **John Sloan Retrospective**

1954 The Museum moves to a new building on West 54th Street, designed by Auguste L. Noel, on land donated by The Museum of Modern Art. Annual attendance grows from 70,000 to 260,000. The Permanent Collection holdings increase to about 1,300 works.

1955 **Reginald Marsh**

1956 A group of public-spirited collectors and art patrons establishes the Friends of the Whitney Museum, the Museum's first membership group devoted to raising funds for the purchase of contemporary art.

Charles Burchfield

1957 To recognize new talent among American artists, the Whitney launches a series of shows titled **Young America**, which include work by Jim Dine, Richard Stankiewicz, and Lucas Samaras. The series continues until 1965.

Hans Hofmann Retrospective Exhibition

Stuart Davis

1958 **Arthur G. Dove**

Lloyd Goodrich, formerly a curator at the Museum, becomes director.

1960 **Milton Avery Retrospective Exhibition**

The Precisionist View in American Art

1961 The Board of Trustees, once composed entirely of Whitney family members, is expanded to include Trustees from outside the family.

1962 **Marsden Hartley**

1963 **Joseph Stella**

1964 **Edward Hopper**

1966 To better accommodate the Whitney's expanding program of acquisitions, exhibitions, and publications, the Museum moves to its present building at 945 Madison Avenue, designed by Marcel Breuer, with his partner, Hamilton Smith, and Michael Irving, consulting architect. During the first year, a record 741,408 people visit the Museum. The Permanent Collection grows to approximately two thousand works.

David M. Solinger becomes the first Museum president outside the Whitney family (serves until 1974).

1967 The Whitney Museum Independent Study Program (ISP) is established, giving advanced students the opportunity to pursue art practice, curatorial work, art historical scholarship, and critical writing.

Louise Nevelson

1968 **Donald Judd**

John I.H. Baur becomes director.

The Painting and Sculpture Acquisition Committee is established.

The entire artistic estate of the late Edward Hopper is bequeathed to the Whitney Museum by his widow, Josephine Nivison Hopper. The collection numbers about 2,500 oils, watercolors, drawings, and prints, and is the largest gift of a single artist's work made to any American museum.

1969 **Anti-Illusion: Procedures/Materials**

1970s The Whitney's sculpture collection grows dramatically thanks to generous gifts from Howard and Jean Lipman.

1970 **Georgia O'Keeffe Retrospective Exhibition**

The Whitney's first Film Department is established under David Bienstock. The New American Filmmakers Series (later renamed the New American Film and Video Series), is launched to support the work of independent, noncommercial American filmmakers. A year later, the Whitney becomes the first museum in New York to present a major exhibition of the new art form of video.

1972 **James Rosenquist**

1973 The first Whitney branch opens at 55 Water Street in Lower Manhattan and serves as a curatorial laboratory for the Independent Study Program until 1979. After moving to several different locations, the Downtown Branch closes in 1984. It later reopens at Federal Reserve Plaza (1988–92).

1974 Howard Lipman becomes president of the Museum (until 1977) and Thomas N. Armstrong III is appointed director.

1975 **Mark di Suvero**

The Whitney acquires Frank Stella's *Die Fahne Hoch* as a partial gift and purchase at a record price for the Museum, marking a new era of commitment to attain masterpieces through specially raised purchase funds.

1976 **200 Years of American Sculpture**

The Drawing Acquisition Committee is formed under the chairmanship of Dr. Jules D. Prown. Paul Cummings is hired as adjunct curator of drawings.

The landmark exhibition **Calder's Universe**, organized by Jean Lipman, draws almost 250,000 visitors.

1977 Flora Miller Biddle (formerly Irving), granddaughter of Gertrude Vanderbilt Whitney, becomes president of the Museum (until 1985).

The third largest gift in the history of the Whitney Museum, the Lawrence H. Bloedel Bequest, is donated by the late Trustee; it includes paintings by Milton Avery, Charles Demuth, Georgia O'Keeffe, Larry Rivers, and Charles Sheeler.

Jasper Johns, the largest international traveling exhibition of the work of an American artist, opens at the Whitney.

1978 Felicia Meyer Marsh, the widow of Reginald Marsh, bequeaths a substantial number of her husband's paintings, oil studies, drawings, and sketches, giving the Museum the most significant collection of Marsh's work. Included in the bequest are works by other artists, such as Isabel Bishop, Yasuo Kuniyoshi, and John Sloan.

1980 **Louise Nevelson: Atmospheres and Environments**

Concentrations is inaugurated—a Permanent Collection exhibition series highlighting the works of major artists: **Maurice Prendergast** (1980); **Gaston Lachaise** (1980); **John Sloan** (1980); **Charles Burchfield** (1980); **Stuart Davis** (1980); **Charles Sheeler** (1980); **Ad Reinhardt** (1980); **Alexander Calder** (1981); **Georgia O'Keeffe** (1981).

Edward Hopper: The Art and the Artist

The National Committee is established, consisting of up to fifty patrons and collectors of American art from various parts of the country who sponsor exhibitions of Whitney works and related programs at other American institutions.

The Museum's 50th Anniversary celebration is marked by the donation of approximately ninety sought-after works by artists such as Calder, Gorky, Hartley, Hopper, Lachaise, Nevelson, O'Keeffe, Prendergast, Rauschenberg, Reinhardt, and Sloan.

Jasper Johns' *Three Flags* (1958) is acquired.

1981 The Whitney devotes its third floor to an installation of more than seventy masterworks from the Permanent Collection (until 1989).

The Whitney Museum at Champion opens in Stamford, Connecticut, in the headquarters of Champion International Corporation.

1982 **Nam June Paik**

1983 Alexander Calder's *Calder's Circus*, which had been placed on deposit at the Museum by the artist in 1970, is purchased from the artist's estate after a public fund-raising campaign.

The Whitney Museum at Philip Morris opens in the headquarters of Philip Morris Incorporated, Park Avenue and 42nd Street.

1984 **Blam! The Explosion of Pop, Minimalism, and Performance 1958–1964**

Jonathan Borofsky

1986 William S. Woodside becomes president of the Museum (until 1990).

John Singer Sargent

The Whitney Museum at Equitable Center opens in the headquarters of The Equitable, 7th Avenue and 52nd Street (until 1992).

1989 **Image World: Art and Media Culture**

Art in Place: Fifteen Years of Acquisitions

1990 Leonard A. Lauder becomes president of the Museum (until 1994).

Fiona Irving Donovan, great-granddaughter of Gertrude Vanderbilt Whitney, is elected to the Board of Trustees.

The New Sculpture 1965–75: Between Geometry and Gesture

1991 David A. Ross becomes director.

The Photography Acquisition Committee is established. Sondra Gilman Gonzalez-Falla is elected chairperson.

1992 **Agnes Martin**

1993 The Whitney inaugurates the **Collection in Context** exhibition series, which brings a fresh perspective to key works in the Permanent Collection. Among the exhibitions are: **Gorky's Betrothals** (1993); **Joseph Cornell: Cosmic Travels** (1995); **Willem de Kooning's Door Cycle** (1996); **Rockwell Kent by Night** (1997).

The Whitney acquires the twelve-panel painting *The Islands* (1979) by Agnes Martin, her most ambitious painting to date and the only multipaneled work in her oeuvre.

1994 Gilbert C. Maurer becomes president of the Museum (until 1998).

Joseph Stella

The Whitney begins a landmark collaboration with the San Jose Museum of Art to organize a series of four major exhibitions from the Whitney's Permanent Collection at San Jose over a period of six years.

Black Male: Representations of Masculinity in Contemporary American Art

1995 **Edward Hopper and the American Imagination**

Gerald Murphy's *Cocktail* (1927) is purchased, one of only fourteen paintings produced by this important American modernist.

Views from Abroad: European Perspectives on American Art is inaugurated. This series of three collaborative exhibitions is organized in conjunction with the Stedelijk Museum, Amsterdam (1995); Museum für Moderne Kunst, Frankfurt (1996); and the Tate Gallery, London (1997).

1996 The Whitney acquires a major group of American prints from the Philadelphia Museum of Art, including key works by Peggy Bacon, Mabel Dwight, Reginald Marsh, Charles Sheeler, John Sloan, and Raphael Soyer.

1997 Construction begins on a renovation and expansion project. Designed by Richard Gluckman and David Mayner Architects, it will provide exhibition space on the Museum's fifth floor for the growing Permanent Collection.

1998 **Bill Viola**

The Whitney acquires fifteen oils and gouaches by Ad Reinhardt, making the Museum's Permanent Collection the largest single holding of Reinhardt's work in the United States.

The Leonard & Evelyn Lauder Galleries on the fifth floor open to the public, the first Permanent Collection galleries in the Museum's history. The eleven new galleries highlight works created between 1900 and 1950. Overall exhibition space is increased by thirty-three percent. The Permanent Collection today consists of approximately thirteen thousand works representing more than 1,900 artists.

Maxwell L. Anderson becomes director. Joel S. Ehrenkranz becomes president.

Brice Marden donates seven major drawings and a workbook to the Permanent Collection, the first time he has donated drawings to a museum. The Whitney's collection of Marden drawings is the largest in the world.

1999 **The American Century: Art & Culture 1900–2000**

The Whitney mounts its most comprehensive presentation of American art, a two-part exhibition that explores the history and impact of American art over the past century.

2000 **2000 Biennial Exhibition**

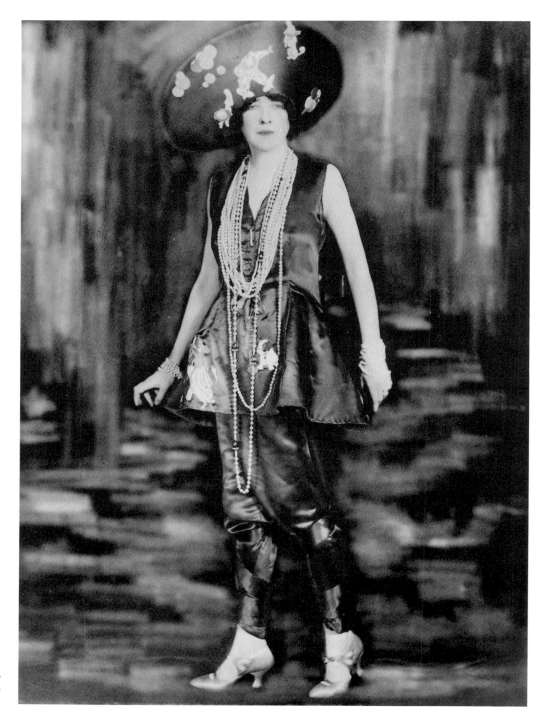

Gertrude Vanderbilt Whitney
dressed for a party, possibly a
Beaux-Arts ball, c. 1910.

Kennedy Fraser

Love and Struggle:
Gertrude Vanderbilt Whitney

Gertrude Vanderbilt Whitney, the founder of the Whitney Museum of American Art, was a tall, thin woman with very white skin and very black hair. In her prime, she wore red lipstick and exquisite, exotically colored clothes. She was not a great beauty, but she had enormous style. Her eyes, under strong black brows, had a light in them; her narrow, long-fingered, and flexible hands were expressive. If the hands were narrow, the life was large. She lived through great changes, public and private, and it was said after her death in 1942 that there "was not a contemporary artist of note in America who has not been helped by her." She was an artist herself, before she became a patron. Much of the sculpture she created was commissioned work for outdoor sites—often oversize figures, with outstretched arms, and on a scale as generous as her gifts to American art and artists.

Both the sculpture and the discovery of how to use her inherited wealth in a fresh way were creative acts for Gertrude Whitney. She arrived at them only after a painful inner journey. She once planned a design for her own sarcophagus, with figures symbolizing Love and Struggle. We know a lot about her because from her childhood on she documented her inner life in a mass of private writings: journals, diaries, affirmations, pep talks to herself, self-reproaches, unpublished autobiographical fiction, copies of

She was, from youth, a passionate Romantic, yearning for the spiritual elevation of Art and Love.

letters sent and unsent. And, outwardly, her person was in the public eye, beginning with her birth in 1875 as the older daughter of Cornelius II, head of the Vanderbilt family, which was then the richest in America. Over the years, there would be thousands of photographs, scores of portraits in different media—many of them commissioned by her in order to put money in the pockets of friends who were artists. She once suggested that Guy Pène du Bois paint her portrait, because she had asked him to take her to the opera and then discovered he couldn't afford a set of evening clothes. She was a complicated person—vain yet shy, liberated yet conventional, secretive yet brazen, selfish yet humble. She was sophisticated about self-presentation.

A photographer visited her in her Macdougal Alley studio, in Greenwich Village, at the beginning of the 1920s. There she perches, up on her sturdy sculpture stand (nothing was ever broken or wobbly in any of her various studios, for she could afford the best equipment and assistants) next to a 9-foot-high figure of a nude youth, who seems to dwarf her. She's dressed not in her usual jewels and couture clothes but in a wraparound smock, with a bandanna on her hair. Her left hand is on her hip, as if she's the signora of one of the cheap spaghetti houses favored by the neighborhood's artists and writers. But the sheerness of the stockings on her slender ankles, and the elegance of the shoes on high-arched feet give the game away; she is the wealthiest working sculptor in the world. At first glance, with her long, pale face, she seems to be peering at us timidly like a small

Over the years, [she commissioned] thousands of photographs, scores of portraits in different media—many of them...in order to put money in the pockets of friends who were artists.

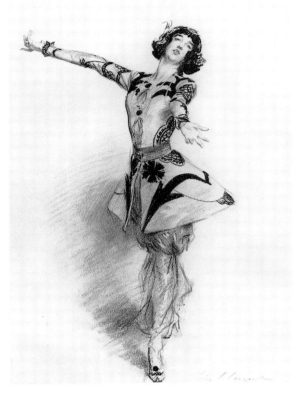

John Singer Sargent
Gertrude Vanderbilt Whitney,
c. 1913
Conté, charcoal, and graphite
on paper, 24 3/8 x 19 3/4 in.
(61.9 x 50.2 cm)
Whitney Museum of American
Art, New York; Gift of Flora
Miller Biddle, Pamela T.
LeBoutillier, Whitney Tower,
and Leverett S. Miller 92.22

Sargent sketched Gertrude in
an Oriental costume designed
for her by Léon Bakst, the
costume designer for Sergei
Diaghilev's Ballets Russes.

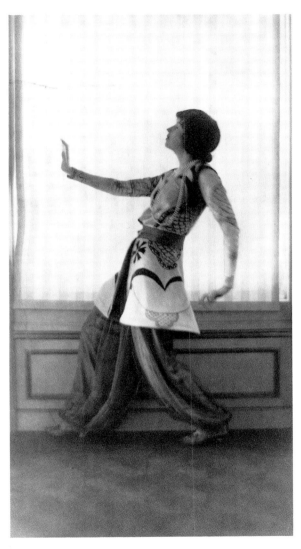

Baron Adolph de Meyer
Gertrude Vanderbilt Whitney,
c. 1913
Gelatin silver print, 9 1/4 x
4 7/8 in. (23.5 x 12.4 cm)
Private collection

Baron de Meyer, a fashion
photographer, photographed
Gertrude in the same exotic
costume in which she posed for
Sargent.

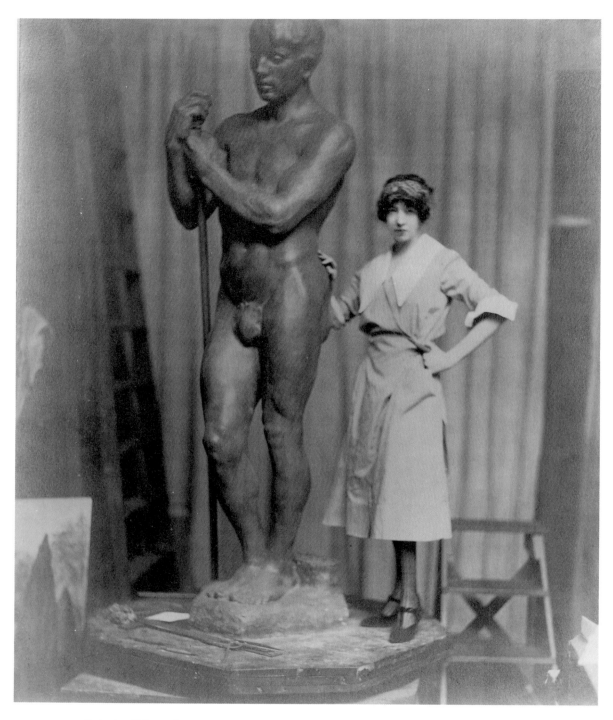

Gertrude with her sculpture
*Shepherd (Memorial to
Herman B. Duryea)*, 1921.

"You don't know what the position of an heiress is!" she confided to her journal with a sigh. **"There is no one in all the world who loves her for herself."**

forest creature. The hand she has placed on her big, cold nude looks detachedly casual. Then we see the defiance with which she stares at the lens, and the proprietary, sensual way the slender hand is resting on the sculpture's muscled buttock. This is one girl-child of the Gilded Age, one society matron who has traveled far, we feel—who has undergone a metamorphosis.

Gertrude Vanderbilt Whitney's art, her life among artists, and her encouragement of artists through purchases and exhibitions (first in her own studio, then in a series of galleries she sponsored on 8th Street) all seem to have grown organically out of being born a Vanderbilt and marrying a Whitney. She was a creative soul in a world that cared first and foremost about acquiring, spending, and (perhaps) conserving money.

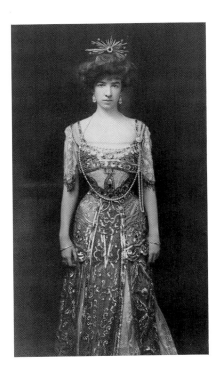

Gertrude posed for this photograph wearing an elaborate dress and tiara, c. 1909.

She came to feel she was trapped. It took a long time for her to begin to escape her small, conventional upper-class world, and indeed she never chose to escape it completely. "If one has been surrounded all one's life by a great high fence," she wrote, in an image straight out of Edith Wharton, "then when one is liberated from prison one's wings are inconceivably weak." She was, from youth, a passionate Romantic, yearning for the spiritual elevation of Art and Love. She read Walt Whitman and the poetry of Oscar Wilde. The family fortune (based

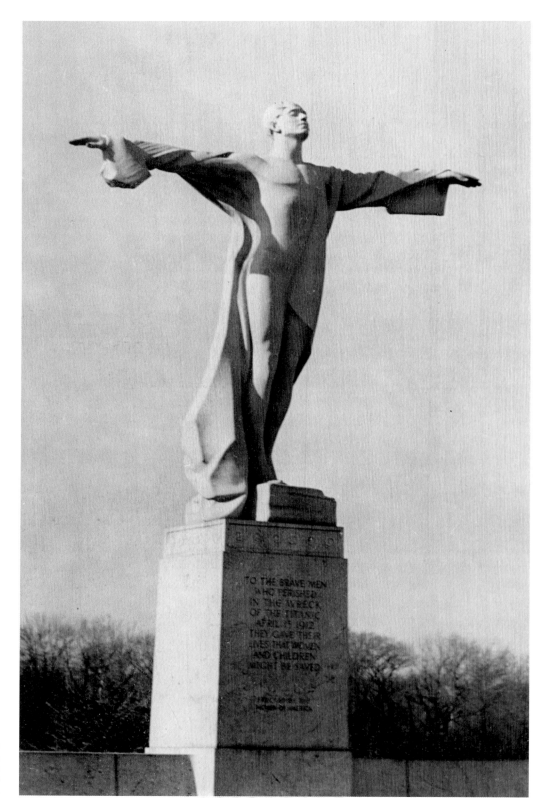

Gertrude Vanderbilt Whitney
Titanic Memorial, 1914
(dedicated 1931)
Granite, 15 feet (45.7 m) height
Potomac Park, Washington, D.C.

24

She wanted to be an artist, but even more she wanted the artist's life—to be part of the community of talent, which seemed a more congenial and authentic elite to her than the world of her birth.

on the New York Central Railroad and estimated at $400 million in 1900) isolated her and kept her from ordinary life. The confines of the fence were tight. As a girl, she never took a streetcar; she toyed with the idea of joining a bicycling party, once, but changed her mind. Cornelius and his wife, Alice, didn't travel, exactly—they moved through the cycle of the year like royalty, cocooned by private trains and yachts or on ocean liners, where they spoke only to the kind of people they knew from Newport and New York. "We had never heard of him," the young Gertrude would say, in docile and censorious mood, of a perfectly respectable man who had eloped with her cousin. Outsiders were a threat to the family's wealth. "You don't know what the position of an heiress is!" she confided to her journal with a sigh. "There is no one in all the world who loves her for herself."

Her father collected paintings in the way that was common to men like him: only the best, which meant paintings full of classical allusions and with heartfelt landscapes by blue-chip artists from Europe who were, for the most part, safely dead. He was a trustee of The Metropolitan Museum of Art. She had been raised with the idea of collecting and appreciating art, but not with the notion of becoming a professional artist, or of working at anything at all. On the family's trips to Paris, she probably spent more time at her fittings at Doucet (her dress allowance, in the 1890s, was $5,000 a year) than in going round the Louvre.

As an heiress, she was to be a living display of her father's wealth and in due course of a husband's. She was to be yet another of the priceless ornaments in Cornelius' house at 1 West 57th Street. This was the grandest and best-positioned of the houses built by the grandchildren of "Commodore" Vanderbilt, founder of the fortune, along that stretch of

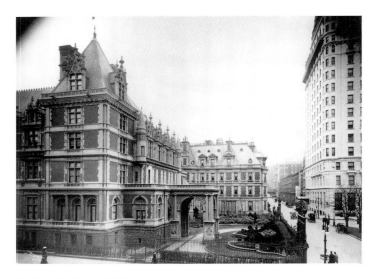

The Cornelius Vanderbilt II mansion on Fifth Avenue with the Plaza Hotel, at right, 1908. The mansion had been remodeled and enlarged by architect George C. Post in 1892. The final building, shown here in a view to the west along 58th Street, occupied the entire block on Fifth Avenue between 57th and 58th Streets.

Fifth Avenue known as Vanderbilt Row. This palace occupied a square block, where Bergdorf Goodman now stands, and was built as a high Victorian version of Henri IV's Château de Blois. It had 137 rooms and almost as many turrets and towers. In its hushed, ornate, and encrusted interiors, Gertrude was to say the right things and do very little—no more likely to make a false step than the silent caryatids holding up the marble mantels or the pale nymphs uncomplainingly lofting their torches among the potted palms. Like all upper-class young ladies before their debut, she was firmly under her mother's thumb. Gertrude compared her life to those of her four brothers and concluded that it would have been far jollier to have been born a boy. Alice, whose family descended from Oliver Cromwell, may have been no more Puritanical than other mothers of young ladies, but she felt she had a right to read Gertrude's correspondence and monitor what she read. And she was known for the frostiness of her manner, for being a tremendous snob. Merchants called on her rather than subject her to the demeaning experience of entering their stores.

To grow up as a princess in the Vanderbilt fairy tale was to receive mixed signals. You didn't build a pile like 1 West 57th Street— let alone a staggering Italianate palace like The Breakers, overlooking the ocean at Newport, where Gertrude's parents lived for part of each year—if you didn't want to draw attention to yourself. The Cornelius Vanderbilts

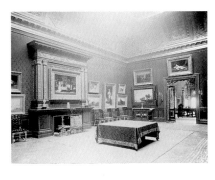

The dining room of The Breakers, Newport, Rhode Island, decorated with landscape, genre, and figure paintings from the collection of Cornelius Vanderbilt II.

Gertrude might have settled into the role of society matron that seemed to be her fate.... But that could never have been enough. She sought change and openness and self-expression....

were devout, churchgoing people interested in stewardship and the right use of wealth. Architecture like that of their homes was part of a semi-sacred WASP mission to demonstrate that Americans had got to the stage of leaving their log cabins and knocking the decadent old Europeans (not to mention business rivals at home) in the eye. If any of the impoverished majority of New Yorkers from the teeming slums and tenements— the huddled masses of immigrants newly funneled through Ellis Island—had business on Fifth Avenue, they could look up at the turrets and dream.

Gertrude grew up expecting to be looked at, but afraid that curious observers might catch her doing something wrong. For years and years she vacillated between feeling like a goddess or a worm. "You (G.W.) are a great personality," she told herself firmly, in 1913. "Genius is the knowledge of one's strength." She got quite grandiose, in the privacy of her journals, after she had won the commission to design the memorial to the victims of the *Titanic*. Hadn't the sculptor Andrew O'Connor, who became a lifelong friend, promised he would make her the greatest woman sculptor in the world? Yet Jo Davidson, another close sculptor friend, remarked after Gertrude's death how self-effacing she was. He had met her in Paris in 1908 when he was an impoverished artist out walking his Great Dane, and she invited him to join her party in a Montmartre café for lobster and champagne. He recalled how she was always amazed and overwhelmed with gratitude when anyone did anything nice for *her*.

The young Gertrude, scribbling away in her boudoir, with its white lace curtains and white

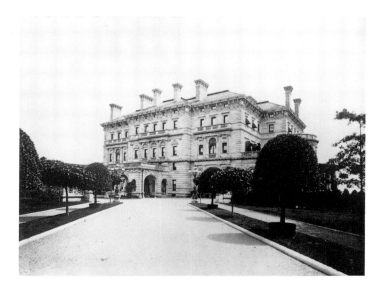

The Breakers, the family's summer "cottage" in Newport, Rhode Island, was designed by Richard Morris Hunt and completed in 1895.

Gertrude and Harry in Japan
on their honeymoon, 1896.

velvet rug, had no doubt that marriage would set her free. Her thoughts turned more and more to young men. She weighed them up, she played them off, she made that age-old female discovery that one good way to attract them was to get them talking about themselves. In case that subject faltered, she had lists of other topics to bring up. She was a great listmaker all her life: a list of ideas for sculpture or short stories; a list of friends and relations who could advise her on how to help artists; a list (in 1904, nearly thirty years before the opening of the Museum) of what form that help should take, beginning with "see artists and find out their wants"; a list, with forty-two names, of men (presumably owners of evening clothes) who could escort her to the opera when she was middle-aged; a list of things to think about in order not to think about herself, including "Buddhism vs. Christianity" and "the formation of rocks." Her conflicted feelings could be resolved, her life seemed clear, and her dreams had a way of becoming reality once she had written it all down.

She had had the highest hopes for what she would have called sexual love, had she been allowed to know the name for the storm of sensations that rocked and frustrated her as an unmarried girl. She had a crush on her friend Esther Hunt, and had held her hand, but she had never kissed a man until she was twenty and she and Harry Payne Whitney were engaged. He was a friend of her brothers, and she fell in love with him because he was handsome and straightforward with her. He didn't fawn. "When your looks give out,"

She found horses and the idle gossip of social life boring, and [Harry] seemed indifferent as she got interested in art.

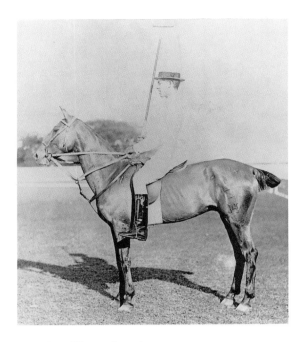

Harry Payne Whitney, dressed in full polo gear, was an expert on horses and one of the leading polo players of his day.

he told her, "you will still be a great heiress." She was stunned by his insight and boldness. She knew he didn't love her for her money, because the Whitneys, though naturally not as rich as her father, were still extremely rich. Harry's father, who was a widower, collected racehorses and multiple country estates, including places at Old Westbury, Long Island, Aiken, South Carolina, and a 110,000-acre camp in the Adirondacks—all of which Gertrude and Harry would regularly visit (though not necessarily together) during the thirty-four years of their married life. In New York City, the bridegroom had lived at 2 West 57th Street. He was the prince from just across the street.

She had dreamed, before she chose Harry, of intimacy and simplicity in a small house with a "delightful library, with a divan and easy chairs," where she and her husband could be alone. This was one of the few dreams she committed to her journals but was powerless to make happen.

There would be no small house. The newly married young Whitneys moved into 2 West 57th Street, the grand Fifth Avenue mansion vacated by Harry's father, who remarried and moved further up Fifth Avenue to no. 871.

A cottage in Newport, conveniently near to The Breakers, was added to the list of other homes. Within two years of her marriage in 1896, she had given birth to her daughter Flora and then to her little boy, "Sonny." A third child, Barbara, was born in 1903, but by then Gertrude was very unhappy indeed. When her father-in-law died in 1904, the family moved to 871. Far from providing an escape from her mother's conservative little world, marriage to Harry had

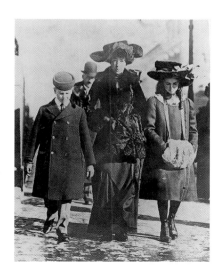

Gertrude with her first two children, "Sonny" and Flora.

tightened the noose. "The house I had stepped into after my marriage," she wrote in a scrap of unpublished memoir, "was furnished, complete and full. Beautiful Renaissance tapestries. Furniture of all the Louis. Old French and Italian paintings hung on the walls." She had moved from her father's house to her husband's, and her restless spirit craved a bigger leap.

"My friends took the attitude of a group of people watching one of their number performing a difficult parlor trick."

The world of American art owes a great deal to Harry Payne Whitney for proving a sorry disappointment to his bride. If he had turned out to be the soul mate she yearned for—instead of a chap obsessed by his polo and his racing stables, his imaginary maladies, his tarpon-fishing, grouse-shooting, yachts, and his other women, especially a fox-hunting mistress he was flaunting even as Gertrude was pregnant with Barbara—Gertrude might have settled into the role of society matron that seemed to be her fate. As it was, she could and did play the hostess superbly, thousands of times—at dinners, receptions, the weekend house-parties favored by the hard-drinking Harry, and in due course their daughters' coming outs. But that could never have been enough. She sought change and openness and self-expression, while Harry was happy with his sports (he was the most famous polo player of his age) and the pleasures of being rich. "I need a god more than anyone and I have none," Gertrude wrote. "Not even Love is my god for I know that does not last." She found horses and the idle gossip of social life boring, and he seemed indifferent as she got interested in art. She never gave up on him, though; never divorced him or thought seriously about leaving him for another man. By mutual agreement, for much of the year they lived lives separate from each other—and often

It is characteristic of the intuitive, decisive nature of Gertrude Whitney that, on the strength of a little juvenile dabbling and a single premonitory dream, she committed herself to the art form that would absorb her for much of the rest of her life.

from their children, of whom they were both, nevertheless, very fond.

They looked out for each other in middle age, and when Harry died in 1930 Gertrude said he had been her "great unselfish love." The other men to whom she had turned in her twenties and thirties in search of consolation for his neglect were often rather selfish loves on her part—stale bread, she noted wryly in her journal, but better than starving with no love at all.

As a young married woman, Gertrude visited the studio of the artist John La Farge. That he had spent time in Japan and been influenced by the simplicity of the interiors there made his studio particularly arresting. She came away with three of his watercolors and the impression that she had opened a door onto another world. "I will never forget the feeling of inadequacy combined with pleasure," she said, of the sensation of meeting a "great man," a real American artist at the heart of his creative world. Around this time, too, she had a significant dream. "I wanted to work," she wrote, in her unpublished memoir of her time of darkness and rebirth. "I was not very happy or satisfied in my life. I had always drawn and painted a little, now I wanted to try modeling [sculpting in clay]. My memory distinctly brings back a dream I had I was in a cellar and modeling the figure of a man. There were a great many difficulties connected with my getting forward with the work." It is characteristic of the intuitive, decisive nature of Gertrude Whitney that, on the strength of a little juvenile dabbling and a single premonitory dream, she committed herself to the art form that would absorb her for much of the rest of her life.

She gave orders to have a studio built on the cliff near the Newport cottage and hired the sculptor Hendrik Christian Andersen to teach her the basics of how to bring the dream to life. He needed the money; his own gargantuan sculpture very rarely sold. "Although she is *very foolish*," he said of his twenty-five-year-old pupil, in a letter to his brother, "I will put the world in a new light to her." He read Ibsen out loud as she worked, and talked to her about his bohemian life in the artists' quarters of Paris and Rome. She made her first figure that same year—a larger-than-life male nude (a favorite subject throughout her career) appropriately entitled *Aspiration*. At first, Harry regarded her art as a harmless hobby. Her mother, for her part, fretted lest Flora, her young granddaughter, see the figure because "the fig leaf is so little!" Years later, Gertrude spoke to a reporter about her beginnings as a sculptor. "My

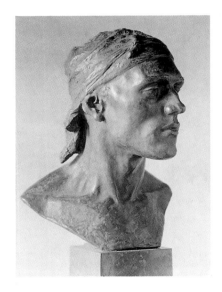

In 1917, A.E. Gallatin, one of the earliest collectors of modern art and founder of the Gallery of Living Art, New York, purchased Gertrude's *Head of a Spanish Peasant* (1911) for his collection.

friends took the attitude of a group of people watching one of their number performing a difficult parlor trick," she said. Andersen was a real artist, dedicated to a life of art. Contact with him opened Gertrude's eyes. "I came to be happy meeting people with big personalities, especially in my own sphere [sculpture]," she would recall. She wanted to be an artist, but even more she wanted the artist's life—to be part of the community of talent, which seemed a more congenial and authentic elite to her than the world of her birth. More and more, she would seek the camaraderie of the artists' world. "When they let me in and we discussed our own interests I felt as if I had been let into a Secret Society," she said.

The dedication ceremony for Gertrude's *St. Nazaire Monument* (1924). Her design for this memorial to the American soldiers who fought and died on European soil in World War I towered above the rocky coast of Brittany, France, where the first American Expeditionary Forces had landed in 1917.

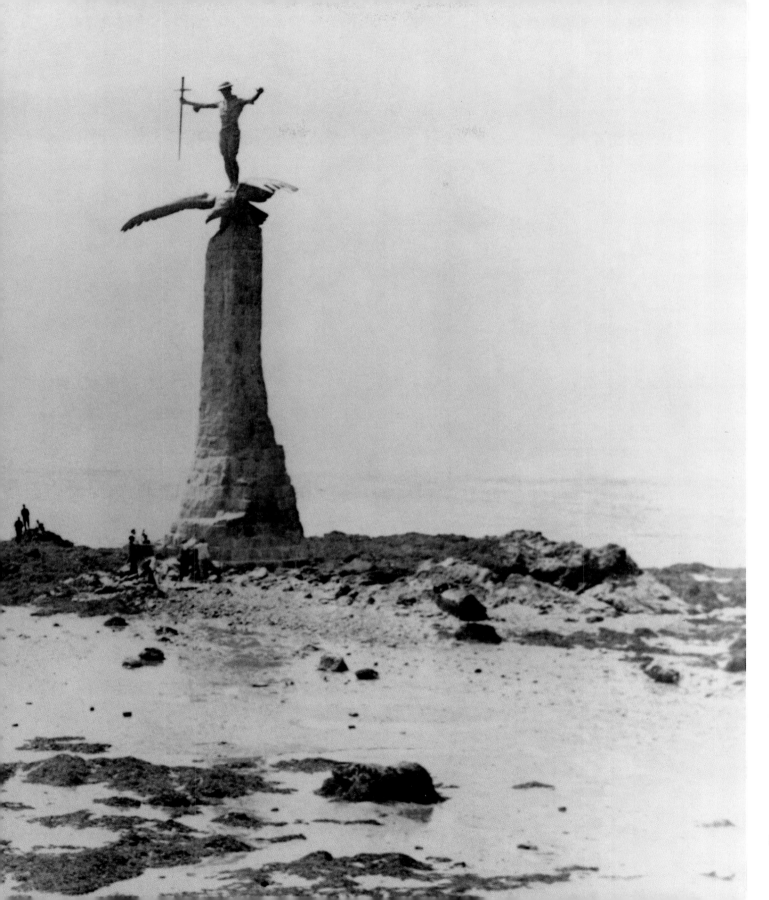

Gertrude at work in her
studio in Macdougal Alley,
New York City, c. 1919.

**"At that time," said
John Sloan, "to buy such
unfashionable pictures was
almost as revolutionary as
painting them."**

"Inherited wealth is a real handicap to happiness," her uncle, William K. Vanderbilt, once said. "It is as certain death to ambition as cocaine is to morality." Gertrude's ambition was alive and kicking. Two of her brothers died young (Alfred sinking, with impeccable *noblesse oblige*, on the torpedoed *Lusitania*) and another became a self-destructive playboy, but it was in any case Gertrude who inherited the Commodore's tremendous drive. But the wealth, for her, was something to come to terms with. Next to the never-resolved conflict of her feelings for Harry, the great psychic struggle of Gertrude's life was her attitude to her money. It struck her as a great revelation, when she was young and launching herself simultaneously as an artist and a patron, that perhaps the millions could work for her more than they could work against her. "Your real power . . . is your money and position," she reminded herself in her journals. "Why do what is fitting for Jane Smith when you are not Jane Smith?" This insight was helpful enough in the context of her early, abandoned plans for furthering the cause of American art by being fairy godmother to some sort of homegrown Beaux-Arts college that she would endow with low tuition, scholarships, exhibition space, and a building costing a million dollars. Certainly, the existence of the Whitney Museum is evidence that Gertrude could use her money to good purpose.

But when it came to pursuing her career as a professional sculptor, it might have been easier for her to be "Jane Smith" than Gertrude Whitney. Even after she had won prizes and commissions for statues of national and international prominence (her monument to the World War I doughboy, standing 30 feet high on eagle wings above the Brittany coast, was unveiled before a crowd of 30,000), she was hypersensitive to

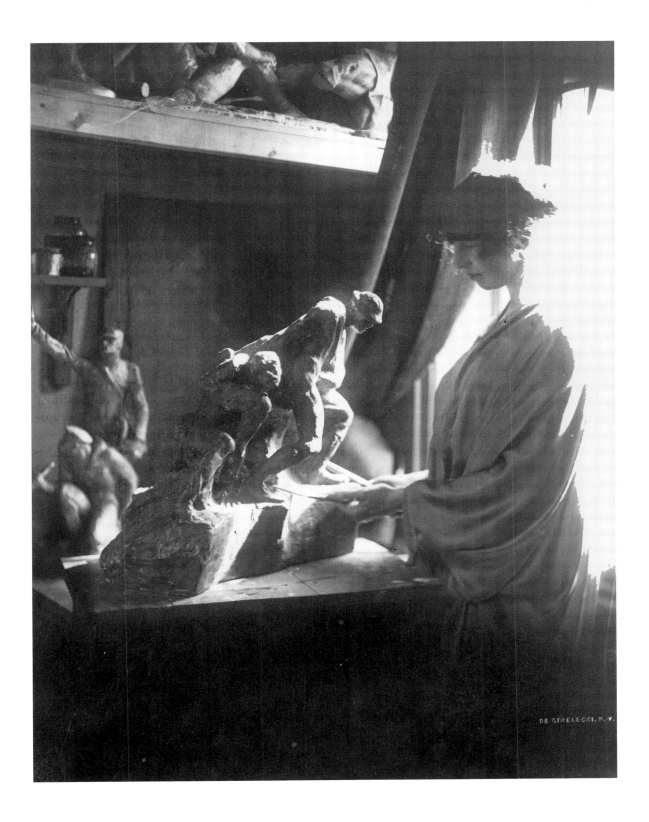

DE STRELECKI, N. Y.

criticism that she was somehow a rich dilettante. "I am not complaining," she told the author of a newspaper article that ran under the snide headline "Poor Little Rich Girl: Mrs. Harry Payne Whitney's Struggles to Be Taken Seriously as a Sculptor Without Having Starved in a Garret." "I should not be doing the work I am today if it were not for the battle I had to fight to show I was not merely amusing myself." She was grateful to the artists who did accept her unconditionally. But, ironically enough, she was heard accusing those artists who did not accept her of being "snobs." She was aware that she had not had the benefit of years of life classes (she studied fleetingly at the Art Students League) or the time for long apprenticeships under established masters that many of her colleagues had known. Sometimes her sculpture had technical weaknesses. Perhaps she also heard whispers that she was getting unfair help in correcting those weaknesses in her commissioned pieces—from her assistants and especially from Andrew O'Connor. It must have crossed the minds of her fellow artists, too, that she might be winning commissions because the establishment, who controlled the committees that awarded them, felt comfortable with her. By 1919, the review of one of her one-artist shows conceded that her name might be a burden. "If anyone but Mrs. Whitney had done that, it would be considered great," the reviewer wrote.

It meant a great deal to her to be paid like any other professional. She was shocked, once, when a monument committee asked her to waive her fee and instead make a donation. Had she done so, she would have won the job unfairly and deprived another sculptor of the chance of income. Nothing, including winning medals and prizes, boosted her confidence in her work like having someone buy it. She would be thrilled when the great collector A.E. Gallatin bought her *Head of a Spanish Peasant* in 1917. It made her feel like going on working. All this firsthand understanding of the financial (and emotional) realities of the artist's

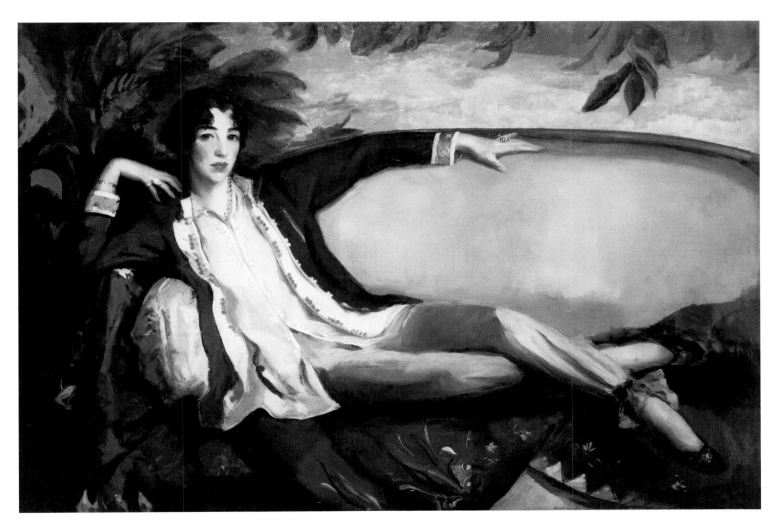

Robert Henri
Gertrude Vanderbilt Whitney,
1916
Oil on canvas, 50 x 72 in.
(127 x 182.9 cm)
Whitney Museum of American
Art, New York; Gift of Flora
Whitney Miller 86.70.3

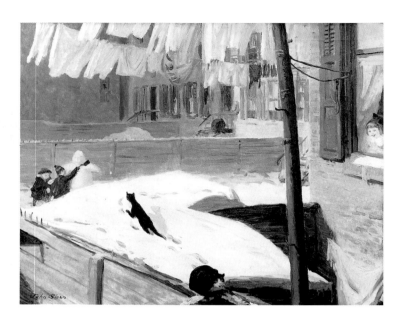

John Sloan
Backyards, Greenwich Village,
1914
Oil on canvas, 26 x 32 in.
(66 x 81.3 cm)
Whitney Museum of American
Art, New York; Purchase
36.153

life was unique in the experience of the founder of a great art institution. As, day by day, she added to that understanding, she was simultaneously building the collection and the informal, democratic, artist-centered institutions that eventually grew into the Whitney Museum of American Art. In 1908, she bought four paintings—*Laughing Child* by Robert Henri, *Revue* by Everett Shinn, *Winter on the River*

(Floating Ice) by Ernest Lawson, and a George Luks—from the exhibition by the artists who came to be known as The Eight, at the Macbeth Galleries, New York. This was then virtually the only place to see the work of progressive American painters working in the realist style.

This daughter of Fifth Avenue was drawn to those who dared to paint scenes of her native city at its grubbiest and most human. In time, she would buy *Backyards, Greenwich Village* and *Sixth Avenue Elevated*, among other works by John Sloan. Like Luks, William Glackens, and Shinn, Sloan had been an artist-reporter for Philadelphia newspapers when he met and fell under the spell of the charismatic painter Robert Henri and followed him to New York. Although Henri was elected to membership in the National Academy of Design, he was in rebellion against its crushing conservatism. "No juries, no prizes!"—the rallying cry of artists excluded from established exhibitions in nineteenth-century Paris—was Henri's cry as well. As a bohemian who also made her peace with being a society matron, Gertrude was drawn to Henri, like her a

Everett Shinn
Revue, 1908
Oil on canvas, 18 x 24 in.
(45.7 x 61 cm)
Whitney Museum of American
Art, New York; Gift of Gertrude
Vanderbilt Whitney 31.346

Ernest Lawson
*Winter on the River
(Floating Ice)*, 1907
Oil on canvas, 33 x 40 in.
(83.8 x 101.6 cm)
Whitney Museum of American
Art, New York; Gift of Gertrude
Vanderbilt Whitney 31.280

Edward Hopper
Early Sunday Morning, 1930
Oil on canvas, 35 x 60 in.
(88.9 x 152.4 cm)
Whitney Museum of American
Art, New York; Purchase, with
funds from Gertrude Vanderbilt
Whitney 31.426

Hopper's first one-artist
exhibition was held at the
Whitney Studio Club in 1920.
When Gertrude founded the
Whitney Museum in 1930,
Early Sunday Morning was
one of her first purchases.

Whitman fan and a romantic believer in what he called "The Art Spirit." She was more comfortable with the idea of subverting and modernizing tradition from within than in throwing it out with the kinds of formal experimentation seen at 291, the gallery run by Alfred Stieglitz.

In 1908, there was nothing fuddy-duddy about the American realists. "At that time," said John Sloan, whose work was also in the Macbeth show, "to buy such unfashionable pictures was almost as revolutionary as painting them." Like Edward Hopper, Rockwell Kent, and Reginald Marsh, Sloan would be given his first one-artist show by Gertrude Whitney. Like most painters doing anything remotely contemporary, Sloan had been shut out from exhibition at the hidebound but all-powerful Academy—an institution he denounced as being no more national than the National Biscuit Company. By the age of fifty, he had painted some four hundred pictures but sold only a handful. This in no way slowed his zeal for work or for the promulgation of artistic freedom for others. The Society of Independent Artists was founded in New York in 1916, first with Glackens and then the indefatigable Sloan as president. The Society's unjuried annuals, open to all artists, whether modern or academic, amateur or traditional, were vital showcases for years but scarcely money-making propositions. Year after year, Gertrude quietly wrote a check to cover the Society's losses.

In this climate of extreme difficulty for progressive American artists, Gertrude began offering space for exhibitions in her own studio at 19 Macdougal Alley. During World War I, she had gained enormous

Charles Sheeler
Office Interior, Whitney Studio Club, 10 West 8th Street,
c. 1928
Gelatin silver print, 7 1/2 x 9 3/8 in. (19.1 x 23.8 cm)
Whitney Museum of American Art, New York; Gift of Gertrude Vanderbilt Whitney 93.24.1

Sheeler and his wife lived in rooms on the third and fourth floors above the Whitney Studio Club galleries from 1924 to 1928. He not only exhibited his own work at the Club, but also curated exhibitions of other artists' works and acted as official photographer for the Club.

"First Annual Sculpture Exhibition" at the Whitney Studio Club, 1928.

After 1918... the focus shifted to the Whitney Studio Club, a lively, eccentric institution with some four hundred members and premises in a series of former town houses in the Village.

confidence from the experience of founding a field hospital in her beloved but now ravaged France. (Harry would have been content to write a check, but she made the dangerous crossing herself, along with eight doctors, twenty-five nurses, and twenty ambulances.) From 1914 on, there was an increasingly ambitious program of art exhibitions at the galleries of the Whitney Studio, some of them benefits for victims of the war. After 1918, the focus shifted to the Whitney Studio Club, a lively, eccentric institution with some four hundred members and premises in a series of former town houses in the Village. Several of these houses, fronting on 8th Street and connected to Gertrude's original studio by a private staircase, became the first home of the Whitney Museum in 1931. In addition to exhibition space, a full schedule of shows by individual artists, and heterogeneous annual members' shows each spring, the club had a library, life class, squash court, billiard table, and Ouija board. The seeds of the Whitney Museum germinated in the hotbed of Greenwich Village, which in the first decades of the twentieth century was home to radical ideas not only about the arts but about the way private and public life might be conducted.

The neighborhood housed an interconnected, bohemian community of extraordinary people—from Mabel Dodge and Willa Cather to John Reed and Margaret Sanger. Downtown, Gertrude gave luncheons with eclectic guest lists unthinkable at 871 Fifth Avenue or in Newport. Often, she left her assistant, Juliana Force, to preside over the crowded, famously lively Club parties, where artists would wolf down buffets provided by uptown caterers and,

DeWitt Clinton Ward
Macdougal Alley in Early Spring
The original photograph appeared in *The Craftsman*, October 1906.

The stables and carriage houses that lined Macdougal Alley became studios for artists in the early 1900s.

Gifford Beal's painting
of artists working on the
"Indigenous Artists"
exhibition at the Whitney
Studio Club, 1918
(whereabouts unknown).
Left to right: Robert
Chanler, Paul Dougherty,
Jo Davidson, Gertrude
Vanderbilt Whitney, George
Luks, and Guy Pène du Bois.

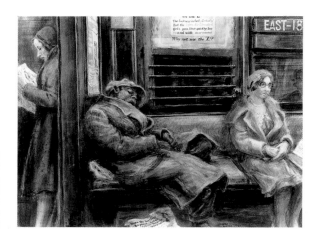

Reginald Marsh
Why Not Use the "L"?, 1930
Egg tempera on canvas,
36 x 48 in. (91.4 x 129.9 cm)
Whitney Museum of American
Art, New York; Purchase
31.293

even during Prohibition, lubricate their genius with wines and whiskies from the capacious H.P. Whitney cellars.

No genius was more generously lubricated than that of George Luks, a charming but incorrigible alcoholic. In 1918, he had to be escorted off the Whitney premises after several days of drunken mischief while working on the "Indigenous Artists" exhibition. For this show, a number of painters associated with Gertrude and the Club were put together in a studio with a good supply of canvases, paints, brushes, cigars, and whiskey. The results were sometimes surprisingly good. The participants included Sloan, Robert Chanler (a hard-living friend of Gertrude's who once expressed a wish to see her let go of her Vanderbilt Puritanism and really "go to the devil"), Guy Pène du Bois, Glenn O. Coleman, and Gifford Beal. Beal's effort was a painting of the "indigenous artists" at work—with Gertrude in the thick of them, wearing a chic hat.

She was one of those remarkable women who came of age at the beginning of the century and who were liberated without being feminists.

Gertrude Vanderbilt Whitney seems to have felt more discriminated against as a rich sculptor than as a female one. Indeed, her generation had quite a few women sculptors, including Malvina Hoffman, who also had a studio in Macdougal Alley. The conventions of the kind of sculpture Gertrude learned to make—mostly academic figures, intended for public places and freighted with allegorical messages—suited her perfectly. Gertrude made lists of subjects like "Friendship," "Hope," "Despair," or "Mental Torture," and settled with a model in her studio, exploring the reverent, sensual pleasures of working from the nude—as male artists had always done—and knowing that the result would be seen as quite respectable, a kind of civic duty. "I will go early to the studio," she wrote in her journal, early in her career. "And Mac [a sculptor who was

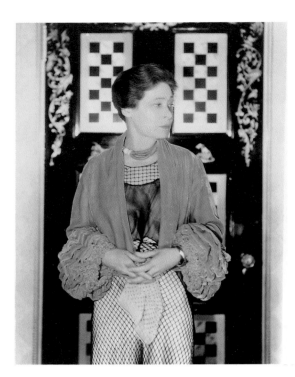

Juliana Force, c. 1930.

The seeds of the Whitney Museum germinated in the hotbed of Greenwich Village, which in the first decades of the twentieth century was home to radical ideas not only about the arts but about the way private and public life might be conducted.

modeling for her] will come and his beautiful bare body will be more beautiful and I will look at him and be happy."

She was one of those remarkable women who came of age at the beginning of the century and who were liberated without being feminists. There is no record of her marching for women's suffrage, like Alva, the first wife of Uncle William. She and Juliana Force, who ran the Whitney Studio Club for her and became the first director of the Museum, were more helpful than most to women artists, but only because they were artists and not because they were women. Juliana, who came from an impoverished family and who entered Gertrude's life as her sister-in-law's social secretary, was a self-made, self-supporting woman and a powerhouse. Very often, Gertrude surrounded herself with men; she was like a queen with her court. (There is a photograph of her alone with three men for an "Oriental feast" in Paris, in 1913. She is wearing the beautiful tunic made for her by Léon Bakst, and like her companions she is smoking.) Yet she formed a real partnership with Juliana, a vibrant, "big personality" who was not intimidated by Gertrude and who (like Harry in his youth) endeared herself by always telling her the truth. When the Studio Club exhibitions grew more frequent and elaborate and the network of Gertrude's generosity to artists grew too wide for her to deal with in person, Juliana took over many of the day-to-day details. "Without Mrs. Force it could never have been accomplished," Gertrude said of the Museum.

Gertrude could still join Harry for the opening day at Belmont, or give formal dinners at 871 Fifth Avenue, but the focus of her life was her

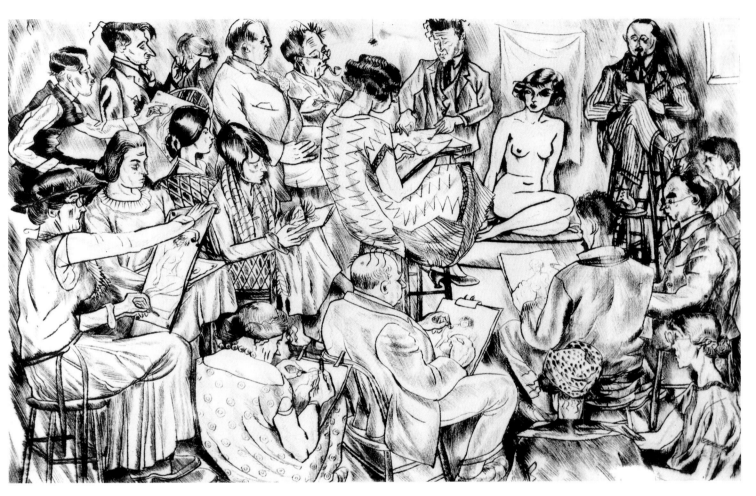

Peggy Bacon
The Whitney Studio Club
(Frenzied Effort), 1925
Drypoint: sheet, 9 x 11 in.
(22.9 x 27.9 cm); plate,
5 13/16 x 9 in. (14.8 x 22.9 cm)
Whitney Museum of American
Art, New York; Gift of Gertrude
Vanderbilt Whitney 31.596

The sketch classes held at the
Whitney Studio Club were
among its most popular
activities. This drypoint of the
class by Peggy Bacon includes
portraits of fellow artists who
were regulars at the Club,
among them Stuart Davis (in
front of the turbaned woman at
right), Mabel Dwight (wearing
a hat, far left), and George
"Pop" Overbury (smoking a
pipe, at top).

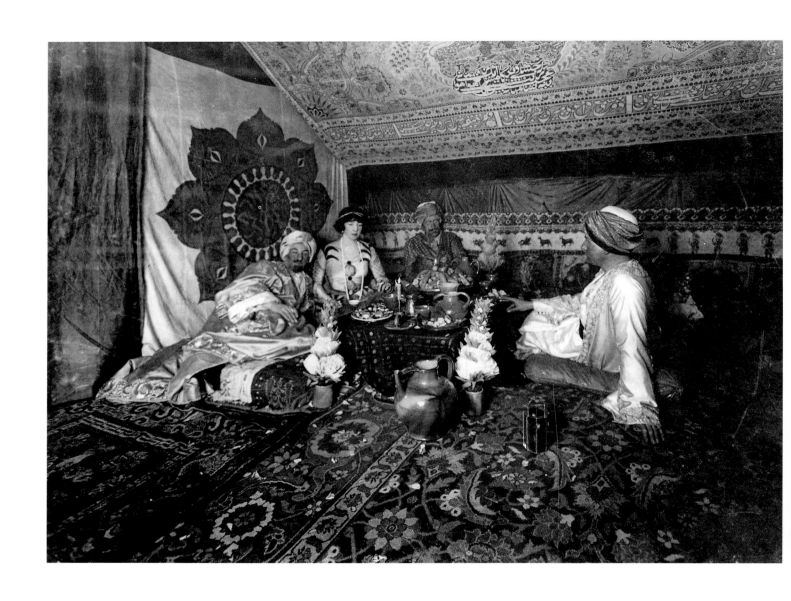

Gertrude with Arthur Knoblock,
Emanuele de Rosales, and
Herbert Haseltine at an
"Oriental feast" in Paris, 1913.

studio—studios, rather, for she had several. In addition to Macdougal Alley, she had one in Paris and one like a grand Palladian villa on the Old Westbury estate, designed by William Adams Delano, the architect of the Knickerbocker and the Colony Clubs. She once complained publicly that a man could take a studio and "do the work that interested him" without objections, but that if a woman did the same she was treated to a "knowing lifting of the eyebrows." In truth, she did sometimes use her studios not just for work but for discreet trysts.

"Mon cher!" she wrote coyly to Count Guardabassi, a handsome, opera-singing Italian portraitist with whom she was madly in love in 1914. "Did I make you the least little bit happy?" She offered to help him in any way, including financially, on condition that he keep her gifts a secret. "My ways are deep and I cover my tracks with discretion, but none the less when I want something it often happens (no one knows why)." As the years went by, the generous yet covert personal assistance she offered her intimates was applied ever more widely to the community of artists who found themselves drawn to the Whitney Studio Club. The Whitney Museum grew organically out of its artist-founder's compassionate sympathy for other artists' struggles. Alfred Stieglitz's 291 gallery was concerned with a fierce modernist ideology, The Museum of Modern Art (founded in 1929) with its somewhat elitist vision and systematic acquisitions, while the Whitney's purpose was more liberal and personal. Gertrude and Juliana put the needs of the talented people who became their extended family first. They might buy a picture because the artist was in danger of despair or had to pay the rent or medical bills. "Her

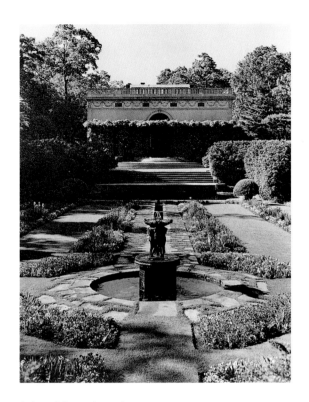

A view of the garden and studio building on Gertrude's Old Westbury estate, Long Island, New York. The bronze fountain in the center of the garden is Gertrude's design. A smaller version of this fountain is part of the Permanent Collection of the Whitney Museum of American Art, and a large-scale version is on the campus of McGill University, Montreal.

collection was not made with a museum in view," wrote Forbes Watson, longtime editor of the magazine *The Arts*, after Gertrude's death, when the artists she had helped were venerable and their work ensconced in the Whitney Museum. "She could easily have had one of the outstanding collections in the world, with all the correct names. . . . Instead she bought hundreds of works by young artists who at the time didn't have dealers, artists unknown to the type of correct collector she might have been had she had less human interest in the artist."

John Sloan remembered Gertrude and Juliana continually putting their heads together in search of ways to make the lives of American artists a little easier. Although one was born rich and the other had known poverty, Gertrude and Juliana were each, in their ways, self-invented women, and they loved helping others grow. In 1926, Stuart Davis, then living with his unsold canvases in an 8 x 11-foot room near Union Square, was given a retrospective at the Whitney Studio Club Galleries; a princely stipend of $125 a month, which enabled him to live for a year; and subsequently a gift of $900 and instructions to go and paint in Paris. On his return, he gave the Whitney *Early American Landscape*, *Egg Beater No. 1*, and *Place Pasdeloup*. In 1924, Charles Sheeler had a one-artist show that ran concurrently at the galleries with a show of Dada and Cubism that he had curated. (The tradition of trusting artists as curators and judges of their fellow-artists was carried on after the opening of the Whitney Museum: all three curators, working under Juliana's direction, were artists.) Sheeler

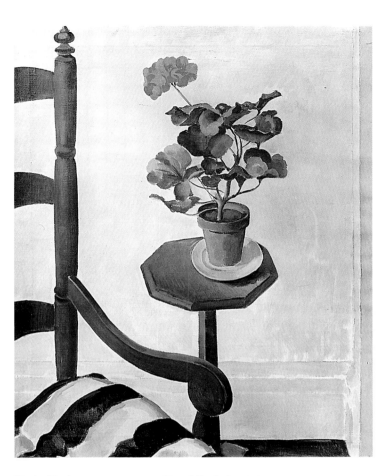

Charles Sheeler
Geranium, c. 1926
Oil on canvas, 32 x 26 in.
(81.3 x 66 cm)
Whitney Museum of American
Art, New York; Gift of Gertrude
Vanderbilt Whitney 31.343

Two of Sheeler's paintings,
Geranium and *Interior* (1926),
were among works in the
Whitney Museum's inaugural
exhibition in 1931.

Stuart Davis
Egg Beater No. 1, 1927
Oil on canvas, 29 1/8 x 36 in.
(74 x 91.4 cm)
Whitney Museum of American
Art, New York; Gift of Gertrude
Vanderbilt Whitney 31.169

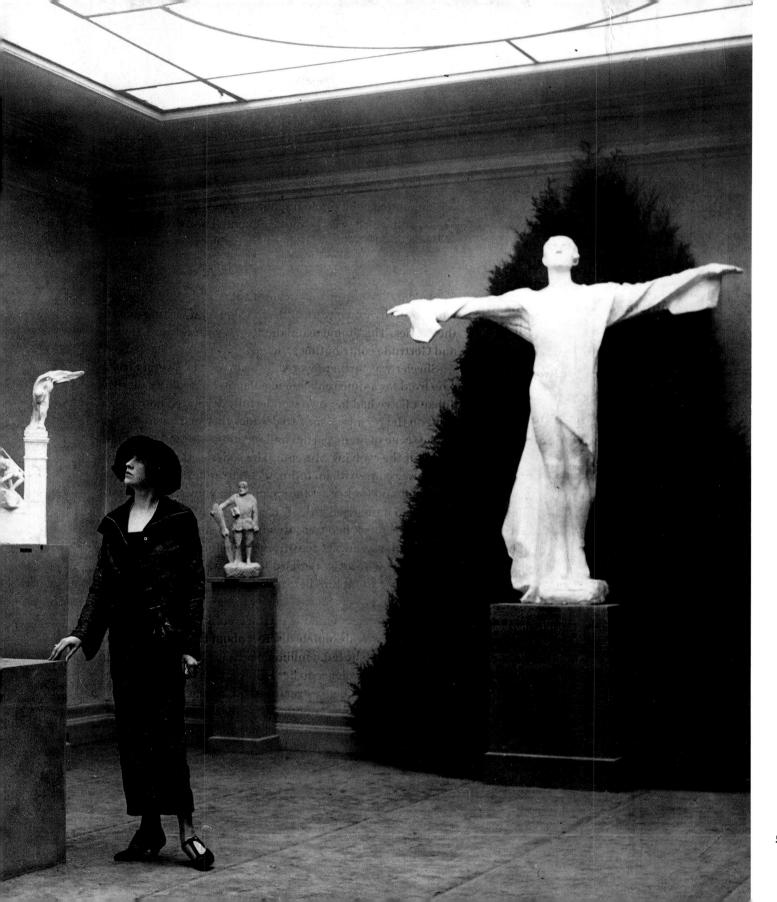

> "She could easily have had one of the outstanding collections in the world, with all the correct names....Instead she bought hundreds of works by young artists who at the time didn't have dealers...."

was appointed chief photographer to *The Arts*, which Gertrude owned and which was the most influential and progressive art magazine in the country in the 1920s. Watson, as editor, covered not just the visual arts in Europe and America, but also architecture, film, dance, and design. The contributors were a dazzling pantheon, including Stravinsky and Picasso writing on their own work and Virginia Woolf writing on the movies. The "home team" did its bit, with Edward Hopper and Gertrude contributing articles.

Sheeler was further favored by being one of several artists who lived for a time rent-free in a flat over the Club galleries. Juliana Force had her own wonderfully decorated home right on the premises; for two decades this apartment would be the scene of many parties and meetings—a kind of engine room for the evolving Museum. The galleries themselves were a series of town-house rooms with an intimate, even domestic feeling. It was as if Gertrude found for her art the small-scale, comfortable setting she had dreamed, as an unmarried girl, of sharing with a husband. And Gertrude, who from the outset had treasured her own studios as the focus of her personal freedom, was always sensitive to other artists' needs for clean, well-lit workspace. The artist Bernard Karfiol, who was desperately poor, was grateful when she lent him her studio in Macdougal Alley so that he and his family could spend the winter there while she was staying in Havana. Gertrude was profligate with her own secrets and the record of her personal journey, but she was absolutely discreet about the lives of others. Unlike her private writings (she left a million words for her biographers to read), the records of her benevolence to her fellow artists were destroyed after her death, presumably on her instructions, by Juliana. The details of her generosity are lost, perhaps, but not the work she nurtured and bought: the mother lode of the Whitney Museum's Permanent Collection.

Gertrude (seated) and Juliana Force (standing), surrounded by Gertrude's sculptures, at the Whitney Museum, 1939.

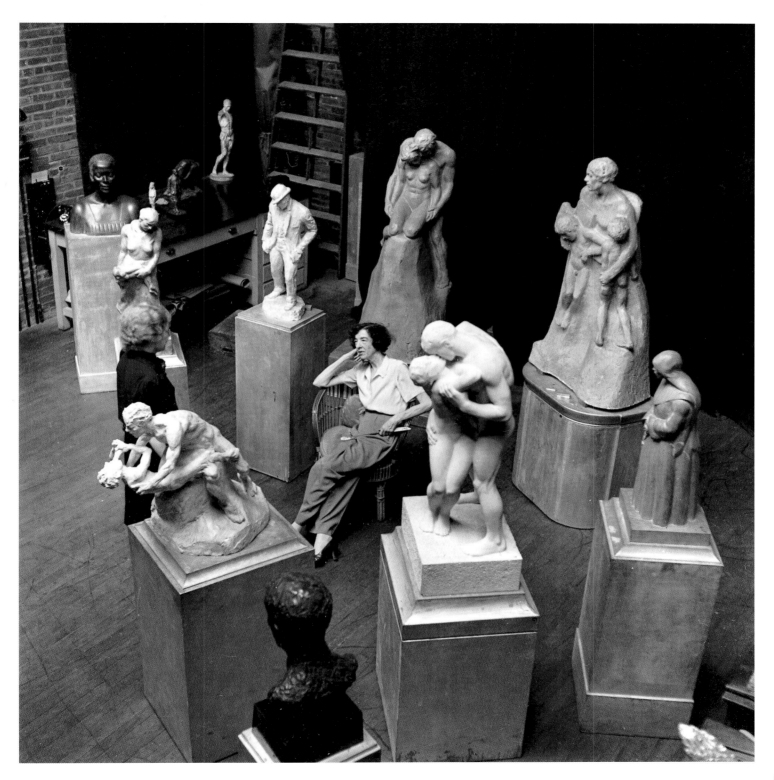

Visual Contexts for American Art

Oil on canvas, 24 x 36 in. (61 x 91.4 cm)
Whitney Museum of American Art, New York;
Purchase 41.34

John Sloan's artistic vision and imagination were shaped by turn-of-the-century American popular culture. At a time when the majority of American artists went abroad to study art and aristocratic subject matter was still in vogue, Sloan forged an American art that rejected elitist themes. This democratic vision can be traced back to his artistic training. Although he attended evening drawing classes at the Pennsylvania Academy of the Fine Arts in the 1890s and later studied painting with Robert Henri, Sloan's real training ground was the commercial realm of advertising, journalism, and publishing. From 1892, when he joined the art staff of the *Philadelphia Inquirer*, until 1916, when he was hired to teach at the Art Students League in New York, Sloan made his living as a commercial artist. In later years, rather than dismissing this experience, as many artists did, Sloan maintained that his work as an illustrator taught him to "go into the streets and look at life." Indeed, Sloan based *The Picnic Grounds* on an observed incident— a visit to the picnic grounds in Bayonne, New Jersey, in 1905, to celebrate Decoration Day, now known as Memorial Day.

Many of the scenes that Sloan illustrated and later incorporated into his paintings were derived from firsthand experience. He participated in the popular leisure activities of the urban middle class, frequenting the city's vaudeville theaters and movie houses or enjoying a summer's day at Rockaway Beach. Unlike some of his fellow illustrators, who regarded their commercial illustration as separate from their painting, Sloan shifted easily between the two. Many of his paintings of middle-class leisure, among them *The Picnic Grounds* and *Movies*, include the same characters that populate his illustrations.

John Sloan. *Movies*, 1913. Oil on canvas, 19 7/8 x 24 in. (50.5 x 61 cm). The Toledo Museum of Art, Ohio; Museum Purchase Fund

"he clutched the big fellow's hat and jumped back with it to the open door"

John Sloan. "Seized His Hat!" published in *McClure's Magazine*, August 1905. Crayon and ink on paper, 3 9/16 x 6 in. (9.1 x 15.2 cm). Delaware Art Museum, Wilmington; Gift of Helen Farr Sloan

Following his move to New York City in 1904, Sloan began a second career as a freelance illustrator of books and magazines. His lively style was well suited to the new, more realistic fiction then beginning to appear in socially progressive magazines. In the summer of 1905, for example, his illustrations for a story entitled "The Steady," by Harvey J. O'Higgins, were published in *McClure's Magazine*, the leading muckraking magazine of the era. The popularity of these scenes of working people in the subways, streets, and parks of New York strengthened Sloan's resolve to use similar everyday subject matter in his paintings.

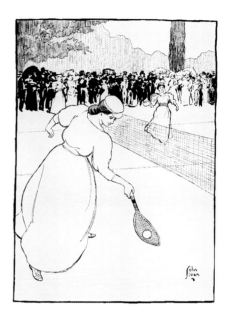

As this illustration from a nineteenth-century newspaper demonstrates, Sloan's theme in *The Picnic Grounds* was not a new one. The seasonal outings of New Yorkers to parks and beaches, along with celebrations marking national holidays, were commonly depicted in the popular press.

Jules Tavernier. "The Picnic Season," published in *The [New York] Daily Graphic*, June 30, 1873. Museum of the City of New York

In the era before the mechanical reproduction of photographs had been perfected, artists were integral staff members at all American newspapers. Sloan worked for two of Philadelphia's daily newspapers in the 1890s, the *Inquirer* and, later, the *Press*. His job at the *Press* was to design decorative borders, puzzle pictures, and illustrations for the sports and women's sections. One of his earliest published illustrations, drawn in a linear Art Nouveau style, was of a women's tennis match.

John Sloan. "Tennis," published in the *Philadelphia Inquirer*, June 13, 1894. Ink on illustration board, 6 1/2 x 5 in. (16.5 x 12.7 cm). Delaware Art Museum, Wilmington; Gift of Helen Farr Sloan

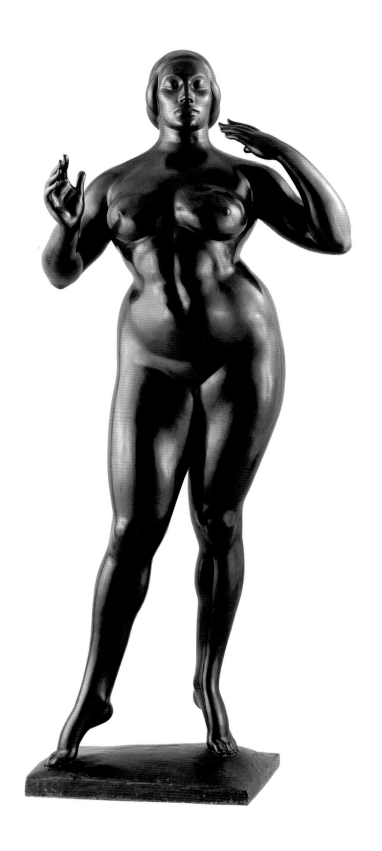

Gaston Lachaise [1882–1935]
Standing Woman 1912–27

Bronze, 69 1/2 x 26 15/16 x 17 in. (176.5 x 68.4 x 43.2 cm).
Whitney Museum of American Art, New York; Purchase 36.91

"At twenty, in Paris, I met a young American
person who immediately became the primary
inspiration which awakened my vision and the
leading influence that had directed my forces.
Throughout my career, as an artist, I refer to
this person by the word 'Woman.'" Thus wrote
Gaston Lachaise about meeting Isabel Dutaud
Nagle around 1902. Although she was ten years
older than he, married, with a child, and living
in Boston, Lachaise was not deterred. He
moved to Boston in 1906 to be close by, and
Isabel became his muse (they were married in
1917). Throughout his career Lachaise made
hundreds of sculptures of women and sculpted
fragments of female anatomy, virtually all of
them inspired by Isabel.

 Standing Woman, sculpted in plaster in
1912 (but not cast until 1927 for lack of funds),
was made at the time Lachaise had moved to
New York from Boston to work as an assistant
to sculptor Paul Manship. *Standing Woman*,
the largest piece he had produced to date, was
an ambitious testimony to the woman he sorely
missed. Although the figure is full-bosomed,
with ample buttocks, hips, and thighs, the
effect is not of earthly lust but of a transcendent,
divine love. Standing effortlessly on tiptoe,
eyes shut in meditation and hands gracefully
gesturing in a manner reminiscent of Indian
buddhas (an art Lachaise greatly admired),
Standing Woman also reflects the restraint of
Manship's art and Art Deco stylization.

One of the most recognized "muses" of twentieth-century American art was Georgia O'Keeffe in her role as a model for photographer Alfred Stieglitz. Stieglitz, founder of the vanguard gallery 291, began photographing O'Keeffe in 1917. He produced about 350 images of her over roughly twenty years in what he thought of as a single, collective portrait. As one biographer noted, he regarded the prints as "clean cut, heartfelt bits of universality in the shape of woman."

Like Lachaise's *Standing Woman*, Stieglitz's portraits of O'Keeffe often exploit an expressive, almost ritual-istic presentation of the hands. Both artists worshipped the female body, sometimes emphasizing a cooler, formal approach and at other times stressing sexual and erotic characteristics. The latter are more evident in Lachaise's later works, such as *Torso with Arms Raised*.

Alfred Stieglitz. *Breast and Hands*, 1919. Palladium print, 7 3/16 x 9 1/8 in. (18.3 x 23.2 cm). The Metropolitan Museum of Art, New York; Gift of Mrs. Alma Wertheim, 1928

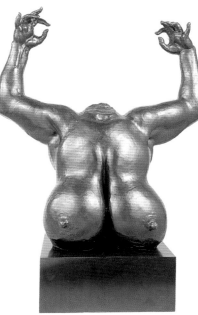

Gaston Lachaise. *Torso with Arms Raised*, 1935. Bronze on acrylic covered base, 43 1/4 x 30 5/8 x 16 5/16 in. (109.9 x 77.8 x 41.4 cm) overall. Whitney Museum of American Art, New York; 50th Anniversary Gift of The Lachaise Foundation 80.8

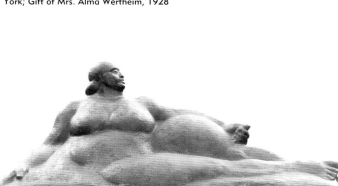

The image of woman has often been identified with the land, mother earth, or a generative force—as it often is in Lachaise's titles, among them *La Force Eternelle* (1913–17) and *Dynamo Mother* (1935). *The Mountain* is a restatement of a theme that had its origin in the artist's *Reclining Woman* of c. 1910 and was then repeated in smaller scale. But in Lachaise's final treat-ment of the theme, the scale is enormous—nearly 9 feet long. *The Mountain* is a bulging, massive figure that coalesces with its base and is almost indistinguishable from a landscape—woman as mother earth. And in this, one of Lachaise's last sculptures, Isabel is still both inspiration and subject. "You may say," he noted, "the model [for *The Mountain*] is my wife. It is a large generous figure of great placidity, great tranquility."

Gaston Lachaise. *The Mountain*, 1934–35. Bronze, 49 x 102 x 42 in. (124.5 x 259.1 x 106.7 cm). The Lachaise Foundation, Boston

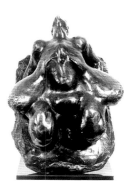

Gaston Lachaise. *In Extremis*, 1934. Bronze, 15 x 10 1/4 x 9 1/2 in. (38.1 x 26 x 24.1 cm). The Lachaise Foundation, Boston

In Gaston Lachaise's late work *In Extremis*, the emphasis on sexuality is a far cry from the classical restraint of *Standing Woman*. Here the mammoth splayed breasts adjoin the woman's hips, and her knees appear to be a second pair of bosoms. The concavity created by the parted breasts and bounded by her thighs suggests an orifice that is in effect a doubling of the vagina. Thus the entire body is metamorphosed into a sexual organ. The woman, head thrown back as if in the agony of childbirth or the ecstasy of orgasm, is propped upon a bedlike plinth.

The exaggerated forms of the breasts and pubis in Lachaise's sculpture have often been compared to those of Neolithic fertility figures such as the famous *Venus of Willendorf*. In both works, moreover, the faces are of little importance, for the subject is not a woman but universal womanhood. And like Stone Age fertility figures, Lachaise's sculptures were objects of worship. As he wrote to Isabel in 1915, "You are the Goddess I am searching to express in all things." Lachaise's endless fasci-nation with the fertility figure was no doubt encouraged by Carl Jung's concept of archetypes, a theory much discussed in the 1930s. Jung believed that certain primal forms, buried deep in ancestral memory, are often expressed in art. Lachaise's *In Extremis*, even as it revels in mortal flesh, becomes a semi-abstract symbol of fecundity.

***Venus of Willendorf*, c. 15,000–10,000 BCE.** Stone, 4 3/8 in. (11.1 cm) height. Naturhistorisches Museum, Vienna

Max Weber [1881–1961]
Chinese Restaurant 1915

Oil on canvas, 40 x 48 in. (101.6 x 121.9 cm)
Whitney Museum of American Art, New York;
Purchase 31.382

In the early decades of the twentieth century, many artists both in America and abroad sought new ways of expressing their impressions of modern life. "This is a wonderful age we are living in," the Russian-born Max Weber wrote in 1915, "surely there will be new numbers, new weights, new colors, new forms." To celebrate his sense of the wonders of the age, Weber painted a group of canvases between 1913 and 1915 that were among the most radically abstract works created by any American artist up to that time. *Chinese Restaurant*, with its kaleidoscopic composition, abstract, geometric design, and brilliant color, is one of the most impressive works from this period in Weber's career. It typifies Weber's desire to fuse a modern, urban subject with decorative motifs and designs drawn from a multitude of cultures and eras. Influenced by his own immigrant background, Weber came to believe that the art of the twentieth century would not only be abstract in style, but would also synthesize the arts of other cultures and times, including the Far East, Africa, and Native America.

The Chinese Delmonico's, 1905. Museum of the City of New York; The Byron Collection

New York's Chinatown, with its blend of East and West, ancient and modern, was an ideal subject for an artist determined to break down cultural and aesthetic barriers. In *Chinese Restaurant*, Weber's aim, as he later explained, was to convey the impression of entering one of New York's brilliantly lit and profusely ornamented Chinese restaurants from the darkness of the street outside. Although abstract patterns dominate the canvas, there are clues to the realistic subject: the repeated pattern of a typical turn-of-the-century restaurant floor, the scrolled leg of a table, and the uniquely Chinese red-gold-and-black color scheme.

Max Weber's earliest memories were of the folk art and architecture of his native Russia. While a student at Pratt Institute in Brooklyn from 1898 to 1900, he was introduced to Pre-Columbian and Native American arts and artifacts by his teacher, Arthur Wesley Dow. Dow believed that universal principles of composition and design united all the arts and encouraged his students to study tapestries, pottery, and other objects of Native American and primitive cultures. The geometric patterning, typical of the design of these objects, can be seen in many of Weber's paintings from the 1910s.

Navajo blanket, Arizona, c. 1860. Wool, 49 x 48 in. (124.5 x 121.9 cm). The Metropolitan Museum of Art, New York; The Michael C. Rockefeller Memorial Collection, Bequest of Nelson A. Rockefeller, 1979

Toward the end of his career, Max Weber said he had learned most, as an artist, from the great masters of Chinese painting. Many of the principles underlying Weber's approach to painting—expressive distortion of form, emphasis on the flat surface of the picture plane, and the use of multiple perspectives—have parallels in the ancient traditions of Chinese art as well as in the theories of modernists.

Daoji (Shitao). *A Man in a Hut Beneath a Cliff*, 17th–early 18th century. Ink and color on paper, 9 3/8 x 10 13/16 in. (23.8 x 27.5 cm). C.C. Wang Family Collection, New York

During a three-year sojourn in Paris (1905–08), Weber first became aware of avant-garde French artists and their fascination with naive and so-called primitive art. He also discovered an entirely new concept of pictorial space in the early Cubist paintings of Picasso. In 1910, back in New York, he saw reproductions of the more developed Cubist work of Picasso and Braque. He then began his first explorations into Cubist form, which were to reach maturity in such works as *Chinese Restaurant*.

Pablo Picasso. *Standing Female Nude*, 1910. Charcoal on paper, 19 x 12 3/8 in. (48.3 x 31.4 cm). The Metropolitan Museum of Art, New York; Alfred Stieglitz Collection, 1949

Charles Burchfield [1893–1967]
Noontide in Late May 1917

Watercolor and gouache on paper, 22 x 17 15/16 in.
(55.9 x 45.6 cm). Whitney Museum of American Art, New York;
Purchase 31.408

One of the deepest and most enduring sources for art has been the unconscious mind. Out of its mysterious depths have come the inspired visions of William Blake, Vincent Van Gogh, and the twentieth-century American watercolorist Charles Burchfield. During his lifetime, Burchfield was known primarily as a poetic painter of nature and small-town American life, however the unconscious sources of his art have yet to be fully explored.

From late 1916 to early 1918, Burchfield produced an extraordinary group of imaginative watercolors that recalled his childhood fascination with natural forces. Burchfield would later describe the year 1917, when he painted *Noontide in Late May*, as his "golden year," a dynamic and highly productive period in which he created deeply emotional and original watercolors.

Noontide in Late May—based on a view of Burchfield's neighbor's garden in Salem, Ohio—is obviously more than a record of external fact. The artist has transformed a banal scene into a visionary world of swaying forms and brilliant colors. Although here the mood seems high-spirited, Burchfield was a reclusive man, at times deeply troubled, and he used his art as an expressive outlet for his inner life—his dreams, fears, fantasies, and regressions. Asked once to explain his art, he wrote that the subject matters little, serving only as the vehicle for the expression of the artist's moods and emotions. "Whenever I am asked questions concerning my artistic aims or methods," he wrote, "I hardly know what to say. So many things about painting, the real things, are intangible [and] the mental processes of an artist are more or less sub-conscious."

The Salem Bedroom Studio, painted in the same year as Noontide in Late May, is one of the most revealing of Burchfield's early watercolors. Rather than the customary daylight scene of the artist in his studio, Burchfield has set the stage at night in his childhood bedroom, where dark shadows and mysterious forms lurk in every corner. In this twilight world, between consciousness and sleep, the mind is free to project itself into the world. Like Noontide in Late May, The Salem Bedroom Studio is both an accurate depiction of an identifiable place and an outward projection of the artist's fears and fantasies.

Charles Burchfield. The Salem Bedroom Studio, 1917. Watercolor, gouache, and graphite on paper, 27 3/16 x 22 in. (69.1 x 55.9 cm). Burchfield-Penney Art Center, Buffalo State College, New York; Gift of the Charles E. Burchfield Foundation, 1975

The winter of 1916, just before Burchfield painted Noontide in Late May, was one of crisis and creativity in his life. At the age of twenty-three, he left Salem, Ohio, for the first time to pursue his art studies in New York City. After only two months, dismayed by city life, he returned home. One of the more grandiose schemes he came up with during this period was a project to invent an entirely abstract visual language for the expression of mood and emotion. Among the surviving sketches are those intended to represent "Fear," "Morbidness (Evil)," "Dangerous Brooding," and "Insanity." Though it appears that Burchfield never compiled a sketchbook dedicated to the more positive forces of life, the exuberant mood of Noontide in Late May, with its undulating vegetation and sun-infused composition, confirms his equally passionate connection to nature's glory and radiant beauty.

Charles Burchfield. Sketchbook: Conventions for Abstract Thoughts, 1917. Pencil on paper, 9 1/2 x 6 1/8 in. (24.1 x 15.6 cm). Kennedy Galleries, New York

By the time Burchfield painted An April Mood, nearly thirty years after Noontide in Late May, his desire to infuse his landscapes with personal and even religious symbolism had intensified. Though both works were produced in the spring, An April Mood is mournful and melancholy. Three foreground trees allude to the three crosses of the crucifixion, while the "darkness over the land" described in the biblical account is conveyed by the heavy overhanging clouds. These same dark forms also suggest that spring will be delayed this year. Burchfield, reflecting on the horrors of World War II and on his own aging, said he intended this painting to represent "the anger of God frowning on delinquent mankind."

Charles Burchfield. An April Mood, 1946–55. Watercolor and charcoal on paper, 40 x 54 in. (101.6 x 137.2 cm). Whitney Museum of American Art, New York; Purchase, with partial funds from Mr. and Mrs. Lawrence A. Fleischman 55.39

Marsden Hartley [1877–1943]
Landscape, New Mexico 1919–20

Oil on canvas, 28 x 36 in. (71.1 x 91.4 cm).
Whitney Museum of American Art, New York; Purchase,
with funds from Frances and Sydney Lewis 77.23

Nomadic by nature, Marsden Hartley was nevertheless deeply affected by the many places he called home. As an adult he never spent more than ten months in any one residence, shuttling between New York and Berlin, New Mexico and the Alps, before finally returning to his native Maine. Hartley appreciated both the anonymity of city crowds and the isolation of the wilderness; Europe's intellectual sophistication and America's undiscovered landscapes. He was especially attracted to the mountains, a recurrent subject of his work. In 1918 he visited New Mexico, and although he spent just eighteen months in the Southwest, the experience left a lasting impression on him. *Landscape, New Mexico*, completed shortly after his return to New York, offers insights into this peripatetic's profound sense of place. Here Hartley painted his memories of New Mexico, altered by time and distance. He captured not only the vivid colors of the desert, but also the spirituality he associated with the land and its native cultures.

When Hartley boarded a train for New Mexico in the spring of 1918, he envisioned the desert as a quintessentially American landscape, as a spiritual place celebrated in the art and rituals of Native Americans. He joined a growing group of modernists who worked in the Southwest—a group that would eventually include John Marin, Georgia O'Keeffe, and Paul Strand. Arriving in New Mexico, Hartley was understandably overwhelmed, gushing that he felt like "an American discovering America." Yet he soon found the Taos art scene unbearably dull, while the high altitude and cold winters proved detrimental to his health. In a letter to Alfred Stieglitz, Hartley complained, "I feel as if I were too near the sky all the time." His discomfort is evident in photographs, which show him in an overcoat and fedora, his urbane appearance out of place in the desert wilderness.

Marsden Hartley in New Mexico, c. 1918–19. The Bates College Museum of Art, Lewiston, Maine; Marsden Hartley Memorial Collection

Living in Germany before World War I, Hartley embraced European culture and its avant-garde, just as he would later seek out indigenous American art in New Mexico. He befriended Wassily Kandinsky and echoed the Russian artist's belief that "Every man who steeps himself in the spiritual possibil-ities of his art is a valuable helper in the building of the spiritual pyramid which shall someday reach heaven." Hartley's work from these German years included a series of abstracted landscapes inspired by sojourns to the Bavarian Alps. In *Painting No. 1*, he reduced the mountains to a series of overlapping triangles, the stars to asterisks—elemental but mystical symbols reminiscent of Kandinsky's own landscape abstractions.

Marsden Hartley. *Painting No.1*, 1913. Oil on canvas, 39 3/4 x 31 7/8 in. (101 x 81 cm). Sheldon Memorial Art Gallery and Sculpture Garden, University of Nebraska, Lincoln; F.M. Hall Collection

Lee Simonson. *Marsden Adopts Germany*, 1913. Watercolor on paper, 21 13/16 x 13 15/16 in. (56 x 35.7 cm). Yale Collection of American Literature, Beinecke Rare Book and Manuscript Library, Yale University, New Haven

A friend parodied Hartley's allegiance to the European avant-garde in a cartoon entitled *Marsden Adopts Germany*. Dressed in military costume, the artist carries a stein of beer and a flag emblazoned with an abstract painting signed "Kandinsky."

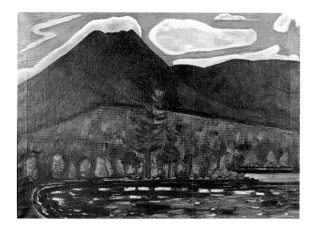

Marsden Hartley. *Mount Katahdin, Autumn, No. 1*, 1939–40. Oil on canvas, 30 1/8 x 40 in. (76.5 x 101.6 cm). Sheldon Memorial Art Gallery and Sculpture Garden, University of Nebraska, Lincoln; F.M. Hall Collection

Toward the end of his life, Hartley returned to spend part of each year in Maine, where he had grown up in poverty and isolation. After years of wandering, he had finally confronted the ghosts of an unhappy childhood, and this homecoming yielded some of the artist's most haunting images. At age sixty-two, Hartley made a pilgrimage to Mount Katahdin, the state's highest peak, and began painting the mountain's brooding form at different seasons and times of day. Of all Hartley's works, these Maine landscapes come closest to revealing the source of his lifelong fascination with mountains, a subject he had traveled around the world to paint. In his 1941 poem "The Pilgrimage and the Game Warden," Hartley describes Mount Katahdin as a site that was both uplifting and humbling.

*The moment of a man clawing at a cliff
is nothing to a cliff.
It is the man that bursts with enmity
toward something bigger than himself—
the whisper of a mountain floors him
suspending his ankles to a laughing
wind.*

Marsden Hartley, excerpt from
"The Pilgrimage and the Game Warden," 1941

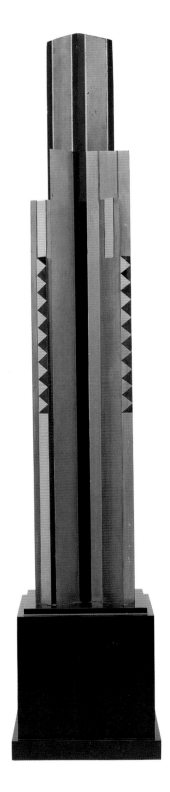

John Storrs [1885–1956]
Forms in Space #1 c. 1924

Marble, 76 3/4 x 12 5/8 x 8 5/8 in. (194.9 x 32.1 x 21.9 cm).
Whitney Museum of American Art, New York; 50th Anniversary Gift
of Mr. and Mrs. B.H. Friedman in honor of Gertrude Vanderbilt
Whitney, Flora Whitney Miller and Flora Miller Biddle 84.37a–b

In the first few decades of this century, many artists embraced bold, new modern forms and styles, among them John Storrs, who made important contributions to the development of a modern sculptural language. The Chicago-born Storrs settled in Paris in 1912, serving an apprenticeship under Auguste Rodin. He soon became one of the master's most beloved students. From this period on, Storrs developed a distinctive style that successfully combined principles of the past with contemporary influences and innovations. He was inspired by a wide range of sources—from Egyptian art and ancient Greek steles to Native American designs and industrial imagery.

Storrs' lifelong interest in the interrelationship of sculpture and architecture culminated in a group of works produced in 1923–24. One of them, the tall, elegant *Forms in Space #1*, stands as the extreme simplification of forms that Storrs had been working toward over the previous decade. The starkness of its pure white marble, the symmetry of its towers, and its repeated zigzag pattern, make it the most purely geometric and abstract of Storrs' work from this time. What for many artists might transpire over decades, for Storrs was a swift evolution from figurative work to the spare geometries of skyscraper forms.

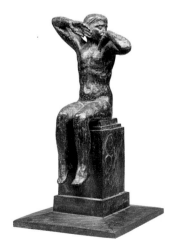

In 1909, when Storrs began to study sculpture, the human figure was the predominant subject and cast bronze the most acceptable material. Storrs held tight to these conventions, only rarely deviating from them in his student years. Even the theme of this early work—a young female nude symbolizing the dawning of a new day—underscores the conservative foundations of his training. It was in 1912, as a pupil of Rodin, that Storrs first encountered a more modern and abstract approach. Though his works remained primarily figurative for the next eight years, he learned from Rodin to eliminate nonessential detail and create rough, modeled surfaces that accentuate light and shadow. Though *Morning* clearly represents an older sculptural tradition, out of which Storrs developed, the stepped rectangular form of the base foreshadows the geometric tendencies of his later work.

John Storrs. *Morning,* 1915. Bronze, 16 3/4 x 8 3/4 x 9 in. (42.5 x 22.2 x 22.9 cm). Estate of John Storrs; courtesy Robert Henry Adams Fine Art, Chicago

While Storrs was studying with Rodin, he was also confronting Cubist and Futurist painting and sought to apply these vanguard concepts to three-dimensional sculptural form. Although still tied to figuration in *Three Bathers*, Storrs treats the traditional subject in a new way, combining the dynamic force lines of Futurism with linear carving to create a thoroughly modern sensibility.

John Storrs. *Three Bathers*, c. 1916–19. Plaster, 14 1/8 x 11 3/4 x 3 1/8 in. (35.9 x 29.8 x 7.9 cm). The Dayton Art Institute; Museum purchase with funds provided by the 1995 Associate Board Art Ball

Storrs took his Cubist experiments a step further in *Le Sergent de Ville (Gendarme)*. The fluid movement and expressive quality of *Three Bathers* is gone. In this work, legs, arms, and head barely emerge from the plaster block. Storrs had learned from Rodin that "a sculpture is constructed by carving and not by adding. It is complete in the primitive mass. What's left is a selection." In *Le Sergent de Ville (Gendarme)*, Storrs reduced all detail to its essential form, separating and defining distinct faceting planes with solid areas of color. It was in such geometric and mechanistic figurative works that Storrs began to combine his interests in sculpture and architecture and to incorporate the saw-tooth angular patterns that he refined in his later skyscraper structures.

John Storrs. *Le Sergent de Ville (Gendarme)*, 1919. Polychromed plaster, 9 1/8 x 2 1/4 x 2 in. (23.2 x 5.7 x 5.1 cm). Collection of Alice and Nahum Lainer

By 1923, in a work such as *Study in Form #1*, Storrs had rejected an active, polychrome surface in favor of simplified rhythmic shapes and a methodical, graduated undercutting of the stone. The human form, so integral to his earlier work, is here only suggested in the most simplified and abbreviated manner, giving the sculpture the appearance of a modern-day caryatid column.

It was during the early 1920s that Storrs found inspiration in the simplified geometries of Frank Lloyd Wright, the dynamic urban scenes of Joseph Stella, Native American motifs, and Art Deco. *Study in Form #1*, along with others from this series, are among the first examples of non-objective sculpture in America and led directly to Storr's important series of skyscraper forms.

John Storrs. *Study in Form #1*, c. 1923. Stone, 19 3/4 x 3 7/16 x 3 7/16 in. (50.2 x 8.7 x 8.7 cm). Estate of John Storrs; courtesy Robert Henry Adams Fine Art, Chicago

Collage of paper, newspaper, fabric, cord, and broken glass,
19 3/4 x 13 1/4 x 4 3/4 in. (50.2 x 33.7 x 12.1 cm). Whitney Museum
of American Art; Purchase, with funds from the Historic Art
Association of the Whitney Museum of American Art, Mr. and Mrs.
Morton L. Janklow, the Howard and Jean Lipman Foundation, Inc.,
and Hannelore Schulhof 76.9

Few American artists before World War II used
the collage medium, but their work yielded an
inventive array of styles and approaches, no
doubt because the precedents for pasting pieces
of paper to canvas ranged far and wide. In
France, the Cubism of Picasso and Braque
introduced the idea of a complicated interplay
between painted and affixed elements. Dada
and Surrealist constructions made the irrational
juxtaposition of unrelated objects and imagery
an accepted form of vanguard expression.
In addition to European modernist innovations,
American artists may have drawn indirect
inspiration for collage from the use of found
objects in nineteenth-century folk art, from
Victorian paper cutouts, and from the Shaker
respect for humble materials.

Arthur Dove, the most proficient of the
American collage artists, created about thirty
collages between 1924 and 1930, several of
which were symbolic portraits. In these works,
he responded to the people and places around
him and took pleasure in the tactile, textural
quality of diverse materials. In *The Critic*, Dove
chose his collage elements in part for their
subject matter. He clipped newspaper art
reviews along with illustrations of roller skates
and a vacuum cleaner and pieced them together
to form a satirical portrait of the New York art
critic Forbes Watson. The critic glides by swiftly
and hastily, gathering up all he views. The
empty head and the unused monocle wittily
convey Dove's poor opinion of the reviewer's
capacity for visual and intellectual judgment.

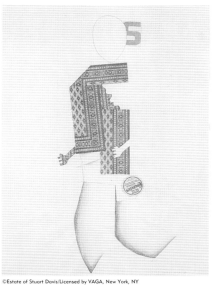

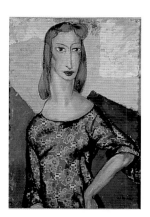

In the early 1920s, Stuart Davis executed a series of simulated collages—works in which he turned the collage principle around by painting elements to mimic collage attachments. In *Untitled*, he combined simulated and actual areas of collage with drawn passages to form an abstracted figure. Like much of his other work, Davis' collages reflect his interest in American popular culture, design, and advertising imagery. His mixing of random elements—a logo as the hip, patterned paper as the torso, and painted wood grain for the hair—recalls the illogical combinations in Marcel Duchamp's and Man Ray's Dada constructions.

©Estate of Stuart Davis/Licensed by VAGA, New York, NY

Stuart Davis. *Untitled*, 1921. Collage and graphite on paper, 23 x 17 1/4 in. (58.4 x 43.8 cm). Collection of Earl Davis; courtesy Salander-O'Reilly Galleries, New York

Alfred Maurer also experimented with collage in the 1920s, developing an inventive method of portraiture. Working with women's dress fabric, Maurer created about a dozen portraits by stretching the material on panels and selectively painting over it. Using a heavy tempera impasto, he built up the figure and background, but left the dress unpainted.

Maurer's system of substituting a found object for its painted illusion was a strategy favored in Cubist collages. Maurer, however, little concerned with the Cubist fragmentation of space and form, preferred to experiment with colors and textures, creating boldly patterned compositions unlike his other, more heavily painted works of the 1920s.

Alfred H. Maurer. *Portrait of Girl in a Flowered Dress*, 1924. Casein on fabric gessoed to board, 25 7/8 x 17 7/8 in. (65.7 x 45.4 cm). Frederick R. Weisman Art Museum, University of Minnesota, Minneapolis; Gift of Ione and Hudson Walker

The sixty-five collages that Joseph Stella created from around 1918 until his death in 1946 were never exhibited in his lifetime. Compared to those of most other American artists, Stella's collages are radical in their severely abstracted character—and far removed from his own paintings, which are filled with intensely colored, recognizable detail. Using discarded bits of magazines and newspapers, leaves, and debris of all kinds, Stella delighted in the accidental effects of water staining and smudging on the irregularly torn fragments; he was endlessly fascinated by what he called "these natural forms that man can never equal."

Joseph Stella. *Collage, Number 11*, c. 1933. Collage of paper, 11 1/2 x 17 in. (29.2 x 43.2 cm). Whitney Museum of American Art; Gift of Mrs. Morton Baum 68.23

Though his career as an artist lasted only eight years, John Covert produced some of the most original avant-garde work of his time. Using startlingly untraditional materials—plywood, cord, wooden dowels, and upholstery tacks—he created collages and constructions that demonstrate a sophisticated assimilation of Cubist and Dada aesthetics, but reflect as well the burgeoning interest among many American modernists in industrial imagery. *Time* is an imaginative construction that combines the machine forms of Man Ray with the found-object aesthetic of Duchamp. The diagrams, compass markings, words, and symbols reflect Covert's lifelong interest in mathematics, word games, and cryptography, producing an original iconography of complex symbolism.

John Covert. *Time*, 1919. Oil and upholstery tacks on wood covered in cardboard, 24 x 24 in. (61 x 61 cm). Yale University Art Gallery, New Haven; Gift of Collection Société Anonyme

Charles Sheeler [1883–1965]
Interior 1926

Oil on canvas, 33 x 22 in. (83.8 x 55.9 cm).
Whitney Museum of American Art; Gift of Gertrude Vanderbilt
Whitney 31.344

Charles Sheeler was one of a group of American artists, writers, and literary critics in the 1920s who assimilated many of the lessons of European modernism but sought to ground their art firmly in native soil. Sheeler became fascinated with the simple, vernacular architecture and artifacts of the American past and began to incorporate them into his work. "My interest in Early American architecture and crafts," he once wrote, "has been as influential in directing the course of my work as anything in the field of painting." *Interior* is the first of a series of seven canvases Sheeler painted between 1926 and 1934 that focus on close-up, abruptly cropped views of American furniture, textiles, and other decorative arts from his own growing collection. By the twenties, Shaker design and architecture had become central to Sheeler's concept of a truly indigenous aesthetic. Two of his Shaker pieces appear prominently in this painting: the trestle table with its curved support legs, a uniquely Shaker design, and the small stand with a pitcher and fruit that seem to be posing for a still life. In many ways, Sheeler's work reflects Shaker design principles—simplicity of line, economy of means, and meticulous craftsmanship. Shaker artifacts thus served Sheeler as both subject matter and object lessons in the development of his American aesthetic.

Sheeler began to collect early American furniture and pottery in the 1910s, while spending weekends in a pre-Revolution stone farmhouse in Doylestown, Pennsylvania. By the late 1920s, when he took this photograph of one of the rooms in his South Salem, Connecticut, home, he had amassed a large collection of textiles, furnishings, and tableware dating from the eighteenth and nineteenth centuries. Many of the objects from his collection appear and reappear in his still lifes and domestic interiors, like actors in a changing repertory. *Interior* was originally entitled *Interior, South Salem* and includes the rag runners, chevron-patterned rug, trundle bed, handwoven coverlet, and a portion of the wall cupboard in this room. Sheeler used a similar high vantage point in both the painting and the photograph, emphasizing the flat patterns of the textiles and the careful arrangement of furniture and objects.

Charles Sheeler. *South Salem, Living Room*, 1929. Gelatin silver print, 7 3/16 x 9 9/16 in. (18.3 x 24.3 cm). Museum of Fine Arts, Boston; The Lane Collection

Nantucket

*Flowers through the window
lavender and yellow*

*changed by white curtains—
Smell of cleanliness—*

*Sunshine of late afternoon—
On the glass tray*

*a glass pitcher, the tumbler
turned down, by which*

*a key is lying—And the
immaculate white bed*

William Carlos Williams, "Nantucket," from *Selected Poems of William Carlos Williams* (New York: New Directions Books, 1969)

Marsden Hartley. *Church at Head Tide, No. 2*, 1938–40. Oil on canvas, 28 x 22 1/2 in. (71.1 x 57.2 cm). The Minneapolis Institute of Arts; Gift of Mr. and Mrs. John Cowles

Paul Strand. *White Fence, Port Kent, New York*, 1916. Aperture Foundation Inc., Paul Strand Archive

Sheeler was not alone in his belief that ideas and images from the American past could be used to revitalize the arts of the present. Along with his close friend, the poet William Carlos Williams, he was a member of a loosely affiliated group of poets, painters, dramatists, novelists, and literary critics in the teens and twenties who fostered an American art that was both modernist in style and yet native in spirit. Sheeler found inspiration in earlier American decorative arts, while other members of the group turned to different aspects of Americana. In fiction, the short stories of Sherwood Anderson and Willa Cather drew on the experiences of ordinary Americans and small-town life. The playwrights Marc Connelly and Eugene O'Neill mined American folk tales and nineteenth-century New England life for their sophisticated modern dramas. In poetry, Hart Crane and William Carlos Williams wove American history and myth into experimental forms. And in the visual arts, many painters and photographers of the period, struggling to shed European influences, depicted simple American forms, from regional architecture to the humble picket fence.

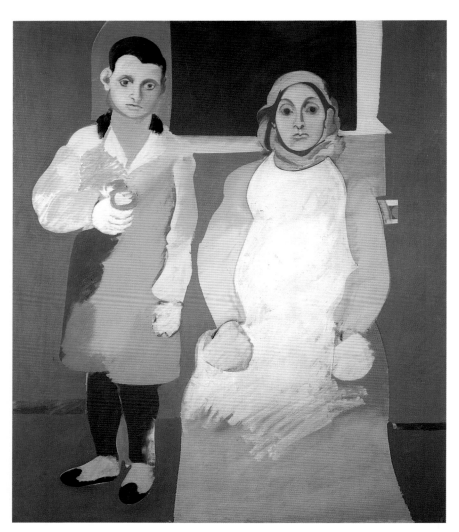

Arshile Gorky [1904–1948]
The Artist and His Mother c. 1926–36

Oil on canvas, 60 x 50 in. (152.4 x 127 cm).
Whitney Museum of American Art, New York; Gift of Julien Levy for
Maro and Natasha Gorky in memory of their father 50.17

In 1924, four years after he left his native Armenia for America, Vosdanik Adoian changed his name to Arshile Gorky. In so doing, he not only proclaimed—falsely—a relationship to the great Russian writer Maxim Gorky, but he also began what would become a lifelong process of assuming different personas. Perhaps the "camouflaged man," as his friends called him, was searching for artistic identity, or just role-playing.

The implicit fragility of such a chameleon persona, however, may be traced back to the trauma of Gorky's childhood in Armenia during World War I, when the Ottoman Turks began a campaign of genocide against the Armenians. In 1915, Gorky, his mother, and his sister were sent on a death march. Although all three survived, Gorky's mother never recovered her health; four years later, she died, and the fifteen-year-old Gorky soon immigrated to America.

The Artist and His Mother, Gorky's haunting memory of his childhood, may expose the core of this man of many masks. Based on a photograph taken in Armenia in 1912, the subject obsessed the artist for nearly twenty years. The boy's lack of physical connection to his mother and his hollow, penetrating stare express the deep sense of isolation and grief that engulfed the artist throughout his life. As Gorky once wrote to his sister, "I am constantly searching for something and I do not know what that thing is....Within each man's soul... there is an emptiness which we continually seek to fill so that we will not remain alone."

Not only did Gorky pretend to be the cousin of Maxim Gorky, at various times he also claimed to have studied with Wassily Kandinsky, to have attended the Académie Julian in Paris, and to have been dismissed from the Rhode Island School of Design. Photographs of Gorky from different periods reflect his various personas: innocent exotic, sophisticated cosmopolitan, or romantic intellectual. As one artist wrote, "He could arrange a performance upon very short order." Another observed, "Whenever Gorky was with a group he would turn his jacket inside out...he would make it right away into a peasant outfit." Gorky's peers continually marveled at his ability to invent different identities. "Nature had provided him with a tall, dark and impressive aspect easily identifiable with the 'artist type,'" Stuart Davis remarked, but "he brought this asset to its maximum intensity by the adoption of a black velour hat pulled low over his eyes, and a black overcoat buttoned tight under the chin and extending to the ankles."

Arshile Gorky, New York City, 1930. Collection of Charles H. Pehlivanian

Arshile Gorky, New York City, 1937. Collection of Charles H. Pehlivanian

Arshile Gorky, 1946, from *Life* magazine

It is common for a young artist to emulate the style of an older master as a form of apprenticeship. Gorky, however, purposefully and extensively borrowed from numerous artists for a prolonged period. As one historian put it, he did so early on "to penetrate the very personae of the older artists." While many critics attributed Gorky's appropriation to a lack of originality, others have come to see his "career of imitation," as art historian Meyer Schapiro termed it, as a measure of genius.

In a series of self-portraits made when he was in his late twenties, Gorky imitated the styles of several painters to whose artistic genius he aspired. These portraits not only reflect his interest in the art of (left to right) Paul Cézanne, Henri Matisse, and Paul Gauguin, but each work reveals a different self-image. In the first we see an urbane gentleman, in the second a suspicious rogue, and in the third a sensuous bohemian. In both style and content, Gorky was continually engaged in a process of personal reinvention.

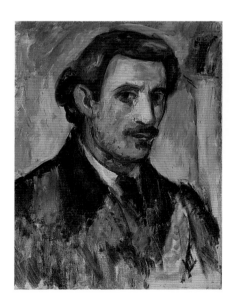

Arshile Gorky. *Self-Portrait*, 1927–28. Oil on canvas, 19 1/2 x 14 1/4 in. (49.5 x 36.2 cm). The Art Institute of Chicago; The Lindy and Edwin Bergman Collection

Arshile Gorky. *Self-Portrait*, c. 1928–31. Oil on canvas, 20 x 16 in. (50.8 x 40.6 cm). Solomon R. Guggenheim Museum, New York; Taffy Holland and David S. McCulloch, 1994

Arshile Gorky. *Self-Portrait*, c. 1933–34. Oil on canvas, 10 x 8 in. (25.4 x 20.3 cm). Collection of the Soyer Family

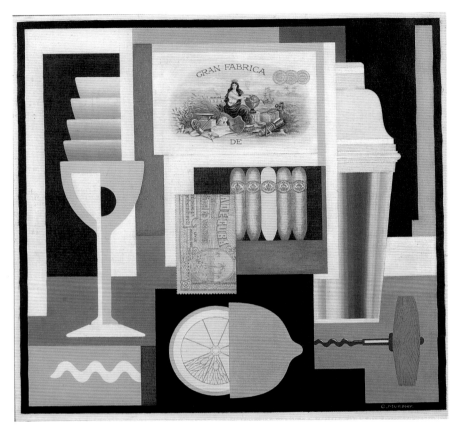

Gerald Murphy [1888–1964]
Cocktail 1927

Oil on canvas, 29 1/16 x 29 7/8 in. (73.8 x 75.9 cm).
Whitney Museum of American Art, New York; Purchase, with funds
from Evelyn and Leonard A. Lauder, Thomas H. Lee, and the
Modern Painting and Sculpture Committee 95.188

In the 1920s, Gerald Murphy's life, like his art, was emblematic of modernity. His commitment to artistic experimentation, early passion for modern design, involvement with many of the most advanced artists, writers, composers, and choreographers, and perhaps most of all, his belief that "living well is the best revenge" made him a quintessential figure of the Roaring Twenties.

In his short, seven-year career as an artist, Murphy produced probably no more than fourteen paintings, of which only six are extant. Their contemporary subjects—an engine room, a laboratory, a boat deck—and their bold, simplified design are signposts of the modern spirit. Key among these works is *Cocktail*, a clean, stylized depiction of what Murphy termed utilitarian "objects in a world of abstraction." In fact, it is a radical still-life painting, reminiscent of Fernand Léger's Cubism and Charles Sheeler's machine aesthetic, but nevertheless unique in its autobiographical approach. Based on the memory of his father's bar accessories, *Cocktail* celebrates a ritual that was forbidden during Prohibition in America and became a distinctive feature of life for the so-called Lost Generation of expatriates living abroad.

Although known primarily as a painter, Gerald Murphy was an artistic polyglot, interested in photography, film, and theater. In 1923, he was commissioned to write the script and design the stage sets for *Within the Quota*, a work for the Ballets Suédois that was presented to great acclaim at the Théâtre des Champs-Élysées in Paris. The story, a biting satire on American life, involves a poor Swedish boy who emigrates to the United States in search of the good life. Scored by Murphy's friend Cole Porter, *Within the Quota* was hailed as the first jazz ballet. Murphy's design for the program, made from cut-and-pasted photographs, reflects his interest in collage and contemporary urban subjects.

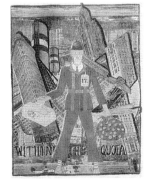

Gerald Murphy. Playbill cover
for *Within the Quota*, 1923

The crisp edges and flattened abstract geometric patterns of Murphy's paintings stem from his immersion in the machine aesthetic of the 1920s. Even before the landmark presentation of Art Deco, or machine age art, at the Exposition Internationale des Arts Décoratif Industriels Modernes, held in Paris in 1925, Murphy had painted a number of machine-inspired subjects. While in Berlin in 1927, he viewed Fritz Lang's film *Metropolis* and was deeply moved by the futuristic, industrial design of the sets. *Watch*, painted in more than a dozen shades of gray, is a close-up rendering of gears, springs, and levers. Murphy explained that he was "struck by the mystery and depth of a watch. Its multiplicity, variety and feeling of movement and man's perpetuity." Murphy's life as well as his art were infused with the streamline aesthetic. In his Paris apartment, the walls were painted dead white, the floors a shiny black, and the furniture was upholstered in black satin. On the grand piano, a giant ball bearing was exhibited as if it were an art work.

In the 1920s, the cocktail, in particular the martini, was a symbol of sophistication and modernity. Designers from Russell Wright to Norman Bel Geddes created distinctive, sleek futuristic Art Deco forms in stainless steel and plastic for cocktail shakers and other accoutrements. In Ernest Hemingway's *Farewell to Arms* (1929), the central character of the book describes his first martini: "I had never tasted anything so cool and clean. They made me feel civilized."

Murphy was proud of the fact that he invented his own cocktails. According to playwright Philip Barry, to whose wife Murphy gave *Cocktail*, "Murphy was like a priest preparing Mass" when he mixed his legendary liquid concoctions.

Norman Bel Geddes. *Cocktail Shaker, Glasses, and Tray*, 1937. Manufactured by Revere Brass and Copper Co., Rome, New York. Chrome-plated metal shaker, 12 3/4 in. (32.4 cm) height. Brooklyn Museum of Art, New York; Gift of Paul F. Walter

Gerald Murphy. *Watch*, 1925. Oil on canvas, 78 1/2 x 78 7/8 in. (199.4 x 200.3 cm). Dallas Museum of Arts; Foundation for the Arts Collection, gift of the artist

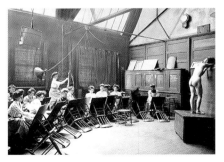

Elsie Driggs [1898–1992]
Pittsburgh 1927

Oil on canvas, 34 1/4 x 40 in. (87 x 101.6 cm).
Whitney Museum of American Art, New York;
Gift of Gertrude Vanderbilt Whitney 31.177

Elsie Driggs was one of the few women artists to achieve renown in this country in the 1920s. At a time when it was almost impossible for women to exhibit and to sell their work, Driggs was soon hailed as one of the country's leading women painters and one of the few tackling industrial subject matter. Despite this early acclaim, by the 1940s Driggs had largely faded from sight as a professional artist. Following her marriage to fellow artist Lee Gatch in 1936, and their move to rural New Jersey, her artistic career was subsumed within her new roles as wife and mother. Only in the 1970s, after Driggs moved back to New York and began to paint and exhibit again, was her work discovered by a new generation of scholars and her name returned to a prominent place in the history of early twentieth-century American modernism. In 1971, at the age of seventy-three, Driggs was given her first retrospective exhibition, at the Phillips Collection in Washington, D.C.

Driggs studied from 1917 to 1920 in the progressive environment of New York's Art Students League. The League was founded in 1875 as a student-run art school. Its radical reputation at the turn of the century was based in part on its commitment to equal rights for women. From the beginning, it was open to "all who are thoroughly earnest in their work, both ladies and gentlemen," and its board consisted of an equal number of men and women. In contrast, the reactionary National Academy of Design—at the time the most important art school in the country—admitted only seventy-five women out of thirteen hundred members from 1825 until 1953.

Women's Life Class with Female Model, Art Students League, c. 1905. Archives of American Art, Smithsonian Institution, Washington, D.C.

A double standard was often applied to women artists. When Driggs first took some of her early work to show art dealer Charles Daniel, his gallery assistant recommended that she sign it with her last name only so that Daniel, not knowing it was the work of a woman, wouldn't be immediately prejudiced against it. Defiantly, Driggs signed her full name. To her surprise, Daniel not only liked her work, but also included the painting *Chou* in his next group show, where it was singled out for praise by every critic.

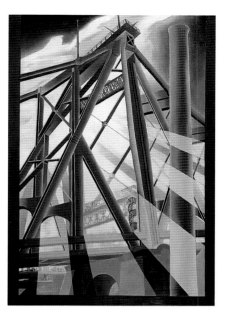

Elsie Driggs. *The Queensborough Bridge*, 1927. Oil on canvas, 40 x 30 in. (101.6 x 76.2 cm). The Montclair Art Museum, New Jersey; Museum Purchase, Florence O.R. Lang Acquisition Fund

Elsie Driggs. *Chou*, 1923. Oil on fabric mounted on wooden panel, 23 3/4 x 23 1/2 in. (60.3 x 59.7 cm). The Montclair Art Museum, New Jersey; Gift of Julian Foss in memory of his wife, Eva Foss

Women artists such as Elsie Driggs and Georgia O'Keeffe were often celebrated for the "feminine" imagery they painted and drew—organic forms rendered in soft, mottled tones. Before turning to industrial subjects, Driggs produced pastels of plants that were sought after by some of America's most renowned collectors. *Cineraria* was purchased by the important modernist collector Ferdinand Howald, who also hung a group of Driggs' pastels in his New York apartment. But Driggs had other artistic ambitions, as suggested by later paintings such as *Pittsburgh* and *The Queensborough Bridge*. Like her fellow Precisionists, she simplified form and eliminated detail in order to hone the underlying geometric beauty of modern technology and industry. Driggs' choice of "masculine," industrial themes was itself an implicit challenge to the traditional notions about appropriate subject matter for women artists in the early twentieth century.

In New York City in the 1920s, there were only about seven commercial gallery owners committed to exhibiting the work of contemporary American artists. Of these, only three regularly represented women: Charles Daniel, owner of the Daniel Gallery; Alfred Stieglitz; and Edith Halpert.

The Whitney Studio Club (1918–28) was one of the few noncommercial venues to support American women artists. The Club was an exhibition space, library, and meeting place for artists, founded and directed by women—Gertrude Vanderbilt Whitney and Juliana Force, respectively. Driggs and numerous other women were among the Club's more than three hundred members. *Pittsburgh* was purchased by Mrs. Whitney from Driggs' 1928 one-artist show at the Daniel Gallery and donated to the Whitney Museum for its opening in 1931.

Advertisement for the Daniel Gallery, in *The Arts*, **December 1928.** Driggs is the only woman among the artists listed.

Elsie Driggs. *Cineraria*, c.1926. Pastel on paper, 16 5/8 x 13 5/16 in. (42.2 x 33.8 cm). Columbus Museum of Art, Ohio; Gift of Ferdinand Howald

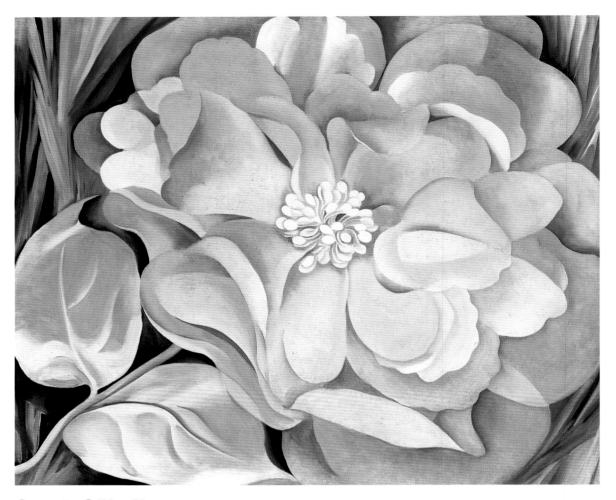

Georgia O'Keeffe [1887–1986]
The White Calico Flower 1931

Oil on canvas, 30 x 36 in. (76.2 x 91.4 cm)
Whitney Museum of American Art, New York;
Purchase 32.26

When asked to describe the inspiration for her well-known paintings of flowers, Georgia O'Keeffe replied, "I said to myself—I'll paint what I see—what the flower is to me but I'll paint it big and they will be surprised into taking time to look at it." Paintings such as *The White Calico Flower* reveal the artist's sensitivity to nature—her attention to the curl of a petal, the curve of a leaf. Ironically, however, this is not a real blossom, but a fabric flower used in New Mexican funeral ceremonies, which O'Keeffe collected and brought back to her studio. Although she also painted real flowers, artificial blooms had the advantage of never fading, and she employed them often. Ultimately, it was the form of the flower that intrigued O'Keeffe—it did not matter if it was real or synthetic. In *The White Calico Flower*, as in so many of her works, the primary subject is not nature itself, but the artist's response to its many forms.

O'Keeffe's approach to nature was shaped by the aesthetic philosophy of artist-educator Arthur Wesley Dow. She studied with Dow at Columbia Teacher's College in 1914 and later recalled, "This man had one dominating idea: to fill a space in a beautiful way—and that interested me." Dow emphasized abstract patterns of light and dark rather than illusionistic shading—sinuous form, not scientific accuracy. In her work, O'Keeffe heeded his advice: "Not a picture of a flower is sought," Dow said, "that can be left to the botanist—but rather an irregular pattern of lines and spaces, something far beyond the mere drawing of a flower from nature."

Arthur Wesley Dow. _Blue Lily_, c. 1914. Color woodcut, 8 15/16 x 2 3/8 in. (22.7 x 6 cm). Ipswich Historical Society, Massachusetts

O'Keeffe's floral paintings are often compared to the close-up nature studies of contemporaneous photographers. There is certainly something photographic in the close cropping and sharply focused center of _The White Calico Flower_. Imogen Cunningham, however, looked at flora with a botanist's eye for detail. Her photograph captures the delicate tendrils ready to unfurl atop an elaborate "tower of jewels." In O'Keeffe's flower, petals and leaves are stiff and bleached; stamens and pistols, abbreviated and sterile. The painting's focus is the blossom's radiating structure and the complex patterns formed by curled, overlapping petals.

Imogen Cunningham. _Magnolia Blossom, Tower of Jewels_, 1925. The Imogen Cunningham Trust, Berkeley, California

Arthur Wesley Dow believed that "one uses the facts of nature to express an idea or emotion." The abstracted buds and leaves of _Crazy Day_, an early charcoal drawing by O'Keeffe, suggest Dow's influence. O'Keeffe's overgrown forest of bold lines and delicate strokes, sharp angles and softened curves, conveys a frenzied mood. The artist, however, affected instead a purely visual impulse: "I am attempting to express what I saw in a flower which apparently others failed to see." O'Keeffe clearly privileged her own perceptions over botanical accuracy: nature resided not just in the flower, but within herself.

Georgia O'Keeffe. _Crazy Day_, 1919. Charcoal on paper, 19 x 25 in. (48.3 x 63.5 cm). National Gallery of Art, Washington, D.C.; Alfred Stieglitz Collection, Gift of the Georgia O'Keeffe Foundation

Charles Sheeler [1883–1965]
River Rouge Plant 1932

Oil on canvas, 20 x 24 1/8 in. (50.8 x 61.3 cm).
Whitney Museum of American Art, New York; Purchase 32.43

Although Charles Sheeler initially took up photography to supplement his income as a painter, he quickly became proficient in the new medium, earning a reputation both for his fine art photography and for his commercial work. In 1927, on a photography assignment for the advertising agency N.W. Ayer, Sheeler visited the recently completed Ford Motor plant at River Rouge, just outside Detroit. His photographs of the plant were part of Ford's extensive campaign to promote the Model A, which was released in December 1927 with elaborate fanfare. Describing the assignment in a letter, the artist declared, "The subject matter is incomparably the most thrilling I have had to work with." Over the course of six weeks, he produced thirty-two meticulously composed photographs of the plant's enormous buildings, conveyor belts, and storage bins. Published in the company's newsletter and in popular magazines, the

photographs served as potent reminders of Ford's dominance of the auto industry. Yet Sheeler's fascination with River Rouge transcended the commercial intent of the initial assignment and persisted even after he had returned home. Using his photographs for reference, Sheeler embarked on a series of drawings and paintings of the site. His *River Rouge Plant* depicts the coal-processing facility looming majestically above the reflective waters of the boat slip. It is a remarkably serene, almost reverential image of a bustling auto plant. In both his paintings and his drawings, Sheeler portrayed River Rouge not merely as the world's largest car factory, but as something even grander— a monument to American industry.

The River Rouge plant represented an extraordinary technological accomplishment, and it is perhaps not surprising that Ford hired Sheeler to photograph not shiny new cars, but the factory that produced them. The images were used for public relations; they also appeared in *Ford News*, the company's newsletter. This cover features Sheeler's photograph of River Rouge's massive iron ore, limestone, and coal storage bins, which dwarf the train in the foreground. Unlike Ford's advertisements for the Model A, which often featured images of the car itself, Sheeler's photographs of River Rouge were used to reinforce, more subtly, the company's unrivaled status in the industry.

Charles Sheeler. *Storage Bins at the Boat Slip*, 1927 (detail). Cover of *Ford News*, May 1, 1929. Ford Motor Company, Dearborn, Michigan

River Rouge Plant is Sheeler's only oil painting of the Ford factory that refers to the plant in its title; the artist gave other paintings of River Rouge more general titles such as *American Landscape* or *Classic Landscape*. Although he was hired to promote Ford's interests, Sheeler clearly found at River Rouge a more universal theme. Certainly the artist and the automaker shared a desire to present River Rouge as the grandest factory ever built. Yet it was not Ford Sheeler worshipped, but the promise of American industry. "It may be true," as he remarked, "that our factories are our substitute for religious expression."

Charles Sheeler. *Classic Landscape*, 1931. Oil on canvas, 25 x 32 1/4 in. (63.5 x 81.9 cm). Collection of Mr. and Mrs. Barney A. Ebsworth Foundation

In 1928, a portfolio of Sheeler's River Rouge photographs was published in *Vanity Fair* under the heading "By Their Works Ye Shall Know Them." The article proclaimed that "in a landscape where size, quantity and speed are the cardinal virtues, it is natural that the largest factory turning out the most cars in the least time should come to have the quality of America's Mecca, toward which the pious journey for prayer." The bold X formed by the conveyor belts in Sheeler's photograph transforms River Rouge into a quasi-religious icon for an industrial era.

Charles Sheeler. *Ford Automobile Factory in Detroit with Criss-Crossed Conveyors*, 1927. Published in *Vanity Fair*, February 1, 1928. Condé Nast Publications, New York

Grant Wood [1892–1942]
Study for Breaking the Prairie 1935–39

Colored pencil, chalk, and graphite on paper,
triptych, 22 3/4 x 80 1/4 in. (57.8 x 203.8 cm) overall.
Whitney Museum of American Art, New York;
Gift of Mr. and Mrs. George D. Stoddard 81.33.2a–c

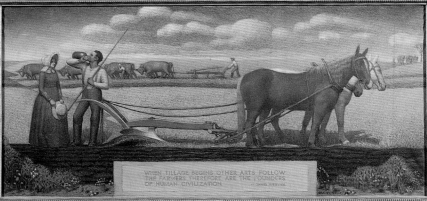

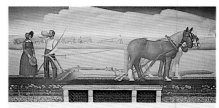

Grant Wood's *Study for Breaking the Prairie* celebrates the industry and spirit of the Midwest farmer in a scene of pioneers transforming the prairie into rich, tillable farmland. This picture of rural America omits all reference to the disastrous conditions actually facing farmers during the Depression. Across the country, the prices of agricultural products plummeted; many families lost their farms and had to give up their traditional ways of life. Artists, responding to these circumstances, made farming a subject of their art. Under the auspices of the Works Progress Administration (WPA) and other national relief programs, some idealized agrarian America in public mural projects for schools, post offices, courthouses, and hospitals. Wishful images of productive farmers working the land were meant to express national strength and continuity at a time of crisis. Other artists, in contrast, faithfully documented the plight of the farmer. Photographers working for the federal government's Farm Security Administration (FSA) were instructed to document and accurately record the devastating impact the Depression had on farmers. These artists traveled to areas of the country affected by economic calamity, migration, and drought. Their photographs carried a special authority since the camera, it was believed, did not lie. However, even the FSA photographers sometimes manipulated reality in order to lend it their own interpretations.

Grant Wood. *Breaking the Prairie*, 1937. Oil on canvas, center panel, 132 x 276 1/4 in. (335.3 x 701.7 cm), side panels, 132 x 84 3/4 in. (335.3 x 215.3 cm) each. The Iowa State University Library, Ames

Grant Wood turned his study for *Breaking the Prairie* into large-scale murals in the library at Iowa State University in Ames. The murals were painted, under Wood's direction, by a group of student-artists who received relief pay for their work from the federal government. Although Wood often enjoyed government patronage, he had numerous detractors in the art press and on the political left. Many complained that his nostalgic outlook was socially irresponsible because it ignored the harsh realities of agrarian America in the Depression years.

Grant Wood was a native of Iowa and the leader of a group of artists known as the Regionalists. They sought an art that expressed the experiences and concerns of plainspoken, honest people living in America's heartland. Here Wood is pictured with fellow Regionalist John Steuart Curry. Both artists wear overalls and affect the postures of simple farmers.

Grant Wood and John Steuart Curry, summer 1933

Dorothea Lange, trained as a studio photographer, first turned to documentary photography in the early 1930s. She joined the FSA in 1935, hoping that her photographs might be used to improve conditions for farm families living in California migrant camps.

She photographed Florence Thompson, a destitute pea-picker, in several different poses and from different angles before she got the shot she wanted. While printing the image, Lange cropped out much of the surrounding imagery, dramatically focusing attention on the migrant mother's anguished expression.

Dorothea Lange. *Migrant Mother, Nipomo, California*, 1936.
Library of Congress, Prints and Photographs Division, Washington, D.C.

This photograph caused a minor scandal when it was discovered that Arthur Rothstein had set up the shot by moving a steer's skull he had found to a nearby patch of parched earth. The photograph had been widely published and praised for its evocative description of the terrible conditions in South Dakota created by years of poor soil conservation and serious drought. Although Rothstein's manipulation only dramatized reality—the land was truly parched and livestock were dying of dehydration—anti-New Deal political pundits used the controversy as an opportunity to criticize the Roosevelt administration and its programs.

Arthur Rothstein. *A Cow's Skull, South Dakota, May 1936*, 1936. Library of Congress, Prints and Photographs Division, Washington, D.C.

Raphael Soyer [1899–1987]
Office Girls 1936

Oil on canvas, 26 x 24 in. (66 x 61 cm).
Whitney Museum of American Art, New York; Purchase 36.149

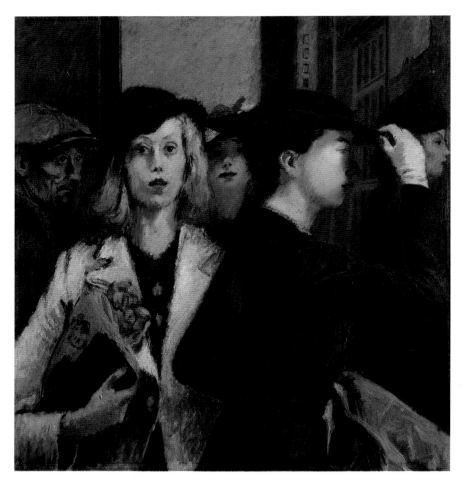

With their bright, fresh faces and fashionable clothing, Raphael Soyer's *Office Girls* represent a new type in American Scene painting. Although working women had long been a subject for nineteenth-century French artists such as Honoré Daumier and Edgar Degas, the "working girl" as envisioned by Soyer was a distinctly modern phenomenon. During the first few decades of the century, large numbers of women entered the workplace, many finding employment as secretaries and clerks. By the 1930s, one of every three working women in New York had a job in an office. No longer confined to the domestic sphere, women assumed a more visible and public presence in the urban landscape. These changing social and economic conditions created an entirely new kind of subject for such urban realist artists as Soyer, Edward Hopper, and Reginald Marsh. In different styles, and with different conceptual emphasis, these artists represented the modern American woman both inside and outside the workplace.

Office Girls (detail, top left)

Although Soyer's young women dominate the surface of *Office Girls*, we are also struck by the profile of a mournful-looking man at left. This one crucial detail adds a strange and somber note to the painting. His name was Walter Broe, a homeless man Soyer found "fishing" for a coin below a subway grating, using a piece of chewing gum attached to a string. Although the Depression caused women as well as men to lose their jobs, the icon of the era was the image of the down-and-out unemployed male. Soyer may have included Walter Broe to remind viewers of the grim economic realities of the Depression. At the same time, he may have been alluding to the commonly held view that such young, industrious women were quite literally displacing men from jobs.

Artists of the 14th Street School, among them Soyer and Reginald Marsh, based their paintings on actual women they observed in Union Square—window shopping, chatting in the park during lunch hour, or going to work in offices or shops. The 14th Street neighborhood was a hub of commercial activity, with discount stores, restaurants, movie theaters, and business offices located up and down the street. The young women portrayed in *Office Girls* probably worked in one of the banks, insurance companies, or offices around Union Square, where Soyer's studio was also located.

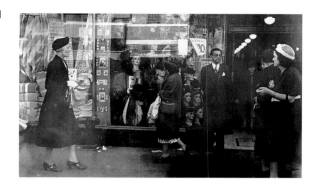

Reginald Marsh. *East Fourteenth Street*, late 1930s. Gelatin silver print, 6 x 9 5/8 in. (15.2 x 24.4 cm). Museum of the City of New York; Gift of Mrs. Felicia Meyer Marsh

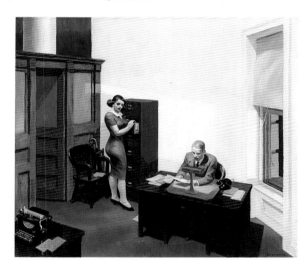

Edward Hopper. *Office at Night*, 1940. Oil on canvas, 22 3/16 x 25 1/8 in. (56.4 x 63.8 cm). Walker Art Center, Minneapolis; Gift of the T.B. Walker Foundation, Gilbert M. Walker Fund, 1948

Inside the office, women worked as typists, stenographers, and secretaries—positions with low salaries and little chance of advancement. Most office work involved long hours of typing, filing, and answering the phone. In contrast to this drudgery, Hollywood offered a different version of the office girl's life. In movies from the 1930s, women work as glamorous detectives, fashion illustrators, reporters, or secretaries to eligible, handsome bachelors whom they marry before the end of the film. These fantasy working women had little in common with their real-life counterparts, depicted by Soyer and his fellow artists such as Edward Hopper.

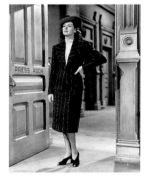

Rosalind Russell in *His Girl Friday*, 1940 (Howard Hawks, director)

Working women represented a new economic power in America. Although the majority worked to support themselves or their families, most could afford to spend a portion of their salaries on consumer goods, especially fashion and beauty products. In the 1930s, women went to the beauty parlor for haircuts and permanent waves. They wore lipstick and they bought clothes. More than one-fifth of the typical female office worker's salary was spent on clothing and accessories—dresses, suits, hats, pocketbooks, gloves, and high-heeled pumps to—wear to the office and out at night.

Sears, Roebuck and Co. catalogue, 1936 (detail)

Reginald Marsh [1898–1954]
Twenty Cent Movie 1936

Egg tempera on board, 30 x 40 in. (76.2 x
101.6 cm). Whitney Museum of American Art,
New York; Purchase 37.43

Reginald Marsh's lifelong
enthusiasm for theater and film
had a marked influence on his art.
After graduating from Yale
University in 1920, he moved to
New York and produced
illustrations for magazines such as
Vanity Fair; occasionally, he
designed stage decor. In 1925, he
joined the staff of the newly formed
New Yorker, illustrating articles
on theater, film, and other New
York subjects.

Twenty Cent Movie is as
theatrical and cinematic in its
conception as in its subject. The
shallow, foreground space in
which the characters loiter and
stride is two-dimensional and
stagelike. Marsh crammed a
profusion of images and signs into
the composition to evoke the
cumulative effect of "moving
images." The vividly characterized
figures gathered under the
marquee of New York's Lyric
Theatre bring to mind the crowded
street scenes favored in 1930s films
by directors such as Preston
Sturges. Marsh's characters, like
film stars, read as exaggerated
stereotypes. The overall effect is
an image that has been directed
rather than painted.

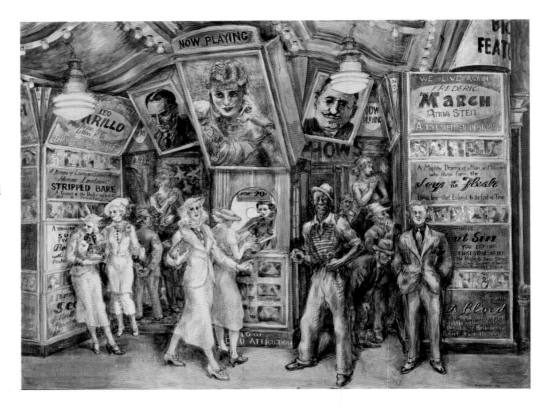

In the study and sketches for *Twenty Cent Movie*, it is
evident that Marsh conceived the composition as a
stage set. He sketched the structure of the entrance as
a series of flat and tilted rectilinear panels, reserving
only a shallow space for the foreground figures. Even the
underside of the marquee and the thin column on the right
suggest a theatrical proscenium. The perspective makes
the grid of the entrance floor seem to tip forward slightly,
as if the viewer were looking upward at a screen or stage.
Equally cinematic is the multiplicity of frames, combined
with the ghostly figures flitting through the scene.

Reginald Marsh. Study for *Twenty Cent Movie*, 1936. Ink and graphite
on paper, 9 1/2 x 12 3/8 in. (24.1 x 31.4 cm). Whitney Museum of
American Art, New York; Gift of Mr. and Mrs. Lloyd Goodrich 73.1

The billboard images and titles that Marsh included in *Twenty Cent Movie* are based on actual films, actors, and actresses of the time. The actress under the "Now Playing" sign is the German-Russian beauty Anna Sten, who was featured in *We Live Again*, the 1934 film version of Tolstoy's tragic novel *Resurrection*. She played opposite the dashing Frederic March, whose photograph hangs to the left (Leo Carrillo, the comic star of *Moonlight and Pretzels*, 1933, is at right). Although the film is a tragedy, for *Twenty Cent Movie* Marsh chose an image that emphasized Sten's glamour.

Production still from We Live Again, 1934 (Rouben Mamoulian, director)

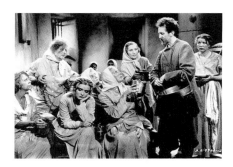

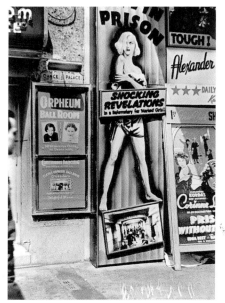

In the early 1930s, Marsh began taking photographs that captured the vitality of city life, using his camera like a sketchbook. Sometimes elements of these photographs found their way into his paintings. Although Marsh did not consider himself a photographer, he loved the medium. "This photography is the maddest activity I have ever taken up. I am planning many new subjects with the camera's aid." He developed and printed his own photographs and kept albums and subject files of the numerous images he produced. Unlike the staged character of *Twenty Cent Movie*, Marsh's photographs are casual and appear to concentrate on recording particular details—a pose, a gesture, a poster, a group of people.

Reginald Marsh. *Untitled View of Times Square*, 1930s. Gelatin silver print, 6 15/16 x 4 15/16 in. (17.6 x 12.5 cm). Museum of the City of New York

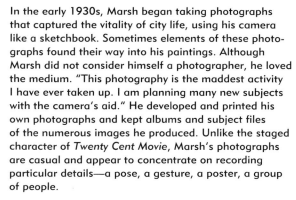

Marsh painted *Twenty Cent Movie* not long after the invention of talking pictures. During this period, the popularity of movies was at an all-time high, and New York's Times Square was a center of the entertainment industry. In the 1930s, some eighty million people went to the movies each week, an astonishing statistic in a country whose population was about 130 million. Before the television age, attending movies was a casual and weekly experience. Even at 20¢ a ticket, movies became an essential distraction from the hardships of the Depression. Approximately five hundred feature films a year were produced by the major studios during the 1930s, more than three times the number produced today.

Samuel H. Gottscho. *Times Square at Forty-Fourth Street*, 1932. Gelatin silver print, 16 x 20 in. (40.6 x 50.8 cm). Museum of the City of New York; The Gottscho-Schleisner Collection

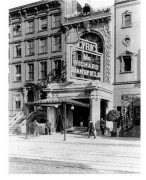

The subject of Marsh's *Twenty Cent Movie* was Times Square's Lyric Theatre on West 42nd Street. It was designed for the legendary theatrical producers, the Shuberts—Sam, Lee, and J.J.—as a house for the performance of commercial musicals. The introduction of talking pictures in 1928 and the Depression-era economics of the 1930s turned the Lyric, like so many other legitimate theaters, into a motion-picture house. During these transformations, many of the original Beaux-Arts facades of the buildings were covered by illuminated marquees and layers of lights and images.

Lyric Theatre, 213 West 42nd Street, New York, 1902

Burgoyne Diller [1906–1965]
First Theme 1938

Oil on canvas, 30 1/16 x 30 1/16 in. (76.4 x 76.4 cm).
Whitney Museum of American Art, New York;
Purchase, with funds from Emily Fisher Landau 85.44

Though many artists spend their careers exploring a range of styles, subjects, and media, others labor within self-imposed limitations, repeatedly mining the same composition or concept. The geometric abstract artist Burgoyne Diller perfected a pure, non-objective aesthetic by restricting himself to a series of related compositions of geometric forms, grid lines, and primary colors. He divided his work into three "themes," each focusing on what he called the "basic plane" and the "movement—and constant opposition" in that plane. The First Theme series explores rectangular forms on a square surface. In this work from 1938, a matte black background heightens the color contrasts and creates a dynamic tension between the differently sized rectangles. Diller enlarged two of the colored rectangles in the 1942 painting to counterbalance the smaller, horizontal black rectangle placed just slightly off-center. In the 1963 work, he returned to the black surface, greatly enlarging the canvas so as to envelop the viewer in its scale.

Burgoyne Diller. *First Theme,* **1942.** Oil on canvas, 42 x 42 in. (106.7 x 106.7 cm). The Museum of Modern Art, New York; Gift of Sylvia Pizitz

Burgoyne Diller. *First Theme: Number 10,* **1963.** Oil on canvas, 72 x 72 in. (182.9 x 182.9 cm). Whitney Museum of American Art, New York; Purchase, with funds from the Friends of the Whitney Museum of American Art 64.26

 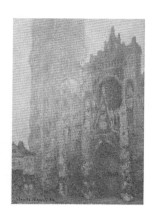 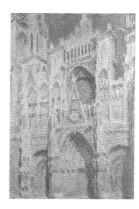

Claude Monet. *Rouen Cathedral, Facade (Gray Day),* **1892–94.** Oil on canvas, 39 3/8 x 25 9/16 in. (100 x 65 cm). Musée d'Orsay, Paris

Claude Monet. *Rouen Cathedral, Facade and Tour d'Albane (Morning Effect),* **1892–94.** Oil on canvas, 41 3/4 x 29 1/8 in. (106 x 74 cm). Museum of Fine Arts, Boston; The Tompkins Collection

Claude Monet. *Rouen Cathedral (Facade),* **1894.** Oil on canvas, 39 x 26 in. (99.1 x 66 cm). The Metropolitan Museum of Art, New York; Theodore M. Davis Collection, bequest of Theodore M. Davis, 1915

The French Impressionist Claude Monet often worked in series in order to explore subtly changing qualities of light and atmosphere. "The further I go, the more I understand that it is imperative to work a great deal to achieve what I seek," he wrote in 1890. Two years later, he began a series of thirty paintings of the Gothic cathedral he saw from the window of his studio in Rouen, reworking many of the canvases over a period of three years. He painted at different times of day, from different vantage points, ever conscious of the changing qualities of light and atmospheric conditions. Working in thick impasto in some areas, Monet left other passages—especially the sky—almost free of paint. Each canvas conveys a decidedly different mood and character.

Constantin Brancusi, one of the most influential modern sculptors, worked in series as a way of progressively moving toward a language of essential form. As early as 1910, he began to sculpt the form of a bird. By 1923, with his first *Bird in Space,* he had settled on a basic shape that merged the head, body, and feet into a streamlined abstraction which he explored in different sizes, proportions, and materials over the next two decades. In the first example here, the stout proportions and noticeable veining of the deep yellow marble produce a visual density that Brancusi later avoided. The 1925 version, by contrast, is in a white marble whose purity, along with the form's slender and elegant proportions, conveys a sense of majesty. By 1941, Brancusi was designing longer and more undulating "feet," which exaggerate the work's verticality.

Constantin Brancusi. *Bird in Space,* **c. 1923–24.** Marble, 45 3/4 in. (116.2 cm) height. Philadelphia Museum of Art; The Louise and Walter Arensberg Collection

Constantin Brancusi. *Bird in Space,* **1925.** Marble, 71 5/8 in. (181.9 cm) height. National Gallery of Art, Washington, D.C.; Gift of Eugene and Agnes E. Meyer

Constantin Brancusi. *Bird in Space,* **c. 1941.** Bronze, 76 1/4 in. (193.7 cm) height. Musée national d'art moderne, Centre Georges Pompidou, Paris; Brancusi Bequest

Oil on canvas, 24 x 29 in. (61 x 73.7 cm).
Whitney Museum of American Art, New York;
Purchase, with funds from the Simon Foundation,
Inc. 72.129

During the 1920s, as Man Ray became absorbed in photography, his paintings gradually ceased to focus on the world around him. By the next decade, he was drawing increasingly on dream imagery for his painted subjects. His vision of a pool table stretching out in the landscape below rainbow-colored clouds is a testament not only to his fascination with the landscape of the mind, but also to his belief in the primacy of game playing in the creative process. Games, whether real or imagined, figure prominently in his art and can be found throughout his work in painting, photography, and constructions. Man Ray and others involved in Surrealism saw games on a par with art as creative endeavors that required imagination, intellect, and problem solving. As such, *La Fortune* is less the image of a distorted landscape and more the product of Man Ray's engagement in Surrealist ideas.

Alberto Giacometti. *No More Play (On ne joue plus)*, 1931–32. Marble, wood, and bronze, 1 5/8 x 22 7/8 x 17 3/4 in. (4.1 x 58.1 x 45.1 cm). Patsy R. and Raymond D. Nasher Collection, Dallas

No More Play is one of the miniature environments Alberto Giacometti constructed between 1929 and 1933. In this symbolic psychodrama, one figure is frozen in place, the other has arms raised in panic or surrender; graves contain a skeletal form and a snake. Modeled on an African pebble game and conceived as a game board with movable elements, *No More Play* suggests a cryptic, apocalyptic exercise, with the game format used as a metaphor for the dream state and a Surrealist fondness for uncertainty and unanswered questions.

To many Dada and Surrealist artists, the game of chess was a metaphor for the creative process. Man Ray learned the game from Marcel Duchamp and developed a lifelong appreciation for the chessboard as "a field for clear thinking, impromptu imagination, surprise...." Chess motifs recur in Man Ray's paintings, photographs, and object constructions. As early as 1920, he sketched a design for a set of chess pieces and constructed his first chess set from materials scattered about his studio. In one of his earliest sets, which he photographed in 1926, the king takes the form of a simple pyramid, symbol of Egyptian kingship. The scroll of a violin, resembling a horse's mane, becomes the knight.

Man Ray. *Untitled (Chess Set)*, 1926. Gelatin silver print, 4 3/8 x 5 3/4 in. (11.1 x 14.6 cm). Zabriskie Gallery, New York

Man Ray shared with Joseph Cornell an interest in games and toylike objects as a way of returning to the lost innocence of childhood. Understanding the associative value of found objects, Cornell incorporated toy clay pipes and marbles into his box constructions and titled many of them *Soap Bubble Sets*. The multicolored balls in *Untitled (Game)* can be made to roll along the metal ruler, be caught in the small hole, or slide between the central double wires. Sitting on a shelf or displayed in a museum setting, Cornell's game boxes remain unrecognized for their playful potential, eliciting a sense of longing that is in fact part of their content.

Joseph Cornell. *Untitled (Game)*, c. 1940. Stained, paper-covered, glazed, wood box for a kinetic construction of wood, wire, metal ruler, and painted wood balls, 13 x 7 1/4 x 6 in. (33 x 18.4 x 15.3 cm). The Art Institute of Chicago; The Lindy and Edwin Bergman Joseph Cornell Collection

André Breton, Man Ray, Max Morise, and Yves Tanguy. *Exquisite Corpse (Le Cadavre Exquis)*, 1928. Ink and watercolor on paper, 12 x 7 1/2 in. (30.5 x 19.1 cm). Private collection

In the late 1920s the Surrealists developed a unique visual game, Le Cadavre Exquis (Exquisite Corpse). In this bizarre exercise, each participant draws a section of a figure, folds the paper to conceal the drawing, and then passes it on. When all sections are completed, the paper is unfolded and the "corpse" revealed. Produced outside the conscious control of any one participant, the game was among the Surrealists' favorite devices for creating visual and verbal enigmas. It offered a method to evade what André Breton called "any control exercised by reason."

Philip Evergood [1901–1973]
Lily and the Sparrows 1939

Oil on board, 30 x 24 in. (76.2 x 61 cm).
Whitney Museum of American Art, New York; Purchase 41.42

Philip Evergood's *Lily and the Sparrows* was inspired by a chance occurrence on the streets of New York: "I happened to stop at the curb, just dreaming, and look[ed] up, and here was an amazing sight. A little, bald-headed, white beautiful face was in a window with little bits of crumbs—alone. Mother out to work probably, father maybe in the hospital. She could have fallen out and been killed." Back in his studio, Evergood painted the scene from memory, naming the child "Lily" and laboring over details such as her fingernails and facial features. Yet the result is not strictly realist: the lurid color of the bricks, the disjunction between the perspective views of the exterior and the interior of the tenement, and Lily's odd expression suggest an experience transformed in the artist's imagination. The innocent, clearly under-privileged child in the window becomes a captive soul, feeding the birds and perhaps envying their freedom. Evergood's concern for Lily's plight reflected his own leftist political sympathies; he was especially active as an organizer of artists' unions and was even beaten and arrested at one protest. Yet *Lily and the Sparrows* also reflected society's changing attitudes toward poverty and childhood. In the early decades of the twentieth century, impoverished children were increasingly seen not as stereotypical Victorian street urchins, but as desperate cases that called for political action.

At the turn of the century, the National Child Labor Committee (NCLC) waged an effective campaign against child labor by shedding light on practices that had long been ignored. In 1906, the NCLC hired photographer Lewis W. Hine to record the abhorrent conditions working children endured. Although he sometimes resorted to deception to gain access to the factories, coal mines, and farms he photographed, Hine's eyewitness accounts of labor conditions were difficult to dismiss. A photograph, he maintained, has "an added realism of its own....For this reason the average person believes implicitly that the photograph cannot falsify." Using Hine's photographs in its propaganda, the NCLC helped enact reform legislation, although widespread abuse of child labor would continue into the 1930s.

Lewis W. Hine. *A Carolina Spinner*, 1908. Gelatin silver print, 4 3/4 x 7 in. (12.1 x 17.8 cm).
Milwaukee Art Museum; Gift of the Sheldon M. Barnett Family

The saccharine Victorian imagery of childhood eventually gave way to more forthright portrayals of working children. In the early years of the twentieth century, artists such as George Bellows depicted the realities of city life, ignoring critics who deemed these subjects distasteful or even offensive. In *Frankie, the Organ Boy*, Bellows painted the young street musician with a dignified expression and enlarged, hardworking hands. Even so, there is no suggestion of the harsh realities of life on the streets, nor does the artist explicitly advocate social reform. Although Bellows' work generally reflects the progressive spirit of the era, it was photographers, not painters, who created the most effective propaganda against child labor.

George Bellows. *Frankie, the Organ Boy*, 1907. Oil on canvas, 48 3/16 x 34 3/16 in. (122.4 x 86.8 cm). The Nelson-Atkins Museum of Art, Kansas City, Missouri; Purchase, acquired through the bequest of Ben and Clara Shlyen

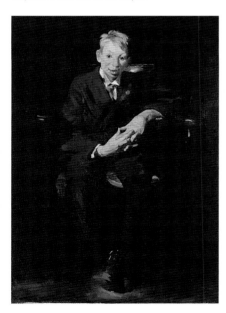

Evergood's sympathetic portrait of Lily is a far cry from the sentimentalized images of poor children presented by Victorian artists such as John George Brown. The often maudlin, nineteenth-century stereotype of the resourceful street urchin allowed adults to ignore the shameful truths of child labor. In Brown's portrait of a shoeshine boy—cloyingly entitled *Perfectly Happy*—the child's rumpled but endearing demeanor suggests that he is content shining shoes, even if his own soles are worn through.

John George Brown. *Perfectly Happy*, 1885. Watercolor on paper, 20 x 13 in. (50.8 x 33 cm). The Butler Institute of American Art, Youngstown, Ohio

During the 1930s, the Farm Security Administration dispatched photographers such as Walker Evans and Dorothea Lange and put cameras into the hands of painters in order to record the devastating economic and social impact of the Great Depression and to garner public support for government relief programs. Artists became increasingly involved in politics as they fought to protect federal work projects and to draw public attention to the human toll of poverty. Some of the most memorable and provocative images of the era depicted destitute children compelled, like the young cotton picker in this photograph by Ben Shahn, to spend their youth performing menial, back-breaking tasks. Philip Evergood knew Shahn through the John Reed Club, a Socialist organization. In *Lily and the Sparrows*, he imaginatively elaborated on the sort of specific incident a photographer might have recorded to create an unsettling commentary on poverty and childhood.

Ben Shahn. *Young Cotton Picker, Pulaski County, Arkansas*, 1935. Library of Congress, Prints and Photographs Division, Washington, D.C.

Theodore Roszak [1907–1981]
Bi-Polar in Red 1940

Metal, plastic, and wood, 54 3/16 x 8 5/8 x 8 5/8 in. (137.6 x 21.9 x 21.9 cm) overall.
Whitney Museum of American Art, New York; Purchase, with funds from the Burroughs
Wellcome Purchase Fund and the National Endowment for the Arts 79.6a–c

At a time when many American artists were intent on representing the present or the past, Theodore Roszak looked defiantly toward the future. Having studied the industrial modernist aesthetic of the Bauhaus and Constructivism during a European sojourn in 1929–31, he came to believe in a utopian collaboration between artists and industrial society. In 1932, using machine processes, he began to fabricate sculpture that resembled engine or aircraft components. He adapted the Constructivist strategy of removing obvious subject matter from his work and concentrated instead on the balance of pure geometric forms. In 1938, when he began his *Bi-Polar* constructions, he viewed the series as the quintessential blending of ideal form, modern material, and universal symbol. He related *Bi-Polar in Red*, for example, to "the same natural phenomenon as north vs. south pole...male vs. female...the bi-polarity of magnetic fields in space...." The work's smooth, streamlined forms also resemble an abstracted human torso—or an airplane propeller, infinity symbol, or a figure eight. The materials Roszak chose for his *Bi-Polar* constructions include new varieties of metals and plastics. The result was a blending of European Constructivist ideals with American industrial innovation—and some of the most radically modern examples of prewar American sculpture.

Theodore Roszak. *The Artist in His Studio*, c. 1938. Gelatin silver print, 8 x 10 in. (20.3 x 25.4 cm). Theodore Roszak Estate

In the early 1930s, Roszak took courses in toolmaking and industrial design. By 1934, he had turned his studio into a shop outfitted with such industrial equipment as lathes and drill presses. Turning his back on the traditional hand-carving and modeling techniques, he used machines not only to fabricate sculptural constructions with tooled precision, but also as a source of imagery. Moreover, the very materials he worked with—metal, wire, and the newly invented plastic—spoke, to Roszak, of the future.

Norman Bel Geddes. *Motor Coach Number 2*, 1931. The Norman Bel Geddes Collection, The Theatre Arts Collection, Harry Ransom Humanities Research Center, The University of Texas at Austin

In the late 1930s, when industrial design was first emerging as a profession in America, Roszak joined the faculty of the newly opened School of Industrial Design in New York. Here he became familiar with the work of leading designers in the field, among them Raymond Loewy, Norman Bel Geddes, and Hugh Ferris. Through this encounter, the streamlined form—with its visual evocation of speed, progress, and industrial efficiency—entered Roszak's constructions. Using the streamline aesthetic, he sought to infuse art with the refined elegance of the modern machine.

Raymond Loewy. *Experimental Single Unit Fast Motorized Commuter Car*, 1932

Roszak's futuristic drawings of the mid-1930s, such as *Study for Airport*, express the artist's excitement about aeronautics and the exploration of space. He was inspired not only by real technological advances, but equally by science fiction literature and movies, especially the popular Buck Rogers films. Rockets, dirigibles, space observatories, and other, more fantastical structures appear in many of Roszak's drawings, and this imagery later found its way into his constructions.

Theodore Roszak. *Study for Airport*, 1934. Watercolor, gouache, ink, and graphite on paper, 22 7/8 x 29 in. (58.1 x 73.7 cm). Whitney Museum of American Art, New York; Gift of the Theodore Roszak Estate 83.33.6

Roszak began to experiment with photography as early as 1931, taking traditional still lifes and portraits. His most innovative photographic works, however, are the more than one hundred photograms he started to produce around 1937. Created by placing real objects on photosensitive paper and then exposing the paper to light, the photogram captures the quality of three-dimensional forms on a two-dimensional surface. This transformation fascinated Roszak, as did the way materials such as wire mesh, translucent plastic, and solid metals reflect and absorb light differently, leaving behind a record of their physical properties.

Theodore Roszak. *Untitled Photogram*, c. 1937–41. Gelatin silver print, 10 x 8 in. (25.4 x 20.3 cm). Zabriskie Gallery, New York

Andrew Wyeth [b. 1917]
Winter Fields 1942

Tempera on canvas, 17 1/4 x 41 in. (43.8 x 104.1 cm).
Whitney Museum of American Art, New York; Gift of Mr. and Mrs.
Benno C. Schmidt in memory of Mr. Josiah Marvel, first owner of
this picture 77.91

Andrew Wyeth is widely considered a master of American
realism. In his paintings from the late 1930s and 1940s,
however, the compositional structure and perspective can
distort the supposed truthfulness of the image. Combined
with Wyeth's precise, almost exaggerated, rendering of
detail, such distortions lend a number of his works an almost
surreal quality.

In *Winter Fields*, a lifeless, twisted crow, is positioned
almost shockingly front and center. The picture plane tilts
forward and both foreground and background are in
complete focus—even though the eye does not register detail
sharply at long distances. Wyeth also presents the scene from
two entirely different perspectives: the dead crow is rendered
in a "worm's-eye" point of view, while the distant fields and
farm buildings appear as they would to a standing person.
Although the two perspectives are woven seamlessly into
a believable whole, the overwhelming physical dominance of
the crow in relation to the land and the toylike background
buildings is rather disquieting.

Wyeth frequently
produces multiple
studies for his paintings.
Sometimes they are
done quickly, often in
watercolor, to seize
an overall mood or a
fleeting impression. At
other times, he employs
the highly detailed drybrush technique to capture the
specifics of a subject. Of the two known studies for
Winter Fields, one is a drybrush of the clump of grasses
and weeds at lower left. The concentrated attention
Wyeth paid to their calligraphic forms contributes to
the emphatic foreground character of the painting.

Andrew Wyeth. *Grasses* (Study for *Winter Fields*), 1941. Drybrush
on paper, 17 1/2 x 22 in. (44.5 x 55.9 cm). Private collection

Wyeth's painting has often been compared to the work of nineteenth-century American landscape painters, especially those of the Hudson River School, who combined scientific observation with transcendental philosophy to celebrate the spiritual in nature. Martin Johnson Heade, an amateur ornithologist, painted numerous close-up views of hummingbirds. The exotic Brazilian jungle setting, fecund vegetation, and colorful palette of this painting at first seem to be the antithesis of Wyeth's somber and barren *Winter Fields*. In both works, however, details are carefully scrutinized and precisely rendered, while the subjects are positioned close up for dramatic effect.

Martin Johnson Heade. *Orchid with Two Hummingbirds*, 1871. Oil on panel, 13 3/4 x 18 in. (34.9 x 45.7 cm). Reynolda House, Museum of American Art, Winston-Salem, North Carolina

Winter Fields was painted at the height of World War II, and the dead crow lying across the stark landscape has often been understood as an allusion to the battlefields of the war. The allusion may also extend back to the battles of the Revolutionary War in the Brandywine Valley of Pennsylvania, where Wyeth, an enthusiast of local history, lived for most of his life and whose regional features permeated his painting in subtle ways. Could Wyeth also have known such famous Civil War photographs as Timothy O'Sullivan's *Dead on Civil War Battlefield*, which documents the fallen soldiers at Gettysburg? This gruesome photograph of contorted bodies stretched across a barren field is intensified by a low vantage point. Similarly, in *Winter Fields*, the worm's-eye view, along with the disproportionately large crow, bring us uncomfortably close to death.

Timothy H. O'Sullivan. *Dead on Civil War Battlefield, Gettysburg, July 1863*, 1863. Albumen print from a wetplate collodion negative, 7 3/4 x 9 3/4 in. (19.7 x 24.8 cm). The New-York Historical Society

Begun in 1942, *Soaring* was not completed until eight years later. (Wyeth stopped working on it because his father told him that it was "not a painting.") A preparatory drawing for this tempera, however, was included in The Museum of Modern Art's 1943 exhibition "American Realists and Magic Realists," which attempted to assert the significance of realism during the ascendancy of abstract art. Although Wyeth's meticulous rendering of three turkey buzzards classified him as a realist, the imaginary position of the viewer above the birds, like the worm's-eye perspective in *Winter Fields*, upgrades the work to the category of "magic realism," a combination of sharp focus realism and surreal fantasy.

Andrew Wyeth. *Soaring*, 1950. Tempera on panel, 48 x 87 in. (121.9 x 221 cm). Shelburne Museum, Vermont

Richard Pousette-Dart [1916–1992]
Within the Room 1942

Oil on canvas, 36 x 60 in. (91.4 x 152.4 cm). Whitney Museum of American Art,
New York; Promised 50th Anniversary Gift of the artist P.4.79

Richard Pousette-Dart saw his studio as a metaphor for the
workings of his mind. "If you wish to understand my painting
come to my studio. My studio is within me." His actual studio
was both a sanctuary and a laboratory, a private space for
creation. Ultimately, Pousette-Dart also came to understand
the canvas itself as a container, a room to be filled, emptied,
or exploded.

Given the metaphorical value Pousette-Dart assigned to
his studio, it is not surprising that a number of his paintings
seem to suggest architectural spaces. In *Within the Room*,
the formal structure is Cubist, but the arrangement of lines
and shapes can also be seen as an intricate floor plan with
interconnected compartments, each bearing visual surprises
in a profusion of biomorphic shapes. Some of the shapes
recall architectural details: the parallel, vertical elements in
the left half suggest fluted columns or clustered pilasters,
while the large semicircle to the right reads as a barrel vault.

From the late 1930s until his death in 1992, Pousette-Dart filled more
than two hundred notebooks. Diaristic in nature, these books contain
small paintings as well as poetry and philosophical musings. The
images represent a parallel activity to painting and sculpture. Although
the artist frequently worked on the notebooks in the studio, he also
carried one around wherever he went. The notebook thus became a
kind of portable studio that enabled Pousette-Dart to physically expand
his creative activity.

Richard Pousette-Dart. *Notebook B212,* **1940s.** Ink on paper, 9 3/4 x 15 1/4 in.
(24.8 x 38.7 cm). Estate of Richard Pousette-Dart

Although his primary medium was painting, Pousette-Dart also produced many sculptures, assemblages, prints, drawings, and photographs. He began making photographs as a youngster, using pinhole cameras, and continued to photograph intermittently throughout his career. The majority of his photographs were portraits of artists, friends, and family, made primarily in the 1940s and 1950s. He also produced a number of self-portraits during his lifetime, including many in which he staged himself inside his studio. This self-portrait shows the artist's face among a network of calligraphic scrawls and notations.

Richard Pousette-Dart. *Self-Portrait*, 1980s. Gelatin silver print, 20 3/4 x 16 3/4 in. (52.7 x 42.5 cm). Estate of Richard Pousette-Dart

At the time he painted *Within the Room*, Pousette-Dart's studio was in New York City. In 1951 he moved to the countryside and by 1958 had relocated to a stone carriage house in Suffern, New York. Here Pousette-Dart established an attic studio, which he used for more than three decades. As he explained in one of his notebooks, the studio was a total environment in which to experience the artist's endeavors: "Paintings are not properly seen in galleries but only in the solitude and wholeness of their studios where casually, easily, mystically one may be in touch with the whole meaning of the man—where no special few are shown polished and isolated or enthroned but the slightest is mixed among with the most bold and grand...."

Interior of Pousette-Dart's studio, 1967, photograph by Richard Pousette-Dart. Estate of Richard Pousette-Dart

This collage is identified at lower right by the moniker Ricardo, the Spanish translation of the artist's first name. While the work may not literally be a self-portrait, it is a veritable dictionary of sources that the artist has woven into a complete but orderly whole. It includes a photograph of his young daughter, architectural fragments, and number and letter forms. This cacophonous jumble yields to a sense of intricate structure, reminiscent of Gothic stained-glass windows. Pousette-Dart wrote in the late 1940s, "Out of the rich inmesh of chaos unfold great order and beauty."

Richard Pousette-Dart. *Untitled (Ricardo)*, 1946–48. Mixed-media collage, 20 x 16 in. (50.8 x 40.6 cm). Estate of Richard Pousette-Dart

Like other New York School artists such as Jackson Pollock, Adolph Gottlieb, and Mark Rothko, Pousette-Dart sought inspiration in "primitive" and tribal arts. During this period he visited the anthropological exhibits at the American Museum of Natural History and began collecting African, Oceanic, and Northwest Coast Indian objects. One can see the influence of such imagery in the swirling, stylized patterns, heraldic birdlike forms, and ovoid shapes of *Within the Room*.

Ancestor board, Papuan Gulf region, Papua New Guinea, mid-twentieth century. Painted wood, 37 x 12 3/4 in. (94 x 32.4 cm). Estate of Richard Pousette-Dart

Jacob Lawrence [b. 1917]
War Series: Another Patrol 194

Egg tempera on board, 16 x 20 in. (40.6 x 50.8 cm).
Whitney Museum of American Art, New York;
Gift of Mr. and Mrs. Roy R. Neuberger 51.8

Jacob Lawrence grew up in Harlem in the 1930s in the rich social and cultural milieu produced by the Harlem Renaissance a decade earlier. He had a small workspace in the studio of painter Charles Alston where he was introduced to artists, writers, and philosophers who promoted black achievement and a strong cultural identity. "We are absolutely a people telling stories," Lawrence once noted. Though the oral traditions of his community laid the foundation for his interest in narrative painting, Lawrence also found inspiration in a range of art historical precedents, from Egyptian art to the mural painting of his peers.

Lawrence's *War Series*, his first work based on personal experience instead of historical events, comprises fourteen paintings that document the sorrow, displacement and regimentation of his years in the U.S. Coast Guard during World War II. In its contrasts of vertical and horizontal formats, single figures and groups, and intense action and contemplation, the *War Series* testifies to Lawrence's belief that one cannot "tell a story in a single painting."

Beginning at age fourteen, Lawrence made regular visits to New York's Metropolitan Museum of Art and studied the techniques and pictorial conventions of Egyptian and Renaissance art. In his *War Series*, as in other works, Lawrence adapted the repeated silhouettes, large prominent eyes, and simplified profiles that are typical of Egyptian wall painting. And like these ancient painters, he transformed groups of figures into surface patterns and eschewed modeling and perspective in favor of the immediacy of bold, abstracted forms.

Egyptian wall painting. *Figures in a Funeral Procession* (detail), **1375 BCE.** Tempera copy from the Tomb of Ramose. Expedition, 1930, The Metropolitan Museum of Art, New York

Jacob Lawrence. *War Series: Beachhead,* 1947. Egg tempera on board, 16 x 20 in. (40.6 x 50.8 cm). Whitney Museum of American Art, New York; Gift of Mr. and Mrs. Roy R. Neuberger 51.13

As a young artist, Lawrence pored over art books at the 135th Street branch of the New York Public Library and studied prints at the influential Harlem Art Workshop in the 1930s. It was here that he first saw reproductions of Francisco de Goya's 1810 etching series, *The Disasters of War,* and his violent 1814 painting, *Third of May, 1808.* Lawrence's dramatic compositions and his focus on war's effect on the individual attest to his great admiration for Goya's groundbreaking imagery.

José Clemente Orozco. *The Trench,* 1924. Mural. Old College of San Ildefonso, Mexico City

Jacob Lawrence. *War Series: Purple Hearts,* 1947. Egg tempera on board, 16 x 20 in. (40.6 x 50.8 cm). Whitney Museum of American Art, New York; Gift of Mr. and Mrs. Roy R. Neuberger 51.15

Jacob Lawrence began painting at a time when the Social Realist art of painters such as Ben Shahn and Philip Evergood predominated. For Lawrence, however, it was the work of the Mexican muralists—Diego Rivera, David Alfaro Siqueiros, and José Clemente Orozco— that had the greatest impact.

The large fresco cycles that Orozco executed in New York and other major cities inspired the young painter, who especially admired the muscularity of Orozco's figures, the expressive, outstretched hands, and the bold, abstracted background forms. But Lawrence was also emboldened by the social content of Orozco's work. The Mexican master's depictions of battle, political protest, and human struggle encouraged Lawrence's budding inclinations toward narrative, socially relevant scenes.

Thomas Hart Benton [1889–1975]
Poker Night (from *A Streetcar Named Desire*) 1948

Tempera and oil on panel, 36 x 48 in. (91.4 x 121.9 cm).
Whitney Museum of American Art, New York; Mrs. Percy Uris Bequest 85.49.2

The success of an art work created on commission depends on how well it fulfills the desires of the patron as well as the artist, and sometimes even how well it represents the subject. *Poker Night* provides a fascinating case study of the nature of commissions. In 1947, Thomas Hart Benton was hired, probably by Hollywood producer David O. Selznick, to create an original painting based on Tennessee Williams' Pulitzer Prize-winning play *A Streetcar Named Desire*. The painting conveys the sexual tension and barely contained violence of the story of Blanche DuBois, a down-and-out Southern belle, her sister, Stella, and Stella's husband, the hot-tempered, childlike Stanley Kowalski. Based on Scene 3 of *Streetcar*, *Poker Night* captures one of the play's most dramatic and memorable moments, when Blanche taunts a drunk and angry Stanley with her petty provocations and refined airs.

The cast photograph shows that Benton based his portrayals on the costumes and physical characteristics of the actors—with one notable exception. Instead of depicting Jessica Tandy as the complex and troubled Blanche DuBois, Benton changed types. The painted figure appears to have more in common with a blond bombshell movie star such as Jean Harlow than with Tandy, second from right in the photograph.

Tandy in fact felt that the overt sexuality of Benton's portrayal of her character misrepresented the play. She also criticized the artist for taking a male standpoint by portraying Stanley Kowalski as the hapless victim of Blanche DuBois' sexual manipulations.

Theater still from the original 1947 Broadway production of *A Streetcar Named Desire*. **Left to right: Kim Hunter (Stella Kowalski), Nick Dennis (Pablo Gonzales), Marlon Brando (Stanley Kowalski), Rudy Bond (Steve Hubbel), Jessica Tandy (Blanche DuBois), and Karl Malden (Howard Mitchell a.k.a. Mitch).**

Jean Harlow, 1929

Irene Selznick, n.d.

Poker Night was a surprise gift for Irene Selznick, the theatrical producer who brought *A Streetcar Named Desire* to Broadway in 1947. Selznick was the daughter of Hollywood studio head Louis B. Mayer and the first wife of producer David O. Selznick. The Selznicks separated in 1945 and divorced in 1948, but most scholars agree that it was David Selznick who commissioned Benton to make the painting. Although intended as a private memento, Irene Selznick used the painting to help market the play. *Poker Night* traveled with the play's touring company and was later exhibited in the lobby of the Ethel Barrymore Theatre. The play, of course, was a huge success, but Benton's painting failed as a publicity gambit.

Ethel Barrymore Theatre, 1931

In the 1930s, Benton was one of the nation's most popular artists; this self-portrait even appeared on the cover of *Time* in 1934. After World War II, however, his career flagged. To many, Benton's narrative style of painting seemed old-fashioned at a time when progressive artists, including his former student Jackson Pollock, were turning to abstract modes of expression. Benton was eager to work on the Selznick project because he thought the national publicity around the play would help restore him to the limelight. But he was disappointed—theatrical sensation did not win renewed favor for his populist realism.

Thomas Hart Benton. *Self-Portrait*, **cover of** *Time*, **December 24, 1934**

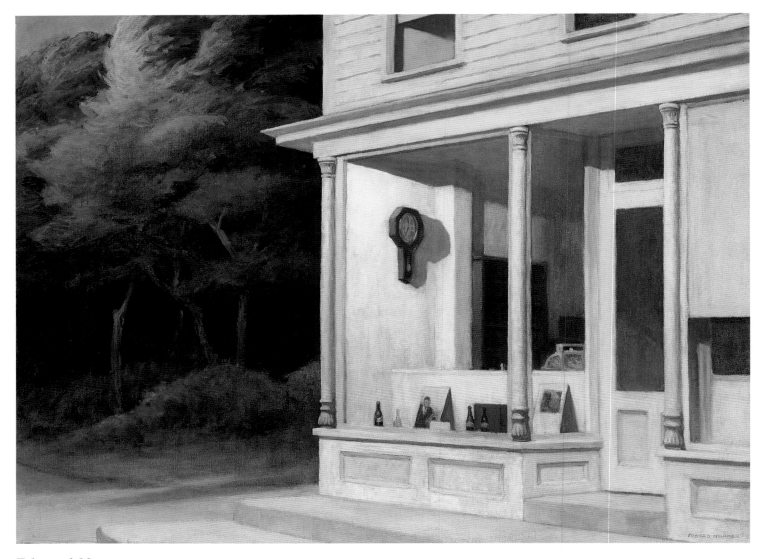

Edward Hopper [1882–1967]
Seven A.M. 1948

Oil on canvas, 30 3/16 x 40 1/8 in. (76.7 x 101.9 cm).
Whitney Museum of American Art, New York; Purchase and exchange 50.8

In her diary entry for September 22, 1948, Josephine Hopper recorded the completion of her husband Edward's most recent painting: "E. has done this canvas in 16 days. I find on looking back he stretched it on Labor Day Sept. 6. This a very short time." The painting she describes, *Seven A.M.*, depicts an anonymous storefront cast in the oblique shadows and cool blue light of early morning. The store's shelves stand empty; a few odd products are displayed in the window.

A clock on the wall, and the title, confirm that it is 7 am. The painting seems to depict a specific time and place, as if Hopper came upon this scene early one morning. Yet Hopper's preparatory sketches reveal that he experimented with significant variations, and even considered setting the painting at another time of day. Although *Seven A.M.* may have been completed quickly, it was still the result of a painstaking creative process.

Although *Seven A.M.* may not depict a particular site, Hopper could have modeled the storefront after buildings like this one in his hometown of Upper Nyack, New York. He typically did not paint scenes exactly as he saw them, but frequently took liberties, adjusting details and simplifying compositions to create the effect he desired. In fact, the building in *Seven A.M.* may be a composite, based on long knowledge of traditional East Coast architecture and on memories of businesses near his boyhood home.

Storefront at 318 North Broadway, Nyack, New York, photographed at 7 am, June 13, 1999

Hopper's preparatory sketches for *Seven A.M.* reveal that he began with a simple idea: a thick copse of trees beside a corner store. In this drawing, he mapped out the painting's basic composition, which is divided into two distinct halves. With a few swift lines, he constructed a contrast between the geometry of the building on the right and the loosely scribbled woods to the left.

Edward Hopper. Study for *Seven A.M.*, 1948. Conté on beige paper, 7 1/2 x 8 3/8 in. (19.1 x 21.3 cm). Private collection

For this sketch, Hopper added a few products on display in the store's window and a clock on the wall. Although the face of the clock is obscured, the steep angles of the shadows suggest midday. A figure leans from an upstairs window, surveying the street below. This presence creates a slightly more hospitable mood, one that Hopper ultimately abandoned in favor of the forbidding atmosphere of the finished painting.

Edward Hopper. Study for *Seven A.M.*, 1948. Conté on beige paper, 7 3/8 x 9 5/8 in. (18.7 x 24.4 cm). Private collection

The more acute angles of the shadows in this preparatory sketch suggest early morning. Although still illegible, the clock is both more ornate and more prominent. Fewer products are displayed in the window; the store seems more desolate. Of all the extant drawings for *Seven A.M.*, this one comes closest to evoking the eerie, early morning atmosphere of the painting.

Edward Hopper. Study for *Seven A.M.*, 1948. Conté on beige paper, 7 3/4 x 9 1/2 in. (19.7 x 24.1 cm). Private collection

After Hopper completed a painting, he made a sketch of it for his records, which were kept in ordinary ledger books from Woolworth's. His wife, Jo Hopper, added lively descriptions of each painting, often imagining anecdotal detail that Hopper always omitted. "This is the impact of stark white against dark green woods, a few intimations of trunks & branches in lighter neutral tone. It is a 'blind pig' or some such. On passing thru door one would find a pool table at the rear. Cash register visible thru window (20¢ last taken in). Room over on 2nd floor, upper centre of canvas has walls painted pale green. Shade over upper part of window extreme right is pale yellow. Canvas full of radiance not acquired thru color." A "blind pig" is a front for some illicit operation, confirming the painting's sinister overtones.

Edward Hopper. Page 27 of *Artist's Ledger—Book III*, 1924–67. Ink, graphite, and colored pencil on paper, 12 3/16 x 7 5/8 x 1/2 in. (31 x 19.4 x 1.3 cm). Whitney Museum of American Art, New York; Gift of Lloyd Goodrich 96.210a–jjjj

Stuart Davis [1892–1964]
Owh! in San Paõ, 1951

Oil on canvas, 52 1/4 x 41 3/4 in. (132.7 x 106 cm).
Whitney Museum of American Art, New York;
Purchase 52.2

Owh! in San Paõ illustrates the
abstraction typical of Stuart Davis'
later work. The artist planned to
exhibit the canvas at the Biennial
in São Paulo, Brazil. Although he
never sent it, a reference remains
in its deliberately misspelled title.
As was often his practice, the artist
based *Owh! in San Paõ* on an
earlier painting, in this case the
1927 *Percolator*, where the
coffeepot's form is reduced to the
suggestion of a cylinder and the
number "6" may allude to its six-
cup capacity. Twenty-four years
later, Davis added the words "else,"
"used to be" and "now," referring
perhaps to the first version of the
painting—or to the passage of
time. In both works, however, the
appliances are readable. Even as
he became one of America's
foremost abstract painters, reality
remained Davis' touchstone.

Stuart Davis. *Percolator*, 1927.
Oil on canvas, 36 x 29 in. (91.4
x 73.7 cm). The Metropolitan
Museum of Art, New York;
Arthur H. Hearn Fund

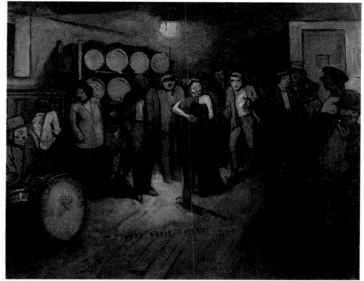

Stuart Davis. *The Back Room*, 1913. Oil on canvas, 30 1/4 x 37 1/2 in. (76.8 x 95.3 cm). Whitney Museum of American Art, New York; Gift of Mr. and Mrs. Arthur G. Altschul 69.114

Davis' career spanned an era in which America gradually won prominence in the international art world on the strength of its contributions to abstract art. Although Davis' mature work reflected developments in avant-garde abstraction, he nevertheless remained connected to his realist roots. Through his father, a prominent newspaper art director, the precocious young painter became a student of he influential realist Robert Henri.

In *The Back Room*, Davis adopted Henri's darkened palette and the urban subject matter of newspaper illustrations—in fact, Davis illustrated a similar scene for the Socialist periodical *The Masses*. *The Back Room* depicts a barrel house in Newark, New Jersey, where patrons gather beneath the light of a single bulb to dance to the rhythms of a new, urban music. Davis frequented such places, developing an appreciation for ragtime and, later, for jazz.

Stuart Davis. *Jackson's Band*, 1913, published in *The Masses*, 5 (February 1914). Ink and crayon on paper, 24 3/4 x 21 1/4 in. (62.9 x 54 cm). Collection of Earl Davis; courtesy Salander-O'Reilly Galleries, New York

Stuart Davis. Drawing for *House and Street*, 1926. Pencil on paper, 6 x 9 in. (15.2 x 22.9 cm). Collection of Earl Davis; courtesy Salander-O'Reilly Galleries, New York

By the 1920s, Davis was developing his own emphatically American brand of Cubism. In 1931, he used an earlier sketch of elevated tracks and skyscrapers in Lower Manhattan as the model for *House and Street*. Davis' style suggests European influences, but his compositions are as distinctly American as jazz, with visual harmonies created from cacophonous patterns of bricks, checks, stripes, and polka dots. For Davis, words—from street signs to political advertisements—were an integral part of this chaotic, vibrant American landscape. The placard in *House and Street* that reads "SMITH" may allude to Al Smith's failed 1928 presidential campaign, and "FRONT" is the name of the street. Yet "FRONT" could also describe the wall's apparent position in "front" of the elevated tracks, or its flat, frontal orientation. Davis then set the right half of the composition at an angle, as if he were painting the scene from two perspectives simultaneously.

Stuart Davis. *House and Street*, 1931. Oil on canvas, 26 x 42 1/4 in. (66 x 107.3 cm). Whitney Museum of American Art, New York; Purchase 41.3

American Icons Interpreted

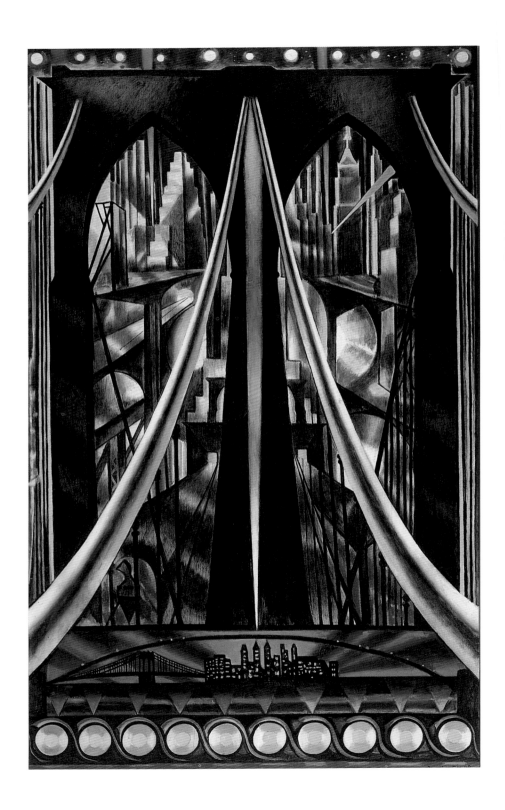

Joseph Stella

The Brooklyn Bridge *1939*

Joseph Stella (1877–1946)
The Brooklyn Bridge:
Variation on an Old Theme, *1939*
Oil on canvas, 70 x 42 in.
(177.8 x 106.7 cm)
Purchase 42.15

1. Barbara Haskell, *Joseph Stella***, exh. cat. (New York: Whitney Museum of American Art, 1994), p. 39. Haskell writes of the Futurists' aim, as described by Umberto Boccioni, to create a work "in which color becomes a sentiment and a music in itself...with the least possible references to the objects."**

Ellen M. Snyder-Grenier

If the aim of the Futurists— the group of early twentieth-century artists who embraced the newness of modern life—was to have color become "sentiment and a music in itself," then Joseph Stella's 1939 *Brooklyn Bridge* is a jazz riff, a dazzling onslaught of notes bursting with energy that mimicked the city's exuberance.[1] It was the fifth time he painted the bridge (hence the subtitle *Variation on an Old Theme*), which had opened in 1883 to enormous celebration.

Joining Manhattan and Brooklyn, then independent municipalities as well as the first and third largest cities in the country, the Brooklyn Bridge took thirteen years to build—and took more than twenty lives in the process. When it was finished, it made commuting across the East River reliable and dependable; earlier commuters had been forced to contend with weather and tides, whether they traveled by rowboat in the seventeenth century or steam ferry in the nineteenth. And even though one of its greatest features was a pedestrian promenade built high above the roadway, for commuters the bridge's real bonus lay in its connections to a growing transportation network in Manhattan and Brooklyn, first of horsecars and then of elevated trains, trolleys, subways, and buses.

The bridge changed commuting patterns and spurred development in Brooklyn. For instance, in the neighborhood known as Bedford (today part of Bedford-Stuyvesant), the opening of the bridge and, in the same decade, the completion of elevated railways led to an influx of residents and transformed a suburban district of largely freestanding homes into a more urban neighborhood of brick and brownstone row houses.[2] With the inauguration of streetcar lines that extended over the Brooklyn Bridge, affluent professionals could live in newly built mansions and elegant four-story homes near Grand Army Plaza in Park Slope and commute easily to jobs in downtown Brooklyn and Manhattan.[3]

The bridge also altered the face of both cities. In Brooklyn, its massive approaches rerouted traffic away from the Fulton Ferry area. The cluster of houses, taverns, and stables that had risen there by the eighteenth century had grown steadily, hastened by the introduction of the steam ferry in 1814. To serve increasing numbers of commuters, in 1871 the Union Ferry Company had erected a huge ferry house, which presided over what was by then a district packed with multistory shops, businesses, hotels, and eating and drinking establishments.[4] The Brooklyn Bridge bypassed, and thus doomed, this thriving Fulton Ferry neighborhood. Not only was traffic routed farther up Fulton Street, but homes, businesses, and a historic church in the path of the anchorages and approaches were torn down. In Manhattan, the bridge's construction had similar effects,

ripping into a thriving sailor-town and a neighborhood of working-class immigrant families located along the water. Other casualties included 1 Cherry Street, where George Washington lived for a short time after he was inaugurated as the country's first president on April 30, 1789.

In effect, then, the bridge tore at the urban fabric of Brooklyn and Manhattan even as it spurred development and cemented a relationship. This irony was probably fitting, considering that the two cities had long had a tumultuous relationship. One late nineteenth-century history of Brooklyn noted that the New York City orators who celebrated the bridge's opening "found nothing more effective than the allusion to Brooklyn as the bride of New York." But it was an uneasy marriage.[5] Brooklyn and Manhattan had long fought over control of the East River ferry lines, among other things. Manhattanites tended to look upon Brooklynites as unsophisticated, while Brooklynites considered their neighbors across the river denizens of a city of sin. The bridge served as a lightning rod in the ongoing storm. In Brooklyn, for instance, some residents felt that the bridge trustees should charge pedestrians a toll to cross the span, in an effort to keep out the "scum of New York."[6] Many Manhattanites, meanwhile, saw magnified their long-standing fears that they might lose their more prosperous residents to Brooklyn's relatively suburban charms (and lower taxes). Ultimately, the bridge foreshadowed the political union of the two cities. In 1898, Brooklyn, the Bronx, Queens, and Staten Island joined with Manhattan as part of Greater New York, a new, consolidated city of five boroughs.

5. Henry W.B. Howard, *History of the City of Brooklyn* (Brooklyn: The Brooklyn Eagle Press, 1893), p. 181.

6. *Brooklyn Times*, April 10, 1883, quoted in Margaret Latimer, *Two Cities: New York and Brooklyn the Year the Great Bridge Opened* (New York: Brooklyn Educational & Cultural Alliance, 1983), p. 103.

2. David Ment and Mary S. Donovan, *The People of Brooklyn: A History of Two Neighborhoods* (New York: Brooklyn Educational & Cultural Alliance, 1980), pp. 27–28.

3. Kenneth T. Jackson, ed., *The Encyclopedia of New York City* (New Haven: Yale University Press, 1995), p. 883.

4. Elliot Willensky and Norval White, *AIA Guide to New York City*, 3rd ed. (San Diego and New York: Harcourt Brace Jovanovich, 1988), p. 597.

But Joseph Stella was probably less inspired by mundane details of the bridge as a practical innovation than by what it symbolized. "In 1918," wrote Stella, "I seized the other American theme that inspired in me so much admiration since I landed in this country, the first erected Brooklyn bridge."[7] He returned to the bridge again and again because he saw it as the quintessential American icon, what he called a "shrine containing all the efforts of the new civilization of AMERICA."[8]

Indeed, the bridge when it opened in 1883 represented the new capabilities of modern technology. It was the longest suspension bridge in the world. It was also huge; its towers dwarfed the Manhattan and Brooklyn skylines. This "bigness" was something of a national trait, what *Scientific American* identified in 1885 as "the reputation that the American people have long had of always doing everything on the grandest possible scale."[9] Some saw the bridge as a symbol of deliverance from an antiquated past. Congressman and industrialist Abram S. Hewitt, who represented Manhattan at the opening-day ceremonies, contrasted images of a "primeval scene" of three centuries before with the modern cityscape. "In no previous period of the world's history," Hewitt asserted, "could this Bridge have been built."[10] The bridge also symbolized the country at a moment when it was becoming more modern, industrial, and urban. By the time the last elements of the bridge—the trusswork, the understructure for the bridge floor, and the promenade—were completed in the early 1880s, it was clear that cities were to be a significant feature of the new American world.

When Joseph Stella came to New York, he was confronted by this aspect of emerging modernity. Stella lived for almost ten years (1900–09) on Manhattan's Lower East Side,

an immigrant neighborhood swelled by the huge influx of Eastern and Southern Europeans at the turn of the century. Packed with tenements and filled with cafés, dance halls, and ethnic theaters, it was a place where pushcarts clogged narrow streets, where the sound of Italian, Yiddish, Russian, Polish, German, Chinese, and other languages of new New Yorkers filled the air. If the Lower East Side was the peopled face of the modern metropolis, then Brooklyn, to Stella, was its industrial visage. From 1916 to 1918, he lived in its Williamsburg section, not far from the Brooklyn Bridge. Stella called the area, known widely by the end of the nineteenth century for sugar and oil refining, cast-iron, pharmaceutical, and glass production, and more, an "industrial inferno." He recalled in particular the "huge factory…towering with the gloom of a prison" opposite his studio, where at night "fires gave to innumerable windows menacing blazing looks of demons."[11]

The experience of living in such distinctive parts of New York introduced Stella to the most salient features of city life—even though by his account he was repulsed by what he perceived as the hellish qualities of industrialism in the "most forlorn region of the oceanic tragic city." Yet Stella clearly saw the bridge, a product of this same world, as truly spectacular. Having grown up in a rural mountain village in Italy, he must have found it especially awe-inspiring when he first set eyes upon it, a phenomenon of modern urban-industrial life that became for him, by his own admission, an "ever growing obsession."[12]

When Stella painted the bridge in 1939, it had become a commonplace feature of metropolitan life. Yet in his depiction it remained a technological triumph, a machine-age icon that looked toward Manhattan, the ultimate American city. Stella turned his back to Brooklyn;

7. Joseph Stella, "Autobiographical Notes" (1946), quoted in Haskell, *Joseph Stella*, p. 213. The other "theme" Stella refers to is Coney Island.

8. Stella, "The Brooklyn Bridge (A Page of My Life)" (1928), quoted in Haskell, *Joseph Stella*, p. 206.

9. *Scientific American*, July 11, 1885.

10. *Opening Ceremonies of the New York and Brooklyn Bridge, May 24, 1883* (Brooklyn: Press of the Brooklyn Eagle Job Printing Department, 1883), pp. 44, 47.

11. Stella, "Interview with Bruno Barilli" (1929) and "The Brooklyn Bridge (A Page of My Life)," quoted in Haskell, *Joseph Stella*, pp. 208, 206.

12. Stella, "The Brooklyn Bridge (A Page of My Life)," quoted in Haskell, *Joseph Stella*, p. 206.

he eschewed the Williamsburg (1903) and Manhattan (1909) bridges, both of which by then also spanned the East River. And although he painted from the viewpoint of the pedestrian promenade, he reduced people to mere suggestion—the blazing lights in the high-rise buildings—even though, arguably, people gave this bridge its energy: the workers who scaled its soaring heights; the rushing commuters; the thousands upon thousands who looked at the bridge and saw it as a gateway to a new home. Stella's bridge is above all a dazzling, monumental, electric structure.

Just as it captured Joseph Stella's imagination, the Brooklyn Bridge continued to beckon countless other artists and photographers. It has served as metaphor in hundreds of works, from the poetry of Hart Crane to such popular culture film classics as *Saturday Night Fever* (1977), in which Tony, a disco-loving hardware clerk from Bay Ridge, turns to the bridge as a route out of his everyday life in Brooklyn. It has long lured advertisers. In the nineteenth century, businesses and manufacturers took advantage of its role as an American icon to sell baking powder, liver pills, sewing machines, French chocolates, souvenir spoons, and more. Such advertisements created a tradition that Madison Avenue perpetuated in the twentieth century to sell everything from perfume to software. And so deeply embedded in America's consciousness is the bridge that it has also come to function as a political stage. In 1985, in a show of pride, Vietnam veterans marched across the bridge from Brooklyn as they made their way toward the dedication of a memorial honoring them in Lower Manhattan. As Jean-Bertrand Aristide was addressing the United Nations General Assembly in 1992, just one year after he had been overthrown by a political coup, Haitians marched across the bridge in a massive display of solidarity with their deposed leader.

The Brooklyn Bridge: marvel of technology and transportation, spur to neighborhood development, inspiration. Joseph Stella captured the bridge in its stunning reality and envisioned its potential as an enduring icon. *The Brooklyn Bridge (Variation on an Old Theme)* is a brilliant, energized canvas, a visual portrait of the melodious cacophony that characterizes modern city life.

Henry Petroski

Joseph Stella's perspective on the Brooklyn Bridge is both uniquely his and familiar to anyone who has walked across the span. Like no other bridge in the world, a walk—better a perambulation or a stroll—along its central promenade is always an accessible, inviting, invigorating, exhilarating, and wholly satisfying experience. This effect is no accidental by-product of modern technology, such as that which Stella framed in the bridge's stone Gothic towers or tied to the world outside by the steel cables that pulled bridge building and a lot more into the twentieth century. It is, rather, the direct result of the bridge's accommodation to the pedestrian.

Stella could see the entire city from the Brooklyn Bridge because it has an elevated walkway down the center, conceived by its designer, the engineer John Roebling. On an earlier bridge, the one across the Ohio River at Cincinnati that is said to have served as a model for the Brooklyn Bridge, Roebling had designed walkways in the customary way—on either side of a roadway that was traveled by horse-drawn wagons and carriages. Pedestrians were always close to one side of the bridge, but they were seldom inclined to look to the other side, because the intervening roadway was uninviting—dusty, dirty, and dangerous—and the traffic was obstructive.

The great bridges of the world with pedestrian access have walkways like Cincinnati's Roebling Bridge, as the

Civil War-era span has since been renamed. The Golden Gate Bridge, though grand and photogenic, has rarely attracted great painters—in part no doubt because it is not juxtaposed with downtown San Francisco the way the Brooklyn Bridge is with Lower Manhattan. (The San Francisco-Oakland Bay Bridge, which does approach downtown, has no pedestrian access.) Furthermore, the toll-paying vehicle traffic across the Golden Gate pushes our view from the bridge's walkways eastward to the bay and to the distant skyscrapers or westward to the expansive Pacific Ocean. Even if we could walk down the centerline of the Golden Gate Bridge and look south through its great Art Deco steel towers, we would not see what Stella and other artists have seen through the stone towers of the Brooklyn Bridge because we are merely at road level.

When Roebling conceived his great bridge, the unspanned East River separated the distinct cities of Brooklyn and New York. For all the brilliance of the central promenade, the New York and Brooklyn Bridge was to be primarily a utilitarian structure. It would eliminate the frustration of waiting for ferries that had to negotiate the teeming port traffic, not to mention the fog and ice that sometimes kept the ferries from embarking at all. Roebling's conception of a bridge with a longer span than any ever built existed only as a sketch on paper for several years before construction was begun in 1869. Ironically, while doing surveying work to lay out the final alignment of the bridge, Roebling had his foot crushed by a ferryboat, and he soon contracted tetanus and died. His son, Washington Roebling, who had graduated from Rensselaer Polytechnic Institute, the premier American civil engineering school of the mid-nineteenth century, and who had apprenticed under his father on the Ohio River bridge, took over as chief engineer and carried out his father's plans with devotion. In 1872, however, while inspecting underwater construction progress, the younger Roebling was incapacitated by an attack of the bends, a common plight of construction workers who labored in the compressed air environment needed to keep the water at bay while the foundations for the towers were being dug. He was confined to his Brooklyn Heights apartment and had to direct the bridge's completion through the intermediary of his wife, Emily Warren Roebling, who effectively served as assistant engineer, carrying instructions and progress reports back and forth between bedside and bridge site.

During construction, as the towers kept rising above the New York skyline, the extraordinary scale of the structure must have awed the entire city. Once the towers were completed, the arduous task of spinning the cables began. Each cable was two-thirds of a mile long and contained over 5,000 wires; each wire had to be carried separately on spinning pulleys from anchorage to anchorage across the East River. If stretched end to end, the total length of the wires in each cable was more than 3,500 miles—a total of 14,000 miles of steel wire in the four cables. Such numbers astounded the public when the bridge was opened in 1883, but they would recede in the record books as the 1,595-foot main span of the Brooklyn Bridge was surpassed, first in small increments by bridges such as the neighboring 1,600-foot Williamsburg

Bridge, completed in 1903. Ironically, the Williamsburg Bridge had to be built because Roebling's bridge had promoted Brooklyn's development and increased traffic between the newly consolidated boroughs of New York City.

Although surpassed in length, the second-longest span in the world (until the Bear Mountain Bridge was completed in 1924) lost nothing in reputation. The Brooklyn Bridge retained its unique status as the bridge one could walk across and get a panoramic view of New York Harbor, where the Statue of Liberty was installed; of Lower Manhattan, where record-setting skyscrapers such as the Woolworth Building were beginning to rise; and of the growing area known as midtown, where skyscrapers would approach heights comparable to the Brooklyn Bridge's span between its towers. It was not until 1931, when the George Washington Bridge and the Empire State Building were completed, that the scale and architectonic character of the Brooklyn Bridge was truly consigned to another era—but only in terms of literal odometric measures.

Still, pedestrians walking across the Brooklyn Bridge set out on a journey of definite distance—about a mile from approach to approach—but of indefinite time. Our crossing is an experience of space in constant change, with the bridge's main cables rising and falling and rising and falling—and its suspender cables lengthening and shortening and lengthening and shortening—as we progress from approach to anchorage to tower to centerspan to tower to anchorage to approach. The more dramatic direction of travel is from Brooklyn to Manhattan, with an obligatory pause midway, where the main cables dip below our line of sight and thus enable us to look out unobstructed over the cables and the forgotten traffic below.

Going toward Manhattan, the city pulls us, as we linger to watch an excursion boat coming upriver from the harbor or look at the light and shadows changing on the face of New York. There is an energy and a sense of motion even in the static skyline, and a pulsing life in the felt, if unseen, tangle of wires, pipes, and subway lines beneath the streets. At night, when the office buildings are mysteriously lit up by late workers and early cleaning crews, the appearance and disappearance of distant windows is like the creation and extinction of stars in the sky. There is a distinct image of time passing, and an urgency to get to the city before we are left behind. Paradoxically, the walk back to Brooklyn can take even longer. We cannot make steady progress because we are constantly looking back at where we have come from, taking one last look at another configuration of clouds above the towers or another constellation of lighted windows.

The New York that Joseph Stella saw through the cables and towers of the Brooklyn Bridge was of a different time but essentially of the same place that we know today. The constancy of the bridge and its promenade, so thoughtfully placed by Roebling on a utilitarian structure, is an anchor to and for New York. To walk across the Brooklyn Bridge is to be transformed, or at least to see the city transformed, as it was seen by Stella again and again. The use of the bridge itself has evolved over time, with lanes of traffic being in turn occupied by cable cars and horse-drawn vehicles, and then by trolley cars and motor vehicles, and finally, only by automobiles. But still today, a walk across the Brooklyn Bridge is as vibrant and evocative an experience as it was in Joseph Stella's day.

John Yau

In 1909, at the age of thirty-two, Joseph Stella returned to Muro Lucano, a mountain village near Naples, Italy, where he was born in 1877. He hadn't been back since 1896, when, sponsored by his brother, Antonio, a successful doctor, Joseph sailed to New York, his head full of Edgar Allan Poe and Walt Whitman, and began establishing himself as a realist artist. In 1911, after traveling throughout Italy, much of the trip spent studying the work of Renaissance artists, Stella went to Paris. Among the works he saw there during the following year was Robert Delaunay's semi-abstract painting *La Ville de Paris* (1910–12), the first attempt to evoke a city through abstract rather than representational means. Stella also attended an exhibition of paintings by the Italian Futurists in February 1912.

For Stella and other American artists who went to Paris before World War I, the expressive dynamics of Futurism and the static balance of Cubism were a revelation, as well as a daunting challenge few of them would be able to live up to. Stella is a notable exception. *Battle of Lights, Coney Island, Mardi Gras* (1913–14), completed when he was back in New York, reveals his fluent mastery of an abstract idiom that combined aspects of Fauvism, Futurism, and Cubism. However, while it is apparent that Stella absorbed

many lessons from Futurism, particularly in his imaginative combination of chips of bright, jarring colors, directional arabesques, and linear elements within a dynamic composition, the painting is not derivative. Thus, in contrast to his contemporaries, Stella was able to move from realism to abstraction without faltering along the way.

In 1919, six years after Stella began developing his own modernist idiom and perhaps in celebration of the end of World War I, he produced the first of his paintings on the theme of New York's Brooklyn Bridge; he would return to this subject again in 1920–22, 1929, and 1936; in 1939, he painted the Whitney Museum's *Brooklyn Bridge: Variation on an Old Theme*; he explored the subject one last time in 1942. All told, there are at least a half dozen large paintings in which Stella incorporated aspects of the bridge's architectural motifs and structural elements into his composition.

In his 1928 essay "The Brooklyn Bridge (A Page of My Life)," Stella suggests why the bridge exerted such power over his imagination:

> *Many nights I stood on the bridge—and in the middle alone—lost—a defenseless prey to the surrounding swarming darkness—crushed by the mountainous black impenetrability of the skyscrapers—here and there lights resembling the suspended falls of astral bodies or fantastic splendors of remote rites—shaken by the underground tumult of the trains in perpetual motion, like the blood in the arteries—at times, ringing as alarm in a tempest, the shrill sulphurous voice of the trolley wires—now and then strange moanings of appeal from tug boats, guessed more than seen, through the infernal recesses below—I felt deeply moved, as if on the threshold of a new religion or in the presence of a new DIVINITY.*[1]

1. Joseph Stella, "The Brooklyn Bridge (A Page of My Life)," (1928), quoted in Barbara Haskell, *Joseph Stella*, exh. cat. (New York: Whitney Museum of American Art, 1994), p. 207.

Stella's wayward torrent of imagery in the Brooklyn Bridge works, influenced by the pulsing syncopations of the Italian Futurist writer F.T. Marinetti, Poe's pessimism and claustrophobia, and the sensuous cataloging of quotidian experiences in Whitman's *Leaves of Grass*, evokes a moment of crisis. It's as if the ritualized turbulence he depicted in *Battle of Lights, Coney Island, Mardi Gras* has spread throughout his urban environment, upending his sense of balance and safety. Although feeling "lost," "alone," and "defenseless" among the towering city, Stella recognizes that the bridge offers him a gateway to a state of ecstatic religious consciousness which both embraces and celebrates the cacophony of the modern world; it enables him to accept his feelings of disembodiment, vulnerability, and isolation, as well as imbues him with faith. He also realizes that a collision has occurred between the external, objective world and his deeply subjective, internal one: the "tumult of the trains in perpetual motion" is "like the blood in the arteries." This complete transference from the exterior to the interior generates a state of well-being: "I felt deeply moved, as if on the threshold of a new religion or in the presence of a new DIVINITY." The Brooklyn Bridge, with its urban panoramic view and constant commotion, offers Stella a sanctuary; he can see, as well as feel, the city coursing through him.

Here it seems reasonable to ask what gave Stella both his strength and his faith. The answer is modern art, which prepared him to see the Brooklyn Bridge as a metaphoric event in his life. Stella isn't walking on a bridge; he is crossing

from one state of consciousness to another as well as bridging past and future.[2] This is what separates him from the Italian Futurists, who wanted to destroy all links with the past. Living in America, Stella recognized that his adopted country, particularly after its triumphant entry into World War I, was trying to connect to its past, trying to establish itself as a major cultural force on the world stage. At the same time, Stella's ability to absorb the Brooklyn Bridge into a modernist idiom makes the city both less threatening and more accessible. Cubism and Futurism equipped him to inhabit New York differently, to feel more secure amidst its hectic streets and immense skyscrapers, to transform the bridge into an abstract pictorial stage where he could declare his faith in progress to the world. No longer threatened by the massiveness of the city, he finally felt that he could imaginatively respond to its visual din in meaningful ways.

In order to understand the significance of the Brooklyn Bridge in Stella's imagination, we must return to Whitman. When Stella landed in America in 1896, he was already familiar with the writings of the ever-optimistic Whitman and the ever-pessimistic Poe, both of whose work had been widely translated in Europe. The importance of Whitman to modernist poetry cannot be underestimated, for his poetic innovations, particularly regarding free verse, laid the groundwork for subsequent breakthroughs in the modern lyric. Vincent Van Gogh read Whitman, as did Mayakovsky, Apollinaire, Kafka, Lorca, Hart Crane, and William Carlos Williams. All of them benefited in some way.

The Brooklyn Bridge opened in 1883, only a few years before Whitman's death, and did not begin to grip the imagination of artists and writers until thirty years later. Yet it was Whitman whose poetry underlay the perception of the structure as symbolic rather than literal—as a monument that signaled the possibility of bridging past and future—and it was Whitman who served as later artists' guide to tomorrow ("O Saunterer on free ways still ahead!" Hart Crane called him).[3] Whitman had self-published *Leaves of Grass* in 1855. His animating pantheism, his sonorous celebration of both the ordinary and the present, and his compulsion to catalogue each and every sensual experience, to name the varieties of individuals one is apt to see passing on the streets of a bustling metropolis, became an immensely liberating inspiration for later generations. Instead of feeling alienated in lively throngs of people, Whitman praised the discrete types as galvanizing spirits who were leading America into the future. Not only was Whitman the first American poet to use a new idiom to celebrate the rise of the modern city, but he also understood its soaring buildings and technological innovations as a sign of progress, saw its cacophony as an embodiment of the industrious, freewheeling, democratic spirit. In contrast to Stella, Whitman wasn't overwhelmed by the diversity of the American experience; he reveled in it.

In "Passage to India," a utopian vision of America's past and future, Whitman celebrates technology and the physical spanning of the world, as signified by the building of the transcontinental railroads and the completion of the Suez

2. Alan Trachtenberg, "Cultural Revisions in the Twenties: Brooklyn Bridge as 'Usable Past,'" in Sam B. Girgus, ed., *The American Self: Myth, Ideology, and Popular Culture* (Albuquerque: University of New Mexico Press, 1981), pp. 58–75.

3. Hart Crane, "Cape Hatteras," in Marc Simon, ed., *The Poems of Hart Crane* (New York: Liveright, 1986), p. 78. For Whitman's influence on artists and writers in the opening decades of the twentieth century, see also Haskell, *Joseph Stella*, p. 80.

4. Walt Whitman, "Passage to India," in James E. Miller, Jr., ed., *Walt Whitman: Complete Poetry and Selected Prose* (Boston: Houghton Mifflin Company, Riverside Editions, 1959), p. 289.

Canal, both in operation before the Brooklyn Bridge was finished. Referring to Christopher Columbus, he wrote:

(Ah Genoese thy dream! thy dream!
Centuries after thou art laid in thy grave,
The shore thou foundest verifies thy dream.)[4]

Whitman's exaltation of technology, as well as his imaginative synthesis of history and notions of progress, helped Stella see the bridge in symbolic terms. By joining the boroughs of Manhattan and Brooklyn, the bridge can be understood as further verification of Columbus' dream: it made different quarters of the city more accessible to the ordinary individual. And for Stella, it was a symbol that could declare America's cultural independence from Europe.

In *Brooklyn Bridge: Variation on an Old Theme*, Stella combines, as he did in earlier works on the subject, abstraction, imagery, and religious symbolism. In the narrow, predella-like strip at the bottom, a centered, nocturnal skyline abuts the span of the bridge. Fanning out behind the structure are thirteen bands, seven blue ones alternating with six darker blue ones.

Both the numbers 7 and 13 evoke a wide range of mystical and mythic associations, all of which Stella knew. According to astrologists, there are seven planets or determining signs which pass through the twelve compartments of heaven; these compartments are divided into two groups (night and day) of six houses. Thus Stella's combination of seven lighter bands and six darker ones suggests the passage of the seven planets through the six houses of the moon or night. Finally, radiating from the centrally placed skyline, the seven bright blue bands express an upward movement, which is counterbalanced by the low black arch spanning the horizontal spread.

The arch cuts across the alternating bands, its curve accented by bright orbs of color. It can be read as both a protective umbrella whose arms reach down toward the earth and an abstract rainbow. It's likely that Stella intended the latter association, since a rainbow is a sign of a covenant between man and God. But, at the same time, the very extension of the arch echoes that of the bridge, and thus suggests passage, a crossing over. This is reinforced by the predella, where there are three images that evoke passage: the bridge on the left, the arch embracing both bridge and skyline, and the thirteen alternating, rising bands of blue.

In the upper, predominant part of the canvas, the strong contrast between the blues, greens, yellows, and reds of the bright, light-filled arches and the black, abstract frame evokes the interior of a church illuminated by stained-glass windows. The tilting, receding planes within the arches, particularly that of the road in the lower center, give the viewer the sense of floating above the pathway rather than standing on it. The two huge cables, which grow progressively thinner as they extend up, underscore this effect. The cables function like arms reaching out to embrace us, pulling both body and sight up to the top of the painting.

Along the top, capping the bridge's massive structure, is a stepped blue band containing rhythmically distributed white orbs: a star-filled night sky. The orbs echo the suns contained in a row of ten decoratively framed circles along the bottom. The ornamental stars and suns frame the modern world's journey toward a new unknown era, thus evoking a vision of acceptance and calm. The Brooklyn Bridge has not only invigorated Stella with a faith in progress, but it has also given him a palpable way to counteract his intense feelings of disorientation and susceptibility amidst "the mountainous black impenetrability of the skyscrapers." As both a sanctuary from the daily commotion and as a guide to the future, the bridge has made him feel safe amidst the city's constant pandemonium.

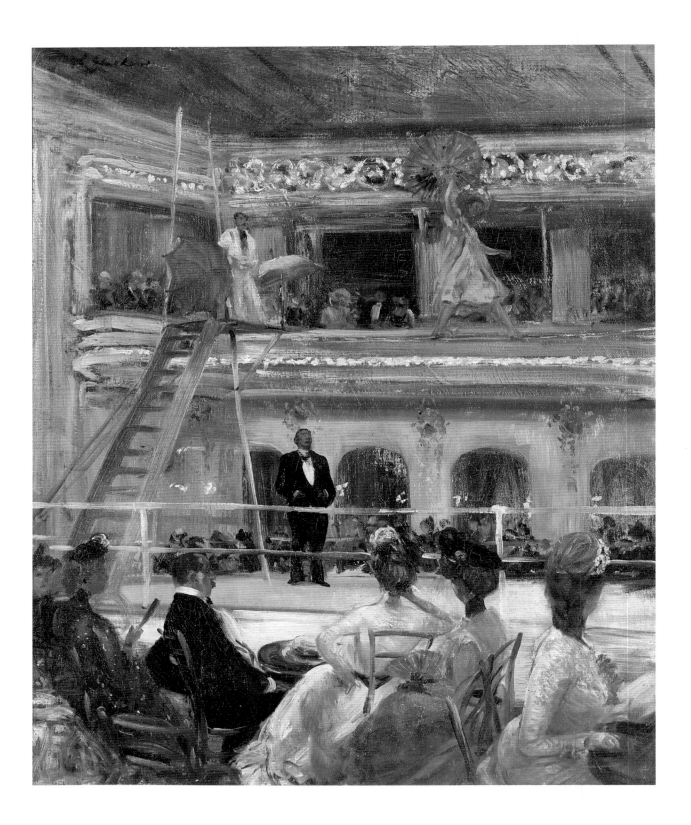

William J. Glackens

Hammerstein's Roof Garden *c. 1901*

William J. Glackens (1870–1938)
Hammerstein's Roof Garden, *c. 1901*
Oil on canvas, 30 x 25 in. (76.2 x 63.5 cm)
Purchase 53.46

Kathryn Harrison

The seated gentleman is distracted. Hat on the table, hands on his thighs, he's settled into that posture of stoic pessimism men assume while waiting for bad news. What preoccupies him? The stock market, perhaps. The heavy block of his head is one shaped to imagine disappointments and disasters. He should have sold those twelve hundred shares. By morning, no doubt, they will have dropped another half point. His eyes, having fallen from the girl on the tightrope, are lost in a shadow of debts and dyspepsia. Why does he persist in eating lobster when he knows it disagrees with him? And on such a sweltering night—if July is this bad, what will August bring!—a glass of beer has made him that much hotter. His feet have swollen in his shoes; the rungs of the chair press uncomfortably against his back. If only he were home, with jacket off and collar unfastened, his feet up on his hassock. It's another half hour before intermission, and he can't leave in the middle of an act, not when he's accepted the woman in white's invitation to sit at her table. Her friend flips her fan and stares across the stage, looking for a more companionable gentleman with whom to spend a hot summer's night. But where is he? At which table?

Drop a plumb line from the acrobat's blue bodice, a line that plunges straight down from her fast-beating heart, a line as taut as her thigh, and there, at its end, his eyes held by her walk overhead, is my grandfather. Don't expect to see him clearly: he's no more than a ghost, a blur in the wake of the painter's brush, but I see him nonetheless. I see him standing at attention like the master of ceremonies, his hat clutched in both hands.

My grandfather, who lost job after job and invested his money badly, had awe for whatever it is that can keep a woman dancing in midair. After all, he fell in love with a girl on the stage, a girl of whom he knew nothing. Why, he'd tell the stolid businessman, it's because you know so little of the blue-frocked acrobat—nothing save the line of her ankle, the tremor in her knee as she balances on a wire—that you can love her. Nothing of her longings or her fears, nothing more than what's expressed by the tilt of her painted parasol. She treads as deftly on your imagination as she does on the high wire.

Summering upstate with her daughters, far from the dirty city's outbreaks of infantile paralysis, the businessman's wife doesn't approve of his frequenting roof gardens. Like her husband, she lacks a talent for pleasure. Alone with the children, the governess, and maid, she worries about a married man left alone in the city. Will he walk the extra block to drop his shirts at the good laundry, not at the Chinese one around the corner—she's seen them spit on the shirts before they iron out wrinkles. As for his dining out every night, he eats food that's too rich, soon he'll have gout like her father. He stays up too late, undermines his health. And what if he should get lonely? What if he meets one of those New Women with new ideas? Women who go out unchaperoned, even at night, and drink iced tea and beer. In the park, by the boathouse, she saw one smoking a cigar. And what if there were a fire? The summer before, a theater burned in seventeen minutes, burned right down to the ground. Oh, how she hates the summers and their sticky diversions! After all, as every woman knows, a girl stays on a high wire only as long as she must—perhaps only as long as it takes to fall into someone's strong arms.

It was in 1915, when he was twenty-five, that my grandfather fell in love with a tent singer. He was in Anchorage, working for the Alaska Engineering Commission, laying railroad track up to Fairbanks and bunking with a crew of Russians who spoke only as much English as they needed to collect their wages and manage the transactions required for room, board, and enough vodka to offset the weather and the loneliness. In summer the town looked raw and ugly, the roads were rivers of mud. For entertainment, there were bars, whorehouses, and silent movies shown in a tent on Saturday nights, using the canvas wall as a screen. Beneath the image, which jerked and trembled with the wind, a woman sang, accompanied by a pianist.

My grandfather had tinnitus, a ringing in his ears, which had been boxed often and violently when he was a boy, and which now suffered the amplified clatter of railroad work. At the end of the day, lying in bed, he heard what sounded like an approaching siren or an alarm clock, a noise so relentless and irritating that it made him feel desperate—a noise that one woman's soprano unexpectedly, magically silenced. An alto wouldn't have done it, he said. There was something about her pitch.

In Alaska, summer nights were so bright that it was possible to take photographs by moonlight, and occasionally, after the movie, my grandfather and the soprano walked together carrying camera and tripod. To show me the pictures, he opened a drawer of his desk, and searched beneath a stack of bills and tax forms to find silvery landscapes of Lake Hood, its surface as still as a mirror, and in it the moon's reflection making a bright eye.

What did she sing? I asked. She sang "Pretty Baby," "Just a Song at Twilight," "Oh Susanna." I nodded, holding the photograph of the lake. These were songs he'd sung to me as a child, in lieu of bedtime stories. Sentimental songs, sweet and cloying, but my grandfather had come from a poor family and a hungry one; there could never be too much sweetness. Not for him or for his sisters, two of whom sang in music halls, the same two who were raised in an asylum because his mother couldn't afford to feed all five of her children. I hadn't known before who'd taught my grandfather the songs, because his second wife, not his first, was my grandmother. The tent singer died when she was thirty-seven, leaving him a widower with two sons.

Fifty years later, when my grandfather was in a hospital, dying, I searched through the top drawer of his bureau, looking for an insurance document. I dumped the drawer out on his bed, sorted through the change, the empty seed packets, shoehorns, pencil stubs, handkerchiefs. A butter knife, borrowed, I imagine, to use its dull blade as a screwdriver. Tenpenny nails, tacks, picture wire, duct tape, a broken compass, its needle stuck pointing west, the direction of sunsets, death, endings—a metaphoric destination I rejected under the circumstances. I shook it until finally the needle shifted a little, to the north. Among the debris was a shaving kit and, inside it, an old mirror, its silver backing clouded and pocked with black marks. I slipped the mirror

out and behind it found a photograph of a woman with dimples and dark hair, a photograph taken at Lake Hood. The woman's skin was as luminous as if she held all the night's light inside her, but still it was a moment before I knew who she was. Then, in another, I knew something else that I hadn't before: he loved her still, he never stopped. Her portrait was hidden there, behind the old mirror, because she was his secret, her name the one he could not say in my jealous grandmother's house ("the boys' mother," he always called her, referring to my half uncles) because to pronounce its syllables without crying would have been as impossible as singing her songs without his voice breaking. It was this woman, whose name I don't know, who sang songs in a tent: it was she, not my grandmother, who still had his heart.

A girl dancing on a wire, holding a parasol: this was the kind of spectacle my grandfather loved. He was riveted by any improbable manifestation of feminine grace, forever alert to whatever singing he could hear; and I remember watching him watch a line of chorus girls on television, caught in the visual hum of synchronism, or at the circus leaning forward to join the perfect arc of a trapeze artist's leap to grasp her partner's hands.

No wonder, then, that the gentleman's wife doesn't want him to frequent roof gardens. But look, there's no danger. He hasn't, like my grandfather, fallen in love. His heart is as earthbound as his feet. He's thinking of their daughters' schooling, he's thinking of bills, he's thinking of a leak in the drawing room ceiling; and already the possibility of love is dead. For passion treads a course as narrow and exalted as a tightrope, and love must, like the acrobat, ignore every distraction, every gesture except those of the beloved.

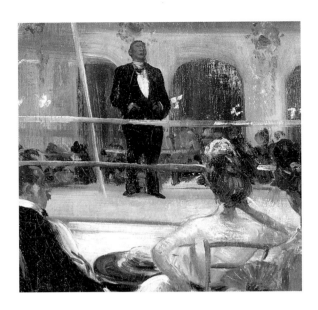

Lewis Erenberg

Hammerstein's Roof Garden depicts turn-of-the-century American society undergoing a cultural revolution. For Glackens and his contemporaries, the modern city exemplified the social problems of the industrial age as well as the excitement that urban life and modern technology could generate. Under these circumstances, Americans witnessed dramatic transformations in every facet of their daily lives and a powerful clash between old and new values. Nowhere else was this more apparent than in New York City, the shock city of the new age, and the symbolic canvas for Glackens and the other painters of the Ashcan School. Like other cultural migrants, Glackens was drawn to New York as the capital of modern urban culture. As an illustrator and artist, he depicted a new city preoccupied with consumption, informal relations between men and women, commercial amusements, and the spectacle of the city itself. In painting the city at play, Glackens and his contemporaries explored the passing of Victorian gentility and morality and the search for new personal and social mores.

Glackens' scene is set in the Paradise Roof Garden, recently opened by Oscar Hammerstein in 1899 atop his Victoria Theatre at 42nd Street and Seventh Avenue. It allows us to view the role that commercial amusements played in the lives of urbanites at all levels of society. Borrowed from naughty Parisian garden *cafés chantants*, but placed atop theaters because space was at a premium, the roof garden made its first appearance in New York in 1883, and grew into a fashionable urban amusement in the 1890s, when nine separate

establishments were in operation. Before air conditioning, roof gardens offered relief from the heat and congestion of the city in summer, when other theaters closed because of the hot weather. This is a summer scene, signified by the fans held by several of the women spectators and by the straw boater placed on the table in front of the man in the foreground.

The roof gardens provided spectacular urban views, public meeting grounds, increasingly elaborate spaces for informal entertainment, and a vicarious thrill of French bohemian naughtiness. To bring the entertainment close to the audience, the center of the roof was dominated by a raised platform 25 feet wide and 40 feet long, and surrounded, as in the painting, by balconies filled with tables and chairs. Gradually, roof gardens were covered to provide shelter for the continuous summer entertainments that became an increasingly more complex mélange of variety performers, acrobats, exotic dancers, and chorus girls, usually "dumb" or loud acts that did not have to compete with the noise of the city and the audience. Drawn by breezes, city views, and light entertainment, urbanites made the roof gardens places to rub elbows with a wide cross-section of the urban crowd.

Roof gardens, like other forms of modern entertainment, embodied a new informality between men and women. Unlike the nineteenth century, when a Victorian code decreed that respectable women could not frequent public drinking spots or take part in fast entertainments, turn-of-the-century roof gardens actively invited the participation of women and men in just such heterosocial settings. The focus is clearly on the women who flocked to the roof garden to see and be seen and to find a measure of personal freedom and privacy in an anonymous public setting, removed from the watchful eye of parents and community. Indeed, four female spectators and the one female performer

occupy the attention of the viewer. While the women in the audience gaze with interest at the performer, the stolid "tired businessman" seems to look nowhere in particular. He has seen it all before; apparently the women have not, and they seem to be looking for something.

In Hammerstein's, women could enjoy a drink in a mixed environment, seated at small cocktail tables that might promote a measure of intimacy with male partners. Small tables and movable chairs also permitted women and men to sit as closely as they chose, or to shift about into relaxing poses so as to turn their attention to others in the audience. Women are clearly part of a promiscuous urban mix, part of the action, bent on new experiences. They are not merely the objects of the male gaze; they too look intensely. Not only is the barrier between men's and women's entertainment bending, but so too is the distinction between "good" and "bad" women. Glackens makes it difficult to tell whether the women in the audience are part of a large party or whether they are unescorted, whether they are prostitutes, young matrons, or shopgirls. In the modern city, commercial amusements, much like department stores, allow women greater leeway in public.

The roof garden also made formerly forbidden variety entertainment acceptable for women. In the nineteenth century, ribald singers, acrobats, and dancers appeared in disreputable dime museums or in the all-male preserve of the concert saloon. Linked to liquor, prostitution, and raucous behavior, the concert saloon was no place for respectable women. In moving from the back rooms of saloons to roof gardens where women were present, however, variety entered the lives and activities of the prosperous classes. And the experience could be measured in physical terms. While vaudeville used the proscenium stage, roof gardens often eliminated the formal proscenium and brought

the performers close to the audience. Ethnic entertainers, virile "coon" shouters, and exotic dancers came into intimate contact with the audience. In the painting, the tightrope act of Bird Milman dominates the small stage area; in later years, "oriental" dancers, ballroom artists, and Ziegfeld chorus girls entertained in close proximity to the crowd. The entertainers offered men sexual titillation while providing women with daring models of personal behavior. The tightrope walker suggests the sexualized nature of the performance, especially since the male emcee can look up her dress. As posed by Glackens, the question that worried civic leaders, religious moralists, and social reformers was whether the modern woman might fall from her own tightrope performance between willful adventurousness and respectability.

Glackens points out other aspects of the modern city. *Hammerstein's Roof Garden* evolved from the fruits of modern technology that the prosperous were learning to enjoy. The roof garden would have been impossible without the elevator that transported patrons from street level. Similarly, a slew of electric lights above the balconies lit the proceedings; such illumination made all the new institutions of night life possible by rolling back the night and making more time for play. Broadway's Gay White Way, dotted with theaters, lobster palace restaurants, and roof gardens like Hammerstein's, acted as an advertisement for the electric light, the wonders of technology, and the new delights of consuming nature rather than husbanding it. In capturing this phenomenon, however, Glackens reveals the conflicts of modern life. At the top of the painting, the electric bulbs are hidden in a natural garland of fleur-de-lis, while the roof garden itself used technology to offer city dwellers and tourists release from the confinement and congestion of a city built on technology. Hammerstein's, for instance,

featured a miniature Swiss farm and dairy, complete with milkmaids and farm animals. How would Americans reconcile this clash between nature and modernism?

Hammerstein's Roof Garden highlights the new era of entertainments that were loud and racy, thus challenging values of order and gentility. Glackens shows barriers bending, but he also emphasizes that they still exist. The man and the women sit far apart from each other, while the tightrope walker and her partner are separated even more. A fence keeps audience members off the stage. The loosening of restraint was still associated with dire consequences. Interpretive dancer Gertrude Hoffman and her imitators made this point clear in 1908, when they performed their Salome dance in scanty clothing about the head of John the Baptist: sex equals death. Yet, by the 1910s, roof gardens overcame Victorian reticence and installed dance floors to attract men and women eager to do the new ragtime dance crazes. The distance between the sexes was closing.

Roof gardens lasted only until the early 1920s. After a spectacular venture into the dance-cabaret business, Hammerstein's closed in 1914, followed by the remainder of the roof gardens, killed off by Prohibition and changing tastes. The roof gardens also had to compete with the other commercial entertainments that they had helped spawn. Vaudeville drew off variety acts, cabarets provided dancing space and intimate entertainments, and movies excelled at depicting exotic climes. Glackens places viewers as spectators in the middle of this world of commercial amusements, focused on a tightrope between older values and a new culture of consumption and moral experimentation. As the center of these emerging amusements, New York stood as the capital of modern culture. No wonder Glackens and his contemporaries were fascinated by it.

Brendan Gill

Some among us have what appears to be an inborn bent toward happiness. If over the years fate proves to be almost always on our side, we are quick to accept this good fortune, nor do we vex ourselves with the question of whether it has been unfairly bestowed. Simply and inexplicably, we are the lucky ones, and it is no wonder that we spring out of bed every morning of our lives expecting agreeable adventures to befall us. William Glackens is a distinguished member of our company. His joyous disposition forms a bond between him and me, though in fact we never met. Well, but no matter! There are not all that many of us lucky ones in the world, and we recognize one another without regard to whether we have met, or live on the same continent, or even in the same century. Glackens was born in 1870 and died in 1938, when I was twenty-three. We frequented the same New York City neighborhoods and the same summer resorts, but the distance between neighboring generations is notoriously wide and perhaps it is just as well that we didn't meet face to face. Glackens was a contemporary of my father and he might have proved (though I certainly hope not) too close a father figure for my comfort. To his own children he was perfection. He never tired of drawing and painting them, and in a way that did them no evident harm, they never got over him.

Another possible problem, aesthetic rather than generational, could have beset Glackens and me. During much of his career, he was painting in a style more or less directly imitative of Renoir at what I consider Renoir's worst. Oh, the soft-focus, peach-fuzz fleshiness of those porky Renoir women! They make my blood run cold, though no doubt an opposite effect was intended. And when the old voluptuary wasn't painting porky women and pinkly edible babies, he was painting flowers that to my eye were also too erotic for their own good. I like a certain botanical exactitude in flowers on canvas—I am not a bee or a butterfly, and I do not look forward to being sexually aroused by a bouquet.

The truth is that my Glackens is not the ambitious "artist," making his way up in the world (and deservedly succeeding—prize after prize was to be his), but the young, superbly gifted newspaper, magazine, and book illustrator. Whether in black and white, watercolor, or oils, working at high speed and seemingly without effort, he depicted the people among whom he lived with an accuracy that caused his friend and early schoolmate, the artist John Sloan, to say of him that he was the "greatest draftsman that ever lived on this side of the ocean."

It was in Philadelphia, his native city, that Glackens learned in his teens the art and craft of being a newspaper artist-reporter—an occupation that flourished before it was superseded by photography and of which Glackens was widely acknowledged to be a master. Another friend, the artist Robert Henri, a few years older than Glackens, inspired him to paint in the vigorous style of Velázquez and Manet, the artists to whom Henri's own work was chiefly indebted. After a year in Paris, Glackens took up residence in New York City, working for a variety of newspapers and magazines during the next twenty-odd years as one of the most sought-after of illustrators. Meanwhile, he was painting "seriously," in the realist vein favored by that group of artists who, exhibiting outside conventional academic circles, came to be known politely as The Eight and, less politely, as the Ashcan School. (Besides Glackens, Henri, and Sloan, the group included Maurice Prendergast, Ernest Lawson, Everett Shinn, Arthur Davies, and George Luks.) They were a convivial group, who ate and drank and went out on the town together, and they hugged life to them in a fashion that some of the more fastidious painters of the period found—or pretended to find—alarming.

The earliest of Glackens' many paintings having to do with the world of entertainment is *Hammerstein's Roof Garden*, which is generally thought to have been painted around 1901 and has been in the Whitney Museum's

Permanent Collection since 1953. It manifests most of the qualities that I find admirable in Glackens: the impetuous attack, the delight in impasto (pigment to Glackens at this period was like pastry to a gourmand—he could not get enough of it), and not least the confidence in his ability to convey in oils the same exuberant liveliness that distinguishes his charcoal and crayon sketches. Here is a young man in love with his talent and with the circumstances that, freely chosen, provide him with the needed degree of formal challenge.

The painting, 30 inches high by 25 inches wide, is not especially large for the amount of physical space it depicts and the amount of narrative it contains. Oddly, in memory I tend to remember it with its measurements reversed, perhaps because the scene is a tightrope performance by a young *artiste* suspended in air well above her audience. Like the eyes of the audience observing the performance, the eye of the viewer of the painting travels from left to right horizontally, ignoring the vertical. Will she, one wonders, succeed in making her way to the far end of the rope? The figures in the foreground of the picture appear to believe that she will—they have seen such performances many times before, having come to the roof garden because it is a fashionable thing to do and because the effort required to be attentive to a play or opera has proved too much for them.

Glackens and his young comrades, especially Shinn, shared with their elder idols in Paris—Degas, Toulouse-Lautrec, and the like—a professional interest in entertainment as subject matter, but it was a highly personal interest as well. Actors, dancers, singers, and musicians, in the intensity of their devotion to their given métiers, were, in effect, mirror images of the artists themselves. The world of the theater existed outside society and escaped its conventions, though always at a price; and so did the world of the artist. For a time, the roof garden in New York City was a setting similar to the cabaret in Paris, the chief (and mighty)

difference being that the roof garden was less openly sexual in nature. It was a permissible place for well-brought-up women to go, and if a pretty young prostitute or two were to be detected in the audience, that added a frisson of daring to the pleasure of the occasion.

Architecturally, the roof garden came into existence to serve an important economic purpose—at a time when air-conditioning had not yet been invented, it helped to keep professional entertainment alive during those long summer months in which our Mediterranean climate rendered New York City theaters unendurably hot. Beer gardens abounded all over America in the nineteenth century—a manifestation of that German culture which was then universally operative here. From beer gardens on the ground to roof gardens in the sky, whether on top of theaters, restaurants, hotels, clubs, or even private residences, was an easy step for architects and builders. In design they used a traditional form, imitating romantic stage sets with an abundance of painted lattice, hanging Japanese lanterns, and peekaboo foliage both real and false.

In 1899, the celebrated impresario Oscar Hammerstein opened the Paradise Roof Garden on top of his newly built Victoria Theatre, on the corner of 42nd Street and Seventh Avenue (almost a hundred years later, still the very heart of the Times Square entertainment district). With his usual combination of precise observation and seemingly slapdash execution, Glackens has evoked the gaudy air of the establishment even in the laying on of his brushstrokes. Many emotions are evoked by the scene, not least the joy of accomplishment felt by its maker. One emotion is missing, that of lust. This may have been simply because acrobats in performance do not often arouse lust (except, one hopes, in other acrobats), and Glackens was therefore quite right

to have omitted it. Or it may be that he was displaying a certain Philadelphian gingerliness in respect to sex, though I doubt it. The man who painted *Chez Mouquin* and *Seated Actress with Mirror* was an acute judge of how to depict sex in a painting. Nevertheless, it may be suspected that, taken as a group, The Ten were more chaste than the supposedly respectable artists of the time, Augustus Saint-Gaudens and Thomas Dewing among them, who were still active members of the pack of predatory males long presided over by Stanford White. Certainly a close friend of The Eight, James Moore, the louche rakehell leaning womanward in *Chez Mouquin*, appears to have been a near twin to White, but I see Glackens in his high-spirited horseplay as a sort of Rover Boy, who kept commercial sex at a distance and for whom even what we now call consensual sex would have been a rare experience.

Glackens didn't marry until he was thirty-four and then the bride was a fellow artist, Emily Dimock, who was pert rather than pretty, who had been thought by her family likely to become an old maid, and who brought with her the advantage of a considerable social position as well as—and how welcomely—a fortune. The handsome William and the clever Emily made an enviable couple, and if as the years passed the gallant young flinger of paint upon canvas became ever more conventionally domestic in both his art and his life, who am I to deplore the consequences? His life was pleasing and his pictures reflected this pleasingness. I began with the proposition that Glackens and I were among the lucky ones, for whom happiness is always ready to hand and upon whom life, however unjustly, heaps continuous good fortune. Is something of value—in Glackens' case, something of very high value—lost in the process? We lucky ones do not stay to hear the question, interesting as it is, and so we need not, in an unaccustomed anguish, strive to provide an answer.

135

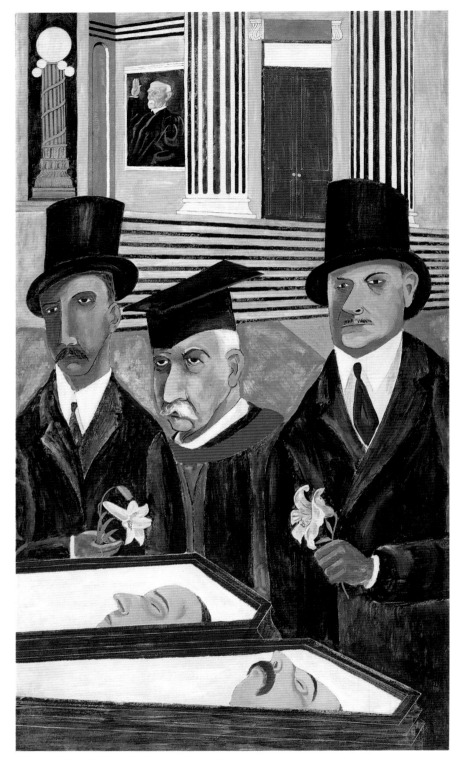

Ben Shahn

The Passion of Sacco and Vanzetti *1931–32*

Ben Shahn (1898–1969)
The Passion of Sacco and Vanzetti,
from the Sacco-Vanzetti *series, 1931–32*
Tempera on canvas, 84 1/2 x 48 in.
(214.6 x 121.9 cm)
Gift of Edith and Milton Lowenthal in
memory of Juliana Force 49.22

Alfred Kazin

On August 23, 1927, the Italian immigrants Nicola Sacco and Bartolomeo Vanzetti were electrocuted at the Massachusetts State Prison in Charlestown. They had been charged with the murder on April 15, 1920, of Frederick A. Parmenter, the paymaster of a shoe company in South Braintree, and Alessandro Bearardelli, his guard. I was twelve when my usually subdued father, an immigrant housepainter, saw the headline screaming across the top page of the pro-labor Yiddish newspaper *Forward*. For the first and last time in my life I saw my father break down in sobs.

Like Ben Shahn, another immigrant from the Russian Empire (he was eight when he arrived from Kovno in Lithuania), my father did not just believe Sacco and Vanzetti innocent, he (and everyone else I then knew) thought them martyrs to capitalist injustice and WASP "prejudice." On the other side were "hangmen in frock coats." Actually, there was a strong case against the two men. Vanzetti had a criminal record and carried a revolver that may have been taken from the murdered guard. Sacco was armed with a .32 caliber Colt pistol containing nine bullets and carried in his pocket twenty-three additional bullets. The prosecution demonstrated that the fatal bullet found in Bearardelli's body had been fired from a .32 Colt and claimed that it had come from Sacco's pistol.

Nobody I knew as a boy even listened to such evidence. The Red Scare that followed the "Great War" was proof enough that the open anarchists Sacco and Vanzetti had been framed. American Socialists and other radicals had bitterly opposed our entrance into the war. Sacco and Vanzetti had fled to Mexico to escape being drafted. The Armistice had seen returned soldiers destroy the offices of radical newspapers. Socialists legally elected were expelled from the New York State Legislature as "un-American." After a bomb exploded in front of the house of President Wilson's Attorney General A. Mitchell Palmer, Palmer carried out mass raids on aliens. Two hundred and forty-nine aliens of Russian birth (including Emma Goldman and Alexander Berkman) were deported to "Red Russia."

No wonder Judge Webster Thayer, presiding over the trial of Sacco and Vanzetti, was widely believed to have privately vowed that he was going to rid the country of "those damn agitators." The rumor originated with the future *New Yorker* drama critic and movie humorist Robert Benchley. A vast company of other Harvard graduates, liberals, and indignant intellectuals believed with Benchley that Judge Thayer was simply incapable of being fair to two draft-dodging "wops," a mere shoemaker and a fish seller. Their defense committee included every literary and artistic notable of the time. Jane Addams of Hull House in Chicago was with Felix Frankfurter; Edmund Wilson with Edna St. Vincent Millay. Norman Thomas, Oswald Garrison Villard, and Harold Laski marched with Roger Baldwin and James Weldon Johnson; Judah Magnes with Helen Keller. Add Upton Sinclair,

Eugene Debs, and dozens more. The *Sacco-Vanzetti Anthology of Verse* carried such pieces as "Two Crucified Jews Also Sinned," "Impaled Upon a Cross of Lies, Christ Also Agonizes," "Golgotha in Massachusetts." *The Nation* editorialized against "Massachusetts the murderer. Men who in the minds of multitudes will take their place with the Carpenter." In radical families inflamed with the cause of Sacco and Vanzetti, children were actually given names like "Sacvan" to keep the flame alive. And how could one help treasuring "our Sacco and Vanzetti" in the face of Judge Thayer's reputed hatred for those aliens when a Vanzetti could shake us forever with the following from his death cell?

If it had not been for these things, I might have lived out my life talking at street-corners to scorning men. I might have died unknown, unmarked, a failure. This is our career and our triumph. Never in our full life can we hope to do such work for tolerance, for justice, for man's understanding of man as how we do by an accident.

There is Judge Thayer top left in Shahn's *The Passion of Sacco and Vanzetti*, hand upraised as he swears to be fair and just to all who come before him. Shahn too described the trial and end of Sacco and Vanzetti as a "crucifixion." His painting is dominated by the hypocritically "mourning" figures of Massachusetts Governor Alvan T. Fuller's "advisory committee," who sealed the fate of Sacco and Vanzetti. These were Harvard's President A. Lawrence Lowell, Judge Robert Grant, and MIT President Samuel W. Stratton. After almost seven years of the most intensive worldwide pleas for "*our* Sacco and Vanzetti," Lowell, Grant, and Stratton were finally responsible for sending the defendants to the chair.

Two of the infamous trio are bitingly crowned with top hats. Harvard's Lowell is in academic dress with the Harvard hood painted a bloody red indeed to recall the blood that this Pontius Pilate washed his hands of. What cold-hearted VIP bastards Shahn gives us.

How utterly removed such Establishment figures are from the shoemaker and fish seller in their coffins. Even the mustaches in the three downturned faces are drawn with bitterness and deadly mockery. Shahn painted the top hats, so excessive in their size and weight, to jeer at them. Big shots pretending to grieve over those they could have saved. Shahn's final scorching addition is the ridiculously drooping single flower two of them hold over the upturned faces of the dead.

Although many reasonable people, even on the left, still doubt Sacco and Vanzetti's innocence, it is not their "passion" but that of Ben Shahn which holds us now. The literature that sprang to their defense was extraordinary in extent and fierceness of accusation. G. Louis Joughin and Edmund M. Morgan in *The Legacy Of Sacco and Vanzetti* (1948) list 144 poems dealing with the case, including works by Witter Bynner, Malcolm Cowley, Countee Cullen, Edna St. Vincent Millay, and Lola Ridge; six plays, including *Winterset* by Maxwell Anderson and *Gods of the Lightning* by Anderson and Harold Hickerson. *The Male Animal*, by James Thurber and Elliot Nugent, uses the famous Vanzetti letter as an important issue. There are eight novels, including Upton Sinclair's *Boston*, Nathan Asch's *Pay Day*, Bernard De Voto's *We Accept with Pleasure*, Ruth McKenney's *Jake Home*, and, less directly, John Dos Passos' *The Big Money* and James T. Farrell's *Bernard Clare*. A section of C.E.S. Wood's *Heavenly Discourse* deals with the case, as does Katherine Anne Porter's *The Never-Ending Wrong*.

The only parallel in literature to Shahn's *Passion* in depth of feeling about the case is John Dos Passos' memory in *The Big Money* (the last section of his brilliant trilogy *U.S.A.*) of agitatedly walking from Plymouth to North Plymouth in his grief over the impending execution:

they have clubbed us off the streets they are stronger they are rich they hire and fire the politicians the newspapereditors the old judges the small men with reputations the collegepresidents the wardheelers (listen businessmen collegepresidents judges America will not forget her betrayers) they hire the men with guns the uniforms the policecars the patrolwagons

 all right you have won you will kill the brave men our friends tonight...

America our nation has been beaten by strangers who have turned our language inside out who have taken the clean words our fathers spoke and made them slimy and foul

 their hired men sit on the judge's bench they sit back with their feet on the tables under the dome of the State House they are ignorant of our beliefs they have the dollars the guns the armed forces the powerplants

 they have built the electricchair and hired the executioner to throw the switch

 all right we are two nations

Alan M. Dershowitz

"Passion" is the perfect word with which to characterize both the legal case of Sacco and Vanzetti and the artistic approach taken by Ben Shahn toward the highly politicized trial and execution of the two Italian immigrant anarchists. Though the murders of the paymaster and guard of the South Braintree, Massachusetts, shoe company occurred more than three-quarters of a century ago, there is still passionate debate over whether Sacco and Vanzetti were the killers, or whether they were instead the victims of a politically and ethnically motivated frame-up. Indeed, two recent books claim to have resolved the question with finality. Each reconsidered the old evidence, provided new information, and reviewed the trial transcript. Each book purported to be definitive, and in the words of one reviewer, "to bring to a close six decades of controversy." Not surprisingly, the two definitive books arrived at dramatically opposite conclusions! One said that Sacco and Vanzetti were "irrefutably guilty." The other was equally certain of their innocence.[1]

I have read the entire trial transcript and remain very much in doubt about the ultimate issue. It is clear that the trial was grossly unfair, but unfairness alone does not equate with factual innocence. There seems to be a reasonable doubt about the defendants' guilt as well as their innocence. If that is so, then the verdict of the Massachusetts courts was certainly wrong, since under our system of justice a verdict of guilty must eliminate all reasonable doubt about guilt but not about innocence. This does not mean that the verdict of history—which generally regards Sacco and Vanzetti as the innocent victims of a racist miscarriage of justice— is necessarily right. Indeed, there may have been a *legal* miscarriage of justice even if it were to turn out that Sacco and Vanzetti were *factually* guilty. And there may have been a *factual* miscarriage of justice, even if the trial had been fair. It is possible for factually innocent defendants to be wrongly convicted after a fair trial, just as it is possible for factually guilty defendants to be unjustly convicted after an unfair trial. Indeed, it is even possible—as some scholars have suggested—that Sacco was guilty and Vanzetti innocent.

The courtroom proceedings were presided over by a Brahmin bigot named Judge Webster Thayer, who could barely conceal his contempt for the Italian troublemakers. The trial was unjust, in the sense that the evidentiary rulings and instructions were one-sidedly favorable to the prosecution. The jury consisted of "native" Americans (which, in the language of the day, meant white, Protestant males). Following the conviction, and a worldwide outcry against Massachusetts justice, Governor Alvan Fuller appointed an "independent" commission, the Lowell Committee, to advise him concerning the fairness of the trial. But the committee's chairman and moving force was also an anti-Italian bigot and an avowed racist—Abbot Lawrence

1. Francis Russell's book *Sacco and Vanzetti: The Case Resolved* (New York: Harper and Row, 1986) concludes they were guilty. William Young and David E. Kaiser's *Postmortem: New Evidence in the Case of Sacco and Vanzetti* (Amherst: University of Massachusetts Press, 1985) concludes they were innocent. The reviewer was William Shannon in *The Washington Post Book World*, January 26, 1986.

2. Martin H. Bush, *Ben Shahn: The Passion of Sacco and Vanzetti* (Syracuse, New York: Syracuse University Press, 1968), p. 13.

Lowell, the President of Harvard University. President Lowell—who introduced racial and religious quotas to Harvard—was anything but objective on a matter pitting the fairness of Brahmin justice against the claims of Italian radicals. His report, which was forcefully criticized by Professor Felix Frankfurter and others, was a whitewash of Judge Thayer, the prosecutor, and the Massachusetts legal system. Despite the availability of new evidence which cast considerable doubt on the ballistic and eyewitness testimony at the trial, Governor Fuller refused to commute the sentence, and Nicola Sacco and Bartolomeo Vanzetti were executed on August 23, 1927. But the passion surrounding the case did not die with the defendants.

Ben Shahn's interest in the case began while the defendants were still fighting for their lives. He participated in demonstrations and became committed to the cause of their innocence, which he never doubted. Indeed, the Sacco and Vanzetti case "had a marked influence on Shahn's work,"[2] pushing him away from French Impressionism and toward political and narrative art. Over time, Shahn developed a passion for documenting the injustice of the Sacco and Vanzetti case through his art. He created several tripartite compositions each portraying, from left to right, the protesters massing against injustice, the defendants in heroic pose, and the martyred victims in their coffins, with President Lowell and the two other members of the committee standing over them in front of the courthouse. One of these compositions, a 60-foot-long mosaic, occupies a large public space at Syracuse University. Shahn also depicted the most powerful part of the sequence, the three committee members standing over the coffins, in several independent versions, one of which is a large painting in the Whitney Museum. It is appropriately housed in a great museum of American art because it is a quintessential part of both American history and American art.

Whether or not Sacco and Vanzetti were innocent, their case has come to stand for the anti-immigration, anti-Catholic, anti-Italian, and anti-radical biases of the American legal system in the early part of the twentieth century. There can be no question that these biases permeated American politics and law, as evidenced by the anti-immigration hysteria that swept the nation following World War I, which culminated in the mass arrests and harassment of aliens and in the enactment of racist anti-immigration laws. The Sacco-Vanzetti injustice was the most visible manifestation of a hysteria that denied the defendants any possibility of a fair trial. Former Massachusetts Governor Michael Dukakis posthumously "pardoned" Sacco and Vanzetti in 1977, after a study concluded that the entire legal process in relation to their case was flawed. Because of the flawed nature of the investigation, trial, and posttrial proceedings, we will probably never know, with any degree of historical certainty, what actually happened during the payroll robbery of 1920. This has not, however, stopped many people from expressing strong opinions—often uninformed by facts—about the justice or injustice of the conviction and execution of Sacco and Vanzetti. That should not be surprising in a highly politicized case with no "smoking gun." Evidence does not become clearer with the passage of time. It only appears more certain to those with a stake in a particular conclusion. A case like Sacco-Vanzetti, which grew out of a highly politicized climate, can never become depoliticized, even with a diminution in the political passions that nurtured the original controversy. Too many people still have too much vested in a particular version of the truth, whether or not it is supported by hard evidence.

But art is not history, nor need it represent objective truth. Ben Shahn's outpouring of artistic passion over the injustice he perceived is a powerful period piece. Tragically, it may also represent some of today's injustices and bigotries. The ethnicity of today's perpetrators and victims of injustice may be different, but so long as human passions govern our legal system, there will be injustice. In that sense, the passion of Sacco and Vanzetti is a timeless piece of protest art representing a universal outcry against injustice; it is as old as Abraham's rebuke of God for threatening to kill the innocent along with the guilty of Sodom and Gomorrah: "shall not the Judge of all the earth do justly?" (Genesis 18:25). Ben Shahn's art eloquently rebukes our temporal system of justice for its hypocrisy.

This age-old passion for justice—which was an important part of Ben Shahn's early Jewish education[3]—is reflected in Shahn's art, but nowhere as powerfully as in his paintings of Sacco and Vanzetti. *The Passion of Sacco and Vanzetti* brings artistic accountability to the judicial villains who denied the defendants due process, while reminding us lawyers of the fallibility of human justice.

3. Ibid.: "Shahn had a Talmudic education based heavily on justice...."

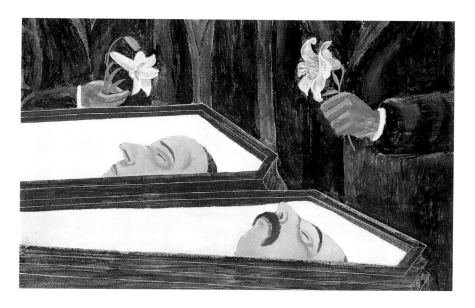

Frances K. Pohl

I was an undergraduate art history major when I first came across Ben Shahn's painting *The Passion of Sacco and Vanzetti*. I remember being struck by the directness of the image, by the combination of roughly painted surface and clearly incised line. While I did not know the identity of the men in the painting or the circumstances that had brought them together, I did know immediately that some injustice had been done. I knew this by the way in which the judge was trapped in the architectural framework of the Neoclassical courthouse, with the vertical shadows of the fluted columns replicating the bars of a prison cell. I also knew by the sallow features of the central mourner and by the rigid grouping of the three men in suits, mortarboard, and top hats, who were so clearly of a different class and ethnicity from the men in the coffins and whose mourning seemed artificial.

Research on this painting confirmed my initial impressions. It also revealed that these impressions were in keeping with what Shahn had hoped viewers would perceive. Shahn had wanted to create a work that would prompt thoughts about the strengths and limits of the American justice system, that would capture attention through both the content of the painting and its style. He wanted to reach not only the traditional art world audience of dealers, artists, collectors, and museum-goers, but also the workers, anarchists, and labor organizers who were part of Nicola Sacco and Bartolomeo Vanzetti's world.

Shahn was not the only artist in the United States in the early 1930s to turn his attention to the plight of workers or instances of political injustice. The economic Depression that began with the stock market crash of 1929 prompted an increased interest among many artists in the struggles and tragedies faced by millions of Americans as well as in the diverse peoples who had contributed to the formation of this country's broader cultural identity. This interest coincided with the desire of many of these same artists to find not only a distinctly American subject matter, but also a distinctly American style. Many, like Shahn, employed popular sources of imagery, such as political caricature, newspaper photographs, and folk art, while at the same time maintaining a foothold on the modernist formal experimentation that had been initiated in Europe by such artists as Pablo Picasso and Henri Matisse.

Unfortunately, much of this search for American content took place within a larger xenophobic environment, one responsible in part for the fate of Sacco and Vanzetti. As growing numbers of immigrants from Southern and Eastern Europe arrived in the United States in the first decades of the twentieth century, earlier Northern European immigrants voiced fears that "American" culture was under attack. These anxieties increased during World War I, when protests against the war and the active organizing of workers in various industries contributed to the growth of a radical working-class consciousness. The successful Bolshevik Revolution of 1917 added further fuel to the antiforeigner and antilabor hysteria, which led to the infamous raids by Attorney General A. Mitchell Palmer in the early 1920s. These raids resulted in the arrest and/or deportation of many labor organizers and real or imagined radicals. Organizations were also formed to stem the flow of immigrants from Southern and Eastern Europe, such as the Immigration Restriction League (IRL), founded in 1894 to encourage the admittance of only "good" immigrants— i.e., those from Northern and Western Europe. The efforts of the IRL and other nativist groups led to the passage of new restrictive immigration laws in the 1920s and of the National Origins Act of 1929, which imposed quotas on immigrants from Southern and Eastern Europe.

Shahn, who emigrated to New York from Lithuania at the age of eight, did not share these sentiments. Instead, he tried to recast the immigrant as part of American culture and as a gauge of the strengths and weaknesses of American democracy. In an interview with John D. Morse in 1944, Shahn elaborated on the circumstances that led to the creation of his series of paintings on Sacco and Vanzetti:

1. John D. Morse, "Ben Shahn: An Interview," *Magazine of Art*, 37 (April 1944), p. 137.

2. Ibid.

I didn't know either where I stood when I came back to America in 1929 [from a trip to Europe]. I had seen all the right pictures and read all the right books—Vollard, Meier-Graefe, David Hume. But still it didn't add up to anything. Here I am, I said to myself, [thirty-one] years old, the son of a carpenter. I like stories and people. The French school is not for me. Vollard is wrong for me. If I am to be a painter I must show the world how it looks through my eyes, not theirs.[1]

It was at this point that Shahn turned to the case of Sacco and Vanzetti, two Italian immigrants arrested in 1920 for the robbery and murder of a paymaster and his guard in South Braintree, Massachusetts:

Then I got to thinking about the Sacco-Vanzetti case.... Ever since I could remember I'd wished that I'd been lucky enough to be alive at a great time—when something big was going on, like The Crucifixion. And suddenly I realized I was. Here I was living through another crucifixion. Here was something to paint![2]

Shahn had been studying at the Marine Biological Laboratory in Woods Hole, Massachusetts, in the summer of 1921, when Sacco and Vanzetti were first found guilty of murder. He had little sense of the political implications of this trial, however, or the ferment it had caused until he went to Europe in 1925. There he witnessed massive demonstrations and protests against what many claimed was a politically and ethnically biased trial. Sacco and Vanzetti were anarchists as well as immigrants, and the prosecution made much of their political sympathies. Upon his return to the United States at the end of 1925, Shahn became actively involved in the growing controversy and defense efforts.

He went to Boston twice to picket and was in Brooklyn Heights the day of the execution in 1927. There he remembered walking the streets, crying bitterly. It nevertheless took several years and another trip to Europe before he was ready to commemorate the "crucifixion" of Sacco and Vanzetti in paint.

When Shahn's series of twenty-three gouache paintings entitled *The Passion of Sacco and Vanzetti* was first exhibited at Edith Halpert's Downtown Gallery in April 1932, many responded favorably to the works, noting Shahn's ability to combine both modernist and popular sources to create what one critic called "a native revolutionary mythology."[3] Some saw the folk influence in his style—the flat, two-dimensional space, unmodulated lighting, and simplified rendering of facial features—while others noted the significance of this series for working-class people. Even those who felt Shahn's images were not sufficiently propagandistic or partisan agreed that the subject matter was of vital importance.[4] At a time of increasing isolationism and xenophobia, when recent immigrants were being blamed for everything that had gone wrong in America since World War I, efforts had to be made to present another picture of the immigrant world, in particular a picture seen through the eyes of one of its own. Shahn had arrived with his family in the United States in 1906, one of many Jews fleeing persecution in Eastern Europe. He subsequently experienced the discrimination and hardships visited upon those immigrants whose physical appearance, religion, and/or politics differed from those of the White-Anglo-Saxon-Protestant elite who ran the country.

Shahn's large tempera painting *The Passion of Sacco and Vanzetti*, which evolved out of the earlier gouache series, presents Sacco and Vanzetti not as the cause of social dislocation, but as its victims. The three men in the

3. Matthew Josephson, "The Passion of Sacco-Vanzetti," *The New Republic*, April 20, 1932, p. 275.

4. See Walter Gutman, "The Passion of Sacco-Vanzetti," *The Nation*, April 20, 1932, p. 475.

5. Allen Eaton, *Immigrant Gifts to American Life: Some Experiments in the Appreciation of the Contributions of Our Foreign Born Citizens to American Culture* (New York: Russell Sage Foundation, 1932).

6. Ibid., p. 153.

foreground represent the Lowell Committee, composed of Judge Robert Grant, President A. Lawrence Lowell of Harvard University, and President Samuel W. Stratton of MIT. The committee was commissioned by Governor Alvan T. Fuller of Massachusetts to look into charges that Sacco and Vanzetti had not received a fair trial. Lowell had been the national vice president of the IRL since 1912, so it was no surprise that the committee refused to recommend clemency for the two men.

The same year that Shahn's images of Sacco and Vanzetti went on view in New York, Allen Eaton published his book *Immigrant Gifts to American Life: Some Experiments in the Appreciation of the Contributions of Our Foreign Born Citizens to American Culture*.[5] Eaton's book examined several exhibitions of folk art by recent immigrants that had taken place between 1919 and 1932. He argued that such exhibitions had "helped bring about better understanding" between different immigrant groups in America and had "stimulated social and civic cooperation." These exhibitions had also provided immigrants with "a sense of validity through expressed esteem for their qualities and achievements" and "given a new meaning to the word Americanization."[6] Shahn, rejecting a cult of Americanism marked by hostility toward foreign-born minorities and an uncritical glorification of America's founders and institutions, also attempted to provide a sense of validity to the experiences of recent immigrants and to redefine in broader terms what it meant to be an American. He reminds us that both individuals and institutions—judicial, political, educational—are worthy of glory only when they protect and promote the interests and rights of all Americans.

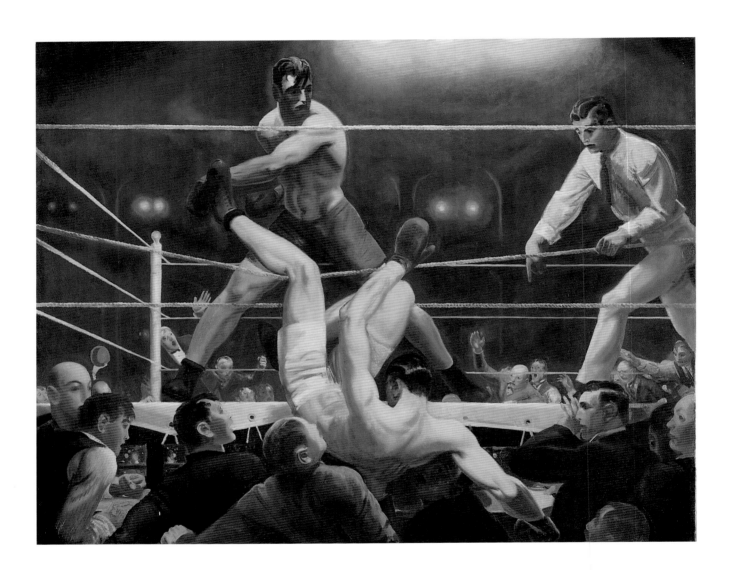

George Bellows

Dempsey and Firpo *1924*

George Bellows (1882–1925)
Dempsey and Firpo, 1924
Oil on canvas, 51 x 63 1/4 in.
(129.5 x 160.7 cm)
Purchase, with funds from
Gertrude Vanderbilt Whitney 31.95

Elliott J. Gorn

Jack Dempsey was one of the great sports heroes of the early twentieth century, and his hold on the public imagination probably was rivaled, in the history of boxing, only by Jack Johnson, John L. Sullivan, and Muhammad Ali. "O, my little Dempsey," the poet Horace Gregory rhapsodized over the former heavyweight boxing champion,

> *my beautiful Dempsey*
> *with that Godinheaven smile*
> *and quick, god's body leaping,*
> *not afraid, leaping, rising….*

Yet in George Bellows' *Dempsey and Firpo* we see the champion falling through the ropes, falling so heavily we cannot imagine him ever rising again. Bellows painted a scene that actually occurred, and he did so with considerable accuracy. The artist was ringside in New York's Polo Grounds that night of September 14, 1923, and he must have seen the widely circulated UPI photograph of the incident. There in black-and-white, the upper body of Argentinian boxer Luis Angel Firpo still shifts to the right with his follow-through, the referee still moves in from behind Firpo's left side, Dempsey's feet still reach for the ceiling and his back for the floor.

On one level, Bellows' painting should not surprise us. A leader of the Ashcan School, he had already painted, a couple of decades earlier, *Stag at Sharkey's* (1909) and *Both Members of this Club* (1909), both works more grotesque and distorted than *Dempsey and Firpo*, perhaps emblematic of boxing's much seamier status at the beginning of the century. But even at its most disreputable, the ring always attracted artists and writers. Other sports have had their interpreters, but no Thomas Eakins ever painted jump shots, no Ernest Hemingway ever described a screen pass. Even in the late eighteenth and early nineteenth century—during England's golden age of bare-knuckle fighting, when, paradoxically, the prize ring was completely illegal—artists like George Cruikshank and writers such as William Hazlitt gave the ring artistic expression, while the poet Lord Byron patronized the great champions and sparred with the best fighters of his day.

So in the early twentieth century, there was nothing new about artists finding drama in the prize ring. Here was the most elemental form of combat, man-to-man, an unambiguous test of masculinity. All of Bellows' boxing paintings emphasized the prize ring's raw physicality. What is unusual here for Bellows, though, is how he chose to depict so literally this particular moment. Firpo appears invincible, with his treelike legs spread wide and anchored to the canvas, his torso taut and muscular, the expression on his face determined and businesslike. He is totally in command. And although Dempsey has not even landed on the ground yet, the referee appears to be counting him out. From the look of Bellows' painting, this fight is about to end.

As it turns out, Bellows merely depicted the most dramatic moment in a remarkable fight. Although he had won a few fights in the American ring, Firpo was little more than a very large amateur, matched against the champion purely for the sake of a big payday. Firpo never had this fight under control, nor was Dempsey ever in free-fall toward defeat. Still, during their one-and-a-half round bout, Firpo's unconventional style threw Dempsey out of his normal rhythm and gave him considerable trouble. Nat Fleischer, editor of *Ring* magazine, called the fight the most exciting he had witnessed in fifty years of reporting, and certainly eleven knockdowns in less than five minutes bears him out.

What is perhaps most noteworthy about Bellows' painting is that Firpo is the center of attention, rising triumphantly over the rest of the picture. Yet historically, it was Dempsey who dominated the boxing scene, dominated it like no one since John L. Sullivan, who lost the championship in 1892 to James J. Corbett under the new Marquis of Queensberry Rules. Dempsey was the one who put fans in the seats, the one who sold newspapers, the one whom Americans paid to see. The decade following World War I often has been referred to as the Roaring Twenties or the Age of Ballyhoo. While such labels can be terribly misleading, they do capture certain tendencies. With the end of World War I and a return of prosperity, trends that began around the turn of the century accelerated. The old Victorian emphasis on restraint foundered on the new imperatives of a consumer society. Ideals like hard work, diligence, sober self-control did not so much disappear as become isolated in the world of bureaucratic work, while the values of play—spending freely, gratifying the senses, displaying the body—took on growing importance. The new economy of potential abundance, unlike the old one based on scarcity, assumed that society functioned best when consumers felt free to pursue an ever-rising standard of living. The end of wartime austerity and the onset of postwar prosperity greatly accelerated these trends.

The "golden age of sports" in the 1920s was part of this growing culture of consumption. In the nineteenth century, the very word sport could mean a dissolute individual who publicly engaged in disreputable acts like drinking and gambling, acts that often centered on activities such as horse racing or prizefighting. But slowly, the term's second meaning, an athletic contest, came to predominate, and the word lost its pejorative connotations as sports themselves became respectable. Indeed, by the twentieth century, an ideology of sports had developed, justifying activities like baseball, football, boxing, track and field, and basketball because they inculcated such values as teamwork, fair play, the will to win, self-discipline, and so forth. Moreover, old Victorian strictures became less compelling as growing numbers of people had a bit more leisure time and disposable income.

Spectator sports of the 1920s reached proportions undreamed of just a few years before. The decade witnessed the building of mammoth stadiums like Soldier Field in Chicago and Yankee Stadium in New York City. Only a couple of years after the 1919 Black Sox scandal seemed to cripple baseball beyond repair, teams were setting new attendance records, player salaries and owner profits skyrocketed, and a new slate of great ballplayers like Babe Ruth and Lou Gehrig compiled statistics once thought unattainable. College football also became a national mania, as millions of people who never thought of attending college closely followed Notre Dame, the University of California, and other powerhouses, while men like Red Grange became the heroes of a generation. Perhaps most surprising of all, that old outlaw boxing, long the *bête noire* of Victorian moralists, now received lavish coverage in respectable newspapers, and praise for its lessons in manly fortitude.

Among the heroes of the twenties, no one had a career more spectacular than Jack Dempsey, the "Manassa Mauler." His personal history was well known to the public. Born in West Virginia, he moved with his family to Colorado when he was just a boy. His was a mining family in an era when the mine country evoked violent images of company thugs and armed union men, of the bloody Ludlow massacre in the 1914 Colorado Mine Wars, of Mother Jones leading "her boys" in the fight to organize. Dempsey left school early, picked up money in bars by challenging anyone to fight him, went on the road as a migrant laborer, and partly supported himself with earnings from the ring. His local reputation in the West grew, and by the late teens he was becoming a national presence in the ring.

Finally, on July 4, 1919, Dempsey was matched against the champion, Jess Willard, the "Man Mountain," almost a half-foot taller and sixty pounds heavier than the challenger. Dempsey knocked Willard down seven times in the first round, and finally won when Willard refused to come out for the fourth. But more, it was Dempsey's looks (his body tanned deep bronze, his face unshaven, the famous Dempsey scowl under his black brows) and his fighting style (bobbing and weaving like a snake, then relentlessly punching away until Willard's jaw broke, his cheekbone shattered, and his ribs cracked) that all the newspapers repeated.

For the next several years, Dempsey was an outlaw figure, the man whose background and ring style fascinated fans, even as they cheered his opponents. Dempsey described himself as a "jungle fighter," referring to the hobo jungles where he fought some of his earliest bouts. Even in championship matches, his aggressiveness always carried him past the rules of the ring. Moreover, Dempsey suffered from various image problems. He failed to serve during World War I, and the "slacker charge" brought him many enemies; he divorced his first wife and married movie star Estelle Taylor, scandalous behavior even for the twenties; and Dempsey always hung around with a disreputable, thrill-hungry crowd.

So here was the paradox of Dempsey's career: on five separate occasions—including the Firpo match—crowds at his championship fights hovered around 100,000, and all five bouts produced gate receipts in excess of $1 million, records unsurpassed until the 1960s. Coast-to-coast radio networks covered his fights, and newspapers devoted page after page of front-section coverage to them. Yet *Time* magazine declared of Dempsey, "he has never been a popular champion," and fans often greeted him with a chorus of boos. His war record, his high living, his seeming disregard of the rules of the ring, all made him suspect. This behavior, moreover, referred back to his hard early life in the mining camps and hobo jungles. Again, *Time* magazine: "Only when he is in the ring do those days come back. Then his brows blacken....His body

muscled like a panther cat's, seems to ignite with malice, to burn and flash; then his fists reach out, savagely, lethally, to destroy the weaving shape in front of him and get revenge for something he has just remembered, a wrong done, a score that must be evened, something that happened to him long ago." Syndicated columnist Westbrook Pegler declared Dempsey to be "as hard and violent as any man living," while William O. McGeehan wrote of his "concentrated cruelty," his "will to kill."

When Dempsey fought Firpo in 1923, then, the champion had captured the public imagination, but more as an avenging nemesis, a dark angel, than as a plumed knight. And the Firpo bout confirmed all the prefight publicity. Another million-dollar gate, another 88,000 spectators at ringside, another highly hyped challenger—the "Wild Bull of the Pampas," a couple of inches taller and twenty-five pounds heavier than the champion. The rich and famous, among them Elihu Root, W.K. Vanderbilt, L.H. Rothschild, Henry Payne Whitney, Florenz Ziegfeld, John J. McGraw, and Babe Ruth sat at ringside. As an American fighting a foreigner, Dempsey should unambiguously have been the favorite. Yet he entered the ring an unpopular champion and left even more so.

In the opening ten seconds, Dempsey threw a wild right, Firpo sidestepped and countered with a left uppercut that dropped the champion to his knees. Reporter Paul Gallico declared that for the rest of the fight, the entire crowd stood "yelling, screaming, climbing up on the benches, falling down, clawing at each other, roaring forth a wild, tumultuous cataract of sound...." Dempsey was always most dangerous when hurt, and he rose before the referee began the count, clinched Firpo with one hand and punched away with the other, culminating with a right hook that sent the Wild Bull down for a nine-count, followed by another flurry and

another knockdown. Firpo rose and clinched, the referee asked the fighters to step back, and as Firpo did so, Dempsey stepped forward with an uppercut that again brought Firpo to the canvas. Now Dempsey stood nearby his fallen opponent, refusing to retire to a neutral corner as the rules specified. When Firpo rose, Dempsey punched him down, then did it again. Now Firpo came up swinging and knocked Dempsey to his knees, but the champion rose again, and punched Firpo down two more times.

At this point, Dempsey was sure the fight was all but over. With less than a minute left in the first round, he threw a right to the ribs that Firpo countered with a tremendous overhand right that staggered Dempsey to the ropes. Seizing the moment, the challenger threw one clubbing blow after another while Dempsey was pinned with his back against the middle cord. Finally, with a right shove more than a punch, Firpo launched Dempsey out of the ring, into the hands of ringside spectators. They pushed the champion back into the fray (his back was cut on a reporter's typewriter), and the two exchanged blows for the remaining few seconds of the round. When the bell sounded, Firpo dropped his hands and began to return to his corner; Dempsey used the occasion to land three more blows.

The second round was an anticlimax. After exchanging cautious blows, Dempsey hit Firpo once more as they broke from a clinch, then threw him down from another clinch. Firpo rose and walked into a Dempsey left, followed by a crushing right hook. The Wild Bull was unable to rise at the count of ten and Dempsey retained his title.

So why did Bellows depict the fight at Firpo's moment of triumph? Surely the challenger knocking the champion out of the ring was the most exciting event of the night, and maybe that was reason enough. But perhaps there was something more. Many American fans were ambivalent about the fight's result. In the crude nationalism of the ring, all were satisfied that the American had triumphed over the foreigner, the "Nordic" over the "Latin." Yet they also muttered about Dempsey's foul tactics, his deceit and treachery. The champion's refusal to retire to a neutral corner, his punching away rather than breaking cleanly from clinches, his hitting after the bell, his blows to an opponent who had barely risen off the canvas—all violated the rules of the ring and the ethics of fair play. And many reporters wrote that had the rules been enforced, Firpo would be champ. Perhaps George Bellows returned to his old subject of the ring to rectify an injustice. Maybe on the artist's canvas Bellows sought to give Luis Angel Firpo the triumph out of which he had been cheated.

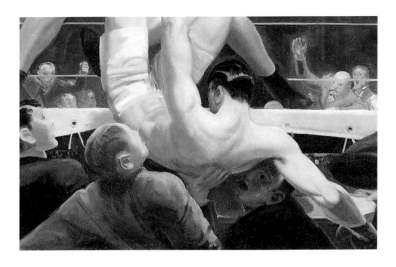

So here we have it, the punch, and in this case, thrown by Luis Firpo, it has knocked Jack Dempsey out of the ring onto a typewriter, so legend has it. It was hardly a fatal blow since Mr. Dempsey climbed back into the ring (with some friendly shoves by the sportswriters) and took care of Mr. Firpo.

George Plimpton

Around the training camps there is inevitably talk about specific punches like Luis Firpo's—knockout blows, rabbit punches, low blows, bolo punches, on and on. "My punches hurt," George Foreman wrote in his autobiography. "But if you feel the pain you know you're OK. You can rub the spot or run back to your corner and cry for a minute. Some shots are so ferocious they *don't* hurt. What they do is interrupt communication between the tower and the ground. Knees jiggle. You're *looking* at your opponent but your legs are somewhere else."

Muhammad Ali once offered an astonishing description of what it was like to teeter on the edge of consciousness after being hit with a heavy punch. He sees himself on the sill of a chamber he described as the "Near Room." Through the half-open door he can see neon, orange, and green lights blinking, and in their glow various animals playing musical instruments in a bedlam of noise—bats blowing trumpets, alligators with trombones, and snakes screaming. Weird masks and actors' clothing hang on hooks along the wall—enticing-looking, as if beckoning to be worn, and he knows that if he steps across the sill into the "Near Room" and reaches for the clothing he will be finished, and that when his mind finally clears and frees him of the confines of the "Near Room" he will find himself sitting on a stool in his corner, while across the way his opponent is exulting, arms aloft as he is carried around the ring on the shoulders of his handlers.

Often the handlers talk about the hardest punches they've ever seen. An old-timer I know mentioned Rocky Marciano's hit on Ezzard Charles in their last fight—a blow to the Adam's apple that caused Charles' neck to swell up so that it was hard to tell where his chin stopped and his neck began. I mentioned that the hardest punch I'd seen was probably what George Foreman hit Joe Frazier with in Jamaica. Archie Moore, who was working Foreman's corner, showed me one of Foreman's gloves. It had a little chip out of it, which he said had been made by one of Joe Frazier's teeth.

I once talked to a fighter named Marty Marshall, who told me what it was like to be hit by Sonny Liston. "He hit me three shots you shouldn't have thrown at a bull. The first didn't knock me down but it hurt so much I went down anyway."

Jack Dempsey once playfully tapped his part-time trainer, Gus Wilson, on the side; Gus was subsequently taken to the hospital where a damaged kidney was removed. I doubt Paul Gallico was aware of this power. One of the first of the participatory journalists, he got into the ring with Jack Dempsey up at Saratoga Springs, where the fighter was preparing for his Luis Firpo fight. Gallico wrote of the reason

he did this: "My burning curiosity got the better of me...."
He was immediately knocked down (Jack Dempsey, the
"Manassa Mauler," as he was often referred to, didn't like
to find anyone else in the ring with him), though he survived
to write marvelously of the sensations he went through:
"the next thing I knew, I was sitting on the canvas covering
of the ring floor with my legs collapsed under me, grinning
idiotically. How often I have seen that same silly, goofy look
on the faces of dropped fighters—and understood it. I held
onto the floor with both hands, because the ring and the
audience outside were making a complete revolution, came
to a stop, and then sent back again counterclockwise....
I learned that there can be no sweeter sound than the bell
that calls a halt of hostilities."

No wonder! When Jess Willard was destroyed by Jack
Dempsey, half blind, his ribs broken, some of his teeth
knocked out (there had been a scramble for them at
ringside—quaint souvenirs!), he was overheard muttering
as he was led down the steps from the ring, "I have a hundred
thousand dollars and a farm in Kansas. I have a hundred
thousand dollars and a farm in Kansas."

Joe Frazier once told me that the force behind good, solid
punches such as Dempsey's was generated by the hate built
up by the very fact of training. "When the fight comes, I hate
everyone," he said. "It's the eight weeks of training that does
it. You *hate* the man for making you spend the length of time
to whup him."

After his loss to Ingemar Johansson, Floyd Patterson
worked up so much hatred for being shamed, for having his
title taken away from him, that one of Patterson's last
punches in their second fight still contained so much pent-up
power that Johansson went down as if hit by some kind
of death ray. He lay on his back, the life seemingly drained
from him. I saw that fight in the Polo Grounds. I remember
Johansson's foot twitching—not unlike the disembodied
nervous reaction of a frog's leg, lying flat on a dissecting table,
when touched by a student's scalpel. Patterson saw this too

and it scared him. Subsequently, the thought of truly
harming someone seemed to curb his killer instincts, what
some old-timers call "finishing" a man.

Archie Moore, my old friend, once told me about a fight in
which he hadn't been able to curb his anger. A fighter named
Len Morrow had hit him hard in the mouth despite the fact
that Archie had his hands extended in apology for a low blow.
This stayed in his mind for a year until they fought again.
"I could have finished him in the seventh," he said. "But I was
mean and angry and I waited too long and the result was I
put him in the hospital with a concussion. He nearly died, and
he wasn't any good after that. That's a fight I'm ashamed of."

George Foreman has a somewhat more phlegmatic view.
"I don't like fights," George once said. "I just land the right
punch and everything is over. Nobody gets hurt and nobody
gets killed."

Back to Firpo. What did he do after Dempsey climbed
back into the ring and knocked him out with a thunderous
left hook? Hardly typical of most fighters, he knew when he'd
had enough. He went back to Argentina, his home country,
with his winnings and became an extremely successful
rancher. On a visit to Argentina, Dempsey met him once
again. He was honored with a dinner to which Firpo invited
the entire town of Rosario. Seeing him off at the airport,
Firpo handed Dempsey an envelope and told him not to open
it until he reached New York. It contained $20,000 in bills
of large denomination and a note that stated simply, "Just a
small token of friendship and appreciation from one old
friend to another...."

What an extraordinary gesture! It suggests that even
the pain and disarrangement of the senses by a heavy punch,
indeed losing his chance for a title, could be wiped away by
the passage of time.

Marianne Doezema

Bellows' boxing pictures garnered considerable notoriety and helped to promote his rapid rise to prominence in the art world. Only a few short years after arriving in New York City in 1904, he was creating a sensation with vigorously brushed paintings of life in the tenement districts, the excavations for the new Pennsylvania Station, and, most notably, prizefights. His choice of these gritty urban subjects and his bravura painting technique resulted from his study with Robert Henri at the New York School of Art. Henri made it clear in his classroom that life was more "real" in the tenement districts than it was on Fifth Avenue. He sent his students to the Lower East Side, to the asylum, to the Bowery, and to the prizefight arena. He encouraged them to ignore artistic conventions and academic formulas of any kind, and instead to paint from fresh visual apprehension— and, most important, to paint the real life they saw around them. Bellows took these lessons to heart and by doing so earned a reputation as an exciting and talented new upstart. One critic labeled him "the infant [*sic*] terrible of painting."

His connection to the Henri circle did Bellows no harm. Their challenge to the outworn conventions of academic idealism that prevailed at the National Academy of Design was considered overdue by large segments of the art audience. Henri and his protégés attracted as much praise as criticism for their notorious rebellion against the Academy. Bellows often received more accolades than his colleagues, in part because of his brilliant technical facility and in part because the implicit meaning of his pictures was quite unrevolutionary. For example, his depictions of the Lower East Side conformed to a moralistic, middle-class view of poverty; the excavation paintings celebrated urbanization;

and the boxing pictures conveyed the requisite condemnation of the sport as brutal and its fans as debased.

Bellows' first boxing painting hung over a doorway at the National Academy of Design's "Winter Exhibition" in December 1907, but it caught the critics' attention nevertheless. In 1909, Bellows returned to the subject, producing two more large-scale oil paintings that garnered even more attention in the press. All three paintings present boxing as a tawdry though tantalizing urban spectacle, patronized by rapacious rogues. Indeed, prizefighting was a forbidden recreation in New York, since public contests had been outlawed in the state in 1900. Fights that did take place were staged in "private" clubs, in secret, on floating barges, and in the back rooms of saloons—the setting Bellows alluded to very specifically with one of his titles, *Stag at Sharkey's*, one of the most notorious of the club-saloons in the city.

By the time Bellows produced another big boxing painting, more than a decade after the first three, prize-fighting had been legalized in New York State. The sport had emerged from the murky back rooms that had provided the setting for the paintings of 1907–09. Boxing's patronage expanded to include, in addition to the small contingent of upper-class gentlemen who had always been a component of the ringside audience, elegantly dressed ladies. Attendance at major boxing events became chic in some circles. During the preliminaries to the battle between Jack Dempsey and Luis Angel Firpo, the subject of the Whitney Museum's picture, ushers escorted to their seats members of the social elite, including A. J. Drexel Biddle, Sr. and Jr., Elihu Root, W.K. Vanderbilt, George Gould, Forbes Morgan, William A. Brady, Henry Payne Whitney, Florenz Ziegfeld, John

Ringling, and Babe Ruth. Bellows' continuing interest in boxing as a subject included not only his fascination with the dynamics of the fight itself, but also the cultural changes that attended the sport.

The Whitney Museum's picture is the third of three boxing paintings produced between June 1923 and the early summer of 1924. The process of creating these pictures, however, differed markedly from that of the earlier boxing paintings. In the 1907–09 series, Bellows worked up the composition, with paint, on the canvas itself. The later paintings tended to be based on more elaborate compositional strategies that had been developed initially in at least one drawing and/or lithograph.

During the decade between the two sets of boxing paintings, which essentially bracket the artist's career, Bellows' style had undergone a significant change. A distinct new direction was noted as early as 1914 by the influential critic Forbes Watson, who took note of Bellows' "deep interest in what might be called the geometrical logic of painting" and the "rediscovery of laws common to all great art." His newfound interests were probably stimulated by the Armory Show of 1913. That exhibition and its aftermath had a significant impact on all the artists in the Henri circle, who had occupied a center-stage position in the New York art scene for several years. The Armory Show changed all that: in the wake of this highly publicized introduction of European modernism to American shores, Henri and his protégés were no longer at the vanguard of artistic trends. It is not surprising that Bellows would have wanted to reassess his position in relation to the art world, to reaffirm the validity of his own work in response to the influx of new ideas associated with Cubism, Fauvism, and other newly imported styles. By reasserting his interest in the geometry

of compositional structure, in "laws common to all great art," Bellows was attempting to establish a connection with venerable tradition as well as to confirm the intellectual content of his work. He certainly considered *Dempsey and Firpo* to be a major effort of his mature career, one that would serve as a demonstration of technical facility and compositional complexity as well as conceptual weightiness.

All three of Bellows' late boxing pictures were included in one public exhibition, in Chicago, prior to the artist's death. The critical response to that exhibition reflected the perception of seriousness, of the profound, in the artist's work. In the *Chicago Daily News*, Marguerite Williams called the roomful of paintings "startling" and "disconcerting"— a distinct departure from "the era of sunshine and trifles in art." In her view, the paintings on display spoke of the artist's essential concern—not merely "what the eye sees in a scene or a person," but "the intangible psychic thing back of the material thing."

Of the three late boxing paintings, *Dempsey and Firpo* attracted the most attention, in part because the protagonists were real fighters, engaged in an actual, indeed, highly prominent fight. Bellows had witnessed the event firsthand. Having been commissioned by the *New York Evening Journal* to produce a drawing of the fight for publication, he viewed the proceedings from the press box, the row directly next to the ring. The very presence of a structured section for journalists demonstrates that boxing had changed since Bellows had painted the rowdy brawls at Sharkey's more than a decade earlier.

The fight itself lasted about four minutes. In a furious exchange, Firpo was floored ten times and Dempsey twice before the latter was declared the victor. One visual image that was printed and reprinted in the media encapsulated the entire encounter—that of Dempsey knocked through the ropes and out of the ring in the first round by Firpo's blow to his jaw.

Bellows recorded that signal moment in his painting. For all the frenzied action of the event, the picture conveys less dynamism than it does a strong sense of stability and balance. Though activating diagonals dominate the composition, they are held firmly in place—in fact, all elements seem frozen in their positions. The falling figure of Dempsey establishes a primary diagonal that extends from the fighter's lower right arm at the extreme bottom edge of the canvas to his left leg that points to the upper right corner. His bent right leg intersects that axis at a ninety-degree angle. Since the intersecting line articulated by Dempsey's right thigh is aligned with the extended left arm of the spectator below and beneath him, as well as with the referee's pointing left arm above him, that line becomes the crossing axis of a central X shape that spans and stabilizes the composition. The scheme is further elaborated by a series of overlapping triangles. Firpo stands defiantly at the apex of the largest, virtually equilateral triangle, which rests firmly on the bottom of the picture. Additionally, all these diagonals are pinned down by a series of horizontal bands defined by the floor of the ring and the ropes that surround it.

The rigorous structure of *Dempsey and Firpo* also reflects Bellows' interest in a compositional system known as dynamic symmetry. Bellows applied himself to assiduous study of the principles of dynamic symmetry beginning in 1917, after hearing a series of public lectures by Jay Hambidge, who developed and promoted the system. Soon thereafter Bellows began to use dynamic symmetry as a scheme with which to manipulate his compositions, essentially to determine the placement of strategic elements according to mathematical relationships. Thus, *Dempsey and*

Firpo can be analyzed in terms of an overall rectangular field subdivided by smaller geometric shapes that bear proportional relationships to one another. Often these relationships are, in turn, related to mathematical proportions such as the golden section, which had been used by artists and architects since the Greeks and derives ultimately from a proportion found throughout the natural world. For example, Firpo's head and torso are positioned on a line that marks the golden section of the horizontal dimension of the canvas.

The dynamic plan of *Dempsey and Firpo* is not apparent to the casual observer. However, certain qualities shared by the pictures Bellows composed according to dynamic symmetry are perceptible: a sense of order and stately pacing as well as a greater breadth and powerful monumentality relative to the artist's earlier work.

Throughout the final years of his career, Bellows continued to believe that contemporary reality would provide the basis for the greatest, most significant art of his age. Like his most ambitious paintings, *Dempsey and Firpo* is more than a document of a particular boxing bout. It is clearly evidence of the artist's observing eye and skilled hand, and his admiration for physical prowess. More important, Bellows intended this painting to stand as testament to the power of his analytical mind and artistic vision. The mathematical proportions that structure the composition resonate with historical precedent and mirror the harmony and balance expressed in natural phenomena. The painting presents itself as a carefully crafted and calculated interpretation of a popular contemporary event, and a meticulously considered work of art.

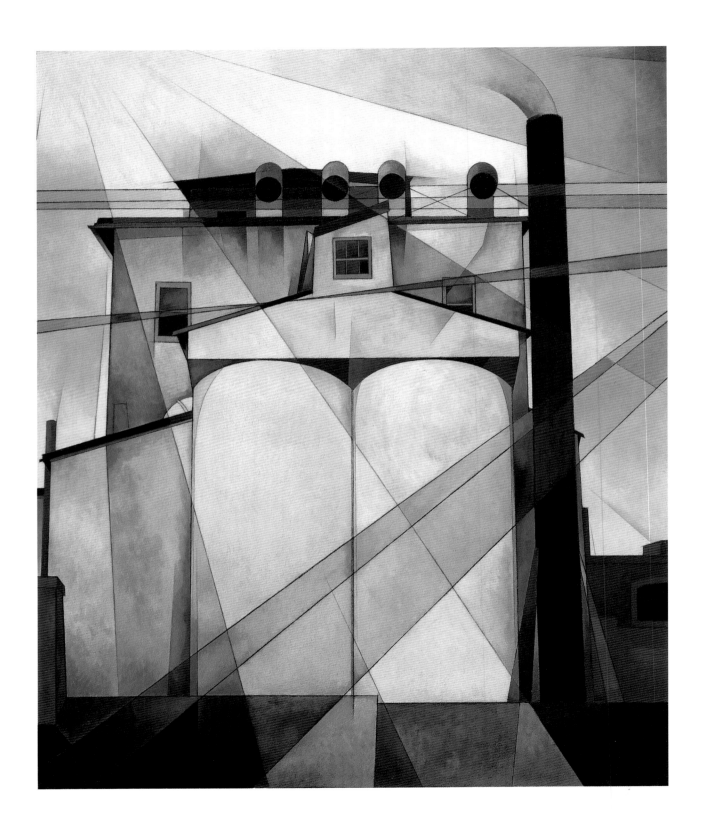

Charles Demuth

My Egypt 1927

| **Karal Ann Marling**

Observing preparations for the flight of Apollo 11 to the empty landscape of the moon in 1969, Norman Mailer saw primal structures like those built by Henry Ford at the beginning of the modern industrial era. At the launch site in Florida stood the VAB, the Vehicle Assembly Building, the largest building on the planet. Windowless, devoid of any ornament suggesting its purpose or its connection to the purposes of those who worked inside, it was, to Mailer, alien and strange, "the antechamber of a new Creation."[1] Down the road, along the Intercoastal Waterway, he saw the whole past history of the space program spelled out in a looming forest of abandoned launch towers for rockets "now as isolated and private as grain elevators by the side of railroad tracks in the flat prairies of Nebraska, Kansas, and the Dakotas,... the quiet whine of the wind like the sound off a sea of wheat. It was the grain elevator which communed on prairie nights with the stars."[2]

Charles Demuth's *My Egypt* of 1927 shows such a grain elevator in communion with the beyond. Observed from below, like a fragment of the River Rouge Plant caught in Charles Sheeler's camera eye, twin concrete cylinders and the apparatus they support loom over invisible railroad tracks and the roofs of the old sheds that once marked the right of way. History unfolds in the picture without human agency: the new concrete silos have displaced the row of ancient wooden structures. But the mood of *My Egypt* is focused less on the past than on Mailer's stars in the heavens above, from which powerful rays of light surge downward across the face of the machine. Before they disappear into the darkness at the bottom edge of the composition, these celestial lines of force act like spotlights, dazzling beams

1. Norman Mailer, *Of a Fire on the Moon* (Boston and Toronto: Little, Brown and Company, 1969), p. 57.

2. Ibid., p. 54.

Charles Demuth (1883–1935)
My Egypt, 1927
Oil on board, 35 3/4 x 30 in.
(90.8 x 76.2 cm)
Purchase, with funds from
Gertrude Vanderbilt Whitney 31.172

of starlight, revealing what may be a strange, new lunar launch vehicle, bound for space, a giant rocket ship equipped, like conventional oceangoing ships of the 1920s, with a row of four curving smokestacks ranged along the upper deck.

Demuth's elevator was a product of the same technological revolution that created Ford's great Rouge Plant. The earliest concrete storage elevator was built in 1900 on the edge of Minneapolis. Word of the technique gradually filtered back East, to Lancaster, Pennsylvania, Demuth's hometown, where, in the summer of 1919, the local feed mill was reconstructed in steel and concrete.[3] In the painting, the arrival of the paired silos on the local scene is dramatized by spotlights, as if two stars had just arrived at a movie premiere. But nobody's there at all, only a cold concrete megastructure, gigantic and impervious, elbowing the remnants of an older Lancaster out of the picture, along with the natural landscape, now concealed by the self-important bulk of the new grain elevator. Yet Demuth somehow equates this dismal scenario with ancient Egypt and himself: despite the pictorial content, he calls his masterpiece *My Egypt*.

The title suggests a witty Dada joke (not unlike *Fountain*, Marcel Duchamp's infamous signed urinal of 1917) or an ironic dissonance between object and title. Egypt, in the 1920s, was almost as modern as Duchamp, Henry Ford, and the concrete grain elevator. Howard Carter's discovery of the tomb of Tutankhamen in 1922 had touched off an extravagant display of commercial Egyptomania. Everything from the humble cigarette pack to the Hollywood biblical epic was sold on the strength of lotus blossom and pyramid motifs. But the domain of art was also affected. Le Corbusier's *Towards a New Architecture* of 1927 included photographs of grain elevators which the author compared to the primal forms of Egypt, the pyramids and the temple at Luxor. "The American grain elevators and factories," he declared, are "the magnificent First Fruits of the New Age.

The American Engineers overwhelm with their calculations our expiring architecture."[4] The light rays beaming across the facade of Demuth's Eshelman elevator form pyramidal shapes that show just how much his silos resemble the swollen, close-spaced columns of Luxor and Karnak.

In the Middle Ages, it had been widely believed that the pyramids of Egypt were hollow—that they were, in fact, the granaries or grain elevators of the captive Joseph described in the Old Testament, where corn was stored up against a coming famine during the seven years of plenty. The association between grain and pyramids and death, of course, was further reinforced in various eighteenth-century editions of Cesare Ripa's *Iconologia*, a popular guide to symbolism. And the pyramid already stood for immortality because the sheer size of the Great Pyramid at Giza guaranteed its survival: it was the greatest funerary monument ever constructed.[5] What some or all of this esoterica might have meant to Charles Demuth is clarified by his insistence that a new Lancaster grain elevator configured in Egyptoid shapes is his Egypt. His pyramid. His tomb. His immortality. *My Egypt*.

In 1920, Demuth's diabetic condition was first diagnosed; he spent part of 1922 in a sanatorium undergoing a radical course of insulin treatments (such therapy had not yet been perfected). Despite aggressive medical intervention, the prognosis remained grim. A death sentence hung over the artist throughout the decade of the 1920s. During this same period, his industrial iconography and peculiar titles first appeared, often in connection with large canvases, like *My Egypt*, so taxing to his strength as to demonstrate a personal involvement with the subjects.[6] The grain elevator alludes to the impending death of a native son, whose forebears had settled in Lancaster in 1736, an artist who still maintained a residence next door to the family business, at 120 King Street.[7] This object, this updated pyramid/granary, marks Demuth's final resting spot. The picture is his bid for the immortality of the pharaohs.

3. Karal Ann Marling, "*My Egypt*: The Irony of the American Dream," *Winterthur Portfolio*, 15 (Spring 1980), p. 33.

4. Le Corbusier, *Towards a New Architecture*, trans. Frederick Etchells (New York: Frederick A. Praeger, 1927), p. 33.

5. Marling, "*My Egypt*," pp. 33–34, 36–37. See also Barbara Haskell, *Charles Demuth*, exh. cat. (New York: Whitney Museum of American Art, 1987), pp. 194–95.

6. Emily Farnham, *Charles Demuth: Behind a Laughing Mask* (Norman: University of Oklahoma Press, 1971), pp. 149–50.

9. Robert B. Riley, "Grain Elevators: Symbols of Time, Place, and Honest Building," *AIA Journal*, 66 (November 1977), p. 50.

There are multiple ironies at work in *My Egypt*, too. Despite its machine-like properties, the Eshelman elevator stood for abundance and fertility. It carried a sexual charge. Demuth, whose biography includes membership in intellectual circles devoted to liberation from the sexual strictures of the day, often used architecture to address questions of gender and sexuality. Indeed, the phallic central image of *My Egypt* seems to allude to Demuth's complicated, sometimes suppressed homosexuality, just as earlier works, such as the 1921 *Aucassin et Nicolette* (Columbus Museum of Art, Ohio), enact elaborate public love scenes between buildings. In *Aucassin et Nicolette*, a bulbous water tank and a thrusting tower, both familiar Lancaster landmarks, are mated like the star-crossed lovers of the thirteenth-century poem alluded to in the title. But the union is ultimately without issue: the clean, hard-edged shapes of industry frustrate the human desire mimicked by the positions of the buildings. In the end, despite the learned allusions and the wit, the images are chilly, sterile, and monumentally lonely. *My Egypt* is a tombstone adrift in the desert of the American soul, a cruel machine that operates without human agency.

Henry Ford's River Rouge Plant opened in 1927, ten miles from Detroit. It was, in its day, a marvel, the largest manufacturing complex on earth. The Rouge had ninety-three miles of railroad track, twenty-seven miles of conveyor belts that crisscrossed at dizzying angles, and 53,000 separate machines.[8] It was vast, cold, overwhelming. It was of an order of magnitude never dreamt of before.

Charles Sheeler's photographs of the factory, taken that year, show smokestacks and water towers and the housings for moving belts from low angles of vision, so they loom up like prehensile monsters over a treeless landscape utterly unmarked by the human presence. In Sheeler's photographs (and in later paintings based on them), people were too small, too vulnerable, it seemed, to survive amid the harsh geometries of the Rouge. The scale of modern technology was inhuman, calibrated to a world that never was.

Norman Mailer saw the astronauts who rode the rockets as adjuncts to the machinery, creatures ultimately less impressive than the environments in which they toiled. The modern workplace is empty and cold because it is a place built by and for machines like these: the people who tend the moving conveyors at River Rouge, if they can be imagined, must be robots who cannot mate, slaves to the giant machine, machines themselves. The grain elevator, built on a scale too large for the heart to love, the VAB, and the engine shop reduce us to tears of terror in the face of a looming unknown. The Eshelman elevator fills all the space, absorbs all the light, and surges forward and upward, with the force of inevitability. The elevator is inevitable, unavoidable, and finally the only thing left. *My Egypt*. Our Egypt: enigmatic and terse, but tantalizingly precise, like a fragment of modern poetry by Demuth's friend, William Carlos Williams.

My Egypt is as appealing to our generation as it was to that of Demuth and Williams, perhaps because the grain elevator has become a key icon of a part of America at some spiritual and geographic remove from eastern Pennsylvania. The elevator alongside the railroad track has evoked the life of the agricultural Midwest heartland for several generations of novelists, filmmakers, and photographers.[9] In a perverse way, too, Demuth's insistence on building a wall of concrete shapes that blocks the vista into a distance suggested by his clear azure sky provokes interest in what cannot be seen behind the elevator: a thereness, a place beyond the urban machine, an arena for human dreams and actions. *My Egypt* delimits a significant boundary between the viewer right here, right now, and everything on the other side. Nature. The eternal West. That final Elysium waiting just past the Pillars of Hercules. That half-mythical frontier place to which all Americans are forever bound. Yellowstone. The Garden of Eden. Tomorrow. Dreams come true. Call it *My Own Private Idaho*. Call it *My Egypt*.

7. "Charles Demuth of Lancaster," *Journal of the Lancaster County Historical Society*, 68, no. 2 (1965), p. 44.

8. Karen Lucic, *Charles Sheeler and the Cult of the Machine* (Cambridge, Massachusetts: Harvard University Press, 1991), p. 90.

Lisa Mahar

The end of World War I marked the beginning of an unprecedented exchange of ideas between American and European artists and architects. Around 1927, when Charles Demuth painted *My Egypt*, architects Le Corbusier and Erich Mendelsohn, who admired American vernacular forms, illustrated their manifestos on modern architecture with photographs of American grain elevators. In the United States, Demuth developed a close friendship with Marcel Duchamp and was also exposed to influential works of the European avant-garde. This cross-cultural attraction occurred because each side saw within the other culture formal solutions to previously unresolved aesthetic problems. Americans were drawn to the machinelike aesthetic of the Dada movement in part because it mirrored their own formal inclinations. Europeans found American vernacular objects appealing because they looked up-to-date and were therefore appropriate symbols of universal form. Grain elevators, bicycle wheels, and spark plugs conveyed technical innovation, geometric rigidity, and industrial precision; yet these were traditional attributes of American vernacular objects. Critics have compared *My Egypt* to the work of artists such as Duchamp and Francis Picabia, but there were significant ideological differences between the American vernacular and European modernism. The first difference concerns the opposing ways Americans and Europeans related subject to context. In *My Egypt*, Demuth created an unbreakable bond between the two by seamlessly integrating the John Eshelman & Sons concrete grain elevator with its actual location in Lancaster, Pennsylvania. His meticulous documentation of the local landscape revealed an intimate connection to the buildings of his hometown.

Demuth's painting frames the elevator, built in 1919, with nearby factories and sheds, clearly setting the elevator in scale with the other buildings. The inclusion of these secondary structures actually reduces the perceived monumentality of the elevator—the shed hides at least 15 feet of bin height, so that the grain elevator seems to belong to the neighborhood rather than tower above it. Yet the title, *My Egypt*, seems to belie this sense of locality by referring to a foreign landscape of temples and pyramids. The "my," however, ultimately narrows the context again to the painter's personal domain. With the natural bond between subject and context affirmed, *My Egypt* remains regionally specific.

Such specificity stood in direct contrast to the approach of Demuth's European colleagues, who broke the link between subject and context in order to create a universally relevant art. Duchamp extracted his subjects from their natural surroundings and set them into unconventional environments. His readymade *Fountain* (1917) is a urinal taken from its mundane setting and relocated to a gallery. This unexpected rupture is, to a large extent, precisely what gives the work meaning. Duchamp's everyday objects are then more like Picabia's spark plugs than Demuth's factories—floating elements, pieces of an absent larger whole. They contrast with Demuth's industrial complexes, which are firmly connected to the earth and sky.

European architects challenged the relationship between subject and context by redefining the connection between a building and its site. In *Towards a New Architecture*, Le Corbusier discussed grain elevators in terms of their relationship to universals such as space and light rather than to their site. His photographs were so tightly cropped that they excluded the surrounding landscape, the neutral sky giving no clue to the time of day. Like Demuth, he compared grain elevators to the monuments of Egypt, but his comparison was based solely on formal similarities, which further removed the elevator from its humble, functional context. Although novel to Europeans, the concrete grain elevator had evolved through more than fifty years of practical experimentation with vertical grain processing—of efforts to find a fireproof, structurally sound building in which to store grain. What Le Corbusier perceived as universal forms were clearly solutions to regional problems of function and form.

The second way in which Americans and Europeans ideologically differed was in their relationship to history. When Demuth was asked by a journalist, "What do you look forward to?," he replied, "the past."[1] For the Precisionists, a group with whom Demuth was often associated, making modern art meant creating work that reflected their culture and history. As Gail Stavitsky observed, the Precisionists "established affinities between America's earlier vernacular traditions and the machine age at a time of growing interest in the country's fine and folk art heritage."[2] This connection between the past and the present underscores the traditional aspects of Demuth's art. T.S. Eliot defined a traditional artist as one who had a "historical sense, which is a sense of the timeless as well as of the temporal and of the timeless and of the temporal together."[3]

Demuth's work clearly possessed this historical sense. His flat, frontal style of painting and choice of subject matter revealed an awareness of local art forms. Amish quilts from the 1870s have the same geometric rigidity and precision as Demuth's work, while Pennsylvania Dutch frakturs of the early nineteenth century closely resemble Demuth's early floral paintings. The frakturs' sharp color delineations, however, have more in common with later work like *My Egypt*.

1. Quoted in Karal Ann Marling, "*My Egypt*: The Irony of the American Dream," *Winterthur Portfolio*, 15 (Spring 1980), p. 34.

2. Gail Stavitsky, "Reordering Reality: Precisionist Directions in American Art, 1915–1941," in *Precisionism in America, 1915–1941: Reordering Reality*, exh. cat. (Montclair, New Jersey: The Montclair Art Museum, 1994), p. 16.

3. T.S. Eliot, "Tradition and the Individual Talent," in Frank Kermode, ed., *Selected Prose of T.S. Eliot* (San Diego and New York: Harcourt Brace & Company; New York: Farrar, Straus and Giroux, 1975), p. 38.

4. Henry Glassie, *Folk Housing in Middle Virginia: A Structural Analysis of Historic Artifacts* (Knoxville, Tennessee: The University of Tennessee Press, 1975), pp. 166–71.

5. Marling, "My Egypt," p. 33.

Here both painting and subject appear modern because of their strict symmetry and frontality but, as folklorist Henry Glassie points out, "symmetrical and frontal structures had for centuries defined the American folk aesthetic."[4] Demuth chose as subject matter local vernacular structures that displayed these attributes, while implementing stylistic techniques common to the region's folk art.

While Americans were invigorated by their past, Europeans felt constrained by theirs. Making modern art for Europeans meant breaking with tradition in order to create a new, original language of form. Futurists like Umberto Boccioni developed original techniques to convey objects in motion while symbolizing the dynamism of the city. Demuth adopted these methods in *My Egypt*, but used them to animate static structures geometrically. He integrated Cubist techniques as well but used geometry in an American way to establish order and hold his subjects together rather than break them apart as the Europeans did. These foreign methods were readily accepted into the American painting tradition because they fulfilled the national need for geometrically precise representational techniques. For Demuth "style established a temporal continuity between the old and the new America" rather than defined a search for the new.[5]

Although Demuth's paintings are regionally focused and traditional, his ironic titles seem to reflect an internal battle between his connection to the past and his longing to create unique and original art. His use of irony seems less consistent with his traditional painting methods than with the European modernists who sought to liberate themselves from context and history. The title, *My Egypt*, is more personal than those generally used by Duchamp or Picabia, and seems at one level to express a lack of confidence in the subject's ability to stand on its own. Perhaps for Demuth the title's external reference made the mundane subject more acceptable as art while also associating it with the work of an iconic figure like Duchamp.

The European enthusiasm for American vernacular themes validated indigenous subjects as suitable matter for serious art. The cross-cultural exchange generated confidence and an appreciation of American culture during the late twenties but eventually contributed to the erosion of our country's regional traditions. By World War II, forms were transported across cultural boundaries at an increasingly rapid pace, with little respect for the traditional bond between subject and context. *My Egypt* was painted before the onset of this precipitous decline. Although it possessed some of the formal characteristics of European modernism, and generated many comparisons with the work of Duchamp, it was clearly an American painting that ideologically differed from its European counterparts. Both regional and traditional in its adherence to enduring American vernacular patterns, it stood apart from the European aspiration to be universally relevant and original. Although Demuth at times questioned his heritage, ultimately he stayed true to it, protecting and developing culturally meaningful symbols for his country and its people.

1. For a discussion of these various arguments, see Karal Ann Marling, "*My Egypt*: The Irony of the American Dream," *Winterthur Portfolio*, 15 (Spring 1980), pp. 25–39. On the issue of the painting's Egyptian imagery as a metaphor for enslavement, see Barbara Haskell, *Charles Demuth*, exh. cat. (New York: Whitney Museum of American Art, 1987), p. 195.

Maurice Berger

Charles Demuth's *My Egypt*— a Precisionist rendering of the John W. Eshelman and Sons grain silo in Lancaster, Pennsylvania—has for decades trapped art historians in an unwinnable game of iconographic hide-and-seek. The following explanations, among others, have been offered about this enigmatic painting: it is a meditation on the legend that the ancient pyramids were actually grain elevators and not tombs; it is a social commentary that likens the modern industrial social order to the oppressive, slave-driven economy of ancient Egypt; it is the fantasy of an ailing artist fixated on the idea of the pyramid as a symbol of immortality; it is a humorous riff on the Egyptomania craze that followed Howard Carter's discovery of Tutankhamen's tomb in 1922; it is an allegory of Demuth's self-imposed enslavement in the staid hometown to which he returned to paint at the end of his life.[1]

There is another, more consequential reading of *My Egypt* that art historians, driven by the need to find specific iconography, sources, and narratives, have overlooked: that the very impossibility of solving the riddle implied by the work's eccentric juxtaposition of title and subject matter is its real point. The origins of this argument lie not in the ruins of ancient Egypt but in Demuth's close and influential friendship with Marcel Duchamp, the Dadaist whom he met in New York in 1915. Over the next two decades, until Demuth's death in 1933, the two men spent a great deal of time together in New York, frequenting Greenwich Village dives and jazz clubs in Harlem. When Duchamp's *Fountain*, an inverted urinal signed by the artist with the pseudonym R. Mutt, was censored by the Society of Independent Artists at its first exhibition in April 1917 (it was displayed behind a curtain), Demuth became the most outspoken American defender of the controversial work.

My Egypt, like many of Demuth's paintings of the late 1920s and early 1930s, picks up on his friend Duchamp's bold rejection of language as a seamless, irreproachable approximation of things in the world. Throughout his professional life and work, Demuth was also committed to disrupting the communicative function of words and images, from the series of plays he wrote between 1914 and 1920 in which non sequiturs were strung together into a fractured, almost meaningless narrative, to the Freudian word-association games he played with friends at Polly Holliday's Greenwich Village hangout in the 1920s, to the odd, incongruous titles he selected for many of his later paintings. Demuth was also profoundly affected by Duchamp's most important work, *The Bride Stripped Bare by Her Bachelors, Even (The Large Glass)* (c. 1915–23), an enigmatic tableau of forms suspended between two layers of glass. Duchamp's pseudo-painting, divided horizontally into the feminine and masculine domains, remains to this day a kind of art historical enigma, despite the publication of the artist's detailed preparatory notes for the work. In the end, Duchamp's "agricultural machine," as he called *The Large Glass*, sets up a universe of abstruse visual puns that allude to such universal dichotomies as that between nature and culture, earth and sky, sexual union and unrequited love. Within months after seeing *The Large Glass*, a work Demuth believed was "the great picture of our time," the artist began painting *My Egypt*, his largest and most complex agricultural-industrial image.[2]

More than any single painting, *My Egypt* transcribes into paint the inscrutability, equivocality, and transgressiveness that exemplified Duchamp's aesthetic vision. The image, independent of its title, is mysterious and hermetic. The dominant and imposing silo appears both industrial and anthropomorphic—a massive edifice and a primitive, masculine idol. While some have suggested that the intersecting rays of light that overlie the painting's arid surface actually superimpose a pyramidal pattern onto the

2. Charles Demuth, as quoted in Marling, "My Egypt," p. 29.

3. Ibid., p. 33.

4. For more on Duchamp's radical linguistic imperatives, see Mason Klein, "Embodying Sexuality: Marcel Duchamp in the Realm of Surrealism," in Maurice Berger, ed., *Modern Art and Society: An Anthology of Social and Multicultural Readings* (New York: HarperCollins, 1994), p. 154, and Rudolf E. Kuenzli, "Introduction," in *Marcel Duchamp: Artist of the Century* (Cambridge, Massachusetts, and London: The MIT Press, 1989), pp. 5–7. On Duchamp's illusory use of language as a kind of aesthetic "autism," see Annette Michelson, "*Anemic Cinema*: Reflections on an Emblematic Work," *Artforum*, 12 (October 1973).

composition, there is, in fact, nothing in the image that specifically alludes to Egypt.[3] The juxtaposition of title to image, then, renders both even more abstruse. Demuth extolled the virtues of this kind of disruption of narrative clarity in a poem he published in the short-lived Dada journal *The Blind Man*. The poem was a paean to Duchamp's *Fountain*: "One must say everything—then no one will know," he wrote in part. "To know nothing is to say a great deal."

This theme—the impossibility of language and the freedom of not knowing—reappears throughout Duchamp's oeuvre, as in the shift from French to English pronunciations for the same word or the use of confusing homonyms. Such strategies resulted in the breakdown of any fixed, culturally assigned meaning. The artist's aesthetic "autism" under-scores the fragility and privation of language itself, reminding us that the word is always marking the *absence* of the thing it represents.[4] Thus, for Duchamp, the act of speaking or writing does not result in the production of "truth," but rather condemns us to live by the rules of a repressive linguistic system that, at best, offers a distant approximation of reality shaped by the biases and beliefs of the speaker and of society at large.

Another aspect of Duchamp's art and ideas that was important to Demuth was the way in which the Dadaist celebrated a sexuality that was as elusive and inscrutable as his use of language. Duchamp favored a sexuality that was literally hard to read: the cross-dressing female alter ego who appears in his works, named Rrose Sélavy (pronounced "Eros, c'est la vie"); the small French window with black leather panes that is provocatively titled *Fresh Widow*

(and copyrighted by Rrose herself); the *Fountain* that simultaneously alludes to the male excretory system and the form of the female sex but can serve no sexual purpose. Sex, for Duchamp, was more about masturbation than about connection or union. *The Large Glass*, for example, recasts the primal scene of both language and sexuality as a place where consummation is not possible: there is no marriage between the sharply bifurcated female and male registers of the work, no instance of an effortless, gliding communication between the bride and the bachelor, no easily discernible narrative that might help the viewer decipher Duchamp's visual conundrum.

The question of the intangibility of language and fugitiveness of sexuality charged much of Demuth's work of the 1920s and early 1930s. He conceptualized the erotic as an important realm of linguistic and visual experimentation—from convoluted pantomimes about suicidal "fantastic lovers" to a series of post-1917 floral paintings that the poet William Carlos Williams pointed out concealed an "explicitly sexual analogy between flowers and male genitals."[5] In a visual precursor to *My Egypt*, the 1921 industrial landscape *Aucassin et Nicolette*, an allusion to the thirteenth-century picaresque tale of lovers tragically separated and then reunited,[6] Demuth painted a smokestack and a water tower "pressed against the Lancaster sky" as a metaphor for the precariousness of sexual union.

But there was a part of the artist's erotic life—"the little perverse tendency" as the usually tolerant Duchamp referred to it[7]—for which words and images served as the ultimate lie, the building blocks of the closet that imprisoned virtually all gay men of Demuth's generation. It was in the ambiguous space of the closet that Demuth learned most dramatically how words and images were never more than allusive, never more than biased, never more than inadequate substitutions

5. Haskell, *Charles Demuth*, p. 53.

6. Ibid., p. 136. For a detailed discussion of this painting, also see Marling, "My Egypt," pp. 30–32.

7. Quoted in Jonathan Weinberg, *Speaking for Vice: Homosexuality in the Art of Charles Demuth, Marsden Hartley, and the First American Avant-Garde* (New Haven: Yale University Press, 1993), p. xiii.

8. Ibid., pp. 1–113, for a groundbreaking account of the role of homosexuality in Demuth's life and art.

9. Marling, "My Egypt," p. 33.

10. Marcel Duchamp, quoted in Pierre Cabanne, *Dialogues with Marcel Duchamp* (New York: Viking Press, 1971), p. 88.

for absent things. He learned this from his decades-long, and perhaps unconsummated, relationship with a "married" gay man. He learned this from his public appearances with a string of female companions for which there could be only the semblance of intimacy but no sex. He learned this from the pornographic watercolors of muscular, sexually aroused sailors that he painted to sublimate his desires after he became impotent and then scrupulously concealed from public view. From all of this, he learned that the systems, laws, and boundaries that Duchamp could afford to travesty because they were repressive were even more dangerous and life-threatening to him.[8]

If *My Egypt* is, as Karal Ann Marling suggests, Demuth's "memorial to himself," it also serves as an ironic allegory of the tragic limitations of language and sexuality as well as of technology and art.[9] In the cold, arid, and enigmatic realm of *My Egypt*, nothing can be consummated: words do not yield meaning; man is no more than a monolithic, masturbatory machine; brushstrokes blend into a rigid and unforthcoming scrim of sharp, cold angles. The painting comes as close as any in the history of modernism to approximating the aesthetic iconoclasm of Duchamp's readymades. Duchamp's subversive eroticism, like his undermining of the linguistic order that imposes itself on all aspects of society and culture, was a strategic device for questioning the way we represent and interpret reality, bringing out into "the daylight things that are constantly hidden…because of social rules."[10] Hiding behind the unknowable mysteries of *My Egypt*, Demuth takes his most extreme position as a visual artist—at once safely in the closet and slyly confounding us with one of the most enigmatic images of the modernist epoch—by sidestepping the repressive linguistic, aesthetic, and sexual rules and standards that determine what is comprehensible and, thus, what is normal and socially acceptable.

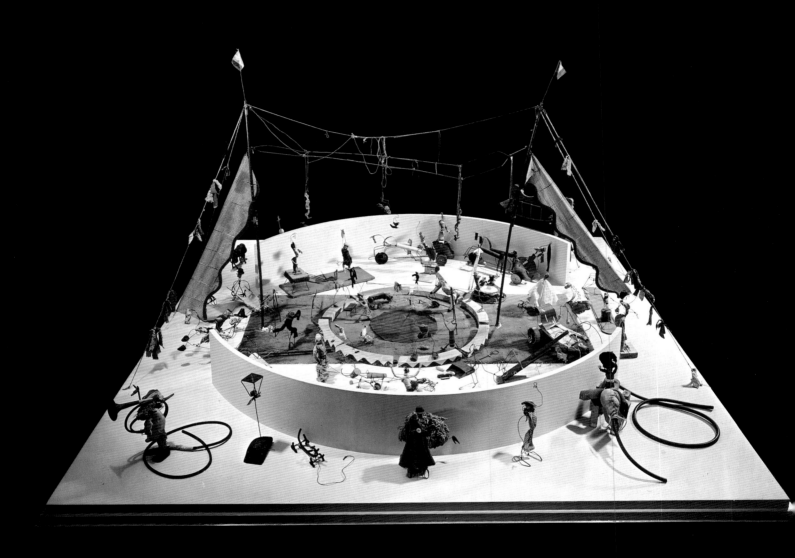

Alexander Calder

Calder's Circus *1926–31*

Alexander Calder (1898–1976)
Calder's Circus, 1926–31
Mixed media: wire, wood, metal, cloth,
yarn, paper, cardboard, leather, string,
rubber tubing, corks, buttons, rhinestones,
pipe cleaners, bottle caps, 54 x 94 1/4 x
94 1/4 in. (137.2 x 239.4 x 239.4 cm)
overall
Purchase, with funds from a public
fundraising campaign in May 1982.
One half the funds were contributed by the
Robert Wood Johnson Jr. Charitable Trust.
Additional major donations were given by
The Lauder Foundation; the Robert
Lehman Foundation, Inc.; the Howard
and Jean Lipman Foundation, Inc.;
an anonymous donor; The T.M. Evans
Foundation, Inc.; MacAndrews & Forbes
Group, Incorporated; the DeWitt Wallace
Fund, Inc.; Martin and Agneta Gruss;
Anne Phillips; Mr. and Mrs. Laurance S.
Rockefeller; the Simon Foundation, Inc.;
Marylou Whitney; Bankers Trust
Company; Mr. and Mrs. Kenneth N.
Dayton; Joel and Anne Ehrenkranz; Irvin
and Kenneth Feld; Flora Whitney Miller.
More than 500 individuals from 26 states
and abroad also contributed to the
campaign 83.36.1–56

Howard Gardner

With a nod to George Orwell, one might say that all artists are unique, but some artists are more unique than others. Among American artists of this century, Alexander Calder stands out in terms of his personal journey, the scope of his creations, and the place that he established for himself in the history of the period.

Continuing in an Orwellian vein, one might add that all works of art are original, but some works are more original than others. No one who has ever seen *Calder's Circus*, especially as performed by the artist, will ever forget this creation, let alone confuse it with any other artistic work of the era.

Let me support these bold claims. The son of a Scottish sculptor and inventor, Alexander Calder began to build small replicas of circus animals and performers out of scraps of wood and pieces of metal and wire when he was eight years of age. He earned a degree in mechanical engineering, but soon returned to the artistic lineage of his family. By the age of thirty, he was already internationally known for his sculpture. He traveled back and forth between Europe and the United States, never feeling a need to establish himself in any particular geographical or aesthetic niche; he may well be the first American artist to have earned the adjective "international." He was easygoing, fun-loving, unpretentious —and followed his own imagination. It is said that there were only three individuals with whom he did not get along: Pablo Picasso, Ernest Hemingway, and Salvador Dalí. Clearly, he saw no need to compete with three of the most outsized egos of our century.

Calder's works are impossible to classify in a straightforward manner. They oscillate between representation and abstraction—recalling equally the world of natural objects and the domain of human artifacts. They present themselves as statuary, but they are not static; indeed, Calder deserves chief credit for having devised moving sculpture, for blurring the boundaries between the mobile and the stabile. Some of his sculptural works depend on motors, but the most appealing pieces exploit the natural currents of the air. Some are small enough to be held in the hand, while others dominate the plazas in front of huge public buildings or the lobbies of airports. *Calder's Circus* can be viewed in static form, and has been on display in many halls around the world. However, it was designed to be performed by the artist himself and is best apprehended in that manner—today, of course, only on film.

Calder serves as the impresario who, in unforgettable French nasal phrases, proclaims each act. Some of the action is quite predictable, as if we were watching a "stylized performance." But a large part of the appeal of *Calder's Circus*, to both child and adult, lies in its unpredictability. Neither Calder nor anyone else knows whether, in a given performance, the trapeze artist will be caught or will fall to a poorly timed death; or whether the Sultan of Senegambi will clobber his assistant with axes. In this sense, the *Circus* is a "high-stakes" performance, where the "performers" may lose their limbs or their lives. But, of course, since the *Circus* is itself a performance, all loss is transitory: the characters will be resurrected in full body and spirit for the next showing. Therein the difference between "tragedy" in art and tragedy in life.

As a developmental psychologist, I have long pondered the relationship between the world of the child, on the one hand, and the world of art, on the other. For me, the most striking aspect of *Calder's Circus* is the insight it yields into this enigma.

Some of the ties are immediate and direct: children are attracted to many works of art; and they themselves become involved for hours at a time in pretend play, singing songs, telling stories, constructing objects out of blocks or clay. Indeed, as noted, Calder in effect began work on the *Circus* when he was still a child.

The ties between children and art have only been noticed in relatively recent times. The French poet Baudelaire was, in fact, the first modern writer to perceive a connection between art and childhood, when he called children "the painters of modern life." While many of us are attracted by the charm of children's drawings, it is virtually unprecedented for any museum to display work done by children below adolescence. And the daily life of the contemporary artist—oscillating between many hours alone in an atelier and feverish attempts to gain publicity, mount a show, curry favor with influential persons—bears little resemblance to the more intimate and fluid world of the child.

Yet it would be a mistake to minimize the ties between "the child" and "the artist." What these "species" share above all is a sensibility. Children and artists follow their curiosity where it takes them. They are willing to spend hours, days, even months pursuing a passion or interest, even if—perhaps especially if—it does not grab other people. They are aware of boundaries—between motion and stasis, representational and abstract, "real" and "pretend"—but they are not intimidated by those divisions; perhaps they revel in them and seek to explore them without limits.

A skeptic might retort that the child comes by these flexible virtues naturally, while they are more "studied" in the artist. And it is true that the artist must go through a lengthy apprenticeship to master the skills of the craft; and that the artist cannot afford to ignore the signals from others in the domain, while these signals are happily irrelevant to the child. Yet even with such awareness, which the child is (perhaps mercifully) spared, the artist will not succeed if the links to childhood are only fleeting or feigned. No, for a large part of each day, the artist must regain access to the feelings, rhythms, freedom, and audacity that constitute the birthright of the child.

Acknowledging the tie between artist and child may be difficult if one focuses on works of art, or on artists, that are esoteric, exotic, or cerebral. The verses of Racine, the late string quartets of Beethoven, the pencil drawings of Ingres may not speak directly to the mind—or the heart—of the child. To ponder the relationship between the child and art, we turn, accordingly, to the whimsical worlds of Lewis Carroll, the narrative ballets of Tchaikovsky, the evocative illustrations of Maurice Sendak, Arthur Rackham, or Beatrix Potter.

Enter *Calder's Circus*. While not designed for children, this work speaks instantly to children everywhere, and to the child in all of us. It seizes a large world and reduces it to a size in which it can be readily apprehended. It uses simple materials—paper, wire, rubber hoses, bits of cork, buttons, bottle caps—to create instantly recognizable forms. It makes comfortable, unstudied use of elements from several art forms—circus music, lively characters, moving forms, the dramatic voice of the impresario—an audience-friendly equivalent of Wagner's formidable *Gesamtkunstwerk*. The *Circus* can be approached by several sense modalities, symbol systems, and human intelligences—and it can be apprehended at many levels of sophistication. It deals in drama and charm—the comic and the tragic—on a human scale.

Great art must induce awe and a sense of the uncanny. Calder lures us into a sense that his circus performance will be manageable—after all, Calder himself is a master craftsman, he has devised all facets of the circus, and he is the sole performer. And yet our confidence is undermined soon enough. We come to understand that the actual events of the circus are not under anyone's control—calamity can strike at any moment. The tension between creation and chaos, between control and serendipity, constitutes the eternal lure of any circus, and the thrill of this particular circus performance. The audience laughs, but its nervousness is palpable.

Of all the boundaries in life, the most formidable lies between control of our own fate and the implacable hand of destiny. Artists remind us of this boundary—they play for high stakes in their own lives and in the fates of their contrivances. Although children do not discuss existential issues in abstract terms, they are intimately conscious of this tension—this is why they are so attracted to myths and fairy tales, to witches, ogres, tricksters, and other gods and demons of ambivalence.

As a masterful artist, Calder intuitively understood and exploited these tensions. Some of his works spoke more audibly (and visibly) to the innocent child in us, others to the sophisticated adult. The *Circus* strives toward a universal language—one equally comprehensible by persons of all ages, drawn from cultures of every stripe.

None of us—young or old—knows for certain what will happen in the next instant: in this sense, *Calder's Circus* provides the ultimate metaphor for life, death, and the terrifying territory in between. But it does so with humor, grace, charm, and whimsy—capturing the generosity of the genius who contrived it.

Robert Wilson

When you see Alexander Calder's *Circus* performed, it is a living sculpture. It is a still life and it is real life. It is both. It is mechanical; it is plastic; and it has a kind of heightened reality that one does not find in daily life. In that way, *Calder's Circus* is like the theater. Both enact the real through unrealistic means. Theater can be thought of as another world, but although it is also something completely artificial and man-made, it too has its own reality. If you accept something as being artificial, then it can have a reality, or truth, of its own, even more so than something trying to be "natural."

In the Western theater, we often find that what we see is merely decoration or illustration of what we hear. When we see a play by Shakespeare, Molière, Goethe, Schiller, or Tennessee Williams, the visual—what we see—is there to support or decorate the audio—what we hear. This is also true of Western opera. But in the *Circus*, Calder has created a theatrical language that is purely visual.

In my own work, I am closer to Eastern concepts of the theater. In these theaters, such as the *Bunraku*, for example, one spends as much time learning to move the head or foot of a puppet as one does training the voice to speak the text or sing in a theatrical way. The same is true of the Balinese shadow puppets, Balinese dance, Peking Opera, and the theaters of India and West Africa. All have highly sophisticated theatrical languages that are visual as well as spoken. Two years ago, I was in Shanghai, and I watched a fifteen-year-old girl sing an aria from the Peking Opera. She sang for an hour and a half, and in that time she moved her sleeve 750 different ways.

In the West we are constrained in the way we think about this problem. We need more mental space in which to conceive of this. Just imagine a radio drama, where the mind is free to see pictures, or a silent movie, where the audience is free to imagine the sound or the music. *Calder's Circus*, to me, offers us this kind of freedom—which is very exciting because it establishes a purely visual form for the theater, something we do not often see in the West.

There is also a sense of danger in the *Circus*. I think that in any circus that is what makes it theatrical and entertaining, but it is certainly present in this work when it is performed. It is true of any great performance as well, whether by a singer, an actor, or a tightrope walker. It is the element of surprise—keeping the audience on edge—that keeps us involved and interested.

Baudelaire once said that genius is childhood recovered at will. I think that is true of *Calder's Circus*.

Neil Harris

When Alexander Calder first performed the *Circus* in Paris in 1927, he was following old American traditions as well as anticipating new ones. Paris had nurtured many European circuses for much of the nineteenth century, but that didn't stop a continuing American invasion. Indeed the export of American spectacles to Europe had become something of a cottage industry by the 1920s, long before the world according to Disney achieved its eminence. Just when this process began is difficult to determine, but even in the eighteenth century artists, actors, and natural scientists from North America had carried their exotica ("red-skinned savages," strange animals, astonishing plants) from across the ocean, fulfilling Old World fantasies in domestic settings. To the oohs and ahs of church prelates and local gentry alike, American visitors did their stuff or told their stories.

The circus, of course, even without the Wild West Show that sometimes accompanied it, was an Old World inheritance reinvented in the New. But that, after all, had been the lineage of many American novelties. Movement was multidirectional. The most celebrated of all American impresarios, P.T. Barnum, had honed his skills importing the great Swedish soprano Jenny Lind, two decades before taking his own circus triumphantly overseas in the later 1870s. Operas and oddities shared space within his repertoire. But it was as a circus master that Barnum toured the world (Paris included), leaving in his wake an appetite for those dizzying three rings Americans had invented. It was his corporate successor, the Ringling Brothers and Barnum & Bailey Circus, that inspired Alexander Calder's first circus sketch. As a free-lance artist for the *National Police Gazette* in 1925, Calder spent two weeks enthusiastically

attending Ringling Brothers performances, and he published a half-page illustration, filled with vignettes of the different acts, in the May 23 issue of the *Gazette*.

Although circus troupes had been entertaining crowds since Roman times, they became favorite subjects for modern writers and artists. Acrobats, clowns, bareback riders, and lion tamers—certainly they had been painted and sketched before the later nineteenth century, but the attention given them by Tissot, Toulouse-Lautrec, Renoir, Seurat, Chagall, Picasso, and Léger, to say nothing of the interest of Kafka, Mann, Wedekind, and Cocteau, was unprecedented. And the circus poster (again with some strong American influences) had become its own art form.

Some reasons for the fascination are obvious. Circus performance was inherently exaggerated, so that its mimes and freaks implicitly raised questions about norms of appearance and behavior. A superb social metaphor, the circus was also a colorful, dynamic, and dazzling extravaganza, mingling music, dance, drama, and athletics. Its highly ritualized performance suggested links between primitive experience and sophisticated skill. Its noises, smells, and tastes evoked childhood memories. While its human performers ranged across the anatomical spectrum, its animals brought the world to one place, and its audiences juxtaposed classes and masses. Artist-observers were caught up in the desire to represent its movement, variety, and intensity.

So *Calder's Circus* built upon a powerful if recently developed set of conventions. It was a natural subject for avant-garde curiosity. But Alexander Calder's take on the circus was special. For one thing, his version was small. And the urban circus—in Paris and Berlin or New York—was big. The American circus especially relied on scale and amplitude to impress. Its vast tents and complex riggings fascinated Calder himself. While miniature versions were not unknown, most models tried to suggest the scale and complexity of the real thing, scattering around hundreds of animals, performers, railroad cars, cages, and pieces of equipment.

The "gross and foolish superfluity" of American city circuses, wrote novelist William Dean Howells at the turn of the century, had accustomed audiences "to see no feat quite through, but to turn our greedy eyes at the most important instant in the hope of greater wonders in another ring." Vast, apparently endless, rapidly changing, the great American circus anticipated some of the features of electronic amusements in coming years.

Calder corrected for this. Mimicking the delicate movements of individual performers with astonishing wit, he substituted clarity for vertigo, marrying circus spectacle to personal intimacy. His tiny world abstracted the essentials from the original, exploiting the most ordinary materials to summon up exotic dreams and childhood memories; the audience shared the smallest details of the enterprise. Simultaneously puppeteer, announcer, and spotlight wielder, Calder broke down and reassembled every circus act, his ingenious insinuations emphasizing the talent of the live performers. These playthings were new kinds of toys.

Calder himself had known circus toys as a boy, and had assembled a collection of Noah's arks with their animals. The Humpty Dumpty Circus he played with was a best-seller in turn-of-the-century America. Produced by the famous toy company of Albert Schoenhut, its animals and clowns had movable joints, made possible by rubber elastic cords. Their novel flexibility must have appealed immensely to the young Calder, and may well have influenced him. Calder would soon be making his own toys, for friends and family, and suggesting improvements for existing ones to toymakers. Nonetheless, during the late 1920s manufacturers were slow to accept Calder's designs and proposals. Only one American toymaker, from Wisconsin, marketed his work, while no French companies at all responded to his overtures.

Calder's colorfully capricious animals did, however, share features with some contemporary children's picture books. If he saw them, Calder certainly would have admired the brilliantly stenciled illustrations of André Hellé, Edy Legrand, and Jack Roberts, published in France in the 1920s,

almost primitive in design and deliberately regressive when compared to the more elaborate toys and dolls then being marketed. Some critics have linked this period of Calder's work to folk art traditions, appropriate since the circus itself owed much of its appeal to generations of self-trained, often anonymous artisans—carpenters, gilders, amateur engineers, and sign painters who created the wagons, costumes, posters, and trapezes that constituted the popular circus image.

What probably distinguishes Calder's production even more than the folklike appearance of his pieces is its fidelity to the circus tradition of mobility. Much of the frenzy of the circus lay in the transit from one venue to the next. The parade through a small town or big city was an event of great magnitude in the life of children and adults; the ponderous pachyderms pounding city pavements on their way to Madison Square Garden or the Chicago Coliseum or the Kansas City Convention Hall were accompanied by a string of animal cages, bands, calliopes, and acrobats. Countless numbers of Main Streets welcomed the same elaborate processions. And while they snaked their way to the arenas, armies of riggers were erecting the tents for the performance. Calder, as an itinerant performer, recapitulated the mobility of the circus manager. His suitcases (they eventually reached five, he reported, and he could carry no more) opened to reveal the magical elements of his acts from start to finish. And in Calder's performances, the spectators were as close to the clowns and animals as they were to the trapeze artists. No one had to choose between a location near the top or the bottom of the arena. There was only one ring, and no need for others. Impresarios had developed multiple rings in order to keep viewers in their seats, giving everybody, no matter how distant from the center, something to see. In the small parties or studio settings of *Calder's Circus*, Calder, the traveling showman, was as easily visible as his toys.

Size was a crucial criterion in real circuses. Barnum & Bailey proudly boasted "The Greatest Show on Earth," feeding the appetite for gargantuanism. But Calder had produced what a Paris newspaper labeled the "smallest circus in the world." The reversal resonated. It might have seemed out of character to associate modern Americans with the diminutive (although Barnum scored a great success with Tom Thumb), but intimacy lies at the very center of the work's charm. More than that, a taste for miniaturization had been gaining strength in early twentieth-century America. Toy theaters, marionette performances, and miniature shows of various kinds had been enjoying something like a craze during the twenties, as artists such as Tony Sarg, a European émigré to the United States, presided over a puppetry revival.

Nonetheless, little compares with the visual ingenuity or dynamic mechanics of *Calder's Circus*. Its secret ingredient remained, of course, its creator-host, who was no hidden puppet master but a whistle-blowing commentator presiding over whimsical creatures. The *Circus* was the perfect party game, as appealing to social swells as to avant-garde artists. High and low mingled affably in Calder's audience, as did children and adults, Europeans and Americans, artists and entertainers, traditionalists and modernists. Yet unlike the real circus, Calder's creation works even without its ringmaster or a live performance. Motionless in repose, figures meant to embody movement inhabit a tiny time capsule, Pompeii before the eruption, a movie still, poised on the edge of action. The show has stopped, but we keep more than just memories of halcyon days of cotton candy and tigers roaring. We marvel also at the links between the exotic and the ordinary, and the embodiment of complexity by simplicity. One hundred years ago, the American sculptor Horatio Greenough defined beauty as the promise of function and character as the record of function. *Calder's Circus* has both. Promise and record between them help explain our wonder at Calder's gift.

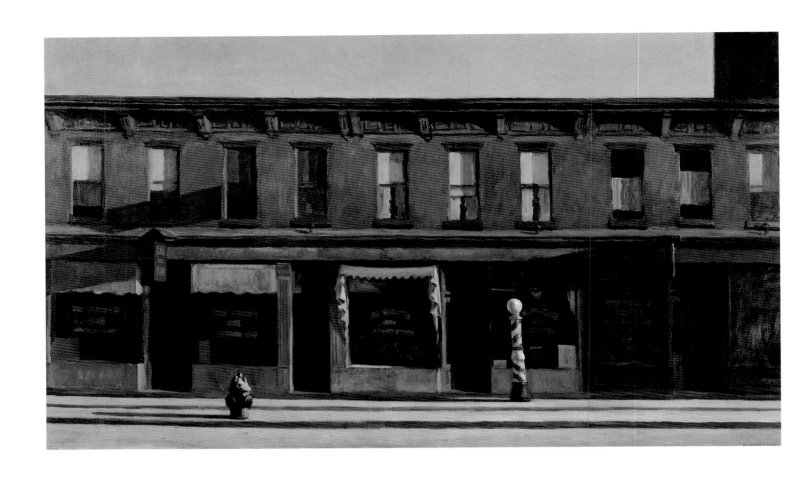

Edward Hopper

Early Sunday Morning *1930*

Edward Hopper (1882–1967)
Early Sunday Morning, *1930*
Oil on canvas, 35 3/16 x 60 1/4 in.
(89.4 x 153 cm)
Purchase, with funds from
Gertrude Vanderbilt Whitney 31.426

John Updike

The silence and plainness of the best Hoppers—and *Early Sunday Morning* is one of them—repel commentary. What is said is said in a visual language that translates into fussy, strained English. Here, the import lies in the long shadows, the sunlight on the flat and ruddy brick, the band of virtually cloudless sky, the yellow shades bisected by shadow, and the barber pole, whose slight tilt, in this intensely rectilinear canvas, has the odd effect of making the street seem to run downhill, left to right. It comes as a shock to learn that the street was New York's Seventh Avenue, the effect of small-town sleepiness is so strong.

Hopper emerged in about 1920 from the impressionism, dramatically daubed and burning with light, that he had practiced in Paris and along the Maine coast, into the calm, stolidly rendered, yet haunting realism that is uniquely his. Resolute in his pursuit of mundane appearances, he painted stark rows of windows in *Williamsburg Bridge* (1928) and, through the bay-window panes, *Room in Brooklyn* (1932); the starkest city windows of all, those in high-rise apartment buildings, figure in *Apartment Houses, Harlem River* (c. 1930) and *City Roofs* (1932). The former is almost as bluntly frontal as *Early Sunday Morning*, but from a riverine distance that conveys little of the warmth and intimacy of the

1930 painting. One of the subliminal sources of *Early Sunday Morning*'s otherworldliness is the peculiar vantage: we and the painter seem to be suspended at the level of the second-story sills, too close to be across the street and yet higher than street level. Hopper was always concerned to demystify his work; the painting's original title was *Seventh Avenue Shops*, and Hopper protested that "it wasn't necessarily Sunday. That word was tacked on later by someone else."[1] Yet often in his work he creates a Sunday mood, of vacant buildings and minimal human activity; *Sunday* was the title of a 1926 oil showing a man sitting idle on the wooden sidewalk before a row of empty shop windows. A human figure in one of the windows was painted out of *Early Sunday Morning*; it is dramatic enough without it. There is a theatricality here that may have been borrowed directly from the set of Elmer Rice's *Street Scene*, designed by Jo Mielziner; Hopper's wife, Jo, mentioned it in a letter as "that Street Scene set we loved so much."[2]

One can imagine the barber pole and the fire hydrant about to break into a courtship dance. The chorus line of apartment windows may suddenly lift its curtains in musical unison, while the black panes below flood with an artificial light to rival the daylight stretching along the sidewalk and presiding in the bright sky. The brick row shows no more depth than a stage set. The Hoppers were keen theatergoers. When one looks for what makes Hopper's paintings so apparently ordinary in their subject matter, so extraordinary in the tension they evoke, the secret is often in their staginess. *Room in New York* (1932) and *Night Windows* (1928) catch the drama of those city rooms whose silent inhabitants, unwitting actors and actresses in a bright-lit space, arrest our attention as we pass. The celebrated *Nighthawks* (1942) was worked up as a movie set in the neo-noir *Pennies from Heaven*. Hopper's earlier *Drug Store* (1927), without a cast of characters, also renders the poignance of a commercial spot hospitably lit in the darkness of the city. *Automat* (1927), with its brooding young woman, mirrors the receding interior ceiling lights in the opaque black outside, and *Summer Evening* (1947) holds its melancholy couple in a box of harsh brightness cut from the inky country air. Our human enclosures are not just illumined stages for our dramas; there is something dramatic in structure itself, dividing light from dark, inside from outside. The architecture in Hopper *acts*, even when, as in *Early Sunday Morning*, it is unpopulated and calm.

From stage light, and from the klieg lights of the early movies, Hopper took a chiaroscuro that gives his most characteristic paintings—*House by the Railroad* (1925), for instance, and *Lighthouse Hill* (1927)—their drama; his shadows are darker than most, and blacker. He subdued the gaudy impasto of his pre-1920s plein-air paintings to a soberer, less restless palette. The color in a mature Hopper names itself, broad patch by patch, and, though based on sketches and watercolors done on the spot, the final product has a monumental simplicity worked up in the studio. In *Early Sunday Morning* the dawn comes rakingly from the right. It arrives stealthily, while the windows still sleep, and we think of the inhabitants behind those curtains, dreaming or groggily stirring, while the day, like an ambitious merchant, is already setting up shop.

The time of day is usually present in a Hopper, as the distinctly shown slant of sun. The chronic solar arc overhead, which makes of each angular object a sundial, is, like our buildings' act of enclosing, not just the context of our human drama but, to an extent, its content. Again and again in Hopper his figures, usually female, seem to be doing nothing but observing the day, and opening themselves—sunlight on skin—to time's inexorable, faithful, fatal passage. Another

1. Gail Levin, *Edward Hopper: A Catalogue Raisonné* (New York: Whitney Museum of American Art in association with W.W. Norton & Company, 1995), III, *Oils*, p. 198.

2. Ibid.

horizontal picture from this same period, *Railroad Sunset* (1929), takes the *end* of the day as its focus; here the color is unrestrained, and focuses the drama away from the lonely railroad signal station in the foreground. In his record book, before delivering this painting to his gallery, Hopper wrote, "Signal station in silhouette. Late sunset, red & gold horizontal clouds. A real beauty this one."[3] An exceptional beauty, in that it comes forth as a painterly feat, a spread of color loudly celebrating natural glory, with the human element minimized—though that element is present as, in Hopper's notation, the "pale gleam on R.R. tracks" which gives the blazing sky back a little of its light.

Humanity was Hopper's usual topic, though he did not paint people very well. They are often stiff and chalky; the most convincing are those with lightly indicated faces, like the brooding women in *Hotel Room* (1931) and *New York Movie* (1939). Yet we find his portrait of the human condition more moving and resonant than that of more exuberant draftsmen like Reginald Marsh and Thomas Hart Benton. Hopper was in comparison cautious; rather than use his subjects to make a statement—in favor of our animal energy, like Marsh, or in summary of our social panorama, like Benton—Hopper seems to wait for people to disclose their own meaning, which their reverie is seeking to discover. Even the inanimate objects in a Hopper appear to be in a reverie. As in a Vermeer, a mystery seeps in and saturates the most modest levels of activity.

3. Ibid., p. 194.

4. Ibid., p. 264.

5. Ibid., p. 334.

In a letter to Lloyd Goodrich, Hopper spoke of a painting being "pieced together from sketches and mental impressions of things in the vicinity."[4] Mental impressions: the painter was not just an eye but a mind. If one asks what elevates Hopper above the relatively programmatic and clamorous art of his contemporaries, the quality might be called largeness— a largeness of patience and peripheral vision, a largeness that includes on the canvas the data of time and of elemental, generally unmet need. His human islands are suspended against an original wilderness—see the oddly frightening *Gas* (1940), with its menacing twilight trees, or the disturbing, faintly hectic *Cape Cod Morning* (1950), of which Hopper said that "it comes nearer to what I feel than some of my other paintings. I don't believe it's important to know exactly what that is."[5]

Early Sunday Morning is a literally sunny picture, with even something merry about it: bucolic peace visits a humdrum urban street. We are gladdened by the day that is coming, entering from the right, heralded by the shadows it throws. The glow on the sidewalk is picked up by the yellow window shades. The barber pole is jubilant, the hydrant basks like a sluggish, knobby toad. But the silent windows, especially the darkened, big shop windows, hold behind them an ominous mortuary stillness. The undercurrents of stillness threaten to drag us down, even as the day dawns. The diurnal wheel turns, taking the sun on one of its sides. But the other side, the side where sun is absent, has its presence, too, and Hopper's apparently noncommittal art excels in making us aware of the elsewhere, the missing, the longed-for. He is, to use a phrase generally reserved for writers, a master of suspense.

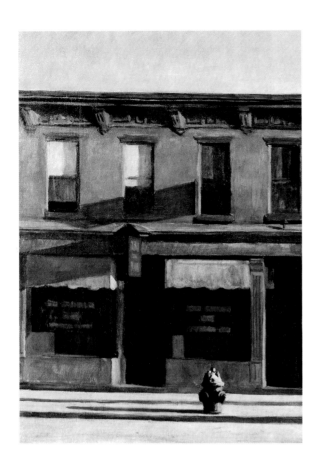

Robert Adams

Edward Hopper's *Early Sunday Morning* is a picture upon which to depend. It is affirmative but does not promise happiness. It is calm but acknowledges our failures. It is beautiful but refers to a beauty beyond our making.

If we encounter the picture after we have been to a shopping mall or a housing development we may see it as less than art, as just cultural history. Our current landscape may seem so much worse than Hopper's that his may strike us as completely removed from the present. If we try by nostalgic reverie to escape into Hopper's picture, however, we are brought up short. His street is in some ways no more easily pleasant than are many of ours.

Nature in Hopper's scene has been almost wholly driven out. The horizon where we might expect to find an organic line has been blocked. Above the architect's straight edge there are no birds, and below it no grass or trees.

The building gives small reason to celebrate the human spirit. There is about the structure some of the dignity of the utilitarian, but refinement has been formulaic—rudimentary pilasters, a cornice that we know has been extruded for miles....Nothing so gracious as a bay window improves the view from outside or in.

The only escapee from this structure, the one slightly comic element in the picture, is a tipsy barber pole, wrapped in the national colors. What inspiration we can find has to come from the variety with which inhabitants have pulled their shades and curtains, careless to the building's tyranny;

though in the background we note a high rise of the kind that will more and more distance us from even such rebellion as this.

In the painting the city is defined by its off-hour quiet. According to Hopper, the title was "tacked on later by someone else," but he let it stick presumably because it was consistent with the evidence.[1] On Sunday we sleep late, and in the picture there are no pedestrians or cars. Nothing moves except the light. Nothing makes a sound.

Most of us would admit to feeling some ambivalence about Sunday. When the mail stops and the telephone rings less often there is a promise of freedom but also of loneliness. Silence. It is a quiet of many levels. We remember that this was the day when God spoke and began the Creation. It was also the day when an angel addressed those who came in grief to the tomb of Jesus, assuring them of a new beginning. It would for centuries be a day marked by church bells, but by Hopper's time there are no spires above the roof.

Why do we love this painful scene? How is it even bearable?

Hopper was uneasy when he was asked to talk about his pictures, afraid that he might try to speak in place of them. He had been brought to his vocation by amazement over light, something he experienced independently of words and ideas, so that his desire was to *show* light. It was an intuitive and emotional commitment: "There is," he said characteristically, "a sort of elation about sunlight on the upper part of a house."[2]

1. Katharine Kuh, *The Artist's Voice: Talks with Seventeen Artists* (New York: Harper & Row, 1962), p. 134.

2. Ibid., p. 140.

3. Ibid., p. 131.

He would have agreed, I think, with the cinematographer Raoul Coutard, who observed that "natural light is always perfect." However much Hopper anguished over the displacement of nature, he never abandoned the city because, in addition to the compassion he felt for those who lived there, he reliably found in the city one remaining natural element—sunlight. With it, nothing was irredeemable.

Compare the way this building would have looked in the architect's drawing with the way it looks in the painting. The two representations are in certain respects similar: Hopper, who described his picture as "almost a literal translation of Seventh Avenue," was careful to register major detail, and to do so from a centered point of view that suggests the objectivity of an architect's elevation.[3] Our interest in the building depends, however, on the painter's subjective decision to record this place in the raking light of a particular hour. With that light he adds not only color but a new richness of form: shadow establishes an additional set of curves beneath the edge of the roof, it divides the upper windows, it unlocks the rectangular grid of the facade by slanting down across it a fresh geometry from protruding signs. The sterilities of the drafting board are enlivened so that we are again interested in the world.

Though the silence remains. Light does not speak (we hope that late risers will do that, gently).

As we consider the painting over time, however, we feel it to be an artist's statement of faith. How else characterize a view in which changing, moving light does not change or move? Hopper's landscape may have been silent, but the discovery to which he testifies is of stillness.

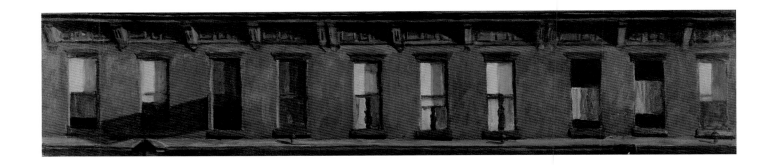

1. Quoted in Helen Appleton
Read, *Robert Henri and Five of
His Pupils*, exh. cat. (New York:
The Century Association,
1946), n.p.

*"The look of a wall or a
window is a look into time
and space. Windows are
symbols....The wall carries
its history. What we seek
is not the moment
alone."—Robert Henri*[1]

Brian O'Doherty

To re-vision *Early Sunday
Morning*, which is as familiar
as an old shoe, requires an
energetic act of recovery. Malleable through reproduction
and overconsumption, it can fit itself to any banal scenario:
does it remind you of going out early for a Sunday paper,
returning to the awaiting cup of coffee in the eerie stillness
before most people are up and about?

Nothing wrong if it does. Everything is received in the
mode of the receiver, and reception theory has democratized
art education's authoritarian idealism of "how you are
supposed to see." Indeed *Early Sunday Morning* can oblige
the sophisticated at more highfalutin levels: Are the run-
down shops a Marxist comment on the Depression? Is the
dialogue between barber pole and hydrant a reference to the
Hoppers' marriage? Are the windows freeze-frames from
some as yet unidentified movie?

Setting aside such farcical meditations, recovering the
picture requires close looking, for it is one of Hopper's most
subtle inventions. Seen from across the street by someone of
Hopper's exceptional height, shops, windows, and cornice
sweep across the picture in a single plane and, as frontal
things do, stare back at you. The sidewalk and road form a
foreground shelf occupied by the hydrant and barber pole.
The foreground is traversed by three shadows which align

themselves obligingly to the edge of the sidewalk: the shadow of the hydrant, the end of which, when projected to its source, is exactly tangential to the globe of the barber pole (the sun is at 17 degrees above the horizon); the brief shadow of the barber pole and the long edge-to-edge shadow cast by an unseen lamp or pole.

The shadow play is only beginning. Three signs, one above the building's stringcourse, two below, project out from the facade. They are described by their shadows more than by the brief vertical axes to which they are reduced. In the dialogue of long horizontals and short verticals, their parallelograms of shadow are among the painting's few obliques, which include the dentils and their shadows, the tilt of the barber pole, and the three hyphens of shadow cast by the ventilators (?) on the inclined top of the stringcourse. The signs' shadows are tracked with close attention. The top shadow's lower margin rises to unfurl itself across the stringcourse, rising again to fuse with the shadow of the windowsill of the leftmost window. The sign, the begetter of this telling incident, remains mute, and is so intended.

This sign on the right shows a black sliver of its left face before tracking its shadow across two shop windows. Its perspective conforms with that of the dentil above it. The sign is suspended some distance from the wall, since an illuminated patch intervenes between it and the commencement of its shadow. The remaining sign—capped by a foreshortened wedge—shows on its right face an indecipherable legend. The lower border of its shadow hitches itself up as it crosses the rose-colored awning before

exiting the picture. These shadows are part of several quiet invitations to read perspective and depth into what at first glance appears a flat frontality. This integrity of detail indicates that careful notes were taken at the scene, perhaps photographs, since the artist said he occasionally used photographs for architectural details. None of these photographs apparently survives. (The Hopper Bequest to the Whitney Museum includes a drawing for the hydrant.)

All the windows are the same height and width, with the tops, bottoms, and mid-sashes exactly in line. Within them (reading from the left) is an almost harmonic play of incident—curtains, shades, all closed with the exceptions of windows 8 and 9, which are open, as is one door of the shop below. In the rightmost window Hopper had painted a figure, then wisely painted it out.

From the way the windows are dressed, five different occupants can be postulated: windows 1 and 2; windows 3 and 4; the next three with curtains and shades; then the open windows 8 and 9; and finally a yellow-shaded window cut by the frame. This assumption, however, is contradicted in part by the relation of these windows to the three shops below: the shop on the left with doubled rose awnings and similar legends on each shop window; the central barbershop with a serrated awning on the left; and the darkened shop to the right. The barbershop probably owns the three quite elegantly dressed windows above it. Access to windows 3 and 4 (and 5, 6, and 7?) is surely through the second door from the left, with pilasters remaining from what may have been a domestic terrace before the ground floor suffered the usual

vandalism in the interests of commerce. Access to the other first-floor windows may be through the two lateral shop doors, but more probably through unseen doors flanking the two shops at left and right. A single pilaster at the left margin indicates that a door will be forthcoming if we pan left out of the picture. Indeed, the row houses are so cropped that there is an open invitation to fill in beyond the frame to left and right. The disjunction between ground and first floor is underlined by the grouping of the windows and the dentils above them.

The intervals between the windows introduce the viewer to almost musical modulations in a work that on first sight advances the idea that it has nothing to hide. Of the nine intervals between the ten windows, four (intervals 1, 2, 5, and 6) are identical. So are intervals 8 and 9. Each of the remaining intervals (3, 4, and 7) is unique and unmatched elsewhere. The relationship of the windows immediately above the doors below varies slightly; window 4 and door 2 (always reading from the left) are exactly consonant; window 6 and door 3 are slightly off, as are the two remaining pairings of lateral doors and superior windows. This, together with the diverging perspectives of signs and dentils, gives a slight stereoscopic hint to what appears to be a plane surface. The intervals indicate which windows belong to which shop— or vice versa. Windows 1, 2, and 3 "belong" to the shop on the left (contradicted by the way the windows are dressed); window 4 could be a hallway; windows 3, 4, and 5 clearly belong (as posited previously) to the barbershop; and windows 8, 9, and 10 belong to the last shop on the right, where inconsistency of window dressing posits a divided occupancy. What at first sight appears to be a more or less regular sequence of windows is, on examination, contradicted by the intervals between them, which have some of the

minute discriminations of a Rothko rectangle ("Hopper is a representational Rothko."—Sam Hunter).

In rehearsing the construction of the picture, further clues to the artist's thinking are offered by the 9 dentils and a partial one at the extreme left. From the way in which they reveal their flanks, the observer is standing in the vicinity of the barber pole, which becomes a surrogate, perhaps, for the artist-spectator. Dentils 4 and 7 are doubled, enclosing the barbershop's three windows. The intervals between the dentils, containing a repeated stamped tin (?) design, appear to be identical. They are in fact uneven, sharing the irregularity of the intervals between the windows but more subtly.

Thus, the three components of the building—cornice, windows, shops—are slightly out of register. They do not exactly conform to the expected vertical orders, and each implies somewhat contrary horizontal shifts. Indeed, the barber pole, which reverses the direction of the spiral between top and bottom, may be said, if one wishes to pursue the matter, to embody this disjunction. The syntactic virtuosity of this apparently plain picture is masked by the relentless horizontals of the roofline, of the stringcourse, of the long pavement shadow, and the sidewalk edge—a kind of under- and overlining this artist used like a signature. The horizontal shifting is powerfully stabilized by the featureless square of the high rise at top right, placed as decisively as a thumbprint. I suspect it was summoned to perform this duty after the picture had been painted. Several smaller rectangles (four, perhaps five) within the shop windows rhyme with the master square above.

The care with which the artist observed and measured this work is confirmed by the identical size and consistent levels of the windows. In Hopper's late works, derived primarily from the imagination, perspectives are frequently imprecise

and sometimes contradictory, a sign of an increasing conceptualism, also indicated by a more summary painting practice. In the early work, however, the artist is remorselessly faithful to what he called "the fact." Were the modulations of this very considered picture copied from the facts before the artist or introduced by him? How much was added—or subtracted? Whatever the answer, the picture—Hopper's first great picture—exhibits (and conceals) what was to become a defining signature of his best work: an overt, unprotected, and frank depiction of a subject, which on examination is supported and inflected by numerous minute qualifications, what Roger Fry called—in reference to Matisse—"equivoque and ellipsis." The ingenuity of these bespeak a pictorial intelligence of the highest order.

The rather muted tonalities and carefully blurred vision of *Early Sunday Morning* are relieved by some signature touches (the rose awning of the shop on the left, the red rectangle below it). The cast shadows are curiously colorless. The panoramic format and compositional virtuosity seem to this observer more advanced than the technique, which is highly efficient but somewhat ordinary. The darkness of the right-hand shop may throw attention back to the rest of the facade; its summary nature (including a painterly last window) may be a bit inconsistent with the general mood. But here one is in the fragile area of opinion; what is clear, I think, is the intense concentration Hopper brought to the image, which became for him a criterion of a work's integrity. Hopper's best works stamp that concentration on every square inch of the canvas.

Early Sunday Morning's ten—almost ten—windows contain much incident which can be read in several ways. There is an almost symmetrical sequence of light and dark windows: two light, two dark, three light, two dark, one light. This, in another of Hopper's subtle discriminations, gives an

interest and depth to the facade that it would not otherwise possess. Behind these windows, in which the irregular levels of the window shades conduct their own subtext, are inhabited rooms. From window to window, *Early Sunday Morning* offers a brief discourse on the occupants. The symmetry of the window shades and curtains in windows 5, 6, and 7 bespeaks a degree of pride in how they present themselves to the street. Windows 3 and 4 (does the sign on the left margin of 3 speak for the shop below?) seem neglected and indifferent to the passerby. Windows 8 and 9 lack the economic privilege of 5, 6, and 7. The last window on the right seems to promise a more upscale continuation. Any facade embodies to some degree the practices and attitudes of those within, but Hopper has forestalled any penetration of the spaces within the rooms by an emphasis—a very sophisticated emphasis—on surface, interrupted by unreadable voids.

When Hopper saw this banal terrace in 1930, it took an imaginative effort to bestow on such architecture the dignity of subject matter. He submitted it, as he did everything, to his steady, even implacable observation, some measure of which may be experienced in the magnificent neutrality of the facade's returning stare.

Georgia O'Keeffe
Summer Days *1936*

Georgia O'Keeffe (1887–1986)
Summer Days, 1936
Oil on canvas, 36 x 30 in.
(91.4 x 76.2 cm)
Gift of Calvin Klein 94.171

Kathleen Norris

As a Westerner, I can't help but read *Summer Days* as a kind of weather report. In the far distance, murky green clouds approach like ocean waves, signifying what denizens of the American West term "serious weather." Tornado-force winds, golf-or-tennis-ball-sized hail, gully-washing rains—several inches of water coming in less than an hour, with fireworks. I have watched such clouds gather ominously in the western sky in late afternoon, and have felt the body-blows of high winds that herald the coming of something big, as magnificent as it is awful, winds that push me back as I try to run toward home and shelter. I have pulled off a country road and sat helplessly in a car, blinded by horizontal rain, praying that the windshield won't be shattered by hail, that the car will remain upright. Thunder rolls overhead. Lightning strikes close by—at once, both sound and flash—making me grateful for rubber tires.

O'Keeffe's painting evokes the heightened state of waiting that envelops a person who spies such a storm on the horizon. A bit of clear blue sky may still be visible, but a drastic change is coming. O'Keeffe places the flowers—aster, cactus, heliopsis—and the enormous skull of a deer, against a background of murky white clouds that are anything but serene. Their dusty cast suggests that they carry soil stirred

up by sudden winds. To my eye, the flowers and skull are not passive presences in O'Keeffe's sky, but seem to move rapidly toward the viewer, spiraling like genies out of those restless and uneasy clouds.

The dramatic placement of skull and flowers at the center of the painting, high above the red hills of northern New Mexico, does not seem odd to one who knows that the western sky is full of wonders; hailstones can fall, for example, out of a cloudless blue. And the Surrealist elements of the image mean far less to me than O'Keeffe's accuracy about the western sky. In a desert, rain is life. But death also attends. The sky that slakes the thirst of all living things also brings with it sudden, fierce storms that can kill anything in its path.

Summer Days is one of the paintings that O'Keeffe made after an unaccustomed fallow period in her art, the longest since she had left the Art Students League twenty-five years before. In 1933, suffering acutely from strained personal relationships, a loss of appetite, and inability to sleep, she painted very little and told an interviewer in March 1934 that she was annoyed to find herself "not interested in work." She added, "If I had a clue I'd start," and recognized her need to "begin all over again." What better place than a desert to flower after a drought? What better light to see by than the crystalline air at 6,500 feet?

In the summer of 1934, O'Keeffe returned to the landscape that she had reluctantly abandoned three years before, and she let it work on her. The mysterious skull-as-mirage paintings soon followed. *Ram's Head with Hollyhock*, completed in 1935, received praise in *The New Yorker* as "one of the most brilliant paintings O'Keeffe has done." In 1936 came *Deer's Head with Pedernal*, her beloved mountain in full view of Ghost Ranch, and *Summer Days*.

"I have wanted to paint the desert and I haven't known how," O'Keeffe wrote for an exhibition catalogue in 1939, two years after *Summer Days* was first shown at An American Place in New York City. "The bones seem to cut sharply to the center of something that is keenly alive on the desert even tho' it is vast and empty and untouchable—and knows no kindness with all its beauty."

Any artist, any poet, experiences dry spells, a between-time in which the work that once sustained you seems barren, and nothing has come to take its place. Getting down to bare bones, as it were; emulating the hardy desert grasses which in a drought die down to the roots but also devise ingenious methods of using any available moisture—this is not a bad way to proceed. *Summer Days* evokes both a time—late summer—and a place, the red hills that O'Keeffe knew others saw as "wasteland" but which she felt was "our most beautiful country." O'Keeffe here staked a lasting claim to the harsh landscape by which she would be remembered.

The painting sums up, with great economy, the mighty paradox of drought and blessed rain, of withered dreams and still-fervent hopes that characterize the region that writer Mary Austin called, in 1903, in her classic of Southwestern literature, *A Land of Little Rain*. Even more subtle is O'Keeffe's appropriation of a fact about the nature of flowering in such a seemingly barren place, in this case northern New Mexico. For, as naturalist Ann Haymond Zwinger observed in 1989, in her study of the four great desert regions of the American West, *The Mysterious Lands*: "Flowering is, after all, not an aesthetic contribution, but a survival mechanism." The tough-minded O'Keeffe let flowers ride the sky, and insisted that the skulls she found and studied did not represent death so much as transformation. "There is no such thing as death," she once stated, "only change."

Anne M. Wagner

"Summer days"—what does the phrase conjure? Heat and holidays? Those "lazy, hazy, crazy" days that lyricists insist are best savored with soda, pretzels, and beer? If these are your associations, it may seem incongruous—perhaps even distressing—that Georgia O'Keeffe used the phrase in 1936 to title a canvas in the series of paintings of skulls she had been working on since 1930. Its floating skull and vivid garland seem far from summer's delights. Its spaces are vast and empty, and there is no relief in sight.

Summer Days: Alfred Stieglitz evidently thought that as a title for an O'Keeffe painting the phrase mattered enough to object to; he declared he "hated" it to the art critic of *The New York Times*.[1] Isn't it odd that as O'Keeffe's husband and dealer and champion Stieglitz should have worried about a title out loud rather than privately, and moreover confessed himself in the company of a newspaperman? Edwin Alden Jewell, the critic in question, wasn't a particular fan of O'Keeffe's painting—or any woman's painting, for that matter. No wonder, then, that Stieglitz's frank avowal crops

1. Alfred Stieglitz, as quoted by Edwin Alden Jewell, *The New York Times*, February 6, 1937, p. 28. The full passage is as follows: "Mr. Stieglitz says he doesn't in the least like that title. In fact he admitted yesterday: 'I hate it.' Mr. Stieglitz hopes that each visitor to the gallery will supply a title of his own. The reviewer's first choice would be Tyltyl's: 'Ou sont les Morts?' and for a second choice, perhaps: 'A Deer's Revenge, or the End of a Well-Lived Life.'"

up in Jewell's characteristically disapproving review of O'Keeffe's 1937 exhibition at An American Place.

What could have offended Stieglitz about this innocuous phrase? Should the offense be taken seriously, or simply registered as a mere dispute over terms? And when O'Keeffe later referred to this canvas as a "picture of the summertime," was she herself shifting ground, generalizing in answer to such objections?[2] The possibility only makes us wonder further what bothered Stieglitz. Nor are these questions eased when we remember that, late in life, O'Keeffe asserted her disinterest in titles. Are we therefore mistaken in our concern? Was Stieglitz?

Questions about the words of a title raise questions about the meaning of a picture when they seem to connect to other quandaries, as they do in the case of O'Keeffe's skulls. Some works in the group have flat, almost taxonomically descriptive titles. Take, for example, *Horse's Skull with White Rose* (1931): the phrase does not begin to hint at the painting's white-on-white effects or its deathly atmosphere. Other pictures in the series, however, were once much more allusively named; I am thinking of two canvases, one called *Life and Transformation*, the other, *Life and Death*. These titles belonged to 1931 paintings now more bluntly named *Cow's Skull—Red, White and Blue* and *Horse's Skull with Pink Rose*.[3]

Given the range of original titles, perhaps we should not be surprised that in the 1930s critics wondered what the skull series might mean. Jewell declared it was "a question

4. Edwin Alden Jewell, "Georgia O'Keeffe Gives an Art Show," *The New York Times*, January 7, 1936, p. L19.

5. Lewis Mumford, "Autobiographies in Paint," *The New Yorker*, January 18, 1936, p. 48.

6. Martha Davidson, "O'Keeffe's Latest Decorative Painting," *Art News*, 35 (February 27, 1937), p. 12.

difficult to answer," in his review of O'Keeffe's 1936 exhibition, in which *Ram's Head, White Hollyhock, Hills* took pride of place. He put the problem with characteristic bluntness: was the work mundane or transcendent? Did the conjoining of flower and skull and landscape make for "merely a bundle of perverse incongruities" or did it register the "opposite extreme...a mystic apotheosis or transfiguration"?[4] Lewis Mumford, for one, weighed in with the latter view; he found that the skull pictures possessed "that mysterious force, that hold upon the hidden soul, which distinguishes important communication from the casual reports of the eye."[5] The question of meaning and symbol was fraught enough to make one champion of *Summer Days*— Martha Davidson, writing in *Art News* in 1937—insist that its allusions and emblems are muted by the painter's brilliant forms and handling, no matter what Mumford might say. In her eyes, "the symbol" was lost in "the decorative," and the mystery of the picture's meaning became the mystery of its presentation: "The fluid brush, the elegant form, the uncompromising clarity, the exotic color—all these together with an impeccable balance of material form and the space that surrounds it—unite to create a design great in its plastic imagination but restricted in its concept."[6] The painting's meaning, in other words, was lodged in—and restricted to— O'Keeffe's artistic technique.

Disagreements like this one have their origins deep in the accumulated layers of response to O'Keeffe's art. By 1937, plenty of critics had had their say (it had been twenty years since O'Keeffe's first exhibition), and Davidson, like O'Keeffe

2. Quoted in Laurie Lisle, *Portrait of an Artist* (Albuquerque: University of New Mexico Press, 1986), p. 236. The anxiety about what this picture actually shows has left its traces in the Whitney Museum file on the painting; it includes notes summarizing Santa Fe weather in the particularly hot, dry summer of 1936, as if the painting's imagery of skull and flowers could be traced directly to the extremes of the season.

3. These titles were used when the works were illustrated in the press, at the time of their first exhibition. *Cow's Skull— Red, White and Blue* was labeled *Life and Transformation* in the *Springfield Sunday Union and Republican*, January 10, 1932, p. 6E; *Horse's Skull with Pink Rose* was called *Life and Death* in an article by F.C., "A Series of American Artists—in Color. No. 1. Georgia O'Keeffe," *Vanity Fair*, 38 (April 1932), p. 41.

herself, makes no bones about her resentment of those "pernicious" contributions, the "emphatic flights of wild fancy" and "subjective delusions" that have gone before her own measured contribution, and given the artist's reputation its overheated and excessive tone.[7] Yet O'Keeffe herself made both extreme and obscure statements about her work. She was frequently ironic and elusive, even though her comments most often took direct, evidently unstudied form. The result can only be considered a peculiarly ambiguous set of declarations; similar ambiguities lurk behind the ostensible look of her paintings. The skull paintings are a key case in point. Late in her life she recounted how one early skull painting—*Cow's Skull—Red, White and Blue* of 1931— came to be. The passage is often cited, with good reason:

When I arrived at Lake George I painted a horse's skull— then another horse's skull and then another horse's skull. After that came a cow's skull on blue....As I was working I thought of the city men I had been seeing in the East. They talked so often of writing the Great American Novel—the Great American Play—the Great American Poetry. I am not sure that they aspired to the Great American Painting. Cézanne was so much in the air that I think the Great American Painting didn't even seem a possible dream....I was quite excited over our country and I knew that at that time almost any one of those great minds would have been living in Europe if it had been possible for them. They didn't even want to live in New York—how was the Great American Thing going to happen? So as I painted along on my cow's skull on blue I thought to myself, "I'll make it an American painting. They will not think it great with the red stripes down the sides—Red, White and Blue—but they will notice it."[8]

7. Ibid. The first decade of critics' responses to O'Keeffe's art have been collected in Barbara Buhler Lynes, *O'Keeffe, Stieglitz and the Critics, 1916–1926* (Ann Arbor, Michigan: UMI Research Press, 1989).

8. Georgia O'Keeffe, *Georgia O'Keeffe* (New York: Viking Press, 1976), n.p. A version of this narrative first appeared in Calvin Tomkins, "The Rose in the Eye Looked Pretty Fine," *The New Yorker*, March 4, 1974, p. 49.

9. D.H. Lawrence, *Studies in Classic American Literature* (Garden City, New York: Doubleday & Co., 1951), pp. 8, 92–93.

This is a passage that divorces O'Keeffe's skull series from several too-obvious contexts: from the West as its literal subject or content; from the "realism" of observation and meticulous description; from attention to purely formal questions of design. In their place stand acts which the artist herself characterizes as both compulsive and repetitive ("I painted a horse's skull—then another horse's skull and then another horse's skull"); memory likewise seems to motivate these pictures. This is clear once we realize that the skulls were first painted at Lake George, fished out from an (imported) barrel of bones. And finally there is ambition: the skull series was meant as "Great American Painting." So much is clear. Less so is what this might mean.

I am not sure that O'Keeffe's notion of "Great American Painting" took particularly visual form. No, that's not quite right. Perhaps what I mean to say is that I am not sure that it had any identifiable visual point of departure: her source was certainly not Cézanne. I think, rather, that the main parallel to her conception was verbal; it is to be found in D.H. Lawrence's *Studies in Classic American Literature*, a book written in 1923. Above all it lies in Lawrence's conception of the American habit of putting up a "sort of double meaning"—what he defined as "this split in American art and art consciousness. On the top it is as nice as pie, goody-goody and lovey-dovey." Such art is not to be trusted or taken on faith: "Look at the inner meaning of their art and see what demons they were. You *must* look through the surface of American art, and see the inner diabolism of the symbolic meaning. Otherwise it is all childishness."[9]

I think painting that took such adages to heart could well look like *Summer Days*. Which is to say: I think O'Keeffe took Lawrence to heart; her work meets his prescriptions. She shared his idea of an art masked by apparent form and content; what lies behind them far exceeds a first impression. In O'Keeffe, we might locate what is "as nice as pie" in meticulous surface, scrupulous form, and relentlessly even-handed light; there is likewise her matter-of-fact linkage of flowers, vista, and skull, which encompasses quite horrifying leaps of scale to convince us, as it did Martha Davidson, that the image makes a decorative whole. But the baroque twists of the antlers, the evanescent posy chain, the bare hills off somewhere—these features take on an "inner diabolism" when we realize the bodily and psychic states our sight is asked to simulate; as viewers of this canvas, we are forced to hallucinate. The pleasures of desert delirium are vivid, but deceptive; they dwarf the viewer, leaving nowhere for the imagination to go.

The skulls in this series of pictures are, I think, the guise or mask of O'Keeffe's artistic ambition. Not quite self-portraits, they stand for the painter's true subject: the fact of death soaring up to overpower even a summer afternoon. The year, remember, was 1936, when the specter of war was gathering momentum across the European landscape— a historical context that underscores the pessimism of the picture's ornate and visionary beauty. Surely it was the sheer anomaly of the contrast that helped make *Summer Days* so hard to name. Yet the same anomaly explains why Lawrence's verdict on an American "sort of double meaning" seems to fit this picture's ambiguities and antitheses so very well. His advice seems tailored to O'Keeffe's painting: "You *must* look through the surface of American art, and see the inner diabolism of the symbolic meaning." And so we should.

1. Georgia O'Keeffe, *Georgia O'Keeffe* (New York: Viking Press, 1976), n.p.

Sarah Whitaker Peters

To me, O'Keeffe is one of those artists that it is a mistake to understand too quickly. Although she constantly strove to simplify her art, it is deceptively simple. When she was in her late eighties she wrote, "I find...I have painted my life—things happening in my life—without knowing."[1] The best way for a viewer to enter a painting as puzzling and visionary as *Summer Days* may be to tabulate what's actually there—using O'Keeffe's own statement as a key. With O'Keeffe it is almost impossible to know what was unintentional self-revelation in her paintings, and what wasn't, because she always refused to help them with words.

She divided the composition of *Summer Days* into two uneven and vastly different spaces. The top three-fourths of it consists of an indeterminate mist—quite easily thought of as metaphysical space. Floating (or levitating) dead center in front of this mist is a huge, precisely detailed buck deer skull, with winglike horns. Just below its sun-bleached nostril cavities float six wildflowers—or are they being blown by a circular puff of wind? I'm not certain.

In the bottom fourth of the canvas is an exquisitely truthful, if ambiguous, New Mexico landscape: red hills (whose Mesozoic rock formations resemble those near the Ghost Ranch where, from the early 1930s on, O'Keeffe spent her summers), and beyond them a rain-filled cloud base. Or is it a green valley, darkened and diffused by thunderheads gathering in a rapidly disappearing blue sky? The skull dominates, immutable and still. The panoramic landscape moves with the weather right under my gaze. And there's something extra going on in it which I finally figure out:

judging from the curious perspective, my eye is also floating way above ground.

How absurd, I think at first, to see a skull in the air. Even mirages don't behave like this. Was O'Keeffe kidding us? (Sometimes she did!) But I discard this notion, as I think further about bones in general, and her bones in particular. She found them "beautiful," she said, and "keenly alive."[2] Her early training with Arthur Wesley Dow, author of the famous American art school text *Composition* (1899), had taught her to use "the facts of nature to express an idea or emotion."[3] And she had often worked with shells, leaves, and flowers for just such purposes. But animal bones were a later choice, made after her recognition that Lake George, New York (where she'd worked for over ten years alongside her husband, the photographer Alfred Stieglitz), had become a dead end for her creativity. By 1930, the year she brought some horse and cow skulls back East to paint, O'Keeffe had come to regard New Mexico as her psychic homeland. A place, she said, where "I felt as grateful for my largest hurts as I did for my largest happiness."[4] She called the bones "my symbols of the desert."[5] What did she mean by this? We can't be sure, but in 1929, during her first summer in Taos, she became fascinated with the still-functioning Anasazi-Pueblo culture there. She went often to Indian dances, "sings," and other sacred ceremonies with Tony Luhan, the Navajo husband of her hostess, Mabel Dodge Luhan. With such intense interest in an ancient tribal culture, she could hardly have escaped knowing that shamans in primitive societies the world over believed bones to be the essential life force animating men and beasts. She once said something suggesting this: "To me they are strangely more living than

7. O'Keeffe to Blanche Matthias, 1926, in *Georgia O'Keeffe: Art and Letters*, p. 183.

8. O'Keeffe to Ettie Stettheimer, Summer 1925, in *Georgia O'Keeffe: Art and Letters*, p. 181.

9. O'Keeffe to William M. Milliken, November 1, 1930, in *Georgia O'Keeffe: Art and Letters*, p. 202.

the animals walking around."[6] Furthermore, from time immemorial, shamans placed bones in graves as regenerative symbols and used them in their divination and healing practices as well. Bones, in other words, were seen as sacred.

It is well known that O'Keeffe was formed by nineteenth-century Symbolist art theories, which had to do with suggestion, allusion, and equivalence. Did she also hold with the radiant Symbolist belief that form and color have curative properties? Apparently she did, judging from her letter to a friend in 1926: "If I could put it clearly into form it would cure you—that is worthy of a laugh—but I am sure it is true."[7] The ancient Navajo practice of healing with sand paintings does not seem all that remote from this.

What about the six flowers? O'Keeffe had been painting flowers happily and meticulously for over twenty years. They outnumber every other category in her work during the first fifteen years of her career. She was also a knowledgeable gardener. A letter written from Lake George to Ettie Stettheimer in 1925 speaks of transplanting sunflowers, her trials with the vegetable garden—and her annoyance with Stieglitz for using her pruning shears to cut wire.[8]

The windblown wildflowers she painted in 1936 in *Summer Days* are all indigenous to the Rocky Mountains—from northern Arizona and New Mexico to British Columbia—and easily classified as to family, if not to species. (Wildflowers are notoriously difficult to categorize, even for botanists.) Should we read anything characterological in her choice of these plants? I think it's a question worth considering. And in a letter from 1930, O'Keeffe herself may have given us a picklock: "Maybe in terms of paint color I can convey...my experience of the flower or the experience that makes the flower of significance to me at that particular time."[9]

2. Georgia O'Keeffe, in *Georgia O'Keeffe: Exhibition of Oils and Pastels*, exh. cat. (New York: An American Place, 1939), n.p.

3. Arthur Wesley Dow, *Composition: A Series of Exercises in Art Structured for the Use of Students and Teachers* (1899; ed. New York: Doubleday, Page and Co., 1913), p. 50.

4. O'Keeffe to Mabel Dodge Luhan, September 1929, in Jack Cowart, Juan Hamilton, and Sarah Greenough, *Georgia O'Keeffe: Art and Letters*, exh. cat. (Washington, D.C.: National Gallery of Art, 1987), p. 196.

5. *Georgia O'Keeffe: Exhibition of Oils and Pastels*, n.p.

6. Ibid.

The most eye-catching flower at first (because of its brilliant red color and central position) is an Indian paintbrush, from the figwort family. I know it well from my many summers in the Rockies. This large plant, which grows from one to three feet tall, is a semiparasite, stealing the food it requires from the roots of others, like sagebrush. Could it be a cryptic abstract portrait of O'Keeffe's mentor and dealer, Stieglitz? I wonder. She apparently made other portraits of him as a tree—some threatening, some not—in her mighty efforts to stand on her own two feet. The abstract portrait was, in fact, a Stieglitz circle specialty. Inspired by New York Dada during World War I, Stieglitz encouraged the artists around him to analyze each other's personalities (including his own) by abstract means in order to create new forms and original symbols. O'Keeffe wrote a friend in 1915 that she was crazy about this stuff—that it just took her breath away.[10] But she never admitted to doing it herself.

Next in order come two asters, judging from their small pinkish lavender rayflowers (petals). They are quite common to northern New Mexico, and belong to the sunflower family. Asters are a composite species: the many in the one. It may be significant to the meaning of the picture that O'Keeffe's first aster rests on the paintbrush, but the second is separated from it. Could this be an allusion to her fraught and ever-changing relationship to Stieglitz?

Slightly above them, drifting off into the mist, is a single stem of three blooms known as little sunflowers: one peculiarly twisted and half-open, one a bud, and one—the last—in robust flower. It is not easy to distinguish between the sunflower family's many species. Complicating matters, O'Keeffe seems to have taken a certain painter's license with her flowers in the interest of form and composition. We can't, for example, see the telltale veins in the little sunflower's leaf. Nevertheless, the disk and rayflowers strongly suggest

10. O'Keeffe to Anita Pollitzer, August 25, 1915, in Pollitzer, *A Woman on Paper: Georgia O'Keeffe* (New York: Simon and Schuster, 1988), p. 12.

Helianthella quinquenervis. Sunflowers have long been a valued foodstuff for mankind.

Looking ruminatively at the artist's choice of these six flower heads—and the manner in which they are painted—I sense a spiritual evolution of sorts going on here. The full-blown little sunflower visually eclipses the Indian paintbrush, and the smaller flowers hanging between them hardly seem to exist. We can even read the top sunflower as straining to get away. More significantly, perhaps, this is the only flower to enter the sacred space occupied by the skull. Is it O'Keeffe herself? Her flowers have long been suspected to be abstract self-portraits, although she never said they were—or were not. And the autobiographical implications of this 1936 work are rife, if you know she had suffered a nervous breakdown between 1932 and 1933 and was unable to paint for nearly two years. (Her biographers have suggested that the reasons had to do with Stieglitz's infidelities, and the failure of her cherished mural project for Radio City Music Hall.)

What of the deer skull, which clearly takes pride of place in the painting? It is an arresting and beautiful shape to be sure. But with O'Keeffe, abstract design is always a means, not an end in itself. Given its centrality, isolation, gravity, and mystery, this bone communicates an almost God-like therapeutic power. Is O'Keeffe celebrating her own healing? Perhaps. But *Summer Days* seems to me to be about much more than that. The bone and the flowers aren't the only things floating above the earth—the viewer is too. Therefore we may also be taking part in the implied spiritual action.

Is this painting saying to everyone who looks attentively at it: "All shall be well"? That, Georgia O'Keeffe has left each one of us to decide.

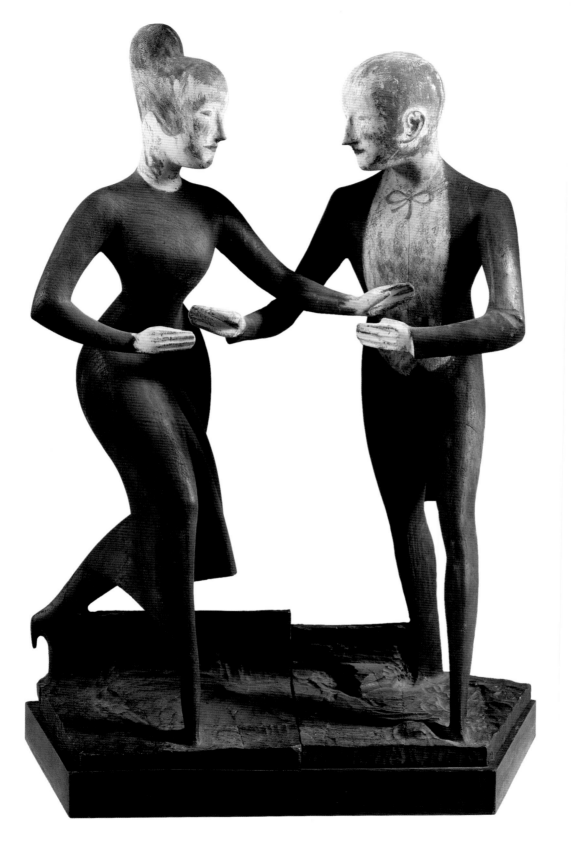

Elie Nadelman

Tango *c. 1919*

Elie Nadelman (1882–1946)
Tango, c. 1919
Painted cherry wood and gesso,
three units, 35 7/8 x 26 x 13 7/8 in.
(91.1 x 66 x 35.2 cm) overall
Purchase, with funds from the Mr.
and Mrs. Arthur G. Altschul
Purchase Fund, the Joan and Lester
Avnet Purchase Fund, the Edgar
William and Bernice Chrysler
Garbisch Purchase Fund, the Mrs.
Robert C. Graham Purchase Fund
in honor of John I.H. Baur, the Mrs.
Percy Uris Purchase Fund and the
Henry Schnakenberg Purchase
Fund in honor of Juliana Force
88.1a–c

Richard Martin

As a child in Philadelphia, I was enrolled in ballroom dancing at Mrs. Coleman Sellers' classes at the Merion Cricket Club on the Main Line. On Monday afternoons, when I would have preferred to watch Philadelphia's *American Bandstand* on television, I was required to train in the etiquette and steps of proper ballroom dancing as doting parents watched from the balcony. After countless fox-trots, waltzes, and an occasional Mexican hat dance, there was one jitterbug allowed in each session. This dance was a distant sexless cousin of what I would have preferred to watch on *Bandstand*. I sensed, rather than knew cognitively, that there was something different and indifferent about the Cricket Club's jitterbug compared to the dancing I was missing on *Bandstand*. Even Thomas Mann's clumsy Tonio Kröger knows the distinction between decorum and desire.

America assimilates. Elie Nadelman's *Tango* is the most genteel tango ever danced. It is the dance without lust, without Argentina, even without Europe. It sets aside the internationalism after World War I and settles immediately for a more wholesome, ripely American version. The dancers are not inflamed with passion and with body-wrapping enthusiasm; they could as readily, from their postures,

be dancing the minuet or promenading on a barn floor. Nadelman championed a reasonable and rational art based on curves and a harmony of forms; his dancers, albeit a frequent subject in various media for him and his contemporaries, are always static or symbolic more than dynamic. Rather than capturing movement in a choreographer's or camera's eye, Nadelman controls it and quells it. Further, in *Tango*, each dancer is a separate block of wood, functioning like an isolated niche figure connected only by whirligig hands that never quite touch the opposite waist or palm.

Nadelman presents no *hombre tanguero* with intimations of machismo and body-heaving ferocity; his etiolated male is slight and suave with no sign of brutality, certainly a gentleman, nearly a Grace. The man's formal attire, invoking American folk art, might be correct to the ballroom, but not to the dance hall. The second Grace is female, ready more for Botticelli's *Primavera* than for the frenzies of a wild dance; her stride is one of elegance, but insufficient for rapture. Her covered-up long dress and coiffure with prim bun at the back is similarly demure as dancing attire. The folkloric Argentine legacy, furious in its rage against class, has become American symmetry and chastity, disinfected of the dance's sweat, synergy, and savagery.

Of course, social dancing in America has been the apex of individual and social confrontations. It has always been a democratic form, from the convergence of folk-dance traditions to the horseplay-farce of square dancing and the Virginia reel straight out of Americana, to Warhol's 1960s easy dance lessons in diagram, derived from magazine advertisements of the 1920s that promised one could learn to dance at home like Valentino (who in 1921 danced the first movie tango in *The Four Horsemen of the Apocalypse*). Vernon and Irene Castle not only invented dances, but they were paradigms of elegance. In the 1940s, the New York

City Ballet staged *Circus Polka* for pachyderms, and Agnes De Mille created graphic dances for cowboys and cowgirls. Movie dancers can be gallant in the manner of Fred Astaire, kinetic on the model of Gene Kelly, or studs like John Travolta.

The tango, a dance of Latin passion, was foreign to America. Ballroom dancing in America succumbed to the rhythm of the tango, but not at all to its sexual candor. The English prophet H.G. Wells dubbed 1913 the "year of the tango," and elsewhere the rage was described as tango-mania. On January 1, 1914, a *New York Times* headline reported "All New York Now Madly Whirling in the Tango: Every Day New Places Where You May Dance Are Springing Up and Older Establishments Yielding to the Craze, Which Apparently, Has Come to Stay." But to Irene Castle, the dance that she and Vernon performed had "nothing suggestive about it." Further, she averred, "If Vernon had ever looked into my eyes with smoldering passion during the tango, we would have burst out laughing." Like the Nadelman couple who are not laughing, but performing an exercise within protocol, Castle's doleful retreat from hedonism only suggests that others elsewhere must have danced a more sultry tango. And newspaper controversy in New York and other American cities in the teens and twenties confirms that even the defenders of the tango had to certify their chastity.

Just as Nadelman's *Tango* is the dance without the wicked pedigree of Argentine squalor, severed from its lusty bordello origins, and denied its innate sexual energy, it is also the dance without death. Sweetly polite and perfunctory, it evades the sinister entrapments of Edvard Munch's *The Dance of Life* (1899–1900), in which female dancers are consumed into the bodies of their male partners in a proto-tango. In endorsing the manners of ballroom dance

over the lubricity of the tango, Nadelman offered an unabashed and innocent sense of life. A related Nadelman drawing of a tangoing couple (The Metropolitan Museum of Art) is equally prim, the man's arm yoking his partner, but not guiding their bodies into contact. In fact, both these figures look out with Nadelman's characteristic incredulity at the spectator and are seemingly more engaged with the onlooker's inspection of their dance than with their own limited contact with each other. Lithe bodies both, this couple nevertheless possesses none of the hurling, recoiling eroticism that one associates with Latin and European versions of the dance.

In 1926, Francisco Canaro, Argentine tango musician—and friend of legendary singer Carlos Gardel—came to New York to appear at the Club Mirador. The club published for its guests "Tango Tips" and program notes, announcing that "Canaro is to the tango what Paul Whiteman is to jazz." Leading off the tips is an encouraging notice: "The fallacy that the tango is a difficult dance has finally been dispelled by Canaro's Orchestra. So fascinating was their tango music that people who heard them at the Club Florida in Paris got up and danced whether they knew the tango or not. Their enthusiasm for Canaro's music really created the simplified tango which became the rage of Paris and London, which success, it is expected, will be duplicated in New York. The simplified tango has been evolved from and can be accomplished by merely adapting the ordinary fox-trot steps to the tango. That is to say, the tango can be danced by simply walking a slow fox-trot and pausing on the fourth step. If one will only remember to take three steps and pause on the fourth, the secret of the tango is yours." Later, as the pointed allusion to Paul Whiteman demonstrates, African-diaspora jazz would mellow and mollify into a mainstream American phenomenon attracting white audiences and dancers.

American assimilation and syncretism triumphed. The licentious dance—forerunner, of course, to "the forbidden dance" of the lambada, the epic *Dirty Dancing* of the 1980s, and their certain progeny—has become little more than a nuanced formality in modification of the fox-trot. The wooden figures of Elie Nadelman's *Tango* had, years before, already made this promiscuous dance look more like a square-dance promenade. "Dancing," claimed psychologist Havelock Ellis in *The Dance of Life*, "is the loftiest...of the arts, because it is no mere translation or abstraction from life; it is life itself." Yet for one artist even dance remained a courtly and Americanized abstraction.

Martin Puryear

What can I say about *Tango*, a wood sculpture of two dancers carved around 1919 by Elie Nadelman?

I am first of all moved by the way Nadelman stacked three distinct gestures on top of one another in each figure, mirroring them to achieve a kind of energy which is both static and rhythmical at the same time. The legs of both figures drive forward, but the man's step is crisp, almost formal, while the woman's is all spiraling curves. Then the arms. They reach across as if to counter the legs' forward momentum, creating a figure eight, a symbol for infinity. Tango means "I touch" in Latin. The dancers' hands almost touch, but don't. The final gesture belongs to the heads. Turned one-quarter inward, restrained, serene, their gazes intersect at right angles somewhere in space. The dancers acknowledge one another only from the waist up. Without touching or direct eye contact they connect across a synapse charged with symmetry.

Tango was carved from cherry wood. Cherry is certainly a lot softer than stone but it's still one of the harder North American woods, and like any wood it has a fibrous grain which is much stronger in the axis of the tree's growth than across it. What this means for a carver is that you can't create long slender forms that protrude across the direction of the grain without risking breakage.

Now it's obvious from a glance at the bases that each figure was carved from a separate block, and that the bases were pushed together to join the pair in the dance. However, what's equally obvious is that one arm of each dancer seems to extend beyond the limit of the block it was carved from to reach across to the partner. To make this possible, Nadelman constructed each block from several pieces glued together before carving. This is what allowed him to orient the grain strategically in the different parts of the sculpture for greater strength, especially in the extended arms, and also to project the arms beyond the original limits of each block.

The crosswise, implicit sliding motion of the two bases having been pushed together strikes me as yet another gesture which much more subtly reinforces that of the arms crossed in union. To see evidence of Nadelman's elaborate provisions for this final union, even before he began to carve, is one of the more delightful aspects of this work for me.

When I ask myself what makes Nadelman's handful of modestly scaled wood sculptures fascinating, two thoughts come to mind. The first concerns influences.

Nadelman's artistic beginnings were classical, but from the start he also incorporated a succession of modern influences into his bronze, marble, and plaster figures. When he began to carve sculptures in wood, however, Nadelman came under the influence of American folk art: cigar-store Indians, ship figureheads, and carved wooden toys. Their effect on his work is unmistakable. Folk carving is not unique to North America, of course, but it's possible to see something in these vernacular objects that reflects a precise moment in American everyday life. By the same token, Nadelman's *Tango* dancers, however idealized they may be

as sculptural forms, depict flesh and blood people caught in a dance that was the rage at the time.

The second thought is that, as a material, wood dictates far more strictly than clay or plaster how the sculptor will be able to work it. Wood fibers tear and split if cut the wrong way, and the strongly directional grain tends to limit the kinds of forms the wood sculptor can carve. The work proceeds from the outside in as material is cut away to reveal the form. The process tends to be stubborn.

By contrast clay, plaster, and wax are soft enough to be pushed and squeezed into shape. Bronze sculpture is usually cast from an original modeled from these materials, so although a bronze casting is hard and durable, it reproduces the surface modeling of the softer material. When he began to work with wood, Nadelman had to contend with a material with a strong character, a material he literally couldn't push around. As a result, the forms he produced in wood had a lot more tautness and vigor than his modeled forms.

The question of material is not unrelated to the question of Nadelman's influences because folk sculpture, wherever it occurs, is largely executed in wood. It's a material that is universally available, and it can be worked in a very straight-forward way using the crudest of tools.

The surface treatment of the cherry wood is somewhat rough, although the contours are refined and flow smoothly into one another. The figures seem to have been finished with a rasp, or some kind of coarse abrasive. Only the bases, at the dancers' feet, retain the crisp marks from the carving tools.

The heads, hands, and the man's front are gessoed white, with the faintest trace of polychrome at the lips, eyes, and the man's bow tie. The gesso was rubbed, no doubt intentionally, exposing the raw wood. Painting sculpture is problematic. Sculpture's main concern is form, not surface embellishment,

and putting a coat of paint on a sculpture can just as easily compromise the form as enhance it. In the case of *Tango*, the result is brilliant. The gesso has the effect of reinforcing the hand gestures and the head postures, and lending a quality of mime to the dance. It also reverses a certain expected order. Clothing is normally conceived as an applied layer of material differing in character from the body it covers. Here clothing is rendered as raw material, whereas the exposed areas of the dancers' bodies are represented by a covering of pigment. In the painting as in the carving of this sculpture, Nadelman owes much of his success to the influence of folk art.

Tango could never be called a radical work of art. At a time when Western art was busy dismantling past ways of seeing, Nadelman strove to affirm them. He did this with a mastery that was not always consistent, and with a certain charm. In *Tango*, both the virtuosity and the charm are muted and the result is successful. Although the figures are beautifully carved, I think it is the energy generated between them that allows *Tango* to transcend its humble stylistic sources and the familiarity of its subject.

I find it ironic that the timelessness that is classical art's claim should find deeper expression in this little wooden object scarcely 3 feet high than in Nadelman's more mannered bronze and marble sculptures, with their more imposing scale and overt classical associations.

Henry Glassie

In Nadelman's *Tango*, the figures spin to meaning on the axis of revulsion and attraction, performing the dance of the modern.

Modernism commences in revulsion, in a passionate negation of the materialism that registers in art as naturalism. As the nineteenth century ended and the twentieth began, the tedious craft of mere depiction ceased to satisfy, and artists turned from the retinal in a search for the hidden and true, the significant and spiritual. Their quest was assisted by their attraction to alternative traditions, to works not complicit in the progress that had led to industrial capitalism and that was hurtling the world toward a war in which fourteen million human beings would perish.

The new artists, the heroes of modernism, took it upon themselves to create the future. They reached back in time, to eras before the Renaissance and the slave-built empires of antiquity. They reached out in space to the civilizations of Asia and Africa, and they discovered the homegrown wonders—least cumbersomely called folk—that were created by artists who had courageously resisted history's urge to the mundane and vain. The new artists were collectors. They gathered strange objects to honor through preservation and exhibition. The Victoria and Albert in London and Skansen in Stockholm remain as early monuments to their endeavor. And they honored strange objects by pondering them, dismembering them conceptually, and incorporating their lessons in the new creations that announced a new age.

Yeats in poetry, Bartók in music, Kandinsky in painting—the list is long of those whose creation of a new art was supported by their collection, analysis, and transfiguration of masterworks from alternative traditions. Elie Nadelman belongs to this group of vanguard creators. After study in the academy in his native Warsaw, he encountered folk art in a museum in Munich, and by 1903, when he was twenty-one, he had gone to Paris. There he wrought at the edge of Picasso's circle, driving sculpture to abstraction. Later he would claim for himself a revolutionary role in the modernist movement.

Escaping World War I, Elie Nadelman fled to New York, where his works had been part of the Armory Show of 1913. In the United States, he fell in with artists excited by American folk art, and after he married a wealthy woman, he began assembling a mighty collection of folk art that was exhibited in a museum on their estate in New York. Through two dispersions, the first when the fortune failed in the Depression, the second after his death in 1946, objects Nadelman had gathered became key components in several major collections of folk art that are still on view to the public. Another enduring consequence of Nadelman's interest in folk art abides in his sculpture. *Tango* is a fine example. He had looked closely.

A refined eye would do, but the eye was aided in Nadelman's day by the democratic and spirited rhetoric of the painter Wassily Kandinsky, and by the social-scientific theory taught in New York City by another immigrant, the anthropologist Franz Boas, whose great career had been propelled by examples of Northwest Coast Indian art that he had seen in Berlin. Validated by study in the contexts of their own tradition and predicament, standing forth in their own excellence, the alternative arts, those that lay beyond the sweep of Western history, did not bear solutions to the problems of modernism by accident. Academic art, after the Renaissance, took shape in a culture of science and humanism; it acquiesced to the ideology of progress and became, thereby, marginal in global terms. The arts of the center offered alternatives.

At the center of the world of art, recent folk art connects to the art of the European Middle Ages, to the art of the native people of Africa, the Americas, and Oceania, to the high arts

of Buddhism, Hinduism, and Islam. The world's dominant arts are characterized by the abstraction of essences and their geometric composition into transcendent forms capable of approaching the eternal. Rooted in disciplined craft and flowering in service to the sacred, these arts—alternative, marginal in the Western academic view, but dominant, central from a global perspective—grow in a cosmological environment in which naturalism is irrelevant, in which the goal is not mimesis or expressivity or novelty, but perfection.

In its search for the abstract, for what Nadelman called significant form and Kandinsky called the spiritual, the eye lit upon the art termed primitive and folk, the art that held the spirit in significant form. Then the mind grasped, and when the hand moved anew, the result was a synthesis of familiar convention and foreign tradition.

Action moved in both directions. The artist of the modern looked backward and outward to find the way forward, employing imported spirit in hybrid works to avoid the dead end of materialism. And the artist of the spirit, adapting to change and drawn to the material, created works marked by odd, charming effects. In their portraits, people out of the world are pictured like the gods: the face is placid, the body stiffens toward symmetry in flat, timeless light. The motion is opposed; the product is similar. In stepping toward the spiritual, while the folk artist stepped toward the material, Nadelman located the same point of synthesis. His dancers shift out of the frontal symmetry of the sacred; they begin to move like human beings, and then they know no joy. Their faces are composed in geometric indifference. Like deities, like Shiva in his cosmic dance, unlike waltzers by Renoir, they are bereft of the right to sensual commitment. Outside time's flow, they might be gods. They might be dead. Pale gesso, like that exposed beneath the paint of a worn wooden saint, shrouds their faces, distancing them from the blush and glow of real dancers.

The abstract, symmetrical form of spiritual art is sheathed with a smooth, luminous surface. In all the great religions, light is a sign of the spirit. The colors are rich, the face of the deity blazes in a halo, the skin is polished to capture the light of the divine and reflect it back to the world. Had Elie Nadelman fully embraced the spirit of folk art, his figures would have been coated in glossy enamel. Then they could have danced before the gods. Instead, they fit an atheistic age of subdued hues in which the glittery brilliance of the sacred is dismissed as kitsch. Nadelman's surface is disturbed. His figures do not resemble sculpture fresh from the atelier of a master of the spirit. They seem like trophies from a hunt through posh antique shops. Unlike folk art, they do not vitalize the past. They deaden the present. Ghosts perform the latest dance, all the rage. It looks tiring. The dancers do not escape time into the eternal. They slide backward, decaying into history, trapped by the dance, unable to free themselves or achieve an embrace.

Sacred art seeks union, its embrace is firm. Mary holds her son, the Light of the World. Radha and Krishna intertwine and smile in delight. The stars on the bright, intricate face of Islam submit, coalescing in the perfect union of God's love. Embrace is not for Nadelman. He pulled away from the workaday world, with its flaws and fusion, and reached for abstract form, but he did not follow abstraction to its end, into the bliss of oneness, symbolized in art by coherence and radiance. He held folk art, as he did the messy world, at arm's length, missing its deepest message and sculpting people who look worn, distressed by life, abraded at their extremities into artifacts extracted from an archaeological dig.

Elie Nadelman was caught between, stopped in uncertainty, and that is where he caught his dancers. The title implies they are dancing, and that is useful, for it could seem as though a fine woman were giving a masher a chop to the belly. They are stuck in their pose, as Nadelman was stuck in his dilemma, as we are in ours. The studied elegance of form that Nadelman shares with the folk artist is not put in service to the sacred. It recapitulates the modern, its tense unease, its dance between revulsion and attraction.

Marsden Hartley

Painting, Number 5 *1914–15*

Marsden Hartley (1877–1943)
Painting, Number 5, *1914–15*
Oil on canvas, 39 1/2 x 31 3/4 in.
(100.3 x 80.6 cm)
Gift of an anonymous donor 58.65

Peter Gay

What does Marsden Hartley's *Painting, Number 5* mean? I am looking at the picture and perform a little thought experiment. Suppose I know nothing about the artist who painted it, nothing about his other work, his native country, his artistic education, his travels, his sexual tastes. What could the painting *mean*—supposing it was meant to mean something? I could offer a subjective response: I enjoy the energy of the brushwork and the freedom with which the artist has juxtaposed his colors. Or I could flee to a formal exegesis and talk of the way that strong straight lines intersect with equally strong circular forms.

There is yet another way of trying to understand this painting without having recourse to external information. *Painting, Number 5* is not altogether non-objective. Rather like the Kandinskys of 1905 or the Mondrians of 1914, it gestures at the objects in the real world, though some of their objective correlatives may be controversial. Toward the lower right, we see what might be a chessboard, echoed at the top in blue and white. Above the two central circles a striped black-and-white flag seems to be fluttering, and there are striped forms that probably belong together and look like fragments of flags, varying from white, black, and red to white, blue, and white. There are disklike circles, one small with a red center

embraced by a white penumbra, and at the bottom a larger, more complex one, reduced to a semicircle. There are five small colorful objects on a blue ground that look like epaulets. There is, in the lower part of the painting, a figure that looks like a slightly truncated 8, and there are other shapes.

I have left to the end the two most conspicuous images, both hugging (or competing for) the center: a red cross, partly covering the image below, inscribed in a circular black surface and surrounded by two concentric rings. The artist may be playing a witty semantic game with the viewer: the object is certainly a red cross, but its shape and the little sphere it inhabits have nothing to do with the Red Cross. With a sense of relief, I turn to the second central object and need not hesitate to name it: it is unmistakably a well-known German medal, the Iron Cross.

If I were to rank the "realistic" elements in *Painting, Number 5* according to certainty of identification, I would put the Iron Cross first, the 8 next, then the epaulets. The flags offer some resistance, though they have been lent a certain plausibility as flags by the shapes, especially the medal, with which they coexist.

After surveying the individual elements as if in a Rorschach text, it seems reasonable to suggest that the painter was thinking of war, or at least of warlike attitudes or memories. But was it painted by a militarist or a pacifist? With only the picture to go on, I would be inclined to opt for the former. A satirist who detests armies and wars would have made his message more obvious, to persuade viewers that war is hell. Probably the painting displays a single soldier. That is, I think, as far as we can go.

There is something teasing about semi-abstract art. It at once offers and withholds a message. Completely non-objective paintings give informed guesses no purchase. They may have a concrete significance—a bouquet to a lover, an experiment in color combinations, esoteric worship. That will become clear only after one has been told by someone who has good reason to know. In contrast, figurative paintings are generally clear enough, although with them, too, what one sees at first does not necessarily reveal what it is designed to convey. The moralistic messages that inform seventeenth-century Dutch genre paintings are a case in point: one "gets" their meaning only if one has studied Dutch proverbs.

But, as I have noted, a semi-abstract work of art like *Painting, Number 5* is at once open and concealed. It divides viewers between the few insiders who know and the many outsiders who will never know. Granted, most paintings have had their enigmas. Who *are* the *demoiselles* in Picasso's breakthrough canvas? *What* is Mondrian showing with his Plus and Minus paintings? Through most of history, such clouds enveloping a work of art have been easily dispelled; a smattering of biblical or classical lore will suffice to make its subject explicit. We stand at the Baptistery in Florence and admire the skill with which the sculptor has depicted a sturdy middle-aged man who seems about to slaughter a youngster, while a winged being swoops from the top and grabs the assassin's arm. That we say, is a Sacrifice of Isaac. We see a painting of a handsome, naked young man looking appraisingly at three equally young beauties, and we need not read the label: that is a Judgment of Paris. With *Painting, Number 5*, such a procedure cannot work. We must learn something about the painter. At least with pictures of this sort, the road from ignorance to knowledge is blocked without external information.

1. Patricia McDonnell, "El Dorado: Marsden Hartley in Imperial Berlin," in McDonnell, *Dictated by Life: Marsden Hartley's German Paintings and Robert Indiana's Hartley Elegies*, exh. cat. (Minneapolis: Frederick R. Weisman Art Museum, University of Minnesota, 1995), p. 27.

2. See Gail Levin, "Marsden Hartley in Berlin 1913–1915," in *Marsden Hartley: Six Berlin Paintings 1913–1915*, exh. cat. (New York: Salander-O'Reilly Galleries, 1992), p. 12.

3. Gail R. Scott, *Marsden Hartley* (New York: Abbeville Press, 1988), p. 46.

My thought experiment, in short, was a failure. We must consult biographies of Hartley and much (though not all) is quickly revealed. We learn, for example, that Hartley took an almost obsessive interest in the number 8, which explains its appearance in *Painting, Number 5*.[1] Equally revealing and far more important is Hartley's homosexual bent. The painting, like another he did at the time, is a eulogy for a beloved German officer, Karl von Freyburg, who was killed on the Western front in October 1914. It made the Iron Cross just conferred to Freyburg a hollow gesture—at least to Hartley. He loved soldiers but (much like his contemporary Stefan George, perhaps Germany's leading aesthete and poet) he hated the war because it threatened to decimate his circle of friends.[2] The meaning of *Painting, Number 5*, then, is a farewell to von Freyburg: "I loved you, I miss you greatly, I shall never get over you." In other paintings, Hartley made his passion more explicit by including his beloved's initials "KvF" on the canvas.

Much has been written about Hartley's homosexuality and little remains to be said. But there are two elements in his life and work that deserve special emphasis. For one thing, Hartley's war paintings done in Berlin were more than personal tributes. He had come to Berlin from Paris, and nothing could have pleased him more; he had come home. Here was the capital of a culture at once neat and imaginative, alert to technical advances and open to mystical experience. The French, though Hartley admitted they had interesting painters, had struck him as irresponsible, cliquish, impossible to reduce to the orderliness that Hartley craved. They were realists, their minds closed to the vague mysticism that Hartley infinitely preferred to the secularism he diagnosed in all Paris. The French were "Bohemian."[3] Berlin, an imperial garrison town, struck Hartley as a delightful alternative: the parades did not only show off dazzling uniforms, but also displayed a readiness to subject one's selfish identity to some higher ideal that the French lacked. That at least some of the soldiers seemed physically desirable to Hartley goes almost without saying.

For another thing, it is worth pondering why Hartley chose to express his emotional needs with a semi-abstract series of paintings. Students of Hartley have noted that he was easily influenced, and that Cubism, Expressionism, abstraction—among other styles—all left their mark on his work. Yet, as has been said in his defense, Hartley took these models and made them his own. A Hartley is unmistakably a Hartley. But his choice of what I called a teasing style was for him an attempted solution to an insoluble problem.

Berlin was more candid about "inversion," as they then called it, than other cities, certainly more than American cities. The closet in which a homosexual found himself—even in Berlin—was permanent. As recent scandals had left no doubt, even influential aristocrats with access to the imperial throne could not evade the censoriousness of their countrymen. An abashed silence, then, was for Hartley the command of good sense. But he found total silence impossible; his passions were too urgent, his need to remember the love he had lost too pressing, to let him deny his feelings in what mattered most: his art. Certainly one did not need to be homosexual to choose a semi-abstract style, but for Hartley it perfectly manifested the conflict he could neither resolve nor forget. I never thought I should be quoting Marshall McLuhan, but here he fits: in *Painting, Number 5* the medium is the message.

1. Ralph Waldo Emerson, "Self-Reliance" (1840), in Stephen E. Whicher, ed., *Selections from Ralph Waldo Emerson* (Boston: Houghton Mifflin, 1960), pp. 148–49.

2. Marsden Hartley, *Somehow a Past: The Autobiography of Marsden Hartley*, ed. Susan Elizabeth Ryan (Cambridge, Massachusetts: The MIT Press, 1997), p. 181.

Charles Eldredge

"Trust thyself: every heart vibrates to that iron string." What young man could resist Emerson's hortatory summons to self-reliance? Not Marsden Hartley. As an aspiring artist, poet, and essayist, and a would-be modernist, emerging from the unlikely crucible of rural Maine, Hartley took solace from his fellow Yankee's assurance that "Whoso would be a man, must be a non-conformist." When the philosopher preached that "Nothing is at last sacred but the integrity of your own mind," surely Hartley must have thought he was being addressed directly.[1]

Hartley was in thrall to the inspiring words of Ralph Waldo Emerson. He received a volume of Emerson's essays from a teacher in 1898, and ever after regarded it as his "bible." Years later, Hartley still recalled "reading it on all occasions, as a priest reads his Latin breviary on all occasions. It seemed so made for me—circles, friendship, the oversoul, and all that." For the young painter, Emerson's essays were nothing less than "holy script."[2]

Hartley's enthusiasm was characteristic of many in his generation, for whom the Concord sage provided inspiration and revelation, even a holy script. Although Emerson and his Transcendentalist cohorts were long gone by the time Hartley emerged in the public eye, their philosophical tenets were still vital, their teachings still pertinent.

Like Emerson, Henry David Thoreau inspired the emerging moderns. For Waldo Frank, Hartley's friend and one of the most influential young critics of the early modern period, Thoreau's "life and his literary work are a whole so simple, so harmonious—strong, that any eager American mind may take him in." In the complex new society, the Transcendentalist seemed more vital than ever. "Thoreau

grows today in our need," Frank continued. "Homogeneous America had no thirst for his simple statement. Now, our life is intricate and hot with clashing consciences." For Americans of Frank and Hartley's generation, "Thoreau is like cold, clear water against our fever."[3]

If Thoreau could cool the fevered creator, he and Emerson could also inspire him. The latter advised that, "in our fine arts, not imitation, but creation is the aim....The details, the prose of nature [the painter] should omit, and give us only the spirit and splendor." Similarly, in preparing a portrait, "he must inscribe the character, and not the features."[4] To a modernist like Hartley, Emerson's advice provided inspiration both for the making and the perception of art. For Emerson, the creative act was akin to the spiritual, insofar as it involved aesthetic judgment and choice: "All spiritual activity is abridgment, selection."[5] So too was the artist's creative act.

The power of artistic vision, of abridgment and selection, set painters apart from the common breed, ranking them among Emerson's "leaders of society." (For a young painter, as yet uncertain of his talent and his calling, this was heady stuff indeed!) Emerson valued those "minds [who] give an all-excluding fullness to the object, the thought, the word, they alight upon," and the artist's vaunted position was due to this "power to detach, and to magnify by detaching...to fix the momentary eminency of an object."[6] This transcendence won the modernists' attention; for instance, Hartley also admired Thoreau's "rare secret of complete identity with the object of his excitement."[7]

3. Waldo Frank, *Our America* (New York: Boni and Liveright, 1919), p. 153. Frank later wrote the introduction to Hartley's volume of critical essays, *Adventures in the Arts* (New York: Boni and Liveright, 1921).

4. Emerson, "Art," in *Essays*, 1st series (New York: Wm. L. Allison, n.d.), pp. 347–48.

5. Emerson, journals, September 1, 1838, in Whicher, ed., *Selections*, p. 92.

6. Emerson, "Art," pp. 350–51. Emerson's rhetoric was echoed in Hartley's praise for Albert Pinkham Ryder, "the painter poet of the immanent in things"; Hartley, *Adventures in the Arts*, p. 41.

7. Hartley, "Letters Never Sent. To E.D.," 1938, Yale Collection of American Literature, Beinecke Rare Book and Manuscript Library, Yale University, New Haven (hereafter YCAL); also, Archives of American Art, Smithsonian Institution, Washington, D.C. (hereafter AAA), reel 1368, frame 483.

8. Hartley, "Mexican Vignettes," 1932, YCAL and AAA, reel 1368, frame 526.

9. Emerson, "Nature" (1836), in Whicher, ed., *Selections*, p. 30.

10. Hartley to Alfred Stieglitz, February 1913, YCAL; quoted in Roxana Barry, "The Age of Blood and Iron: Marsden Hartley in Berlin," *Arts Magazine*, 54 (October 1979), p. 167.

The objects of Hartley's excitement were many and varied over a long, itinerant career. While his style changed as often as his settings and subjects, there was throughout (despite the artist's sometime protestations to the contrary) an ongoing subjectivity in the art that reflected a Thoreauvian "identity with the object of his excitement."

Early evidence of this was offered in the wartime series of Berlin military abstractions, the most famous of which, *Portrait of a German Military Officer* (1914; The Metropolitan Museum of Art, New York), has long enjoyed an iconic place in the annals of modern American art. But the Metropolitan painting was scarcely unique. Rather, it was part of an extended series of pictorial ruminations on symbolic objects and the nature of portraiture. Hartley's was an Emersonian effort to give "the spirit and splendor," inscribe the subject's character and not just the features, to achieve transcendent identity with the object of excitement. *Painting, Number 5* is a prime example of that subjective exploration.

For Hartley, the painter's challenge was not to render the beautiful, but to reveal "the magic [that] is beneath the surface of what the eye sees....I want to paint that which exists between me and the object."[8] Or, in Emerson's words, to realize "an abstract or epitome of the world...[an] expression of nature, in miniature."[9]

In 1913, Hartley moved from Paris to Berlin, where the spiritual concerns of his youth found sympathetic resonance among the Germans. To his patron Alfred Stieglitz, he explained that "it is in Germany that I find my creative conditions—and it is there that I must go....I proceed at once to place myself among the German mystics...."[10] In addition

to spiritual company, Wilhelmine Berlin provided Hartley with exciting themes, especially the military element which, he reported, "stimulates my child's love for the public spectacle."[11] He remarked excitedly that "From these sensations I hope to produce something in time."[12] And soon he did. The military spectacle prompted designs incorporating forms of mounted, helmeted soldiers in colorful regalia. However, after his close friend, Lt. Karl von Freyburg, the embodiment of manly virtue, was killed in battle on the Western front in October 1914, Hartley was pitched into a despondency which altered his treatments of the military theme. Soldiers, animals and birds, and other subjects drawn from the prewar environs and arrayed on colorful grounds yielded to more abstract forms, painted against somber fields of black. The representational images of 1913–14 gave way to increasingly abstract designs derived from flags, banners, and military insignia, coupled with symbolic letters and numbers.

Hartley's preoccupation with the fallen German officer signaled a fascination with death. The mortal theme had been suggested earlier by Hartley's brooding Maine landscapes, reminiscent of Albert Pinkham Ryder, whom he considered "the father of my esthetic convictions."[13] The motif recurred periodically throughout his lifetime, culminating in the series of symbolic still lifes and archaic portraits of Nova Scotia fisherman, but arguably found its most memorable expression in the military paintings of 1914–15.

Late in life, Hartley continued the funereal theme in a series of "Letters to the Dead," among them one to the late lieutenant. In it, Hartley recounted a dream about the dead soldier: a large snake, with mouth agape, writhed in flames (an apparition worthy of William Blake), after which von Freyburg appeared, "clad in full uniform, but the uniform

11. Hartley to Rockwell Kent, [March 1913], AAA; quoted in Gail Levin, "Hidden Symbolism in Marsden Hartley's Military Pictures," *Arts Magazine*, 54 (October 1979), p. 157.

12. Hartley to Stieglitz, June 1913, YCAL; quoted in Barry, "The Age of Blood and Iron," p. 169.

13. Hartley, untitled statement about Ryder, typescript, YCAL and AAA, reel 1368, frames 769–70.

14. Hartley, "Letters to the Dead. Karl von Freyburg," 1938, YCAL and AAA, reel 1368, frames 438–47. Hartley also recalled the vision in his late poem, "K. von F.—1914—Arras-Bourquoi"; Gail R. Scott, ed., *The Collected Poems of Marsden Hartley* (Santa Rosa, California: Black Sparrow Press, 1987), p. 219.

15. Hartley, "Copley's Americanism" (c. 1930), in *On Art*, ed. Gail R. Scott (New York: Horizon Press, 1982), p. 176.

purged of all military significance was white." In the dream state, the hero had achieved immortality, the luminous soldier becoming the "symbol of an exact idea." If the ghostly image provided one sort of immortality, Hartley also held more tangible remains of the friendship. "I have the few souvenirs of your departure still," Hartley wrote, "—your silver shoulder straps with glittering copper buttons of the now defunct regime—as brilliant as the day you wore them in your youth." He wondered: "Why does one hold to objects with affection—but, one does."[14] It was these souvenirs of the dead that prompted the military abstractions of 1914–15, replete with copper buttons, Iron Crosses, flags of Bavaria and the German state, as well as the black-and-white pattern associated with von Freyburg's favorite game, chess.

In what might seem an unlikely subject for the modernist, Hartley once wrote admiringly of John Singleton Copley. He praised the Colonial master's tonal range and the fresh conceptions in his portraits, "as if he had a strong aversion to conventional sensibilities, and sought to recreate them by fresh personal standards." Copley's palette avoided the "banalities of color and tone which are apt to appear in so much painting, especially portrait painting, and most of all, sought to avoid all cloying sweetness...."[15]

Although totally different in appearance, Hartley's Berlin military paintings likewise suggest a novel chromatic sensibility and are mercifully free of cloying sentiment. He combined the abstracting tendencies of Transcendentalism, which were his by personal inclination as well as native tradition, with the formal inventions of the European moderns and the occult symbolism of the mystics to effect a revolutionary mode of portraiture. The German military paintings convey place and personality through distillation of significant forms and subjects, thereby achieving the "abstract or epitome" of the world prescribed by Emerson.

Patricia McDonnell

Karl von Freyburg was a lieutenant in the German military when he died on October 7, 1914, an early casualty of World War I. He had been American painter Marsden Hartley's close friend, possibly his gay lover. The two first met in Paris in 1912, but Hartley moved to von Freyburg's Berlin by spring 1913. Hartley remembered him in a 1914 letter as "a true representative of all that is lovely and splendid in the German soul and character."[1]

Painting, Number 5 is part of the War Motif series, twelve known paintings by Hartley which began as a response to his friend's death. This work memorializes von Freyburg, but it does much more as well. It is an amalgam of meanings and signs. Its continuing power depends on the fact that it and others in the series are many things at once—they speak multiple languages and tell complicated stories.

Scholars agree that the works in Hartley's War Motif series stand as icons in the history of American painting and international avant-garde art. With these paintings, Hartley launched into abstraction and put himself on equal footing with the most radical painters of his day. In 1912 to 1915, he moved quickly between London, New York, Paris, and Berlin, feasting on art and learning about his own as he went. He admired Picasso, Kandinsky, Franz Marc, and wove the inspiration he drew from their Cubism and Expressionism into daring canvases. The result is pure Hartley, an original modernist voice of his own devising.

His stunning pictorial vocabulary articulates his various experiences in Wilhelmine Berlin, a dynamic and teeming metropolis. The city became the imperial capital of the newly federated principalities of Germany after the country's triumph in the Franco-Prussian War of 1871. As the new center of a powerful nation and as its industrial and cultural heart, Berlin was electric with energy, and Hartley was infatuated with it. He found it "packed with the live-wire feeling" with an "intense flame-like quality of life."[2] His agitated German canvases give visual form to that energy. Patches of bold primary colors knit together in flat, unmodulated fields. They blare raucously from the canvases, which conjoin a tumble of disassociated parts. Here a recognizable motif drifts, there an abstract element jumps forth—creating a dizzying effect that replicates the whirl of metropolitan Berlin in the years of Wilhelmine rule.

An essential element of life in Berlin under Kaiser Wilhelm II was its pervasive male culture. Hartley registers this too in his paintings—they act as barometers and bring so many cultural phenomena then at play into focus. Hartley

1. Marsden Hartley to Alfred Stieglitz, March 15, 1915, Yale Collection of American Literature, Beinecke Rare Book and Manuscript Library, Yale University, New Haven (hereafter YCAL).

2. Hartley to Stieglitz, May 9, 1913, YCAL; Marsden Hartley, *Somehow a Past: The Autobiography of Marsden Hartley*, ed. Susan Elizabeth Ryan (Cambridge, Massachusetts: The MIT Press, 1997), p. 86.

3. Hartley to Rockwell Kent, March 1913, quoted in Jonathan Weinberg, *Speaking for Vice: Homosexuality in the Art of Charles Demuth, Marsden Hartley, and the First American Avant-Garde* (New Haven: Yale University Press, 1993), p. 147.

4. Hartley to Stieglitz, May or June 1913, YCAL.

5. Hartley, *Somehow a Past*, pp. 86–87.

6. George L. Mosse, *Nationalism and Sexuality: Middle-Class Morality and Sexual Norms in Modern Europe* (Madison: University of Wisconsin Press, 1985), and *The Image of Man: The Creation of Modern Masculinity* (New York: Oxford University Press, 1996).

clearly relished the fact that "Germany is essentially masculine with masculine ruggedness and vitality."[3] A conspicuously visible aspect of Germany's Wilhelmine cult of manliness was the pomp of the court. The Kaiser was an arrogant, conservative leader who loved showy public displays of his sovereignty, perhaps in reaction to the actual limits the German government placed on his authority.

As a consequence, Berlin was alive with imperial guards, troops who escorted royalty from palace to court to Potsdam and stepped high to their own unrelenting drills. Hartley loved these processions and their colorfully uniformed soldiers. In calling Berlin "essentially the center of modern life in Europe," he described its military culture as a driving force in its dynamism. "The military life adds so much in the way of a sense of perpetual gaiety here in Berlin," he wrote in 1913.[4] When later writing his autobiography, he again emphasized that "The military life provided the key and clue to everything then—...the whole scene was fairly bursting with organized energy and the tension was terrific and somehow most voluptuous in the feeling of power—a sexual immensity even in it...."[5]

George Mosse has analyzed what Hartley calls Germany's "military life."[6] He argues that the chaos and change wrought by racing industrialization in the late nineteenth century pressured people to seek stability in most any form they could find it. In the face of sweeping change, Europeans as a whole grasped for familiar anchors from the past, customs and rituals which by virtue of their ingrained habit offered security. Gender roles flattened to stultifying clichés in this

context, and sexuality, like other spheres of social exchange, needed to fit strict codes of conduct. Men were to be manly and heroic, and women maternal and submissive. In turn-of-the-century Germany, virile manliness became a potent symbol for strength and stability in a world troubled by dislocation and disorder, and the Kaiser's ubiquitous troops were a cipher for permanence and security.

Painting the German military uniform, Marsden Hartley celebrated this Wilhelmine cult of manliness. Paradoxically, he also slyly voiced his homosexuality. Against the backdrop of social conservatism, a sizable homosexual community developed in nineteenth-century Berlin. Historians today believe that the Kaiser himself was at least bisexual and "went through life neither realizing or accepting his own homosexuality."[7] The strength of Berlin's gay community and the comparative license accorded it factor into Hartley's enthusiasm for this city. As a gay man, it is part of what allowed him to feel "every sense of being at home among the Germans."[8]

In fact, this city was the center for the formation of gay culture. The first organizations anywhere to study, encourage, support, and argue for legal freedoms for homosexuals began in Berlin.[9] This rich history, beyond the limits of this essay, is essential to understanding Hartley, his experience, and his art in Germany. Evidence confirms that Berlin's gay community exceeded thirty thousand around

7. John C.G. Röhl, "The Emperor's New Clothes: A Character Sketch of Kaiser Wilhelm II, " in Röhl and Nicolaus Sombart, eds., *Kaiser Wilhelm II: New Interpretations* (Cambridge, England: Cambridge University Press, 1982), p. 48.

8. Hartley to Stieglitz, May or June 1913, YCAL.

9. See James D. Steakley, *The Homosexual Emancipation Movement in Germany* (New York: Arno Press, 1975); Michael Bollé and Rolf Bothe, eds., *Eldorado: Homosexuelle Frauen und Männer in Berlin, 1850–1950. Geschichte, Alltag und Kultur*, exh. cat. (Berlin: Berlin Museum, 1984); *Goodbye to Berlin? 100 Jahre Schwulenbewegung*, exh. cat. (Berlin: Schwules Museum and Akademie der Künste, 1997).

10. Patricia McDonnell, "El Dorado: Marsden Hartley in Imperial Berlin," in McDonnell, *Dictated by Life: Marsden Hartley's German Paintings and Robert Indiana's Hartley Elegies*, exh. cat. (Minneapolis: Frederick R. Weisman Art Museum, University of Minnesota, 1995), p. 33.

11. James D. Steakley, "Iconography of a Scandal: Political Cartoons and the Eulenberg Affair in Wilhelmine Germany," in Martin B. Duberman, Martha Vicinus, and George Chauncey, Jr., eds., *Hidden from History: Reclaiming the Gay and Lesbian Past* (New York: New American Library, 1989), p. 233. See also Isabel Hull, "Kaiser Wilhelm II and the Liebenberg Circle," in Röhl and Sombart, *Kaiser Wilhelm II*, pp. 193–220.

12. As quoted in Allen Ellenzweig, *The Homoerotic Photograph: Male Images from Durieu/Delacroix to Mapplethorpe* (New York: Columbia University Press, 1992), p. 89.

1910.[10] Understanding the norms of the day, most of this community operated in the camouflage of the closet, however, and are not tallied in this count. For all the relative tolerance accorded gay men in Wilhelmine Berlin, the practice of homosexuality was still a criminal offense.

One safe haven where German homosexuals could find one another in this period was the military. The entire world became aware of this fact when a scandal of international proportion broke in 1907. In its aftermath, the German soldier became a symbol for homosexuality the world over. Historian James D. Steakley, whose research tells of the cultural repercussions of this flap, argues that its legacy "contributed to the making of modern homosexuals."[11] The scandal was called the Eulenberg Affair, after a central character, Philipp Prince zu Eulenberg-Hertefeld, a Prussian nobleman who counted among Kaiser Wilhelm's closest friends. He and another member of the same circle, Kuno Count von Moltke, were identified as homosexuals, as "perverts," in the April 1907 press. A series of trials ensued which continued into the Weimar period. Especially at the beginning, these trials attracted international attention, partly due to the titillating sensation caused by the charges of homosexuality and partly to the accused men's high rank and close proximity to the Kaiser. In the end, no one actually did jail time, but the affair allowed the public into the bedrooms of the Kaiser's advisers and into the barracks of his high-standing officers. The news was that homosexuality was not only common knowledge among the German military, it was also commonplace.

Marsden Hartley moved to Berlin in 1913 while the trials still persisted. No direct evidence exists that he knew of this scandal. Nonetheless, as a gay man in Berlin who counted German officers among his friends, including von Freyburg, he could not have avoided the public connection between homosexuality and the German military. When he began to paint German soldiers, Hartley handled an imagery charged with specific references in a specific setting. In fact, he discovered an avenue to represent his own homosexuality in his art.

In an era of strict social and sexual proprieties, homosexual men and women were not free to disclose their sexual sides. Instead, they turned to the art of the code and invented cryptic ciphers which would signal homosexuality to a knowing viewer, while concealing it from the average passerby. There is a wealth of evidence from gay artists in this period that acknowledges this system of covert signs. As just one example, French Surrealist and gay author Jean Cocteau stated that "Homosexuals recognize each other.... The mask dissolves, and I would venture to discover my kind between the lines of the most innocent book."[12] Hartley devised just this sort of mask by depicting the German military from 1913 to 1915.

His War Motif paintings offer a sophisticated construct of meanings, with many things posed at once. Their importance lies in the breadth of artistic and cultural concerns they encompass. They achieve a level of pictorial innovation rivaling the best in the period and celebrate the frenetic dynamism of Berlin's early metropolitan culture. They feature the overblown masculinity of the Wilhelmine era and signal Hartley's identity as a gay man within it. They commemorate the lost youth of World War I and memorialize Karl von Freyburg in particular. *Painting, Number 5* and other works in this major series present a visual and intellectual tour de force that speaks eloquently of its time.

Acknowledgments

The underlying philosophy of this publication emerged from a long-standing resolve to reconsider how a museum's collection can open doors to new ways of understanding well-known art works. The very nature of such an undertaking is collaborative, and all who have contributed their thoughts, criticisms, and encouragement are owed an enormous debt of gratitude.

Above all, we wish to thank the authors who joined with us in realizing the potential of this project. Kennedy Fraser wove together not only an informative and captivating narrative of the Whitney Museum's beginnings, but also an inspired tribute to the many facets of its founder. Her admiration for Gertrude Vanderbilt Whitney makes a fitting and engaging introduction to this volume.

For the section entitled "American Icons Interpreted," thirty authors accepted our challenge to write about a familiar work from a new or unexpected perspective. We applaud their adventurous spirit and thank them for their wonderfully diverse methodologies and analyses. Their patience and understanding throughout the sometimes long and arduous gestation of this book was especially appreciated. And we honor the memory of Brendan Gill and Alfred Kazin, who both contributed insightful essays.

For the section "Visual Contexts for American Art," we sought to unite the collective knowledge of several current and former Whitney staff members. Kate Rubin penned some of the first entries, providing a framework for those that came after. Kathryn Potts not only wrote a number of texts for this volume, but also offered thoughtful perspectives and contributed immeasurably to the way in which the

publication was conceptualized. We have long relied on Angela Kramer Murphy for her consistently solid and informative prose in Whitney projects; once again, she has made a stellar contribution to a Museum endeavor. In our work on this section, we drew on the original scholarship of many of our colleagues in the field. We thank them collectively for establishing the foundations for our analyses of individual art works.

Numerous Whitney staff members played a role in shaping this book. Their belief in the unique character of the project and in the value of such a collaborative venture has been essential. Kate Rubin joined in many initial meetings as we solidified the overall concept and began to identify the various perspectives that could be explored. She conducted extensive research on works of art and collateral illustrations and became a great advocate for the book during its formative stages. Jean Shin enthusiastically delved into the Whitney's past for her useful compilation, "The Whitney: Biography of an Institution." Her intelligent perceptions and keen understanding of the Museum's unique character form an important part of this book.

We are especially grateful to Naomi Urabe, who authored one of the "Visual Contexts" entries and who served as project coordinator through all but the last stages of the book. Her diligence, patience, and good humor were a great asset. Yukiko Yamagata bore the sometimes thankless task of coordinating the publication's many details during its last stressful months of production, when the pressure of deadlines loomed; we thank her for jumping in at such a critical time. Other curatorial staff as well as interns in both the curatorial and Publications and New Media departments obliged us by lending assistance at key moments. We heartily thank Sarah Choi, Susan Cooke, Anne Hartshorn, Jillian Krell, Min Lee, Veronica Roberts, Jessica Royer, Christine Sciacca, and Zoe Starling.

This book would never have come to fruition without the constant support and tireless encouragement of the entire staff of the Publications and New Media Department, who never wavered in working to fulfill our initial ideals—with the highest standards of scholarship and publishing. The nontraditional nature of this book placed an extra strain on the ambitious department, from the initial concept and photo research through editing, design, and production. In short, the collaboration of Publications and New Media has been essential and invaluable.

We also owe a great debt of thanks to designer J. Abbott Miller and his staff. As so much of this book is dependent on visual no less than verbal analysis, their involvement has gone beyond that usually found in an art publication: their work is integral to the very conception of this book.

We are indebted to the numerous institutions, foundations, estates, private collectors, and artists who provided us with images and granted us permission to reproduce works from their collections. Above all, we wish to acknowledge the overwhelming support of Flora Miller Biddle, who encouraged us and counseled us not only about this book, but in all our work at the Museum. As always, we thank her for sharing her knowledge and are especially grateful for her generosity in making available photographs from the Gertrude Vanderbilt Whitney family albums. Her enthusiasm for this project continues a family tradition of commitment to collecting, exhibiting, and studying twentieth-century American art.

Beth Venn and Adam D. Weinberg

Robert Adams is best known for his photographs of the American West. His numerous publications include *The New West: Landscapes Along the Colorado Front Range* (1974), *Denver: A Photographic Survey of the Metropolitan Area* (1977), and *To Make It Home: Photographs of the American West* (1989). Adams' work has been widely exhibited. He is the recipient of the Charles Pratt Memorial Award (1987) and two fellowships from the John Simon Guggenheim Memorial Foundation (1973 and 1980).

Maurice Berger, cultural historian and art critic, is a senior fellow at the Vera List Center for Art and Politics of the New School University in New York. His books include *Labyrinths: Robert Morris, Minimalism, and the 1960s* (1989), *How Art Becomes History: Essays on Art, Society, and Culture in Post-New Deal America* (1992), and *White Lies: Race and the Myths of Whiteness* (1999). He has also written articles for *Art in America, Artforum, The Village Voice*, and *October*.

Alan M. Dershowitz is Felix Frankfurter Professor of Law at Harvard University and one of America's leading defenders of individual rights. An appellate lawyer who writes for the layman as well as the specialist, Dershowitz has published widely, including *The Best Defense* (1982), *Reversal of Fortune: Inside the von Bulow Case* (1986), *Chutzpah* (1991), and *Just Revenge* (1999).

Marianne Doezema, formerly on the staff of the National Endowment for the Humanities, is currently director of Mount Holyoke College Art Museum, South Hadley, Massachusetts. She is an expert on the art of George Bellows and the author of *George Bellows and Urban America* (1992).

Charles Eldredge is Hall Distinguished Professor of American Art and Culture at the University of Kansas and former director of the National Museum of American Art, Smithsonian Institution, Washington, D.C. Among his many publications are *Marsden Hartley: Lithographs and Related Works* (1972), *American Imagination and Symbolist Painting* (1979), and "Nature Symbolized: American Painting from Ryder to Hartley," in *The Spiritual in Art: Abstract Painting, 1890–1985* (1986).

Lewis Erenberg is professor of history at Loyola University of Chicago. A social historian specializing in American entertainment and popular culture, Erenberg is the author of *Steppin' Out: New York Nightlife and the Transformation of American Culture, 1890–1930* (1981) and *Swingin' the Dream: Big Band Jazz and the Rebirth of American Culture* (1998). He has been the recipient of a Mellon Grant (1979) and a Fulbright Senior Fellowship (1990–91).

Kennedy Fraser grew up in England and has lived in New York City for many years. A longtime writer for *The New Yorker*, she is also a contributing writer to *The New York Times* and *Vogue*. She has been a Guggenheim Fellow and the recipient of a Whiting Writer's Award and is the author of *The Fashionable Mind: Reflections on Fashion, 1970–1981* (1981), *Scenes from the Fashionable World* (1987), and *Ornament and Silence: Essays on Women's Lives* (1996).

Howard Gardner is Hobbs Professor of Cognition and Education and adjunct professor of psychology at Harvard University. A former MacArthur Fellowship winner (1981–86), he is considered one of America's leading authorities on the mind and creativity. He is the author of *Art, Mind and Brain: A Cognitive Approach to Creativity* (1982) and *Creating Minds: An Anatomy of Creativity...* (1993) among many other works.

Peter Gay, distinguished educator and author, is Sterling Professor Emeritus of History at Yale University and director of the Center for Scholars and Writers, The New York Public Library. His many scholarly works include *Weimar Culture: The Outsider as Insider* (1968), *Art and Act: On Causes in History—Manet, Gropius, Mondrian* (1976), and *Freud: A Life for Our Time* (1988). In 1967, he received the National Book Award for *The Rise of Modern Paganism* (1966).

Brendan Gill was perhaps best known for his memoir *Here at The New Yorker* (1975). A contributor to *The New Yorker* for many years, Gill was also a poet, art, film, and drama critic, and the author of many works of fiction and nonfiction. His recently published works include *Many Masks: A Life of Frank Lloyd Wright* (1987) and *Flatiron: A Photographic History of the World's First Steel Frame Skyscraper, 1903–1989* (1990). Gill was active in New York City cultural affairs and landmarks preservation for many years. He was chairman emeritus of the Institute for Art and Urban Resources, a Trustee of the Whitney Museum of American Art, and a founder of the Landmarks Conservancy of New York.

Henry Glassie is one of America's leading experts on folk art and architecture. Currently professor of folklore at Indiana University, Glassie is former president of the American Folklore Society and a former Guggenheim Fellow. Among the titles he has published are *Pattern in the Material Folk Culture of the Eastern United States* (1968), *The Spirit of Folk Art: The Girard Collection at the Museum of International Folk Art* (1989), and *Art and Life in Bangladesh* (1997).

Elliott J. Gorn teaches American history at Purdue University. He is author of *The Manly Art: Bare-Knuckle Prize Fighting in America* (1986), co-author of *A Brief History of American Sports* (1993), and editor of *Muhammad Ali: The People's Champ* (1995).

Neil Harris is Preston and Sterling Morton Professor of History at the University of Chicago and writes on American cultural history. His books include *Humbug: The Art of P.T. Barnum* (1973), *Cultural Excursions: Marketing Appetites and Cultural Tastes in Modern America* (1990), and *Building Lives: Constructing Rites and Passages* (1999). He co-chairs the Visiting Committee to the J. Paul Getty Museum, Los Angeles, and sits on the board of the National Museum of American History, Smithsonian Institution, Washington, D.C.

Kathryn Harrison is the author of four novels, *Thicker Than Water* (1991) and *Exposure* (1993), both *New York Times* Notable Books, *Poison* (1995), and *A Visit from the Foot Emancipation Society* (2000). Her memoir, *The Kiss* (1997), was a best-seller. Her personal essays and memoirs have appeared in *The New Yorker*, *Harper's Magazine*, and other publications. She lives in New York with her husband, writer Colin Harrison, and their children.

Alfred Kazin was Distinguished Professor of English (Emeritus) at the Graduate School and University Center, City University of New York. He wrote many books on American literature and on the experience of growing up Jewish in New York City. Among his best-known titles are *A Walker in the City* (1951), *New York Jew* (1978), and *A Writer's America: Landscape in Literature* (1988). His recently published works include *An American Procession* (1984), *A Lifetime Burning in Every Moment* (1996), and *God and the American Writer* (1997).

Lisa Mahar is an architect who has worked for Polshek and Partners and Aldo Rossi. In 1993, she won an AIA International Book Award for her book *Grain Elevators*. The following year she formed the multidisciplinary design firm MAP with her partner, Morris Adjmi. Her second book, *American Signs: Tradition and Innovation On Route 66*, is forthcoming.

Karal Ann Marling has written extensively on American art and culture in the first half of the twentieth century. She is professor of art history and American studies at the University of Minnesota. Among her publications are *Designing Disney's Theme Parks: The Architecture of Reassurance* (1997), *Norman Rockwell* (1997), and "*My Egypt*: The Irony of the American Dream," in the *Winterthur Portfolio* (1980).

Richard Martin is curator of The Costume Institute of The Metropolitan Museum of Art, adjunct professor of art history and archaeology at Columbia University, and adjunct professor of art at New York University. He is former editor of *Arts Magazine* and was elected a Fellow of the Costume Society of America in 1996. His many books include *Fashion and Surrealism* (1987), *The New Urban Landscape* (1990), and *Contemporary Fashion* (1995).

Patricia McDonnell is curator at the Frederick R. Weisman Art Museum at the University of Minnesota, Minneapolis. An expert on the relationship between American modernism and German Expressionism, McDonnell is the author of *Painting Berlin Stories: Oscar Bluemner, Marsden Hartley, and the First American Avant-Garde in Expressionist Berlin* (1997). In 1995, she curated the exhibition "Dictated by Life: Marsden Hartley's German Paintings and Robert Indiana's Hartley Elegies," at the Weisman Art Museum.

Angela Kramer Murphy has written for the Whitney Museum of American Art on a range of topics; her essay on Joseph Cornell and astronomy was published as part of the "Collection in Context" series. Most recently, she contributed to *The American Century* website. She also serves as audio archive project coordinator for the Skowhegan School of Painting and Sculpture, Maine.

Kathleen Norris is an award-winning poet and author of *The New York Times* best-sellers *Dakota: A Spiritual Geography* (1993), *The Cloister Walk* (1996), and *Amazing Grace: A Vocabulary of Faith* (1998), as well as three volumes of poetry, the most recent of them *Little Girls in Church* (1995). A recipient of grants from the Bush and Guggenheim Foundations, she has been in residence twice at the Institute for Ecumenical and Cultural Research at St. John's Abbey in Collegeville, Minnesota, and is an oblate of Assumption Abbey in North Dakota.

Brian O'Doherty, a.k.a. Patrick Ireland, is the author of *Inside the White Cube: The Ideology of the Gallery Space* (1986; to be republished by the University of California Press); he recently published the novel *The Deposition of Father McGreevy* (1999). As Patrick Ireland, his most recent exhibition was "Language Performed/Matters of Identity" at the Orchard Gallery, Derry, Northern Ireland (1998). His film, *Hopper's Silence*, premiered at the New York Film Festival in 1980.

Sarah Whitaker Peters has written several essays on Georgia O'Keeffe and is the author of the book *Becoming O'Keeffe: The Early Years* (1991). She was previously adjunct assistant professor of art history at Long Island University (C.W. Post campus) and a freelance critic for *Art in America*.

Henry Petroski is Aleksandar S. Vesic Professor of Civil Engineering and professor of history at Duke University, where he also serves as chairman of the department of civil and environmental engineering. Petroski's books include *The Pencil* (1990), *The Evolution of Useful Things* (1992), *Remaking the World: Adventures in Engineering* (1997), and *The Book on the Bookshelf* (1999). He has held National Humanities Center and Guggenheim Fellowships and was elected in 1997 to membership in the National Academy of Engineering.

George Plimpton is a well-known journalist and author. He writes regularly for such magazines as *Esquire* and *Sports Illustrated*. Editor-in-chief of *The Paris Review* since 1953, Plimpton has also been on the editorial staff of numerous other publications and has written more than twenty-five books. Particularly interested in sports, Plimpton published *Shadow Box* in 1997, a firsthand account of the world of professional boxing.

Frances K. Pohl is professor of art history at Pomona College, Claremont, California, and the author of two monographs on the work of Ben Shahn: *Ben Shahn: New Deal Artist in a Cold War Climate, 1947–1954* (1989) and *Ben Shahn* (1993). Her most recent book is *In the Eye of the Storm: An Art of Conscience, 1930–1970* (1995).

Kathryn Potts is head of adult programs and interpretive materials at the Whitney Museum of American Art. Before coming to the Whitney, she held curatorial positions at The Jewish Museum, New York, and the Museum of Fine Arts, Boston.

Martin Puryear is a sculptor who has had one-artist exhibitions at The Art Institute of Chicago; the Museum of Fine Arts, Boston; the Brooklyn Museum of Art; and The Museum of Contemporary Art, Los Angeles. He has been a Guggenheim Fellow (1982) and a MacArthur Foundation Fellow (1989–94). Puryear's sculpture, primarily in wood and other organic materials, and produced mostly by hand, is admired for its delicate balance of the abstract and the sensual.

Kate Rubin is a freelance researcher specializing in American art. She has an M.Phil. in American studies from Yale University and lives in New York City.

Ellen M. Snyder-Grenier is deputy director for special projects at the New Jersey Historical Society and former chief curator at The Brooklyn Historical Society. She is the author of *Brooklyn! An Illustrated History*, winner of the 1996 New York Society Library New York City Book Award, and has written extensively on American material culture.

John Updike is the author of over forty books, including eighteen novels and a book of art criticism, *Just Looking: Essays on Art* (1989).

Naomi Urabe holds an M.A. from New York University in Visual Arts Administration. She is currently curator-in-residence at About Art Related Activities (AARA), a contemporary visual arts organization, in Bangkok, Thailand. She was formerly senior curatorial/research assistant at the Whitney Museum of American Art and curated a number of independent projects in New York. She was exhibition coordinator of "Thaw" (1996) at Art in General and co-curated "Still" (1998) at De Chiara/Stewart Gallery.

Beth Venn is curator, touring exhibitions, and director, branch museums, at the Whitney Museum of American Art. Formerly associate curator of the Permanent Collection, she organized several Whitney Museum exhibitions, including "Louise Nevelson: Structures Evolving" (1998) and "Joseph Cornell: Cosmic Travels" (1996). She also curated a series of exhibitions at the San Jose Museum of Art as part of the Whitney's collection-sharing program and served as co-curator of "Edward Hopper and the American Imagination" (1995). She has an M.A. in art history from the University of Delaware.

Anne M. Wagner is professor of the history of art at the University of California, Berkeley. She is the author of *Jean-Baptiste Carpeaux: Sculptor of the Second Empire* (1986) and *Three Artists (Three Women): Modernism and the Art of Hesse, Krasner, and O'Keeffe* (1996).

Adam D. Weinberg is currently director of the Addison Gallery of American Art in Andover, Massachusetts. As senior curator of the Permanent Collection of the Whitney Museum of American Art from 1993 to 1998, he curated numerous exhibitions, including the installation of the Museum's first galleries devoted to the Permanent Collection in 1998. He also initiated and developed the exhibition series "Views from Abroad: European Perspectives on American Art" (1995–97) and "Collection in Context" (1993–98). He curated "Richard Pousette-Dart: The Studio Within" (1998) and co-curated "Edward Hopper and the American Imagination" (1995).

Robert Wilson has won numerous awards and prizes in the United States and abroad for his work as a playwright and director. Among his many productions are *The Life and Times of Joseph Stalin* (1973), *Einstein on the Beach* (1976) with music composed by Philip Glass, *Alice* (1992), and *Time Rocker* (1996). While known for creating highly acclaimed theatrical pieces, Wilson has also exhibited his drawings, paintings, and sculptures at the Museum of Fine Arts, Boston; the Contemporary Arts Museum, Houston; and the Centre Georges Pompidou, Paris.

John Yau is a poet, writer, critic, and curator who has written extensively on contemporary art. He has published nearly two dozen books of poetry, fiction, and criticism, including *In the Realm of Appearances: The Art of Andy Warhol* (1993), *Ed Moses: A Retrospective of the Paintings and Drawings 1951–1996* (1996), *The United States of Jasper Johns* (1997), *My Symptoms* (1998), and *Fetish* (1998).

This publication was organized by Beth Venn, Curator, Touring Exhibitions, and
Director, Branch Museums, and Adam D. Weinberg, Director, Addison Gallery of
American Art, Andover, Massachusetts, and former Senior Curator, Permanent
Collection of the Whitney Museum of American Art, with the assistance of Jean Shin,
Curatorial/Research Assistant, Naomi Urabe, Senior Curatorial/Research Assistant,
and Yukiko Yamagata, Curatorial Assistant.

This publication was produced by the Publications and New Media Department at the
Whitney Museum.
Mary E. DelMonico, Head, Publications and New Media
Production: Nerissa Dominguez Vales, Production Manager; Jennifer Cox, Publications
and New Media Assistant
Editorial: Sheila Schwartz, Editor; Dale Tucker, Associate Editor; Susan Richmond,
Production Coordinator/Editorial Assistant
Rights and Reproductions: Anita Duquette, Manager, Rights and Reproductions;
Jennifer Belt, Photographs and Permissions Coordinator.
Additional assistance: Sarah Newman and Christina Grillo.

Design: J. Abbott Miller and Roy Brooks, Pentagram